How Art Works

Other books by Ellen Winner

Invented Worlds: The Psychology of the Arts (1982)

The Point of Words: Children's Understanding of Metaphor and Irony (1988)

Gifted Children: Myths and Realities (1996)

Studio Thinking: The Real Benefits of Visual Arts Education
(co-authored, 2007; second edition 2013)

Studio Thinking from the Start: The K-8 Art Educator's Handbook
(co-authored, 2018)

How Art Works

A Psychological Exploration

ELLEN WINNER

OXFORD
UNIVERSITY PRESS

Oxford University Press is a department of the University of Oxford. It furthers
the University's objective of excellence in research, scholarship, and education
by publishing worldwide. Oxford is a registered trade mark of Oxford University
Press in the UK and certain other countries.

Published in the United States of America by Oxford University Press
198 Madison Avenue, New York, NY 10016, United States of America.

Library of Congress Cataloging-in-Publication Data
Names: Winner, Ellen, author.
Title: How art works : a psychological exploration / Ellen Winner.
Description: New York : Oxford University Press, 2018. |
Includes bibliographical references and index.
Identifiers: LCCN 2018010721 | ISBN 9780190863357
Subjects: LCSH: Art—Psychology.
Classification: LCC N71 .W535 2018 | DDC 700.1/9—dc23
LC record available at https://lccn.loc.gov/2018010721

For my grandchildren, Oscar, Agnes, Olivia, and Faye

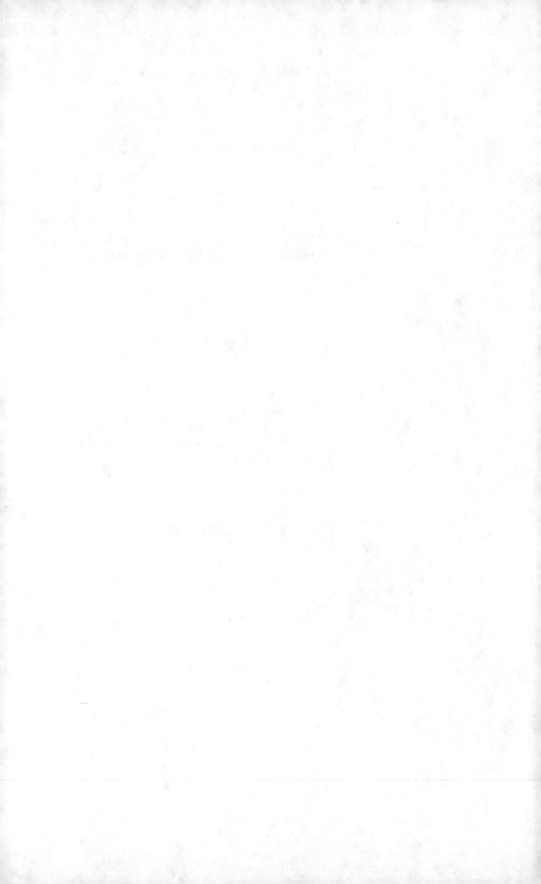

CONTENTS

ACKNOWLEDGMENTS

I thank my husband Howard Gardner first and always—for inspiring me to write this book, for encouraging me along the way, for discussing these ideas with me on our morning walks, and for the toughest and most valuable comments on drafts ever.

I also want to express my deep gratitude to my philosophically oriented lab manager, Nat Rabb, who played a key role in designing studies coming out of the Arts and Mind Lab, and who provided extensive and excellent comments on every chapter.

Numerous others have helped me in this enterprise. To begin with, I thank the research group Harvard Project Zero, founded by philosopher Nelson Goodman in 1967. I joined this research group in 1973, and Project Zero has had a lasting and deep influence on my thinking. I also thank my lab at Boston College, the Arts and Mind Lab, whose members—undergraduates, doctoral students, and lab managers—have helped me carry out so many of the studies reported in this book. Other current and former lab members read either the entire manuscript or numerous chapters and gave me valuable comments: my former doctoral students, now assistant professors, Jennifer E. Drake and Thalia Goldstein; my current doctoral students Mahsa Ershadi, Jill Hogan, and Maria Eugenia Panero; and my former lab manager Jenny Nissel. I received excellent comments from my long-time philosophy friends Marcia Homiak and Naomi Scheman: Marcia commented on the book's introduction and Naomi commented on a number of chapters. Eric Blumenson, a close friend and a lawyer steeped in philosophy, provided cogent comments about the issue of objectivity of aesthetic judgments. Psychology colleagues Aniruddh Patel and Isabelle Peretz commented on

the two music chapters, and my philosophically inclined mother, Irene Portis Winner, commented on the entire manuscript.

Thank you to Ryan Hynes, who found the articles and books I needed, who worked on the endnotes and references, and who took on the task of securing copyright permission for all of the images reprinted. And thank you to Barbara O'Brien for her tremendous help with department chair responsibilities, which gave me the space to write this book. My sister, Lucy Winner, provided the idea for the cover—turning a painting into a puzzle. I extend my thanks to my Editor Joan Bossert at Oxford University Press, along with Phil Velinov, Assistant Editor, and Devasena Vedamurthi, Production Editor.

PART I | Introduction

- LaGrange Kentucky Prisoners convicted of violent crimes spent 1yr. rehearsing/performing Shakespeare's The Tempest
- Lady Gaga sold out 3 Madison Square Garden concerts in 1hr.
- 2017 painting by Jean Michel Basquiat auctioned at Sotheby's for $110.5million

CHAPTER 1 | Perennial Questions

A painting is not a picture of an experience. It is an experience.[1]

—MARK ROTHKO

AT LUTHER LUCKETT CORRECTIONAL Center in LaGrange, Kentucky, prisoners convicted of violent crimes spent a year rehearsing and finally performing Shakespeare's *The Tempest*. Lady Gaga sold out three Madison Square Garden concerts in one hour and performs to adoring fans. It has been said that in 1841 people waited on the New York docks for the ship carrying the final chapter of Charles Dickens' *The Old Curiosity Shop*, to find out whether the character Little Nell had died. Parents in the United States and many other countries make sure their children learn to play an instrument, and make sure they work hard at it. By the age of two, my granddaughter Olivia had made over 100 "abstract expressionist" paintings. In 2017, a painting by Jean-Michel Basquiat was auctioned at Sotheby's for $110.5 million.

These strange behaviors we call art are as old as humans. As early as *Homo sapiens*, and long before there was science, there was art. Archeologists have found ochre clay incised with decoration from 99,000 years ago,[2] musical instruments from over 35,000 years ago,[3] and masterful figurative paintings on the Chauvet cave walls from 30,000 years ago.[4] There has never been a culture without one or more forms of art—though not all cultures have had a word for art. Anthropologist Claude Lévi-Strauss[5] placed art above science, describing the work of the painter, poet, and composer as well as the myths and symbols of primitive humans as

> if not as a superior form of knowledge, at any rate as the most fundamental form of knowledge, and the only one that we all have in common; knowledge in the scientific sense is merely the sharpened edge of this other knowledge.

In modern, literate societies, there is no end to wondering about "art" and "the arts." What makes something art? Do two-year-old Olivia's paintings count? If I say that *Harry Potter* is a greater novel than *War and Peace*, is this just a subjective opinion, or could I be proven wrong? Are the primitive looking paintings of Jean-Michel Basquiat that sell for millions something any child could have made? If a revered painting turns out to be a forgery, does it become less good? Does the sorrow we feel when we read about the death of Little Nell have the same quality as the sorrow we feel when someone we know dies? Did reading about little Nell make us better, more empathetic people? Do we make our children smarter by enrolling them in music lessons? Is Lady Gaga's musical talent something she was born with, or due to hundreds of hours of practice?

Many of these kinds of questions were first posed (and answered) by philosophers. But even those who have never read philosophy may wonder about these questions—for whether or not we realize it, ordinary conversation often encroaches on philosophical questions. Psychologists who study the arts have often taken philosophical questions as their starting point but have tried to answer these questions not as philosophers but by using the methods of social science—interviews, experimentation, data collection, and statistical analysis. What psychologists want to unpack is what art does to us—how we experience art. As the painter Mark Rothko states in the epigraph to this chapter, art is not about an experience, it *is* an experience. This profound statement holds for all of the arts.

In the pages that follow, I take you to the labs of the growing number of psychologists carrying out studies of "experimental aesthetics," including my own lab at Boston College—the Arts and Mind Lab—where I have worked for over three decades with my graduate students, lab managers, and many undergraduate psychology majors eager to learn about how psychologists do their work. I start out in the next chapter by raising a vexed question: What is this thing we call art that has existed since the earliest humans, that no other animals do, and that no culture has ever been without? Do the things we call art have any necessary and sufficient features that unite them and distinguish them from things we don't call art? Over the centuries, philosophers have tried (and failed) to define art. Psychologists (perhaps wisely) ask a somewhat different question: not "what is it," but rather what do people think it is. And this is an empirical question.

The questions raised in these pages are not easy to answer. My goal is to bring to life the observational studies and experiments that psychologists have designed to answer these questions. There is much work to be done, of course. But preliminary answers have emerged, and some of them may surprise you.

CHAPTER 2 | Can This Be Art?

ART IS ONE OF the most complicated of human endeavors. This claim will become apparent to anyone who tries to define what art is and what it is not to a visitor from another planet, and who tries to defend this definition from one counterexample after the next. Attempts to define art have a vexed philosophical history. (These definitional attempts have focused primarily on the visual arts; hence the arguments and examples in this chapter are primarily visual.) British aesthetician Clive Bell[1] remarked, "Everyone in his heart believes that there is a real distinction between works of art and all other objects." Invariably, however, carefully crafted definitions leave out many things we want to call art, just as they typically include many things we don't want to call art. Yet all (or most) of us think we know art when we see it.

Sara Goldschmied and Eleonora Chiari's installation *Where Shall We Go Dancing Tonight* consisted of empty champagne bottles, cigarette butts, and confetti spread around on the floor of a room in the Museion Bozen-Bolzano in Northern Italy. The museum's website discussed this piece as an exhibition about consumerism and hedonism in Italy in the 1980s. But when the cleaning staff was asked to clean up the room after a book party had been held there, they not surprisingly mistook the installation for after-party trash and dumped it all into recycling bins. When this blunder was discovered, the museum retrieved the trash from the bins and reconstructed the work.

What happened to the Goldschmied-Chiari installation is a clear-cut case of someone implicitly classifying a work displayed in a museum as "not art." It is similar to the case of French conceptual artist Marcel Duchamp's porcelain urinal, a "ready-made" found object that he titled *Fountain* and submitted to the Society of Independent Artist's 1917 exhibit. The submission was rejected. But today, museums and art historians treat his ready-mades as

art. Duchamp's original work was lost, but Duchamp made a replica, which was auctioned off at Sotheby's in 1999 for $1,762,500. His snow shovel that he titled *En prévision du bras cassé* [In advance of the broken arm] hangs in the Museum of Modern Art in New York, as does the third version of his *Bicycle Wheel*, mounted on a painted wooden stool, shown in Figure 2.1 (the original from 1913 was lost). Duchamp believed that any ordinary object could be elevated to the status of an artwork just by an artist choosing that object. The artwork is thus not the actual object but the idea behind it. Duchamp wanted to move art away from something to look at (he called that "retinal art") to art that makes us think—and to ask the question, "Why is that art?"

But to the uninitiated, like the cleaning staff in the Italian museum, these objects provoke a negative reaction. Why would anyone think these are art?

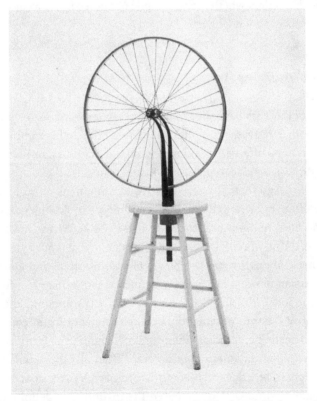

FIGURE 2.1 Marcel Duchamp (1887–1968). *Bicycle Wheel*. New York, 1951 (third version, after lost original of 1913). Metal wheel mounted on painted wood stool, 51 × 25 × 16 1/2" (129.5 × 63.5 × 41.9 cm).

One could ask the same question about avant-garde composer John Cage's work *4'33"*, which requires the performers to remain completely silent on stage for the amount of time given in the title so that the audience members can listen to naturally occurring sounds and consider these as music. Why would anyone think of silence on stage, and coughs and creaking chairs and raindrops heard in the concert hall as music?[2]

We not only feel entitled to declare something presented as art as "not art"; we also willingly and freely denounce certain works of art as no good—recall the nineteenth century salon critics rejecting works by impressionists, or the near-riot that ensued in 1913 when Igor Stravinsky's ballet *The Rite of Spring* was performed. However, claiming that something is not art is not the same as claiming that something is bad art. I consider how we evaluate what is good and bad in art in Chapter 8. For now, are there any rules on which we can agree that tell us whether or not a pile of bottles in a corner of museum gallery is or is not a work of art?

Philosophers Define Art

Centuries of thinkers have tried to define art in terms of one or more necessary and sufficient features. I offer you here a brief and incomplete laundry list of definitions offered by philosophers (and one Russian novelist). Plato (in *The Republic*) made representation, or mimesis, the defining feature of art. He believed that all works of art were imitations of ordinary objects (and, therefore, inferior to them, just as ordinary physical objects were inferior to the ideal non-physical forms of these objects). Immanuel Kant[3] defined art as a kind of representation that has no external purpose, that exists only for itself, though it has the power to communicate and stimulate our minds. Russian novelist Leo Tolstoy[4] defined art in terms of its function: to express emotion. Clive Bell[5] defined a work of art as something that has "significant form"—nonrepresentational combinations of lines, colors, shapes that lead to aesthetic emotion—because only significant form can provoke an aesthetic emotion, an emotion different from all other kinds of human emotions, one that transports us out of ordinary human concerns into an exalted state. George Dickie[6] proposed the institutional definition of art: a work of art is an artifact that has been offered up as a candidate for appreciation by the art world. Monroe Beardsley[7] offered a functional definition: a work of art is something that affords, or is intended to afford, an aesthetic experience—that is, it causes us to consider the aesthetic value of the object. Jerrold Levinson[8] proposed an intentional-historical definition: a work

of art is anything intended to be understood like previous artworks were understood.

The problem with some of these definitions is that they are non-inclusive. Defining art as a form of representation leaves out non-representational forms of art, such as most music or abstract art, just as it includes representations that we would not call art, such as diagrams and mathematical equations. Defining art as something that expresses emotion leaves out art that is not highly expressive—conceptual art, decorative art, minimalist art. Defining art as something presented to the art world as art leaves out "outsider art" never shown in a museum. Some theories are circular: if something is art because it provokes an aesthetic experience (Beardsley) or an aesthetic emotion (Bell), and an aesthetic experience or an aesthetic emotion is what is provoked by art, we have a circular, non-testable proposition.

Some theories confuse or conflate the distinction *art–not art* with the distinction *good art–bad art*. For example, paintings that Clive Bell dislikes are said to lack significant form and thus are not art. Sir Luke Fildes' painting *The Doctor*, which hangs in the Tate Museum in London, was deemed not a work of art by Bell because he found it sentimental and descriptive and unable to provoke aesthetic ecstasy. Bell did realize that not everyone is moved by the same works of art, and he dealt with this problem by saying that "I have no right to consider anything a work of art to which I cannot react emotionally."[9] Thus, apparently, a work can have significant form for you but not for me; and thus it is art for you but not art for me.

In 2009, Denis Dutton, a philosopher of aesthetics in New Zealand, published a scholarly but also highly entertaining book called *The Art Instinct: Beauty, Pleasure, and Human Evolution* in which he analyzed our need for the arts by invoking arguments from evolution, considering this need as an "instinct."[10] In my view, one of his most important contributions was to take on the problem of defining art. He argued that we should not begin by pondering how to include atypical cases in the category of art—cases such as a museum gallery floor strewn with bottles and confetti. Instead, he insisted we should begin with indisputable cases of art so that we can understand "the center of art and its values."[11] He offers us not a set of necessary and sufficient features meant to apply to all works of art but instead an extensive list of features that he believes characterize *typical* works of art.

Here are the characteristic (but not necessary) features that prototypical works of art possess, according to Dutton:

Skill and virtuosity
Novelty and creativity

Representation
Expressive individuality
Emotional saturation
Direct pleasure
Intellectual challenge
Imaginative experience
Culture of criticism
Style
Special focus
Existing within art traditions and institutions

Though none of these are meant to be necessary features, that does not mean that anything goes because "even if . . . there is 'no one way' to be a work of art, it does not follow that the converse 'many ways' are so hopelessly numerous as to be unspecifiable."[12]

I think it is useful to divide Dutton's features into three broad categories: what we perceive in works of art, how we respond to works of art, and contextual aspects of art. In the next sections I explain what he means by each one. See what you think. I'm sure you will think of counterexamples, art that does not possess a particular feature, underscoring that this feature need not be present for something to still be considered art.

What We Perceive in a Work of Art, per Dutton

Skill and Virtuosity

An art object is made with skill. This connects to pleasure: we admire skill, and recognizing great skill is deeply pleasurable. Necessary? Duchamp's ready-mades did not require technical skill because they were found, not made. Nor did Cage's *4'33"*. Exclusive to art? No, just think of sporting events, chess matches, great speeches. All of these take skill. Indeed, Dutton never argues that any one of his features are either necessary or sufficient.

Novelty and Creativity

An art object is novel and original. This also connects to pleasure. We like to be surprised, we admire novelty, and recognizing it is pleasurable. Necessary? What about art in the school of a great master? Not so novel. Novelty is also not exclusive to art. Just think of the taxi driver who finds a creative way around traffic, or a scientist who makes a new discovery.

Representation

Much art involves representation. And, harking back to the first criterion listed, Dutton notes that we take pleasure in representation for the skill behind it, and because we may find the depicted objects pleasing in themselves. Necessary? Not for music and abstract art. And not exclusive to art since maps, equations, and codes are also representational.

Expressive Individuality

Artworks express something about the artist who made them, and we enjoy thinking about the mind behind the works. Necessary? Perhaps, in my view. When in the presence of a work of art, we cannot help but wonder about the mind and personality of the maker. But certainly individual expression is not exclusive to art, for this can also be said of any activity that is not totally rule governed and that allows for creativity—whether cooking, hair-styling, or advertising.

Emotional Saturation

Artworks are emotional, as is the experience of perceiving these works. The representational content of a work provokes emotions in us (such as sorrow at a sad scene in a painting), and the tone or expression of a work is also perceived and felt. Necessary? No. Minimalist paintings are not saturated with feeling. And emotion is not exclusive to art because funerals and weddings and many other of life's experiences are saturated with emotion.

How We Respond to a Work of Art, per Dutton

Direct Pleasure

Art causes immediate pleasure for its own sake, with no utilitarian value. Necessary? No, a work that does not please us at all is still art, even if we do not like it. And pleasure is not exclusive to art, since lots of things give us pleasure for their own sake: a game of tennis, a sunrise, ice cream, sex.

Intellectual Challenge

Artworks challenge us intellectually (and this, too, is pleasurable). The philosopher Alva Noë[13] echoes this view when he writes that art aims to disclose us to ourselves, and expose to us what we did not know about ourselves. He calls art a "strange tool" because unlike most artifacts, art is a tool that has no

ordinary utilitarian function. Because it has no practical function, Noë writes, art forces us to ask what is this thing that I see in front of me. If we ask this, we extend our minds and have experiences we would not otherwise have. Necessary? Not for those artworks that are hackneyed. Not for a pop romance novel. But likely necessary for art we classify as great. Is this characteristic exclusive to art? Perhaps not, because many non-art activities also challenge us when we try to make sense of them—like listening to a lecture on string theory, or working out a mathematical puzzle. And yet these do not "expose us to ourselves." Perhaps immersing ourselves in art is more like going to a psychiatrist: both experiences challenge us and force us to introspect.

Imaginative Experience

Artworks create imaginative experience for both the maker and the perceiver, and Dutton thinks this is maybe the most important of his 12 features. So do I. Artworks are experienced in a pretend world. We know that fictional characters are not real, yet they make us frightened, sad, relieved, and happy. We listen to music and experience emotions even though no events are causing us to feel sorrow, joy, or excitement. The imaginative experience caused by art is decoupled from any practical concern—in Immanuel Kant's eighteenth-century words,[14] art is for disinterested contemplation.

Dutton offers the example of a football game, asking why this is not a work of art even though it gives pleasure, elicits emotion, requires skill, is associated with criticism, and is given special focus. It's not art, because watching the game is not an imaginative experience. This is not the virtual reality of art, it is actual reality. And we care who wins.

A similar point was made by the Spanish philosopher José Ortega y Gasset[15]:

> [T]he artistic object is artistic only to the extent that it is not real. In order to enjoy Titian's equestrian portrait of Charles V, it is a necessary condition that we do not see the authentic, living Charles V but only a portrait of him, that is, an unreal image. The man portrayed and his portrait are two completely distinct objects: either we are interested in the one or in the other. In the former case, we 'associate' with Charles V; in the latter, we 'contemplate' the artistic object as such.

In my view, imaginative experience may well be a necessary feature of a work of art. All forms of art—whether visual art, music, literature, or dance—invite us to enter into an imaginary space, taking us away from "non-art reality." But this cannot be a sufficient feature: other domains also invite us to

enter into an imaginary world—games, pretend play, and perhaps mathematics (though some mathematicians may disagree!).

Criticism

A critical language accompanies artworks: critics talk about art, as do audiences. Necessary? If no critic ever wrote about a work of art, we would still call it art, wouldn't we? Exclusive to art? No, for any human activity that is complex is accompanied by criticism, whether science, politics, or athletics. We have critical discourse about diving competitions where form is important and somewhat subjective to judge, but not much about speed swimming, where all that counts is the fastest time.

Contextual Aspects of Art, per Dutton

Style

Artworks are made in particular styles, and hence abide at least loosely by sets of rules, just like most human activities—language use, norms of politeness, nonverbal communication, cooking. Researcher Shigeru Watanabe[16] showed that even mice and pigeons can distinguish paintings by style, discriminating Monets from Picassos, Kandinskys from Mondrians. Infants[17] and young children[18] can do this as well. We also group together different artists working in the same style. Computers, too, have been trained to classify by styles, distinguishing impressionism, surrealism, and abstract expressionism at 91 percent accuracy.[19]

Special Focus

Artworks are typically set apart from ordinary life, whether by a stage, a frame, a concert hall, or a museum. This sounds like what the philosopher Schopenhauer[20] meant when he wrote that art "plucks the object of its contemplation from the stream of the world's course, and holds it isolated before it." This is what another theorist of art, Ellen Dissanayake,[21] meant when she said that art is set apart, made special. A curator at a major museum once mentioned how artists toss around their works in their studios but as soon as they are brought into the museum, the curators treat these same works with exquisite care, as sacrosanct.

When artworks are not formally set apart and thus "made special," we sometimes do not recognize their value. An amusing illustration of this happened when the acclaimed violinist Joshua Bell agreed to participate in an

experiment. After recent sell-out crowds at Boston Symphony Hall, he sat in the Washington, D.C. subway in the morning with a hat laid out to collect coins as he played Bach. Most passersby barely noticed him and gave no indication of recognizing that they were in the presence of an accomplished artist.

Art Traditions and Institutions

Artworks exist within a historical tradition, as do all organized social activities of humans. But of course this is not true of outsider art—by prisoners, mental patients, children, and animals.

How to Evaluate Dutton's Approach

It is difficult to disagree with anything on this list when it comes to prototypical works of art. But how far does this get us in pinning art down? Can we use this list as a tool to test whether something is or is not a work of art? Not if none of these features are necessary, as Dutton thinks. And not even if some of these features are necessary. And that is because none of these features are jointly sufficient to make something a work of art. Every one of these features can be found outside of art. Dutton tells us that if all of his features are present, we know we are looking at a prototypical work of art. But he also says all need not be present! Dutton's list (as he would readily admit) tells us what we know about prototypical art but not art on the fringes.

In some cases, Dutton confuses the art–non-art distinction with the good art–bad art distinction. That's because some of his features apply only to great art. Novelty and expressive individuality are necessary only for great art: lesser works of art are often derivative—but they are still art (think of works by someone "in the school of Leonardo," where the artist strives to paint in Leonardo's style rather than develop an individual style). Intellectual challenge is a feature of the experience of great works, but what about romance novels we buy at the airport? Maybe these are not great, but if they are not instances of literature, which is a kind of art, what are they?

Why Is Art So Hard to Pin Down?

Is defining art a more difficult task than defining other kinds of things? Yes, because it is not a "natural kind." Natural kinds can be defined by a set of necessary and sufficient features. Water is a natural kind, and we can readily define it as a certain combination of hydrogen and oxygen, H_2O. Anything with this combination is water, and anything lacking this combination is

not water. The make-up of water does not change over historical periods or across cultures. Water is a real thing that is mind-independent. It exists whether or not humans are aware of it. The same goes for gold, or elephants. And we can verify objectively whether or not something is water, gold, or an elephant. Art is something very different.

Art is a socially constructed concept created by culture. Because it is socially constructed, it is not mind-independent. It is our minds that pull together into one category the things we call art. Moreover, art is a socially constructed concept with very blurry boundaries, unlike the clearer boundaries of money, another socially constructed concept. And what counts as art can change over time and over culture.

We can liken the concept of art to the concept of game, another kind of mind-dependent category. Here is what the philosopher Ludwig Wittgenstein[22] said about games. There are many kinds of games—chess, bridge, solitaire, board games, Olympic races, ring around the rosie, pretend play—and there is no one feature or set of features shared by all games. Instead, games are connected to one another by family resemblances; one game resembles another in some features (like eye color in families), but no one feature runs throughout all games (or all members of a family). Some games are physical, some cerebral; some are serious, some fun; some are competitive, some not, and so on. And there is no "best" example of a game. Wittgenstein used the metaphor of a rope made up of twisted fibers with no one fiber running throughout the whole length of the rope.

Nor is there any way to verify whether something is a game. If people consider something a game—say, trying to beat the traffic lights, trying not to step on a sidewalk crack, or eating bugs on the "game" TV show *Fear Factor*,—then it is a game for them, though others might disagree. The concept of game, like art, is functional, defined by its use. Such concepts are open ones: things we never dreamed of as games may become games for the next generation because new kinds of games with different kinds of properties can be invented. The philosopher Morris Weitz[23] argues that art is also an open concept. Its boundaries are infinitely expandable because it must encompass previously undreamed of forms. We cannot list the defining features of art because this would close the concept.

Replacing "What is art?" with "When is art?"

To ask whether the Goldschmied-Chiari installation *Where Shall We Go Dancing Tonight* is a work of art is to ask a question that cannot be empirically

answered. For how could we ever put this question to an objective test? That installation is art if we treat it as art. Whether or not we like it or deem it good is an entirely different question.

The philosopher Nelson Goodman[24] (also the founder of Harvard Project Zero, the research group where long ago I began my investigations into the psychology of the arts) argued that we should replace the question "*What is art?*" with the question "*When is art?*" The same object can function as a work of art or not, depending on how the object is viewed. When an object functions as art, it exhibits certain "symptoms" of the aesthetic. For example, an object functioning as art is relatively *replete* (full), meaning that more of its physical properties are part of its meaning and should be attended to than when that same object is not functioning as a work of art. Goodman asks us to consider a zigzag line, such as the one shown in Figure 2.2. Told that the line is a stock market graph, all we attend to are the peaks and dips. We could get the same information from a set of numbers. But if this same line is part of a drawing (say, the outline of a mountain), all of the line's physical properties are suddenly important and part of what the artist wants us to attend to—its color, texture, edges, thickness, among other things. And we cannot translate this experience into a set of numbers.

I take Goodman's concept of repleteness to be a psychological claim—about the attitude we shift into when we categorize something as a work of art. This is a claim that psychologists could actually test. The importance of repleteness reminds me of Bell's significant form. When something is functioning as a work of art, we do not only look through it to what it represents. We also attend to its formal, surface properties. Ortega y Gasset makes the same point as Goodman. When we look at a painting of a garden, we can see right through the surface properties of paint and focus just on the garden. But if we do this we are not adopting an aesthetic attitude. He

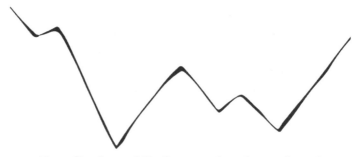

FIGURE 2.2 Zigzag line that could be from a stock market graph or a line drawing of mountains.
Drawing by Nat Rabb.

makes an analogy to looking at a garden through a window. We can focus our eyes on the garden, or we can make an effort and refocus our eyes on the windowpane.

> Then the garden disappears from our eyes, and all we see of it are some confused masses of colour which seem to adhere to the glass. Thus to see the garden and to see the window-pane are two incompatible operations: the one excludes the other and they each require a different focus.[25]

This refocusing requires the capacity to reflect on the character, rather than the content, of visual experience—and this focusing on the nature of our visual experience may well be at the heart of an aesthetic experience.

The philosopher Roger Scruton[26] makes a similar psychological point in his description of a carpenter who chooses the way to frame a door just on the basis of what looks right. This is a purely aesthetic judgment, not an instrumental one, and Scruton[27] defines such an attitude as

> a desire to go on hearing, looking at, or in some other way having experience of X, where there is no reason for this desire in terms of any other desire or appetite that the experience of X may fulfill, and where the desire arises out of, and is accompanied by, the thought of X.

We care about the way things look when we set a table for guests, when we arrange our living room furniture, when we pick our clothes. This aesthetics of everyday life, Scruton argues, is a state of mind that is fundamental to human nature, and lacking in other animals. Birds may sing, but there is nothing in their behavior that allows us to say that the birds are contemplating how the song sounds. Thus works of art are things that function in certain ways: they are "objects to be enjoyed for their appearance and whose appearance is to be interpreted purely for what it means and without reference to some (further) practical function."[28] This seems to me to be close to the idea of repleteness. And also close to Kant's[29] belief that the aesthetic attitude is one of disinterested pleasure, divorced from practical constraints, divorced from any desire for the object causing the pleasure.

Consider a second Goodman symptom of the aesthetic, *metaphorical exemplification*, which I prefer to refer to with the more transparent term, *expression*. When an object is functioning as a work of art, it has the peculiar property of evoking without representing. It can express properties that it does not literally possess, such as a mood. A painting can express sadness or joy, but is not literally sad or happy. A painting can express loudness, but is

not literally loud. A symphony can express color, but is not literally colorful. One would not describe a scientific graph as expressing emotion or loudness or sharpness. So that same zigzag line can express properties it does not literally possess when a perceiver attends to its visual properties (and thus treats it as a work of art in Goodman's functional sense) as opposed to its informational content (and thus treats it as a graph). Of course, we can still respond to a scientific graph in terms of how ugly or beautiful it is, but we do not impute non-literal properties to graphs.

Dutch cognitive psychologist Rolf Zwaan carried out a study in 1991 that I believe provides direct support for Goodman's claim that the same object can function as art or not-art.[30] He presented people with six texts, some of which were originally from newspapers, others from works of literature. Both could pass as either news stories or literature. Half of the people were told they were reading an excerpt from a newspaper account of events; the other half were told they were reading an excerpt from literature. The hypothesis was that texts read as literature would be read more slowly because literature is to be savored rather than skimmed. As the linguist Roman Jakobson[31] noted, in literature the poetic function of language is primary—and we focus on the structure of the message rather than looking through the message to the meaning. It follows, then, that *how* the meanings are conveyed (the precise wording) should be recalled better in a text read as literature rather than as news. Following is one of the texts used in this study, originally a news article, about a former Romanian political prisoner:

His first confrontation with the police dates from winter 1983. He studied to be a stage director at night-school, and worked in a studio during the daytime. The energy shortage, a consequence of megalomaniac investments in the petrochemical industry, was dire. Two measures became simultaneously operative: the energy prize was multiplied and the supply of energy was severely reduced. A propaganda campaign accompanied the cold under the slogan: 50 percent materials, 100 percent performance. Sorin drew a man cut in two, wrote the slogan under it, and sneaked at night to a factory gate. He pinned up the drawing, believing himself unseen. The next day, he was picked up from his work. At first, he was treated in a friendly manner at the police station. He was offered some coffee. During the interrogation, the central question was by whose order Sorin had pinned up that drawing. Sorin remained silent. They hit him. He refused to talk. They threatened to cut his wrists. He denied having anything to do with the drawing. They showed him the door. 'Just go'. As he walked down the corridor, an officer grabbed hold of him and knocked him unconscious. When he came round, he lay in the comer of a cell, his hands and face covered in blood. Two fingers of his right hand were

paralyzed; they had cut the tendons. He was then allowed to go. In the bus people wondered at his blood-covered face and hands.

When people believed they were reading literature, they read more slowly. Consistent with this finding, verbatim memory for the surface features of the text was higher when people thought they were reading literature. This was measured by presenting people with sentences from the texts with one word in capital letters. Some of the time, this word was a synonym of the original word read. The task was to decide whether this was the word used in the text or not.

In Goodman's terms, the text became replete when it was approached as literature. In contrast, when the participants thought they were reading a news account, they looked through the words to their meaning and hence confused synonyms with what they had originally read. For Goodman, it makes no sense to ask if a text is literature. We can only ask whether it is functioning as literature. And the same goes for any kind of art.

Goodman's approach differs from Dutton's in his insistence that what makes something art is how it is perceived. A pattern made from accidentally spilled paint can function as a work of art if I attend to its repleteness and its expression. The Goldschmied-Chiari installation was functioning as a work of art to viewers who attended to the patterns created by the way the bottles were laid out (whether they were carefully laid out or just tossed there) and who noticed that this work expressed corruption and decadence. But this same installation was not functioning as a work of art for the cleaning staff, who presumably noticed none of these things.

But in another way, Goodman's approach is similar to Dutton's: both give us a probabilistic way to determine whether something is a work of art, or is functioning as one. Like Dutton, Goodman believes his symptoms are neither necessary nor sufficient, but if all or most are present, the object is likely functioning as a work of art. Thus neither Weitz, Goodman, nor Dutton give us a set of rules against which we can definitively test an object's art–non-art status.

Replacing "What is art?" with "What do people think is art?"

Philosophers worry about what art *is*. Psychologists do not. Instead, they want to find out what people *think* art is. These are quite different questions. The philosopher's question presumes a right answer if we can think clearly

enough. A philosopher's methods entail reflection as well as thought experiments—for example, testing an imagined example of art against a proposed theory to see if it is encompassed by that theory. The philosopher's right answer could be a logical definition, as Bell offered, a probabilistic definition as per Dutton and Goodman, or an acceptance that there is no definition because art is an ever-open concept, as per Weitz. In principle, philosophers could come up with a definition they propose is true that would differ from the answer that ordinary people would give. That would not trouble the philosopher, and would likely have no influence on the ordinary person.

Both questions have merit. But they require very different ways of going about answering them, one by reasoning and introspection, one by empirical study. Some philosophers have become interested enough in psychologists' questions to engage in what has come to be called "experimental philosophy."[32] They take philosophical issues and study how ordinary people think about them. Richard Kamber[33] is a philosopher who carried out a psychological study on the question of what non-philosophers—art professionals as well as ordinary people—think is and is not art. He believes that this kind of study can actually illuminate a philosophical problem: how to define art. Other philosophers might disagree. Nonetheless, what a psychologist (and Kamber) want to find out about is what the category "art" looks like in the mind of the non-philosopher.

Kamber used the simplest method available to psychologists—a self-report survey. He posted two online questionnaires designed to test people's intuitions about whether various objects qualified as art. Unlike Dutton, he used only potentially controversial, non-prototypical cases of art—with the goal of discovering where people draw the line. He gave people examples of things we might or might not classify as art, and for each, participants had say whether it was art or not art, or whether they were unsure. One hundred and fifty-one participants, most of whom were university or college faculty members, completed the surveys. Of the respondents, 52% were "art professionals" (which included artists, art historians, employees of art organizations, and philosophers of art), 39% were "art buffs" (people who had taken three or more courses in the history, theory or philosophy of any of the fine or performing arts, and had visited museums at least twice a year, as well as had attended concerts or plays also at least twice a year); and 9% were neither of these and were considered "ordinary folk."

Each example Kamber presented to his participants was selected to test a particular hypothesis. To see whether people would be willing to allow "bad art" to be art, he offered a painting of Elvis Presley on velvet. The majority

answer was yes, art. To see whether plain old ordinary objects could be art, he gave them white envelopes. The majority answer was no, not art. To see whether art is something that has to be human-made, he showed them a painting by an elephant given a brush to hold in its trunk. The answer was no, not art. To see whether nature qualifies, he proposed a dead tree. Again, not art.

Kamber's informal survey tells us that educated people who know a lot about art (the majority of his participants) are able to agree on average on where they draw the line between art and not art. And yet . . . even when most people agreed that an object was not art, responses were *never* unanimous. Take the example of the dead tree: 84% said a dead tree was not art, and 16% said it was art. Over half of those who said it was a work of art were art professionals. Kamber imagines a group of biologists asked to decide whether a plastic Christmas tree is a plant. Not one would say yes. Unlike the boundaries of the biological category plant, the boundaries of the socially constructed category art are porous. And that is why people disagree.

Kamber designed his study very informally, testing a grab bag of theories, using only one or two examples to test each one. Psychologists are more likely to design a study to zero in on one or two criteria that might be used to distinguish art from non-art. One such study was carried out by cognitive psychologist Jean-Luc Jucker and his colleagues.[34] The potential criterion he addressed was perceived intentionality: are people more likely to judge something as art if they believe it was intentionally crafted rather than being the product of an accident? Jucker and his colleagues presented non-art experts with images and asked them to decide, using a seven-point scale, how strongly they considered these images to be works of art. This is a more sensitive measure than the yes-or-no, all-or-nothing, response that Kamber asked of his participants because it can tell us about degrees of "artness."

The clever manipulation was that participants saw the images accompanied by artist statements either making it clear that the image was intentionally crafted to look the way it did, or making it clear that the image was the by-product of some other action and thus was accidental. For example, the out-of-focus photograph shown in Figure 2.3 was presented in the high-intentional condition accompanied by an artist statement that the defocussing was an attempt to make the colors more vibrant. In the low-intentional condition this same image was presented along with the artist statement that he had forgotten to focus his camera. There was also a control condition in which the images were presented with no statements at all.

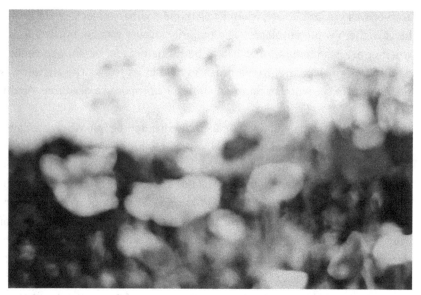

FIGURE 2.3 Out-of-focus photograph used in Jucker, Barrett, and Wlodarski's (2014) study.

Photograph by Jean-Luc Jucker. Reprinted with permission of SAGE Publications Inc. © SAGE Publications.

Here is another pair of artist statements that stress either intentionality or accident.

Accompanying a wooden board with a large trail of black paint, participants read one of the following two artist statements:

(1) Because of its simplicity and expressivity, this piece may look like a branch painted in Japanese style. In fact, it is just a wood board on which I had laid a chain that I needed to paint in black for another work.
(2) This piece is inspired by Japanese art, which I like for its simplicity and expressivity. In this instance, I have tried to represent a single branch using just black paint, which I applied on a wood board using a chain.

If you responded like the participants, you would have given higher artness ratings to the image you believed was created intentionally rather than as a byproduct of some other action. In a control condition where no artist statements accompanied the images, artness ratings were as high as those for images accompanied by high-intentionality statements. Thus people assumed that these images were intentionally produced and thus art.

Jucker's study shows us that concept of intentionality is central to art. Works of art are things that are made intentionally. Yet recall that Kamber's participants did not unanimously classify a dead tree as not art, even though a dead tree is not anything anyone intentionally made. Again, this just shows us how the boundary between art and non-art is slippery and is not the same for everyone. This is the fate of a socially constructed concept, in contrast to a natural kind concept (described in the next section).

Forced-choice studies like Kamber's and rating-scale studies like Jucker's lack ecological validity: in daily life, we do not ask ourselves whether a dead tree is art, nor do we ask ourselves the degree to which an object is a work of art. That's why Nathaniel Rabb, manager of my Arts and Mind lab, and I sought out less explicit ways to get at how adults (and children) mentally represent the concept of art.

Linguistic Judgments

Instead of asking what is and is not thought to be art, we explored the kind of concept people implicitly believe art to be.[35] We did this by asking people to judge how sensible various sentences about art and other kinds of concepts sounded, drawing on work by psychologist Barbara Malt[36] in her investigation of intuitive differences in how we think about different kinds of concepts. The concepts she investigated were *nominal kinds* (like triangle, true by definition, and defined by necessary and sufficient features), *natural kinds* (like animal, which reflects the structure of the natural world, and has some necessary features), and *artifacts* (things made by humans and defined by their use, lacking necessary and sufficient features).

Each sentence presented to participants began with a linguistic "hedge"— a modifier that qualifies the statement in some way—as shown next. Try this out: on a scale from not at all sensible to very sensible, how would you judge each of these three sentences?

Loosely speaking, that's art.
According to experts, that's art.
By definition, that's art.

Now try this for a natural kind category, animal:

Loosely speaking, that's an animal.
According to experts, that's an animal.
By definition, that's an animal.

And now for a nominal kind category, triangle:

Loosely speaking, that's a triangle.
According to experts, that's a triangle.
By definition, that's a triangle.

And finally, an artifact concept, tool.

Loosely speaking, that's a tool.
According to experts, that's a tool.
By definition, that's a tool.

Our question was whether people treat the concept of art more like artifact concepts (since artworks are artifacts) than like natural or nominal kinds. Here is what our respondents told us. It sounds better to say "loosely speaking" and "according to experts," and worse to say "by definition," when classifying something as art than when calling something a tool, an animal, or a triangle. So even though art is a kind of artifact like a tool, people do not treat art and tools the same way. "Loosely speaking" is better for art—because art has such loose boundaries. And "according to experts" is also better for art—since when something has loose boundaries, we might need to appeal to experts. These findings tell us something about the *kind* of concept that art is. Namely, in comparison to other kinds of categories, including non-art artifacts, art concepts have the loosest boundaries, are delimited by experts to the greatest degree, and are least definable.

What Things Do Children Call Art?

In a second kind of "implicit" task, we explored whether children show us by their namings whether they distinguish art from non-art. Our question was whether young children have formed an implicit category, art. Children certainly engage in art activities in preschool and kindergarten, and teachers certainly use the term *art* around young children ("Time to make art!"). Has this allowed children to form an art category?

We showed children (ages three to eight) photographs of art and non-art artifacts, explained that they were made deliberately and with care, and then we asked "What is this?"[37] The non-art artifacts included familiar human-made functional objects like a ball, a book, a cup, and a toothbrush. For example, while looking at a picture of a hand-made toothbrush, children were told, "Lucas had some wood and plastic. He carefully sawed the wood

and cut the plastic with some tools. Then he glued them together. This is what it looked like. What is it?" The art artifacts were abstract paintings and drawings. While looking at one of these, children were told, "Nora took some different-colored paints and three jars of water. She mixed the paints with the water and then carefully applied the mixtures to a page with a brush. Here is how it looked at the end. What is it?" Some of the abstract images looked a little like something in the world, others resembled nothing. We expected children to name the represented content whenever they could (e.g., shown a picture that looks like the sun and asked, "What is it," a perfectly reasonable response is to call it a sun), and so we were particularly interested in what they would say about purely abstract images.

Children had no trouble naming the hand-made toothbrush and other non-art artifacts correctly, as did an adult comparison group. But when it came to naming the artworks, even the oldest children rarely used the terms *art, painting,* or *drawing*. Instead, when they could imagine something representational in the image, they named the represented object ("It's a sun." "It's an onion with lines coming out."). When they could not see anything representational in the image, they often named the material ("It's paper and pencil." "It's lines, ink, a splatter of paint.") or described the shapes ("It's blue and pink spots.").

In a follow-up study using the same images we asked children, "Why do you think he/she made it?" after each item. They gave correct utilitarian explanations for the non-art artifacts like a toothbrush ("To brush his teeth."), and very different kinds of reasons for the artworks. About half of the time children were able to come up with reasonable non-utilitarian reasons for why someone would make what we presented as an artwork, saying things like "For it to look pretty"; "He felt like drawing"; "To look at it"; or "To put on the wall."

The fact that children were reluctant to name a painting "art" or "a painting," but had no trouble naming a toothbrush "a toothbrush" shows that they have not yet acquired an explicit category, "art." But the fact that they gave utilitarian reasons for why someone would make a non-art artifact, and non-utilitarian reasons for why someone would make an art artifact, shows that they recognize, implicitly, a distinction between these two kinds of artifact. Moreover, many of the reasons they gave for making a picture (listed earlier) are perfectly sensible: artists do make images just because they feel like it, because they want to display them, and because they want them to look beautiful. These children were actually right on the mark!

And so, while we may not be able to agree on whether certain boundary cases count as art, as Kamber showed, we do agree on intentionality as a

criterion for distinguishing art from non-art, as Jean-Luc Jucker showed. And we make an implicit distinction between art and non-art artifacts, as shown in our study of linguistic hedges. And even young children make an implicit distinction between art and non-art artifacts, as shown by the non-utilitarian reasons they offered us for why someone would make a picture, as opposed to a toothbrush.

In Sum: Art Works as a Socially Constructed Category

The definitions of art proposed by great philosophical minds have them-selves all been disputed by other great philosophical minds. What makes art impossible to define conclusively is that artists are always widening the boundaries. Artists intentionally set out to confuse us about our definition of art, to make us question our definition, and to make us expand our defini-tion. In contrast, as my philosopher friend Naomi Scheman said, elephants do not intentionally set out to mess with our concept of the species elephant. In addition, as Alva Noë says, art makes us think about ourselves and art makes us think about art—what it is and what it is doing to us and how it is doing this to us. Artists like to come up with new ways to do these things to us.

Dutton's analysis shows us the characteristics that are present in pro-totypical cases of art—and I think most of us would not dispute these as typical characteristics. But when it comes to non-prototypical instances of what some might call art, Kamber's survey study shows that even art experts cannot agree on where to draw the line between art and non-art. And yet the human mind cannot help but see a similarity across all of the so very dif-ferent kinds of things that we can all agree are art—a symphony, a painting, a sculpture, a dance, a play, a cathedral, a film. Perhaps we are implicitly using the characteristics described by Dutton to group these things under one all-purpose term, *art*.

Goodman's analysis shows us how adopting what I would call an aes-thetic attitude can make anything function as a work of art. Splatters of paint (or bottles on the ground) become works of art (irrespective of whether we call this good or bad art) when we decide to construe them as such. Most important is the psychological claim: this construal changes how we respond to something like paint splatters—we start to attend to surface properties (Goodman's repleteness) and we start to wonder and theorize (what is the artist trying to make me think)? Ortega y Gasset made the same kind of psychological claim about visual art: when we

look at a painting as art, we refocus away from what is represented and focus instead on the quality of our visual experience. Zwaan's experiment presenting texts as literature versus news articles provides empirical evidence that Goodman and Gasset are right: construing a text as literature (art) slows us down as we read so we can attend to and remember the surface properties of the language rather than look right through the words to what they mean. And so, while neither philosophers nor laypeople can define art in an airtight fashion, psychologists, following along the lines of Zwaan's study, may well be able to demonstrate the psychological effects of adopting an aesthetic attitude.

Whatever art is, we know that it is tightly bound up with feeling. The next section of this book, which I have called "Art and Emotion," takes up the question of how it is that we can perceive human emotions in art and how it is that art can make us feel so strongly. The problem is particularly puzzling for non-representational art, such as music and completely abstract art, with no depictions of humans showing emotions and no depictions of emotion arousing situations. Can pure form show emotion? Can pure form evoke emotion? And if so, how does this work?

PART II | Art and Emotion

Art is inextricably linked to emotion. All sorts of other-
wise disparate authorities agree. Emotion was central
to Tolstoy's definition of art, and also takes a promi-
nent place in Denis Dutton's list of characteristic
features. Nelson Goodman reminds us that when an
object functions as a work of art, we perceive it as
conveying properties that it does not literally possess—
such as emotion. The painter Mark Rothko said he was
interested only in expressing basic human emotions—
tragedy, ecstasy, doom.[1] Franz Kline said the he painted
"not what I see but the feelings aroused in me by that
looking."[2] And we assume that art has the power to
move us emotionally. When works of art are praised,
we talk about them as moving and as having a pow-
erful emotional impact.

Both the perception and elicitation of emotion in
music pose non-obvious questions. Do we read emo-
tional meaning into the pure form of music, without
lyrics? And does music make us feel emotions? The
same questions arise for abstract visual art. While we
can certainly understand that a representational pic-
ture of a person suffering, or a picture of a barren land-
scape both convey sadness, do we also read emotional
meaning in the lines, forms, colors, and compositions
of abstract pictures? And does abstract art evoke

emotion in the viewer? If the answer to any of these questions is yes, we must then try to explain how this is possible. And there is another puzzle: why is it that we willingly seek out works of art that make us feel sad or that represent objects that in "real life" we try to avoid? These considerations of art and emotion are the questions explored in Part II of this book. I start with music.

| Wordless Sounds
Hearing Emotion in Music

THERE IS NO KNOWN culture without music,[1] and as mentioned earlier, musical instruments have existed for at least 35,000 years.[2] Today we are continually inundated by music—and so we experience music far more often than any other art form. We work at our computers as Spotify plays our curated lists. Students on college campuses walk to class with ear buds playing their song lists. A survey in Sweden where students were contacted seven times a day at random intervals for two weeks found that students were listening to music 37% of their waking hours.[3] We apparently now spend more time listening to music (probably with lyrics) than reading or watching TV or film.[4]

As we listen, we often describe pieces of music as sad or happy, tragic or cheerful, tender or harsh. We praise particular pieces of music or particular performances as powerfully expressive, and we critique others as cold, mechanical, or lifeless. At least today, Western listeners use emotional expressiveness as the most important criterion in evaluating music.[5]

But there is a puzzle here. What sense does it make to claim that music expresses emotions? After all, only sentient creatures can have emotions. And music is non-sentient. Of course, this puzzle only arises for music without lyrics (since words can be about emotions)—hence the title of this chapter, "Wordless Sounds."

The nineteenth-century Viennese music critic Eduard Hanslick tried to resolve this puzzle by denying that music expresses emotions. He argued that music expresses musical ideas, not feelings, and that "a musical idea reproduced in its entirety is not only an object of intrinsic beauty but also an end in itself, and not a means for representing feeling and thoughts."[6]

In his 1936 autobiography, composer Igor Stravinsky articulated a similar formalist position[7]:

> For I consider that music is, by its very nature, essentially powerless to express anything at all, whether a feeling, an attitude of mind, a psychological mood, a phenomenon of nature, etc. Expression has never been an inherent property of music. That is by no means the purpose of its existence. If, as is nearly always the case, music appears to express something, this is only an illusion and not a reality. It is simply an additional attribute which, by tacit and inveterate agreement, we have lent it, thrust upon it, as a label, a convention—in short, an aspect which, unconsciously or by force of habit, we have come to confuse with its essential being.

These are extreme positions, ones I believe more likely to be taken by musical experts who focus on the structure of the music, rather than by the more typical listener. The view that music expresses emotion is far more common both among philosophers of music and participants in psychological studies, whether musicians or non-musicians.

One way that music could express emotion is simply through a learned association. Perhaps there is nothing intrinsically sad about a piece of music in a minor key, or played slowly with low notes. Maybe we have just come to hear certain kinds of music as sad because we have learned to associate them in our culture with sad events like funerals. If this view is correct, since different cultures probably make different kind of music–event associations, we should have difficulty interpreting the emotions expressed in culturally unfamiliar music.

Diametrically opposed to this view is the position that the link between music and emotion is one of resemblance.[8] For example, when we feel sad we move slowly and speak slowly and in a low register. Thus when we hear slow, low music, we hear it as sad. If this view is correct, we should have little difficulty understanding the emotion expressed in culturally unfamiliar music.

Of course, it would be naïve and simplistic to say that music is only about emotion. It is also about ideas. In a 2017 *The New York Times* interview, conductor Semyon Bychkov described the end of Tchaikovsky's *Pathétique Symphony* in these terms: "Because of these violent accents, because of the tempo, because of the theme taken to B minor: All that makes me feel very strongly that this is not about an acceptance of death, but a protest against it."[9] Similarly, in a *Live from Lincoln Center* broadcast in 2013, cellist Yo Yo Ma talks about music as storytelling.[10] Playing an excerpt from Edward Elgar's cello concerto, Ma describes this piece as representing "almost the end of

the British empire, or the knowledge that big changes are going to happen."
He asks us to imagine the reality of that era for millions of people. We can
read about it, of course. But music can also depict this, he said, as he played
an excerpt from Dmitri Shostakovich, who reportedly wrote this about his
Symphony No. 10:

> I did depict Stalin in music in . . . the Tenth [Symphony]. I wrote it right after
> Stalin's death, and no one has yet guessed what the symphony is about. It's
> about Stalin and the Stalin years. The second part, the scherzo, is a musical
> portrait of Stalin, roughly speaking. Of course there are many other things in
> it but that is the basis.[11]

In this chapter I raise the following questions about music and emotion—
without assuming that music is only about emotion. First, what kind of
emotions do we agree on as conveyed in music—specific emotions like
happy, elated, wistful, nostalgic, mournful, or only very general kinds of
feelings, positive as opposed to negative, and energetic as opposed to calm?
Second, what are the underlying mechanisms that cause us to hear emo-
tion in wordless sounds? And third, is our ability to hear certain kinds of
music as expressing certain emotions learned or innate, culturally specific
or universal?

Does Music Express Discrete Emotions or Something More General?

Philosopher Susanne Langer[12] argued that music expresses the subtle
complexes of feeling that we cannot name, and that music reveals the nature
of our emotional life in a far more nuanced and truthful way than language
can reveal. The emotions we hear in music often seem difficult to capture
in words. Finnish composer Jean Sibelius said, "If I could express the same
thing with words as with music, I would, of course, use a verbal expression.
Music is something autonomous and much richer. Music begins where the
possibilities of language end. That is why I write music."[13] And yet most
research on the perception of emotion in music asks people to describe in
words, or choose from a list of words, the emotion they believe the music
conveys. It is difficult to imagine how we can find out what people perceive
without reverting to language.

Langer also believed that music does not express discrete emotions but
rather mirrors the dynamic structure of emotional life—tension and release,

conflict followed by resolution, preparation for a goal and then achievement of that goal, excitation followed by calm, sudden changes and gradual changes. All of these have their parallel in music: "The tonal structures we call 'music' bear a close logical similarity to the forms of human feeling—forms of growth and of attenuation, flowing and slowing, conflict and resolution, speed, arrest, terrific excitement, calm, or subtle activation and dreamy lapses. . . . Music is a tonal analogue of emotive life."[14] According to the Langer view, we should not be asking which discrete emotions a piece of music expresses. Instead, we should be asking whether we perceive in music those dynamic properties of feelings that Langer describes. And yet almost all of the research on music's power to express emotions asks about the perception of discrete emotions like happiness and sadness, and not about whether people perceive a structural analogue of emotional life. Perhaps this is because the latter question is so much more vague, and it seems much crisper to ask people to name the emotions they hear.

What have psychologists uncovered about the perception of discrete emotions in lyric-free music? The first question is whether people agree on what they hear being expressed. Composers of film music must assume such agreement, or their music would seem wrong, out of place. Many studies, almost all conducted with Western classical music and with Western listeners, show considerable agreement, but only about very basic emotions and dimensions of emotions.[15] People agree on whether a piece of music expresses emotions with positive valence (naming feelings like happiness, joy, gladness, etc.) or negative valence (grief, melancholy, sorrow, anger, hate etc.). They also agree on whether the music expresses emotions high in arousal (agitation, violence) or low in arousal (gentleness, soothingness). Within these categories, though, people agree less on the specific nuance. Nonetheless, people do feel that music conveys specific emotions, not just general feelings of something positive or negative, or something high or low in arousal.[16] Contrary to what Sibelius said, people can capture in words the emotions they perceive in music, and they agree with one another—even though the words are just shorthand for the richer experience of the emotion in the music.

People also agree about whether a piece changes in arousal over time. When asked to press their fingers on a pair of tongs as they listened to a piece of music, pressing harder when perceiving greater tension, both musically naïve and expert listeners agreed.[17] These findings about valence and arousal together support Susanne Langer's view that the fluctuations in the emotions conveyed by music are like the fluctuations in our core affect—from feeling good to feeling bad, from feeling energized to feeling sleepy.

Two questions about the expression of emotion follow from the finding that people agree on what they hear expressed. First, what are the underlying mechanisms by which music expresses emotion? And second, can agreement be found when we listen to unfamiliar music from other cultures?

Underlying Mechanisms

In the 1930s, psychologist Kate Hevner[18] pioneered the attempt to pinpoint the structural properties of music that convey specific basic emotions. She presented people with pairs of brief musical compositions created by rewriting one member of the pair, altering one of its properties. Though brief, Hevner insisted that these compositions be complete musical ideas: she opposed using isolated elements of music, like single chords, because she did not accept that these would be perceived as music.

The properties she varied were tempo (fast versus slow), pitch (high versus low), harmony (consonant versus dissonant), mode (major versus minor), rhythm (firm versus flowing), and melodic direction (ascending versus descending). All pieces were performed by a pianist.

Listeners were given a large number of adjectives and were asked to mark the ones that they heard expressed in the music. The terms were arranged in an "adjective circle," with terms clustered together close in meaning, as shown in Figure 3.1. The top and bottom clusters contrasted in valence, with positive terms at the top (bright, cheerful, gay, happy, joyous, merry) and negative terms at the bottom (dark, depressing, doleful, frustrated, gloomy, heavy, melancholy, mournful, pathetic, sad, tragic). A horizontal pole captured a contrast in arousal, with high-arousal terms at the left (emphatic, exalting, majestic, martial, ponderous, robust, vigorous) and low-arousal terms on the right (calm, leisurely, lyrical, quiet, satisfying, serene, soothing, tranquil). The circle was filled out by four more "in-between" clusters.

Hevner showed that the factors with the biggest effect on perceived emotion were tempo and mode; then came pitch level, harmony, and rhythm. Melodic direction had no effect. Emotions in the sad/heavy cluster were marked most often when hearing music in the minor mode, with slow tempo and low pitch. Emotions in the happy/bright cluster were marked most often when hearing music in the major mode, with fast tempo and high pitch. These factors affected the responses of the musically trained and untrained alike.

Since Hevner conducted her studies, many other investigators have examined the association between particular structural features and perceived

6

merry
joyous
gay
7 happy 5
_____ cheerful _____
exhilarated bright humorous
soaring playful
triumphant whimsical
dramatic fanciful
passionate quaint
sensational sprightly
agitated delicate
excited light
impetuous graceful 4
8 restless _____
_____ lyrical
vigorous leisurely
robust satisfying
emphatic serene
martial tranquil
ponderous / quiet
majestic soothing
exalting 1 3
 _____ _____
 spiritual dreamy
 lofty yielding
 awe-inspiring 2 tender
 dignified _____ sentimental
 sacred pathetic longing
 solemn doleful yearning
 sober sad pleading
 serious mournful plaintive
 tragic
 melancholy
 frustrated
 depressing
 gloomy
 heavy
 dark

FIGURE 3.1 Hevner's adjective circle.

emotions.[19] These studies confirm that tempo is the most important factor in determining perceived expression. Fast tempo is associated with high arousal (e.g., in positive emotions such as joy, or in negative emotions such as anger or fear). Slow tempo is associated with low arousal (e.g., in positive emotions such as calmness, or in negative emotions such as sadness). Studies since Hevner have also confirmed the valence effects of the major versus minor mode, as well as the role of many other structural features: volume (loud versus soft), pitch (high, versus low), intervals (consonant versus dissonant),

pitch range (large versus small), harmony (consonance versus dissonance), rhythm (regular versus varied), and articulation (staccato versus legato).

The emotions we perceive in music are rarely caused by a single cue. Cues act in concert with one another, and one cue can override another. Thus, a piece in the minor mode might sound happy if its tempo is fast. Most of the research has examined only one expressive property at a time, using musical pieces that highlight one emotion. But the expression in "real" music changes over time as emotions are perceived to shift and conflict. Still, this kind of breakdown of emotion by underlying structural feature proves very illuminating.

Why do these structural features convey emotion? What is it about loudness or speed that conveys feeling? A powerful explanation is that these structural features mirror how emotions are conveyed by the human voice. We are very good at picking up emotional cues from how people speak, and these cues—things like speed, pitch level, and loudness—are independent of the meaning of the words spoken. One way this has been shown is by asking people to judge the vocal expression of emotion when the semantic content is filtered out by removing high voice frequencies. This method renders the words unintelligible but retains the prosodic features such as pitch, tempo, intonation contour, and rhythm of the speech. American listeners could correctly identify the emotion in both American and Japanese speech presented in this way.[20] Thus the emotions conveyed through speech prosody are perceived cross-culturally. The same conclusion has been reached by studies asking people to judge the emotion conveyed in foreign speech[21] or in sentences composed of nonsense syllables.[22]

How does music mirror speech prosody in the conveyance of emotion? Music psychology researchers Patrik Juslin and Petri Laukka[23] asked this question about anger, fear, happiness, sadness, and love/tenderness. They conducted a monumental review of 104 studies of the speech cues to these emotions and 41 studies of the music cues to these same emotions.

The first finding was that across three sets of studies—speech in one's own language, speech in a foreign language, and music—people agreed on which of these five emotions was being expressed at a rate significantly above chance. The second finding was that the accuracy rates for specific emotions were similar across these three data sets. Anger and sadness were recognized at a significantly higher rate than the other emotions (91% and 92% accuracy, respectively). Fear (86%) and happiness (82%) came next, followed by tenderness (78%). Some of these studies involved children, and showed that by the age of four, children can decode basic emotions

in voices speaking foreign languages, and by age three or four can decode basic emotions in music.

But the most important question is whether the cues that conveyed specific emotions were the same across speech and music. The answer to this question is yes for tempo, volume, pitch, high-frequency energy, and regularity. Slow tempo and low pitch in both speech and music are sadder and tenderer; fast tempo and high pitch are happier. Irregularities (e.g., in intensity and duration) in both speech and music are more negative than are regularities. High acoustic energy in both speech and music is heard as sharp, while lower acoustic energy is heard as soft.

These cues are probabilistic, not deterministic, and cues intercorrelate so that multiple cues are used to decode emotions. Thus, happiness is conveyed in both speech and music by such cues as fast speed, medium–high sound level, high pitch level, high pitch variability, and rising pitch contour. In contrast, sadness is conveyed by slow speed, low sound level, low pitch level, low pitch variability, and falling pitch contour.

The conclusion that Juslin and Laukka reached is that music expresses emotions by the same principles through which speech expresses emotion. Core affect—positive versus negative feelings (*valence*), and energized versus sleepy feelings (*arousal*)—is also conveyed by a number of the same features of music and speech.[24] Vocal expression of emotion is also found in nonhuman primates, showing that vocal expression of emotion originated phylogenetically before music. Musicians rely (perhaps unconsciously) on the principles of vocal expression of emotion. This, incidentally, was the view of the German physicist Hermann von Helmholtz, a pioneer in the study of music, who speculated that music arose from an attempt to imitate expressive modulations of the human voice.[25]

There are also cues that convey emotion in music that have no counterpart in speech, and vice versa—for example, harmony (consonance and dissonance), mode (major and minor), and melodic progression. For these kinds of cues, which are out of the performer's control (as they are fixed in the music's composition), other explanations will have to be sought besides their links to speech prosody.

Learned or Innate?

To the extent that cues to emotion in music are based on cues to emotion in speech, we should expect children to recognize emotion in music early. And they do. By age five, children use tempo as a cue to emotion,[26] with faster

tempos conveying positive emotions, and slower ones sounding more negative. Tempo conveys emotion in the same way in both speech and music. So do pitch and loudness; when children are asked to sing songs showing basic emotions, they use the cues of tempo, pitch, and loudness by the age of five.[27]

Mode (major and minor), however, has no counterpart in speech, and though one small study in 1990 showed that even three-year-olds heard major-minor as happy-sad, a more recent study found no sensitivity to mode until age six.[28] Sensitivity to the difference in emotional tone between major and minor modes may thus emerge only once children have been exposed to this contrast, suggesting that this is a learned association rather than a "natural" one, as one philosopher, Peter Kivy,[29] has argued.

Universality?

To investigate the potential universality of cues to emotion in music, we need to compare music and participants from different cultures. Musical traditions across cultures differ structurally—for example, different scales and different kinds of intervals.[30] Yet there is striking evidence that people perceive emotions expressed in a culturally unfamiliar piece of music, and the emotions they identify accord with those perceived by those within that culture. Psychologists Laura-Lee Balkwill and William Forde Thompson showed this with Hindustani ragas—which are traditionally associated with certain emotions.[31] They played excerpts from 12 ragas that Indian performers agreed expressed either joy, anger, sadness, or peace, to American listeners. These listeners were able to guess the emotion conveyed, though they did often fail to distinguish sadness and peace. In a second study carried out by these same researchers along with a Japanese collaborator, Rie Matsunaga, compositions from India, Japan, and the United States were played to Japanese listeners. The compositions expressed anger, joy, or sadness. The Japanese listeners judged the emotions accurately. They were accurate not only when judging music from their own culture but when judging the others as well. Joy was conveyed in all by a fast tempo and a simple melody, sadness by a slow tempo and complex melody, and anger by high intensity and complex melody.[32] Note the parallels between two of these kinds of cues (speed and intensity) in music and in speech in terms of emotions conveyed.[33] And, of course, to the extent that cues to emotion in speech are universally perceived, we should expect cross-cultural agreement in decoding these same cues in music.

While this study shows some level of universality in the way that music conveys emotions, it is still the case that we are better at recognizing the emotions in music from our own rather than from another culture. This was demonstrated by a team of researchers from Sweden, Finland, India, and Japan.[34] They asked musicians from different musical traditions (Swedish folk, Hindustani classical, Japanese traditional, and Western classical) to play music conveying various emotions. Paralleling the results of the study just discussed, emotions were recognized at an above-chance level by Swedish, Indian, and Japanese participants. However, recognition of the emotion was more accurate when participants judged their own culture's music. Thus we recognize the emotional properties of music both because of universal cues to emotion and because of cultural cues that must be acquired through exposure.

Any study across cultures checking for universality must include cultures untouched by Western music, and given the global reaches of the World Wide Web, it is becoming increasingly difficult to find such cultures. A strong test of the universality hypothesis comes from Thomas Fritz and colleagues,[35] who studied an isolated group who, it was claimed, had had no exposure to Western music—the Mafa in the Cameroon in Africa. Most of the Mafa remain in their isolated villages (without any exposure to Western music through radio) for their entire lives.[36]

The researchers played these participants brief 9- to 15-second excerpts of computer-generated piano music designed to express the emotions happy, sad, and scared/fearful via mode, tempo, pitch range, tone density, and rhythmic regularity. Fourteen excerpts for each emotion were heard through headphones and listeners judged the emotions conveyed not with words but by pointing to one of three faces. These faces were taken from emotion researcher Paul Ekman's archive depicting three basic emotions: happy, sad, and scary.

Both the German and the Mafa listeners identified the emotions correctly at a rate above chance. Not surprisingly, the German listeners were more accurate than the Mafa, but this could be due to the fact that the Mafa were not used to listening to music with headphones and not used to being tested.

The Mafa responded to the cue of tempo like Westerners do, with faster tempos heard as happy and slower tempos as scared and fearful. Since the expression of emotion through tempo is not specific to music but is also conveyed by the human voice, one does not need exposure to Western music (or music of any kind) to respond to a fast tempo as happy. The really surprising finding in this study was that the Mafa heard most of the pieces played in the major mode as happy, those in an indefinite mode

as sad, and those in minor mode as scared and fearful—suggesting that the association between mode and emotion is not learned but innate! This is especially puzzling given that research with Western children discussed earlier reveals that children do not hear minor as sad and major as happy until age six, suggesting learning. However, a close look at the table they present in their supplemental findings shows that the Mafa responses are still quite different from the Western ones.[37] While Westerners identified pieces in the major mode as happy 99% of the time, the Mafa identified these as happy only 65% of the time, and as sad and fearful each 17% of the time. And the Mafa were less likely than Westerners to hear minor pieces as sad: they classified minor pieces as sad 31% of the time but as happy 29% of the time, while Westerners heard these as sad 36% of the time and as happy only 5% of the time. In addition, melodies in the minor mode also tend to be lower in pitch than those in the major mode, and thus it is possible that the Mafa's partial success at identifying minor pieces as negative in emotional tone could stem from lower pitch rather than minor mode.[38]

One way to zero in on whether the association of happy and sad with major and minor is a product of our auditory system or a learned association would be to determine whether it is easier to teach someone (a child below the age of six, or a member of a culturally isolated group never exposed to Western music) to hear minor as sad than to hear it as happy. If there is something natural in the minor–sad link, then it should prove more difficult to teach the opposite association.

In Sum: There Is Truth to the Claim that Music Works as a Universal Language of Emotion

We listen to speech in order to understand what someone is saying and feeling. We do not necessarily derive aesthetic pleasure from this experience; our goal is communication and understanding the other. In contrast, music without lyrics never conveys a transparent "message." Its meanings are not translatable into words. And yet a complex piece of music can convey a universe of emotions.

We listen to music not only to perceive (and often experience) the expressed emotion but also, of course, for the great pleasure we take in its beauty, and for our interest in its form. Moreover, the parallels to speech prosody should not be taken too literally. Though music uses vocal cues as indicators of emotion, music often exaggerates these cues. To be sure,

a violin sounds somewhat like a human voice. But no human voice has as extreme a range of pitches as a violin, nor can any human voice move from sound segment to sound segment as rapidly as a violin can move from note to note. That is why music researchers believe that we process instruments as "superexpressive" voices.[39]

We can conclude that people are sensitive to the emotional content of music from unfamiliar musical traditions (even if they are more sensitive to the emotional content of their own music). Thus, to some degree, the common view that music is a universal language of emotions is correct. But perceiving emotions in music is not the same as experiencing emotions from music. In the next chapter I explore how music makes us feel.

| Feeling From Music
Emotions in the Music Listener

WHEN CELLIST YO YO Ma performs, his head is often thrown back, eyes closed, face contorted with emotion. How do the wordless sounds of instrumental music evoke emotions in him and his audience? We hear Elgar's *Cello Concerto* as sad, but why should hearing this make us *feel* sad? We are not sad *about* the music. Nothing regrettable has happened. So what makes us feel sad? This question has worried philosophers of music.

One way to resolve this puzzle is to deny that listeners experience emotions from music. Philosopher Peter Kivy[1] is one of several who have taken this position, arguing that when we report emotional responses to music, what we are actually feeling is pleasure from the beauty of the music. We feel moved, and we confuse this with the idea that we are experiencing an emotion.[2]

Philosopher Stephen Davies[3] disagrees, arguing that there is nothing wrong with claiming that sad music makes us sad, even though we are not sad *about* the music. We can have an objectless emotion. Sadness is *in* the music, and we catch this sadness and feel it ourselves. We mirror the emotion we hear in the music. We are sad, but not sad *about* anything.

In this chapter I address four questions. First, what emotions do we actually feel from music, and what is the best way to find out? Second, can we differentiate between the emotions we hear *in* the music and the emotions we feel *from* the music? That is, when we say we feel an emotion from music (say, sadness), do we really feel it or are we just confusing what we feel with perceiving that the music is expressing sadness? Third, do emotions evoked by music feel different from emotions by the same name evoked by other contexts? And finally, are our emotional responses to music acquired or inborn?

What Emotions Do We Feel from Music and How Do We Know?

Biological Responses to Music

There are two parts of the nervous system that are crucially involved in emotion: the brain's limbic system and the autonomic nervous system. Music affects both. And this, of course, has implications for music therapy. When we listen to music, all of the limbic and paralimbic structures of the brain are activated. Listening to music that we experience as pleasing activates brain areas involved in reward and other kinds of experiences of pleasure.[4] For example, in a study conducted by neuroscientists Anne Blood and Robert Zatorre, musicians were asked to bring in music without lyrics that they said gave them a feeling of "chills"—a euphoric feeling that may include goosebumps or a feeling of shivers down the spine.[5] Participants (remember, they were musicians) said that this feeling came from the music itself and were not due to any personal memories that were triggered. As they listened to the music, their brains were scanned. The brain areas activated were the same as those involved in biological pleasure—pleasure from food and sex. Intense pleasure from music (and intense pleasure anticipated from music) also activates the release of dopamine in the brain, a neurochemical response to pleasure.[6] As demonstrated in another study, the sensation of chills is reported most often in response to sudden changes in loudness or harmony— and again it was musicians reporting this, raising the question of whether the capacity to feel chills from music is seen typically in people with deep musical knowledge.[7]

Music activates not just areas of the brain known to be associated with reward. Neuroscientist Stefan Koelsch has shown that, unlike other kinds of rewards, such as money, food, and sex, music activates the hippocampus, which is involved in music-evoked positive emotions as well as attachment-related emotions such as love, compassion, and empathy.[8] This is consistent with an understanding of music as a social activity, one that can strengthen social bonds. We often engage with music with other people; we listen, sing, and move together, and hippocampal activity increases even when we tap in synchrony with a simulated virtual partner.[9]

Our autonomic nervous system also responds. Music affects our heartbeat and respiration rate, galvanic skin response, and temperature.[10] For example, fast, accentuated, and staccato music leads to faster and deeper breathing, higher heart rate, and higher skin conductance.[11]

Music-induced arousal changes even occur when listening to unfamiliar music from a different culture, showing that music-induced arousal is based on universal features of music. This was demonstrated by an interdisciplinary team of social scientists studying listeners from Canada and those from an isolated group in the northern Congo (the Mbenzele Pygmies) with no exposure to Western music. Both groups heard Western and Pygmy music and rated their subjective feelings of arousal, from calm to excited.[12] Physiological measurements were also taken. For Western music rated by the Canadians as arousing, both groups showed both increased subjective arousal ratings and increased physiological arousal. Arousal ratings and physiological measures of arousal were due to the acoustical properties of the music—tempo, pitch, and timbre. For example, a fast tempo predicted higher subjective arousal ratings for both groups.

In his influential book *Emotion and Meaning in Music*, musicologist Leonard Meyer[13] argued that music evokes feelings of tension, by building up and then violating the listener's expectations, and feelings of relief when the musical sequence is resolved. Now there is physiological support for this theory. Feelings of surprise and tension can be seen in physiological indices (skin conductance) and in brain activation (e.g., in the amygdala).[14] Note that even when listeners are very familiar with the piece of music and hence know what comes next, surprise and tension are felt when the expectation is violated. This was theorized by Meyer[15] and demonstrated in the brain by Koelsch.[16] These are automatic processes. To understand this better, think of the analogy of a suspenseful film. Even when you have seen the film before and you know that the hero escapes death, as the hero is being chased by a murderer you cannot help but feel tension.

Despite these generalizations about physiological responses to music, it is nonetheless the case that people differ in their emotional response to music—in how often they feel emotion, and in how intensely they feel it, as demonstrated by music psychologist Patrik Juslin and his colleagues.[17] And those who score high on measures of empathy and emotional contagion (they report that seeing someone clearly sad makes them feel sad, for example) report more intense emotional experiences to music.[18] At the other extreme, some individuals report no emotional response to music, either as a result of brain damage or congenital tone deafness.[19] There are also reports of individuals who feel no pleasure from music yet are able to experience normal pleasurable responses from sex, food, money, exercise, and drugs.[20] It's not that these individuals fail to *hear* the emotions expressed by music. They do. But they have no emotional response to music (as measured by self-reported pleasure). They also fail to show the typical elevated

skin conductance and heart rate responses when listening to music. But they demonstrate a normal pleasure response when engaged in a gambling game where they could win or lose money. Here their heart rate and skin conductance are elevated in response to winning, just like the groups without music anhedonia. What this shows us is that the capacity to experience pleasure from music is not part of a general capacity for pleasure; rather, there may be reward circuits in the brain that respond specifically to music. This absence of feeling from music occurs despite no loss in the ability to make non-emotional judgments about music, such as recognizing whether two phrases were the same or different, or in detecting errors.[21]

But people who fail to experience emotion from music are in the minority. The biological evidence—from brain imaging and physiological measures—shows clearly (and in contradiction to what some philosophers have maintained) that most people are indeed experiencing emotion in response to music.

What People *Say* They Feel

As mentioned in Chapter 3, philosopher Susanne Langer[22] believed that the meanings we assign to music are outside of the range of language. Dancer Isadora Duncan is said to have said when asked what her dance meant, "If I could say it in words I would not have to dance it." And yet language is the primary tool that psychologists have used to investigate emotional responses to music. Peering into the brain and the autonomic nervous system gives us important but very general information: it tells us about pleasure and arousal. But if we want to find out the specific emotions people feel when they listen to music, we have to ask them. We can get them to describe what they feel, or we can give them checklists of emotion terms and ask them to circle all those that they feel. We just cannot avoid using language, even though the words we use to describe the emotional experience of music may not be fully adequate. But then, are the words we use to describe any emotional experience fully adequate? Probably not. And that is one reason why we have art.

One way that we can assess emotional responses to music is by using the framework of basic emotion theory. Emotion researchers Paul Ekman and Wallace Friesen proposed six universal, basic and discrete emotions—anger, disgust, fear, happiness, sadness, and surprise.[23] These basic emotions are argued to have evolved for adaptive reasons: they provoke strong behavioral reactions in us that help us survive. We flee when we feel fear, we avoid

that which disgusts us, we approach when we feel joy, we fight when we feel anger. Using this framework, music psychologists have asked people to report (by use of a checklist) which of the basic emotions they feel when listening to music.[24]

But the reliance on basic emotions does not seem to me to be sufficient here. To begin with, the emotions we feel as we listen to music provoke none of the behavioral reactions that real-life anger or fear or disgust provoke. We do not flee, we do not approach. Emotions experienced from music do not seem related to any ancient evolutionary survival functions. In addition, the emotions we feel from music seem much more nuanced and varied and complex than these few basic ones.

Psychologists can also assess emotional responses to music using a broad dimensional approach. Here feelings are captured by a two-dimensional space, with valence as one dimension (positive to negative) and arousal the other (high to low).[25] Thus, we can present a two-dimensional affect grid to listeners (as shown in Figure 4.1a) and ask them to indicate where their feelings lie, from positive valence/high arousal (happy) to negative valence/high arousal (tense); from positive valence/low arousal (calm) to negative valence/low arousal (depressed). This is based on the circumplex model of affect developed by James Russell (and anticipated by Hevner's adjective circle discussed earlier) and shown in Figure 4.1b.

When this approach is used, we can see rapid change in core affect (arousal and valence) as people listen to music.[26] Changes in felt arousal are predicted by changes in loudness and tempo, with loudness having the dominant effect, while the relationship between changes in the music and changes in valence are less clear.

But the problem with this kind of approach is its generality. We can start with valence and arousal, but we must not end there if we want to capture the many full-blown emotions people say they experience from music. To capture these, we need to use a detailed and nuanced inventory of emotion terms that are potentially evoked by music and ask people to use this to indicate their feelings. The most recent and most thorough attempt at developing such an inventory comes from psychologists Klaus Scherer and Marcel Zentner.[27]

These researchers first identified 500 emotion terms from published research on emotion and asked people whether each adjective described "an internal affective state with a special affective 'color' so that, to describe this feeling, you would choose to use this adjective over another one." By picking those that people agreed on, the list was winnowed to 146 distinct emotion terms. Another set of respondents then judged the extent to which

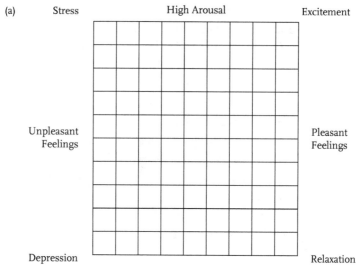

FIGURE 4.1(a) Affect grid.

Figure 1 from Russell, J., Weiss, A., & Mendelsohn, G. (1989). Affect grid: A single-item scale of pleasure and arousal. *Journal of Personality and Social Psychology, 57*(3), 493–502. Published by the American Psychological Association. Reprinted with permission.

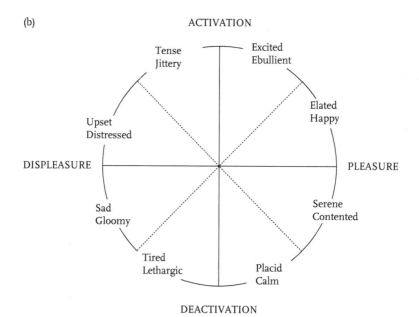

FIGURE 4.1(b) Circumplex model of core affect, with valence represented on the horizontal axis and arousal/activation represented on the vertical axis.

Figure 1 from Russell, J. A. (2003). Core affect and the psychological construction of emotion. *Psychological Review, 110*, 145–172. Published by the American Psychological Association. Reprinted with permission.

each one was an emotion perceived in music, induced by music, and experienced outside of music. Of course, they were instructed to consider only music without lyrics. Terms that people believed were neither perceived nor induced by music were excluded.

After several more iterations, the number of terms was reduced to 40, and these were shown (statistically) to cluster into nine groupings, or scales: wonder (including happy, amazed, moved); transcendence (including inspired, thrills); tenderness (including in love, tender); nostalgia (including nostalgic, melancholic); peacefulness (including serene, meditative); power (including strong, energetic); joyful activation (including joyful, animated); tension (including agitated, tense); and sadness (sad, sorrowful). Note that with the exception of happy and sad, these terms do not correspond to "basic" emotions. This list of terms, now called the Geneva Emotional Music Scale, is intended to capture the very large numbers of nuanced emotions we can feel from music. And there is no reason to think that we can only feel one of these at a time—for example, we can experience wonder and transcendence and peacefulness all at once as we listen to the famous opening passage of Richard Strauss' *Also Sprach Zarathustra*, used as the introduction to the movie *2001: A Space Odyssey*.

Among the most commonly reported emotions from music in Scherer and Zentner's study were ones that we often call "aesthetic emotions"—feeling moved, nostalgic, enchanted, dreamy, and tender. Participants reported such "aesthetic" emotions more often than everyday basic emotions. We call these aesthetic because they are reported in response to art, but note that these emotions are also reported in response to nature and to certain life events (a baby's birth, a wedding, a graduation, etc.).

Not all emotions were equally felt. Negative emotion terms such as guilty, shameful, angry, depressed, anxious, contemptuous, disgusted, embarrassed, and jealous (note that these are, for the most part, interpersonal emotions) were rarely reported as either perceived or evoked by music. Most of the emotions felt were positive ones. This, too, makes sense: why would we voluntarily choose to listen to music so much of our time if it did not make us feel good? As I will show in Chapter 7, even music we perceive as sad makes us feel good (as well as sad).

Which kind of scale—simple or varied, general or specific—do people feel best allows them to indicate their emotional response to music? Zentner and Scherer chose people who liked classical music and asked them to listen to 16 two-minute classical music excerpts. Listeners were to rate their felt emotional reactions to the music on three checklists. One was the Geneva Emotion Scale, whose construction I have just described. A second was the

Differential Emotions Scale,[28] a basic emotion scale listing 10 discrete, basic emotions: interest, joy, surprise, sadness, anger, disgust, contempt, fear, shame, and guilt. And a third was the dimensional emotion model derived from Russell,[29] with these terms capturing positive and negative valence and high and low arousal: activation, unpleasant activation, unpleasantness, unpleasant deactivation, deactivation, pleasant deactivation, pleasantness, and pleasant activation. Participants were also asked to say which checklist best captured the feelings evoked in them by the music. People preferred the Geneva Emotion Scale, perhaps not surprisingly, given that this scale was specifically developed to measure people's emotional experience of music. Keep in mind, also, that the respondents were not a random sample of the population—they were people who liked classical music.

The preference for the Geneva scale shows that the emotions people report feeling from music are many and are nuanced (in contrast to the small number of broad emotion categories people say they perceive and feel when looking at visual art, as discussed in the next two chapters). The research just described purported to capture a very wide range of emotions people report from music. But if we want to figure out what is so special about music, perhaps we need to ask about the strongest and most powerful emotional experiences that music causes. Are musical experiences like the kinds of experiences the psychologist Abraham Maslow[30] described as peak experiences? Maslow asked people to describe the most wonderful, happiest, and most powerful experiences in their lives. People talked about feeling totally engaged, losing awareness of time and space, a feeling of transcendence, wonder, and awe and surrender.

When music researcher Alf Gabrielsson asked people to describe the most intense experience of music they had ever had, people talked about emotions. Fifteen percent reported extremely intense emotional experiences. One woman wrote that "the music began to take control of my body . . . the mystery and the power really gripped me. I was filled by an enormous warmth and heat. . . . Nothing else existed. . . . Tears came into my eyes. . . .The music set me free from my sober everyday life . . . afterwards I remained standing flushed with joy, as if intoxicated. . . . I felt religious and the music was my god."[31] People reported intense transcendental experiences as if at one with the infinite. These quasi-religious experiences were reported by only 10% of the respondents, but when they were recalled, they were felt to have been of great personal importance. People described such experiences as unique, fantastic, unforgettable, and hard to put into words. They also reported physiological reactions (tears, chills, shivers, goosebumps); they felt weightless; they felt fully absorbed

as if the world disappeared, and time stood still; they reported a feeling of surrender to the experience.[32]

Peak emotional responses to music were more often positive than negative. Seventy-two percent of the respondents in this study reported positive emotions, but 23% reported sadness and melancholy, feelings which, by definition, are excluded from Maslow's peak experiences.

Can we make any generalizations about links between specific musical properties and specific felt emotions, as Hevner did for perceived emotions? Patrick Juslin and his colleagues have been addressing this question by presenting music with different kinds of properties and asking listeners (most of whom had had some music training) to rate their responses on 15 emotion scales (like happiness-elation, sadness-melancholy, etc.).[33] Thus far, here is what they have uncovered. Surprise is the emotion most often reported in response to extreme acoustic events in music, as when the music is getting louder and louder, or faster and faster. Sadness is the emotion most often reported in response to hearing sad lyrical, slow music in minor mode featuring the violin or cello (the instruments most like the human voice), showing that people hear the sadness and then "catch it" by some kind of psychological contagion. Nostalgia and happiness are the emotions most often reported in response to music heard at weddings and graduations, showing that music can evoke emotions because they are triggered by memories associated with the music. And anxiety is the emotion most often reported in response to sudden violations of musical expectancy.

These investigations of what people say music makes them feel allow the following three conclusions. (1) Emotions from music are best captured by highly differentiated scales—if we want to capture them in all of their nuanced complexity. (2) Negative emotions are experienced much less often than positive ones. (3) Emotions from music can be extremely intense and powerful, but these are rare (as are peak emotions from any kind of experience). (4) There are some lawful relationships (at least for Western listeners responding to Western music) between certain musical properties and certain emotional responses.

Can We Differentiate Emotions We Hear in the Music from Emotions We Feel from the Music?

Musicologist Leonard Meyer wondered whether we are mistaken when we say we feel an emotion from music. Perhaps we are simply naming the emotion that we hear being expressed in the music. He stated it this way: "it may

well be that when a listener reports that he felt this or that emotion, he is describing the emotion which he believes the passage is supposed to indicate, not anything which he himself has experienced."[34]

When we say we feel happy as we listen to a piece of music, do we really *feel* happy, or are we just reporting the mood we hear expressed in the music (in effect, misunderstanding the question)? The biological evidence discussed earlier tells us that we are really having the feelings. Another way to answer this question is to determine whether people differentiate between what they perceive in the music and what they feel in themselves. And the evidence is clear that people do make this distinction. For example, perceived emotions are typically rated as more intense than felt emotions[35]. And negative emotions are often perceived but rarely felt.[36] We often respond with positive emotions to music that we perceive as sad. (I discuss these findings in Chapter 7, where I ask why it is that responding to something we classify as art leads to positive feelings even in cases where the artwork is sad, horrifying, or disgusting.) The fact of non-perfect overlap between perceived and felt emotions shows that we can differentiate between the emotions we hear in the music (e.g., the music feels tragic) and the emotions we feel when listening (we feel nostalgic). This state of affairs should alleviate Leonard Meyer's concern that we confuse what we perceive with what we feel. In addition, the brain and autonomic nervous system evidence makes it clear that listening to music really does elicit feelings in us.

Do Emotions from Music Feel "Special?"

Kant distinguished aesthetic pleasure from other types of pleasure, arguing that aesthetic pleasure is the result of disinterested contemplation.[37] This kind of distinction leads to the view that the emotions aroused by music are special ones, unlike the ones we experience outside of musical contexts. In the nineteenth century, this view was articulated by the British music theorist Edmund Gurney, who wrote, "Music is perpetually felt as strongly emotional while defying all attempts to analyze the experience or to define it even in the most general way in terms of definite emotions. . . . The emotion aroused by music is "unknown outside the region of musical phenomena."[38] I heard something similar when I asked an amateur musician friend whether he felt emotions from music. He replied that he did not feel emotions. Rather, he said, "I feel musical emotions."

Music emotion researchers make a distinction between utilitarian, everyday, basic emotions (e.g., happy, sad, angry) and aesthetic emotions (e.g.,

awe, wonder, transcendence, thrills).[39] As already discussed, basic emotions likely evolved to trigger adaptive actions on our part—to flee when we feel fear, to approach when we feel happiness, to fight when we feel anger. Unlike basic emotions, aesthetic emotions do not trigger us to act—they just invite us to savor and admire in Kant's disinterested way.

The research I have described shows that we experience both basic and aesthetic emotions from music. The basic emotions people report from music are most often happiness and sadness. Two of the nine scales of the Geneva Emotion Music Scale are wonder and transcendence. The emotions in the wonder scale include being moved; those in the transcendence scale include feeling inspired and thrilled. These are aesthetic, not basic, emotions. And as mentioned, Zentner's participants reported feeling "aesthetic" emotions from music in addition to everyday basic emotions such as happiness.

But two questions arise. (1) Are the aesthetic emotions that people report feeling from music also evoked by contexts other than music? (2) And when we experience emotions from music (whether of the basic or aesthetic variety), do these *feel* (subjectively) different from emotions by the same name but evoked by non-music situations?

The answer to the first question is clearly yes. By definition, the causes of aesthetic emotions are things we find beautiful, inspiring, spiritual. When asked whether the experience of the aesthetic emotions reported was unique to music, Gabrielsson's[40] respondents said they felt these same emotions in other contexts as well—they felt moved, awe and wonder not only from music but also from other art forms, from nature, from religious experiences, and from peak interpersonal experiences, such as holding a newborn baby or falling in love.

The second question is more difficult to answer because it asks about the subjective conscious feelings of emotions, their "qualia." The only way we can answer this is by asking people to introspect. Consider the common example of feeling the basic emotion of sadness as we listen to music— assuming that this sadness is not all or in part due to the music triggering memory of a sad life event. We *know* that the sadness we are feeling is caused by the music, not from some "real-world" situation. It is a bit like responding to virtual reality, or to fiction (which can be seen as a form of virtual reality)—we know that our sadness is not caused by anything real, anything we must figure out how to cope with. We are dealing with simulated emotional experiences.

I am suggesting that sadness-from-music and sadness-from-life feel very different because of the situation we know is causing us to feel this way. We can allow ourselves to feel grief from music because we know that we do not

need to react to this emotion; we know it is not "for real," and that we can just savor it. We experience "vicarious emotions" when listening to sad music.[41] Vicarious emotions can be pleasant because they are indirect, unlike the direct sadness from actual life events. In philosopher Stephen Davies'[42] words, sadness from music lacks "life implications." Sadness from music is pure and unadulterated; sadness from life events is tinged with anxiety because we know we need to figure out how to cope. Perhaps this is why sadness and happiness ratings are significantly more extreme when these emotions are reactions to life events as opposed to reactions to music.[43]

Because sadness experienced through art means sadness experienced from an imaginary space, the experience of sadness through art feels different from what we might call "real sadness." Thalia Goldstein demonstrated this with respect to film.[44] She showed people film clips presented either as fiction or as nonfiction and asked people to rate how sad they felt after watching them. They also rated how sad they felt recalling an autobiographical sad event. Respondents felt equally sad in response to both kinds of films and in response to remembering a sad personal event. What differentiated the personal-memory response, however, was that it also triggered anxiety. The sadness from the films—as we project ourselves into the worlds of others—results in pure sadness, untinged with the aversive feeling of anxiety. That's why Goldstein titled her paper "The Pleasure of Unadulterated Sadness." Of course, sometimes when music evokes an emotion, we are reminded of a life event that caused the same emotion. If we feel sad (or nostalgic) from music and then are reminded of a personal loss, then the sadness is no longer sadness from music, it is sadness triggered by a remembered life event.

Music neuroscientist Aniruddh Patel suggested to me that perhaps we should not make a categorical distinction between sadness from the music and sadness from memories triggered by the music. He believes the two types of sadness can be co-experienced—and that the sadness felt from the music makes us feel a connection to the "larger human experience of sadness in human life, not just in one's own life."[45]

Whether this same kind of distinction can be made for positive emotions—happiness-from-music versus happiness-from-life—I do not know. This would also include the aesthetic emotions of awe and wonder and transcendence and feeling moved, all of which are positive in valence. Perhaps these feel the same when they are experienced from any kind of aesthetic experience (music, visual art, dance, theater, nature), from religious experiences, and perhaps even from interpersonal ones, like holding a newborn baby. The aesthetic emotions do not require us to act; they just invite us to savor.

Whether we experience positive aesthetic emotions from music or the ocean, it is likely that these feelings feel the same.

So what did my musician friend mean when he said he did not feel emotions from music, he felt musical emotions? He might have meant that he did not feel basic emotions like happiness and sadness, but instead felt more nuanced ones like nostalgia and dreaminess. Or he might have meant that emotions by the same name just feel differently when we know they come from music and not from life.

Emotional Responses to Music: Learned or Innate?

The question of whether our emotional responses to music are acquired culturally or are innate has been addressed in two ways. We can ask whether music experts feel the same emotions as those of music novices. And we can ask whether culturally isolated groups who have never heard Western music respond in the same way emotionally to Western music as those familiar with such music.

Expertise

When we compare the kinds of emotions musicians and non-musicians say they feel from music, the answers are, surprisingly, not very different. The participants in Zenter and colleagues' study included many musicians, and it was from these participants that they concluded that aesthetic emotions from music outnumbered basic emotions. But Juslin and his colleagues studied non-musicians and asked them to report their daily emotions and whether music was involved.[46] Participants were contacted seven times a day at random intervals over a period of 14 days. They were given a checklist of 14 emotion terms to use. The 10 most frequent emotions reported as experienced from music were happy, enjoying, relaxed, calm, amused, moved, nostalgic, loving, interested, and longing (with happy the most common, reported over half of the time). This list includes fewer of the aesthetic emotions reported by Zentner et al., but it does include the aesthetic emotion of feeling moved.

A direct comparison between Zentner's and Juslin's studies cannot be made because the two research teams did not present their respondents with the same checklist of emotions. One study that directly compared emotional responses by musicians and non-musicians asked people to group 30-second musical excerpts in terms of the emotions they elicited.[47] They were not asked

to name the emotions they experienced. The non-musicians distinguished eight different groups. The interesting finding was that the musicians also distinguished eight groups. And the excerpts in the groupings made by the musicians and the non-musicians correlated.

These studies show that the emotional experience of non-musicians to music is not so different from the experience of musicians. But it is still possible that the route to emotion differs for the musician and the non-musician. I would speculate that people with limited musical understanding or musical sensibility are more likely to respond with daydreams and associative memories. Hearing sad music, I—a non-musician—may associate to sad events in my life, and this is what makes me feel sad. Those with formal understanding of musical structure are better equipped to be able to hear (and thus respond to) violations of expectancy, simply because they know what to expect. They are better equipped to respond emotionally to the ways in which one part of a piece of music speaks to and responds to and resolves another part.

Responses by Culturally Isolated Groups: Preference for Consonance?

Does familiarity with our culture's music shape our emotional responses or are these emotional responses universal and independent of culture? This question has been asked with respect to our pleasure response to consonance in music. We know that Westerners find consonant chords like the perfect fifth, consisting of a B and an F sharp, more pleasing than dissonant ones like the minor second, a D sharp and an E. Is this a product of culture, due either to a familiarity effect (we hear many more consonant than dissonant chords) or to a learned association (consonance is good, dissonance bad)? Or is this preference innate?

In the previous chapter I discussed a study of the culturally isolated Mafa tribe in the Cameroon.[48] I return to this study here because the researchers presented both Mafa and Western music to Mafa and Western participants and asked them how much pleasure they felt from each. The music was presented in its original form, but a dissonant version was also created, by playing the original version synchronously with two other versions, one shifted one half-tone up (from one adjacent note to the next, e.g., from C to C sharp, or from E to F), and one shifted one tritone down (downward three whole tones, e.g., from F sharp to C). If the association between consonance and pleasure is universal and due to the human auditory system, as the German physicist Hermann von Helmholtz believed,[49] then the Mafa should

rate the consonant versions as more pleasurable, as do Westerners. However, if this association is a Western convention, the Mafa should show no preference. The results: both Mafa and Western listeners rated the consonant items as more pleasant than the dissonant ones, leading the researchers to conclude that consonance-pleasure is a natural, not a cultural, association. And yet, the difference was much more pronounced for Western listeners: they rated the consonant music as far more pleasant and the dissonant music as far less pleasant than did the Mafa listeners, for both Western and Mafa music. Pleasure from consonance may have some biological component, but this inborn tendency seems to be accentuated in those familiar with Western consonant music.

A more recent cross-cultural study on this question supports culture over nature in our preference for consonance. Cognitive scientist Josh McDermott and anthropologist Ricardo Godoy[50] studied the Tsimane tribe in the Amazon rainforest in Bolivia, whom they believed had had no exposure to Western music because of their limited access to radios. Tsimane music has no harmony or polyphony and no group performances; in their music only one line of melody is played at the same time. Without exposure to Western music, and without polyphony and harmony in their own music, the Tsimane would have had no exposure to consonance and dissonance.

The Tsimane participants were played both consonant and dissonant chords and asked to rate how much they liked them. They indicated no preference. Their lack of preference for consonant over dissonant chords was not due to an inability to discriminate, as shown by another test. And as a control measure the Tsimane were asked to rate the pleasantness of smooth and rough tones. Like Westerners, they preferred the smooth tones, showing that their failure to differentiate consonant from dissonant chords was not due to failure to understand the instructions nor to the sounds being unfamiliar. These findings could show that preference for consonance is not innate, is not a product of the human auditory system, and may well depend on exposure to music that has consonant harmony.

But another interpretation has been suggested by Robert Zatorre.[51] It is possible that a preference for consonance is innate but that the Tsimane lose this preference as they grow up because they are never exposed to tones played at the same time. Something like this is known to occur for the perception of phonemic contrasts: the ability to discriminate many of the consonant distinctions used in languages around the world is present at birth, but this ability is affected by the language the infant is exposed to. When a distinction does not carry meaning in the language environment of the child, the ability to perceive this distinction fades away.[52]

Further evidence for preference for consonance being inborn comes from a study of two-day-old newborns of deaf parents.[53] These infants had not heard maternal speech in utero, and one theory for the preference for consonance is that this comes from exposure prenatally to the simultaneous overtones of speech.[54] And yet the infants born to deaf parents looked longer to the original version of a Mozart minuet than to an altered, dissonant version, behaving just like same-age infants of hearing parents. This study has been interpreted as showing that preference for consonance is inborn and not shaped by perceptual experience in utero. Of course, the possibility remains that these infants could have heard some Western music in utero, though clearly they would not have heard anything like the amount heard in utero by infants of hearing parents.

In Sum: Music Works by Eliciting Atypical Kinds of Emotions

We think of music as good—something that calms, inspires, brings us together, makes us happy. But *The New Yorker* music critic Alex Ross pointed out in 2016 that music has not always been considered inherently good.[55] Because music is such a powerful elicitor of emotion, and because we cannot blot it out by turning away, it can be used for evil. The CIA blares heavy metal music as a form of auditory torture. Ross cites writer and Holocaust survivor Primo Levi as recounting that as prisoners at Auschwitz returned to camp from hard labor, they were forced to march to cheery polka music. This was another form of torture. Ross tells of interviewing Iraq veterans who listened to violent "predator" kinds of music to rid themselves of empathy. The fact that music can be used for terrible ends serves as a reminder of the power of music to elicit powerful emotions (or in the case of the Iraq veterans, to counteract one powerful emotion with another).

But are emotional responses to music "true" emotions? Of course they are true emotions, but they are not prototypical cases of emotion. The study of emotions from music must be part of a general theory of emotion. Any theory of emotion must be able to account for our prototypical instances of emotion, such as our emotional reaction of fear when we see a bear, which in turn prompts us to flee, or our reaction of joy when we reunite with a long-lost family member. And any theory of emotion must also be able to account for atypical instances of emotion. Emotional reactions to works of art are atypical because we are reacting to situations that do not require any behavior on our part; reactions to purely non-representational works such

as music and abstract art are even more atypical because the art we are experiencing does not refer to any of the human experiences that normally give rise to emotion. And there is probably no direct evolutionary explanation for these kinds of emotions.

Is the emotional experience of music more intense than the emotional experience of visual art? Is there something more emotional about sound than sight? Fascinating anecdotal evidence for the power of sound to elicit emotion comes from reports from individuals who lose their hearing as adults. They report a "draining of feeling" from the world.[56]

Studies of visual art tell of a less powerful relation to emotion than we find with music. We can speculate why music may elicit more powerful feelings than do the visual arts. First, there is the issue of the human voice. Sorrow, yearning, and joy sound similar in music and in a person's voice. Second, there is the issue of time. We may look at a work of art in a museum for three seconds, but we listen to a piece of music for a long time because music occurs over time. Third, there is the issue of envelopment. We can avert our eyes from a painting, but we cannot block out music by turning away.

In the next two chapters I consider the emotions expressed and evoked by visual arts and ask how it is that purely abstract forms and colors can both convey and elicit feelings.

CHAPTER 5 | Color and Form
 | *Emotional Connotations of Visual Art*

HOW IS IT THAT abstract arrangements of sounds express emotion? This is the
question discussed in Chapter 3, and now I take up the same question with
respect to visual art: how can abstract arrangements of forms, lines, colors,
and textures express emotion?

Few would deny that paintings express emotion. When we look at a
painting or drawing, whether abstract or representational, we are apt to
comment that it is sad, joyous, tragic, conflicted, agitated, or calm. We will-
ingly ascribe these kinds of emotional properties, knowing full well that
these are not properties that the picture literally possesses (like its actual
colors, textures, size, or content)—just as we know that a sad piece of music
is not literally sad. These are emotional properties that we feel we see di-
rectly, yet we know they are only metaphorically possessed by the physical
picture. In Nelson Goodman's terms, when a picture is functioning as art
for the observer, that observer notices metaphorically expressed properties.
For Goodman this is a form of symbolization distinct from representation.

Pictures convey human emotions in three very different ways. They do
so literally by depicting scenes we recognize as happy (dancing) or angry
(fighting) or scenes with facial expressions showing emotion. Ask a four-
year-old to draw a happy picture and she is likely to draw a smiling face.
Ask her to draw a happy tree and she will draw a tree with a smile on it.[1]
This child has created emotion in a picture by representing emotion literally.
Clearly, one way that paintings convey emotion is literally. This way does not
interest me here. This is no more of a philosophical puzzle than the fact that
a song with sad lyrics conveys sadness. Both the song and the picture are
representing the emotion.

A second way that pictures convey emotions is metaphorically, by depicting things that we associate with emotions, such as barren versus lush landscapes. A painting of a ship on a stormy sea conveys a negative emotional tone because such a scene is violent and terrifying; a lush landscape expresses a positive emotional tone because it is inviting and filled with life. In a letter to his brother Theo, Vincent Van Gogh[2] described a drawing of bare trees with gnarled roots "clinging to the earth convulsively and passionately and yet being half torn by the storm." He said he wanted to express the struggle for life "in the black, gnarled, and knotty roots." I call this means of expression metaphorical since a tree or a landscape cannot actually have emotions. These are examples of expression via representation. The drawing of the roots is representational, and the idea of roots clinging to the ground expresses the struggle for life.

Expression in pictures can also be wholly independent of representational content, based on purely formal properties—color, line, texture, composition. This is the third way pictures can express. Abstract expressionist painter Mark Rothko said that he was not interested in form and color for their own sake. Instead, he said, "I'm interested only in expressing basic human emotions—tragedy, ecstasy, doom and so on—and the fact that lots of people break down and cry when confronted with my pictures shows that I communicate those basic human emotions. . . .The people who weep before my pictures are having the same religious experience I had when I painted them.[3]

A Rothko triptych is reproduced (in black and white, alas) in Figure 5.1. His signature style consists of huge, richly colored, atmospheric, rectangular areas with soft, blurry edges (typically two, one above the other) that seem to float. In a July 8, 1945, letter to the art editor of *The New York Times*, Rothko wrote that his paintings were a "pictorial equivalent for man's new knowledge and consciousness of his more complex inner self."[4]

The art critic and curator Kirk Varnedoe entitled his Mellon lectures on abstract art *Pictures of Nothing*. He made the argument that abstract art is a visual language that is deeply meaningful and capable of expressing a wide range of emotions and ideas. He describes abstraction as "a bedrock form of expression . . . a tradition of invention and interpretation that has become exceptionally refined and intricate, encompassing a mind-boggling range of drips, stains, blobs, blocks, bricks, and blank canvases [that] can snare and cradle vanishingly subtle, evanescent, and slender forms of life and meaning"[5]— reminiscent of Clive Bell's[6] definition of art as "significant form."

The same formal properties that express emotion in abstract art can be seen operating in representational art. Psychologist of art, Rudolf Arnheim,

FIGURE 5.1 Darkly colored paintings by Mark Rothko in the Rothko Chapel, Houston, Texas.

Photo by Hickey-Robertson. Reprinted with permission of the Rothko Chapel. © 1998 Kate Rothko Prizel & Christopher Rothko/Artists Rights Society (ARS), New York.

traced the major outlines of two still lifes, one by Cézanne and one by Picasso, to show how these paintings express very different feelings, simply through the properties of their lines, as shown in Figure 5.2.[7] The underlying geometry of the still life by Cézanne has horizontal lines and rounded forms and feels stable and calm. The Picasso has diagonal lines and sharp contours and feels unstable and distressed. Arnheim also gives us the example of Michelangelo's painting of the *Creation of Adam* on the Sistine Chapel ceiling. Adam's body is in a passive concave curve; God is reaching for him in an energetic forward motion. This contrast in energy is conveyed by the differentially expressive forces of the two bodies.

It is not difficult to explain how it is that we recognize paintings of weeping people as sad, nor how we recognize paintings of barren landscapes as sad. What is more mysterious is how we are able to recognize paintings as expressing emotions by their compositional structure, as Arnheim showed with the Cézanne and the Picasso, or as expressing emotions when, like the works of Rothko, the pictures contain no representational content at all—just lines, colors, and forms.

FIGURE 5.2 Tracings by Rudolf Arnheim of still life by Paul Cézanne (a) and by Pablo Picasso (b) showing different expressive properties through line properties alone.

Figure 269, Diagrams A and B, p. 459, from *Art and Visual Perception: A Psychology of the Creative Eye*, Fiftieth Anniversary, by Rudolf Arnheim. © 2004 by the Regents of the University of California. Published by the University of California Press. Reprinted with permission of University of California Press.

In this chapter I ask two questions. If we do perceive emotions in abstract art (we do), are these perceptions universal, independent of culture, or are they arbitrary and learned, much like we learn to associate the sound *apple* with an apple if we are growing up speaking English and the sound *pomme* with an apple if we are growing up in France? And second, is our proclivity

to perceive emotions in abstract art a part of a larger tendency to recognize metaphorical connotations of simple lines and forms?

Perceiving Emotions in Paintings: Social Convention or Natural and Universal?

Two theorists of art have clashed over whether the perception of emotions in visual art is due to arbitrary association or to universally perceived similarities between the structure of visual forms and the feeling of emotions. Rudolf Arnheim came out of an idealist German tradition—believing that there are basic, fundamental forms of life that are built-in and guide how we see the world. This view can be seen in the field of Gestalt psychology, which posited that there were "good" forms (e.g., regular, simple, balanced, organized) that we have evolved to recognize and make. Nelson Goodman, in contrast, came out of the British-American empiricist tradition of philosophy, which held that we begin as a blank slate and what we know and perceive is based entirely on learning and sensory experience.

Goodman rejected the concept of similarity as vacuous, arguing that everything is similar to everything else in innumerable ways.[8] When we perceive two things as especially similar, this is due only to a learned association. Thus he would have to conclude that we perceive a dark Rothko painting as sad because we have learned to associate sad with dark; we could just as readily have learned to associate sad with bright or neutral colors. The analogy in music would be that the major minor association with happy and sad, respectively, is a learned association, especially given the fact that children under six do not yet make this connection.[9]

Rudolf Arnheim embraced the concept of similarity and believed that the structure of a work of art conveys emotions that we cannot help but see. Learning—in any powerful sense of that term—is not involved. What we perceive in a picture is dynamic. We see the motions, the weights, the forces. And these dynamic forces are what convey the emotional properties of pictures. These properties are perceived immediately and directly because of a structural similarity between the forces that shape our physical behavior (not only posture but also facial expression and handwriting) and the forces that shape our mental states. We see a drooping willow tree as sad because its passive hanging is how we stand when sad; we see flames as striving because their dynamic upward motion is structurally similar to the reaching feeling of striving toward a goal.

Psychologists have stepped in to this debate to test whether there is any consensus among people about the emotion expressed by an abstract painting. The answer is that people do agree about very broad emotion categories (like happy and sad, or negative and positive valence or emotional tone), but only for some abstract paintings. David Melcher and Francesca Bacci asked participants to rate 500 abstract paintings on a seven-point scale, from negative to positive.[10] For most of the paintings, people either agreed on neutral ratings or disagreed, with some giving positive, others negative, ratings. (Note how different this is from music studies, where there is high agreement about positive and negative valence.) However, the ones that people agreed were positive differed consistently in their visual properties from those that people agreed were highly negative. The positive ones had bright colors, complementary color contrasts, and simple, regular forms. The negative ones were dark and contained irregular marks. And the researchers were able to train a computer to judge the emotion that humans perceive in these paintings using line, form, and color information, demonstrating that the perception of emotion in some abstract paintings is based on objectively perceivable features of the paintings.

We know that pictures of facial expression can prime us to see that same emotion in neutral faces.[11] Melcher and Bacci showed that abstract paintings could do the same thing: abstract paintings viewed as happy primed people to see more positive affect in a neutral face presented 800 milliseconds later; and abstract paintings viewed as sad primed people to see more negative affect in the neutral face.[12] Another study showed that when we look at abstract paintings that are classified as negative in tone, our frowning muscles are activated; when we look at paintings classified as positive, smiling muscles are activated.[13]

One way to test whether the expressive properties in pictures are transparently perceived and agreed on by all or whether we have to learn to perceive them is to test responses of young children. A second way is to compare responses of people from very different cultures. If young children agree on the emotional content of abstract art, this is a point for Arnheim. And if people from different cultures agree, this is a yet stronger point for Arnheim.

When I was just starting out in my research into the psychology of the arts, I tested the ability to perceive mood in abstract art in children between the ages of five and ten.[14] To construct our items we showed adults a series of abstract paintings and asked them to judge for each work whether it was predominantly happy, sad, excited, or calm. Using those paintings on which 9 out of 10 adults concurred, we made color slides of 16 pairs of paintings with each pair contrasting in mood (happy–sad; excited–calm). For example,

we paired a colorful painting by Miro rated by adults as expressing happiness with a dark painting by Soulages rated as expressing sadness.

Even the five-year-olds agreed with the adult choices at a rate significantly above chance. Strikingly, children were even able to explain their choices by pointing to formal properties (e.g., this one has brighter colors; this one has darker lines). And they were not just describing the formal features of the paintings after any kind of match—these kinds of formal reasons were twice as common following correct matches than incorrect ones. The matches made by the children, and their reasons offered, show that children as young as five have considerable sensitivity to the formal means by which moods are expressed in paintings.

This kind of task can be made more difficult or can be made easier. When paintings were presented one at a time, rather than in contrasting pairs, the task was harder. Richard Jolley and Glyn Thomas showed children and adolescents abstract paintings and asked them to label each one as happy, sad, angry, or calm.[15] These paintings had first been rated by adults for each one of these emotions, and only those on which there was clear agreement were used. Five-year-olds succeeded (at an above-chance level, showing they were not just guessing) only for happy paintings; seven-year-olds succeeded on all but sad paintings. After age seven, everyone was above chance. The task can be made easier by asking children to match paintings to pictures of a face showing the emotions of happy, sad, excited, and calm. Using this method, and mixing abstract works with representational ones (but never including human figures) expressing moods metaphorically (such as Van Gogh's painting of a beat-up pair of shoes), Tara Callaghan found that at age five, children's matches were consistent with adult artist matches at an above-chance level, with greater consistency for calm and sad than for excited and happy.[16] With some adult modeling for how to do such a task, and also when the drawings to be matched were by children, even three-year-olds succeeded.[17] Figure 5.3 shows four paintings used in this study, each conveying one of the four moods.

A somewhat more difficult task was used by Thomas Carothers and Howard Gardner.[18] They showed children the scene in Figure 5.4, which expresses sadness via subject matter (dark clouds, shuttered store, bent-over human), and asked children to choose from two images that would best complete this drawing—a drooping leafless tree and wilted flower (sad) or an upright blooming tree and flower (happy). Seven-year-olds picked both options equally, showing no realization that the mood in the completion should match the mood of the rest of the picture. But by the age of 10, children

FIGURE 5.3 Paintings used by Callaghan (1997): (a) Brightly colored painting by Henri Matisse expressing happiness; (b) dark painting by Robert Motherwell expressing sadness; (c) cloudscape by Georgia O'Keefe expressing calm; (d) painting by Vasily Kandinsky expressing excitement.

(a) Henri Matisse (1869–1954) © Copyright. *La Gerbe*, 1953. Ceramic, Ceramic tile embedded in plaster, 108 × 156 in. (274.32 × 396.24 cm); weight: 2,000 lbs. Gift of Frances L. Brody, in honor of the museum's twenty-fifth anniversary (M.2010.1). © Succession H. Matisse, Paris I/ARS, NY. Los Angeles County Museum of Art. Digital Image © 2018 Museum Associates/ LACMA. Licensed by Art Resource, New York. © 2018 Succession H. Matisse/Artists Rights Society (ARS), New York.

(b) Robert Motherwell (1915–1991) © VAGA, New York, NY. *Elegy to the Spanish Republic, No. 35*, 1954–58. Oil and magna on canvas, 80 x100 1/4 in. (203.2 × 254.6 cm). The Muriel Kallis Steinberg Newman Collection, Gift of Muriel Kallis Newman, in Memory of Albert Hardy Newman, 2006 (2006.32.46). The Metropolitan Museum of Art. Image copyright © The Metropolitan Museum of Art. Image source: Art Resource, New York. Rights and Reproduction: Art © Dedalus Foundation/Licensed by VAGA, New York, NY; (c) Georgia O'Keefe (1887–1986) © ARS, New York. Sky Above Clouds, IV, 1965. Oil on canvas, 243.8 × 731.5 cm (96 × 288 in.). Restricted gift of the Paul and Gabriella Rosenbaum Foundation; gift of Georgia O'Keeffe, 1983.821. Artist's © The Art Institute of Chicago. Photo credit: The Art Institute of Chicago/Art Resource, New York; (d) Vasily Kandinsky. *Orange*, 1923. From a private collection. © 2018 Artists Rights Society (ARS), New York. Photo Credit: HIP/Art Resource, New York.

succeeded, selecting the bare tree and dying flower. When Richard Jolley and Glyn Thomas tried the same thing, but this time simply asked children which tree and flower picture in Figure 5.5 was sad and which happy, even four-year-olds recognized the bare tree and wilting flower as sad.[19] Thus the problem for children in the Carothers and Gardner study was to realize that mood *mattered* in completing the picture.

FIGURE 5.4 Drawing expressing sadness.

Figure 5 from Carothers, T., & Gardner, H. (1979). When children's drawings become art: The emergence of aesthetic production and perception. *Developmental Psychology, 15,* 570–580. Published by the American Psychological Association. Reprinted with permission.

These studies show widespread agreement about expressive properties of paintings, with the caveat that these studies looked at only a few kinds of emotions. Surely if researchers had asked about subtle emotional distinctions—like whether a painting is wistful, sad, tragic, or

FIGURE 5.5 Blooming tree and flower versus leafless tree and wilting flower.

From Figure 1 in Jolley and Thomas (1995). Reprinted by permission of John Wiley and Sons and Copyright Clearance Center. From Figure 1 of Jolley, R. P., & Thomas, G. V. (1995). Children's sensitivity to metaphorical expression of mood in line drawings. *British Journal of Developmental Psychology, 13*(4), 335–346. ® 1995 The British Psychological Society.

nostalgic—disagreement would be much larger. But about the broad dimensions of happy and sad, calm, excited and angry, adults concur, as do children—suggesting, with Arnheim rather than Goodman, that these associations are not arbitrary ones. When we turn next to research on the perception of expressive properties of simple visual forms rather than actual paintings or drawings, we find even stronger evidence that these associations are natural, not conventional—evidence in the form of agreement across cultures.

Is Perception of Emotion in Art Part of a Broader Tendency to Ascribe Emotional Content to Simple Visual Forms?

According to Arnheim, visual art cannot help but be expressive of emotions, because we invariably perceive expression in objects and scenes. This occurs in representational art (as in the position of Adam's and God's bodies, or the positioning of the Cézanne versus Picasso still lifes), as well as in non-representational art. Hence, there really is no such thing as pure form. All forms have expressive meaning. People agree on what these meanings are. And we agree because we perceive a direct structural similarity between *any kind of visual experience* and emotional experience.

Sad, tired, and striving are all properties of animate beings. And yet a draped and faded blanket can look sad and tired, and flames can look like striving. We see these properties in inanimate things, just as we see them in paintings. We can test the generality of this ability by looking at whether people from different cultures read the same kind of emotional symbolism into very simple colors, lines, and forms.

Cross-Cultural Studies

Almost a century ago, psychologists began investigating whether people could perceive the expressive properties of visual stimuli (lines, shapes, colors), and we now have a large body of evidence showing that most people, including people from different cultures, agree on what very simple colors, lines, and forms express. Helge Lundholm, a researcher at Harvard at the time, asked a small group of people to draw lines expressing specific affective tones: sad, quiet, lazy, exciting, angry, cruel, strong, and the like.[20] The lines that people drew varied systematically for the different adjectives. Lines with long, low waves were drawn to show sadness. Curved lines were used

for pleasant emotions, angular ones for anger, agitation, and excitement. Downward-directed lines were used for sad, upward-directed ones for happy. And people also elaborated verbally. They said that sharp angles hurt and that they express violence, while curves express grace and are pleasant. They said that downward motion of a line shows loss of energy, while upward-moving lines convey strength.

An experiment published a few years later showed people the kinds of lines that these participants had drawn and asked them to match the lines to the adjectives that had been used as prompts.[21] Responses were in clear agreement with Lundholm's findings. The lines people drew to convey feelings, and the feelings people perceived in drawn lines, converged. Similar findings have been reported for color–mood associations, with red showing excitement and heat, orange showing distress, blue showing tenderness, black showing power and heaviness.[22]

Evidence that these ways of seeing are not learned but are primary kinds of connections that all humans see directly comes from cross-cultural studies. In one study, Shigeko Takahasi asked Japanese participants to depict a variety of expressive properties using lines—anger, joy, tranquility, depression, human energy, femininity, and illness—without recourse to representation.[23] Drawing a smiling face to show joy, or a crying one to show depression would not count. The drawing had to be non-representational. Other Japanese participants were then asked to guess what each was intended to convey.

The drawers and the perceivers agreed. Thick and rough lines showed anger, depression, energy. Thinner, smoother lines showed joy, tranquility, femininity. Jagged pointed forms and thick lines showed anger. Curving lines showed joy, horizontal ones showed tranquility. Descending thin lines conveyed depression, while rising triangular forms showed energy. Takahasi reports that when a similar study was carried out in the United States,[24] moods and meanings were expressed in ways very consistent with the Japanese study. In another study, participants from Germany, Mexico, Poland, Russia, and the United States agreed that the colors of anger were black and red, the color of fear was black, and the color of jealousy was red.[25]

Further cross-cultural evidence for this kind of symbolism comes from how people respond to the Semantic Differential Scale, developed in 1957 by psychologist Charles Osgood.[26] This scale presents people with a wide variety of words, such as *man, woman, horse, war, kiss, city, engine, fire, yellow, black, tight, child.* Participants are asked to rate each word on a number of bipolar scales—from good to bad, strong to weak, big to little, young to old,

noisy to quiet, sweet to sour, and many others. While these bipolar scales do not always involve emotion terms, placing a concept such as horse or city along one of these scales can only be done metaphorically.

Ratings cluster statistically into three broad dimensions: evaluative, potency, and activity. Scales like good–bad, sweet–sour, and helpful–unhelpful form an evaluative dimension. Scales like strong–weak, powerful–powerless, and big–little form a potency dimension. And scales like fast–slow, young–old, noisy–quiet form an activity dimension. *Fire* is strong, *child* is weak, *engine* is active, *stone* is inactive, *kiss* is positive, *disease* is negative, and so forth. The Semantic Differential Scale has been given to people across a wide variety of cultures, and the results are clear: there is strong cross-cultural agreement about the connotations of concepts.[27]

Most relevant for our purposes is that connotations of concepts are just as easily captured in pictures as in words, as shown by a pictorial form of the semantic differential.[28] Here, instead of judging concepts on verbal bipolar scales, people were asked to judge them by pointing to opposite kinds of visual forms. Think about how you would respond to the following. You are given the word *good* and a choice of two patterns—a homogeneous one with three circles or a heterogeneous one with a circle, a square, and a triangle, as in Figure 5.6. Which do you pick? Or if you are given the word *noisy* and the choice of a horizontal or a crooked line?

If you are like Osgood's respondents, you will pair *good* with the homogenous pattern, and *noisy* with the crooked line. This is how American university students responded, as well as Japanese recently arrived in the United

FIGURE 5.6 When asked which one of the two shapes on the left should be matched with *good*, participants typically choose the one with the homogeneous shapes. Asked which of the two lines on the right should be paired with *noisy*, participants picked the crooked line.

Images traced from p. 148 of Osgood, C. E. (1960). The cross-cultural generality of visual-verbal synesthetic tendencies. *Behavioral Science*, 5(2), 146–169. Reprinted by permission of John Wiley and Sons, Inc. and Copyright Clearance Center. © 2017 Copyright Clearance Center, Inc.

States, Navajo Native Americans, and Mexicans. Education level did not play a role, as some of Osgood's participants were urban and highly educated and some were rural and not educated at all. Such cross-cultural evidence strongly suggests that these connections are not arbitrary links that we learn by association. For if they were, we would not expect people from different cultures to converge on the same matchings.

How unnatural would these kinds of matches feel if the forms and emotions were paired in the opposite way? What would happen if we told people that jagged, pointed forms expressed joy, and curving lines expressed anger? Would people reject such pairings? This is the question asked in a clever experiment described next.

Evidence from Mismatches

Chang Hong Liu and John Kennedy showed that people agree very strongly about whether a particular word is more like a circle or a square.[29] *Soft, happy, light, bright,* and *love* belong with a circle; *hard, sad, heavy, dark,* and *hate* belong better with a square. To begin with, these are not the kinds of associations that would have been learned: there is nothing in our language or our culture that links circles with happiness and squares with sadness. But to demonstrate "naturalness" rather than learned association, the researchers went further. They asked how readily these linkages could be overcome. They presented people with 20 word pairs to remember, with one word in each pair presented in a circle, the other in a square. Half of the participants were in the "congruent" condition: they saw words like *happy* and *bright* and *love* inside the circle; and the other half were in the incongruent condition, seeing these same words presented instead inside the square. Later, in the memory test phase, they were shown each word pair and asked which one had been shown in the circle, which in the square. The congruent group recalled significantly more of the word–shape associations. Several more experiments by these researchers using slightly different methodologies confirmed these findings. This finding is a strong piece of evidence in favor of form symbolism being universal rather than simply a matter of social convention.

Evidence from the Blind

Another powerful piece of evidence for the non-learned mapping of visual forms to metaphorical expression of emotions comes from John Kennedy's remarkable studies of blind people, including the congenitally blind.[30]

Kennedy showed that blind people can recognize what is represented in drawings with raised lines that can be apprehended through touch, and then went on to show that blind people can also recognize non-literal properties of these line drawings. For example, he showed the four hand drawings in Figure 5.7 to sighted and blind adults (the blind received raised line versions) and asked which hand showed the thumb in pain, the thumb numb, the thumb making a circular motion, and the thumb moving to and fro. What is important here for our purposes is the blind person's ability to detect the metaphorical conveyance of pain and numbness, as these are closest to emotional states. And the striking finding is that the blind and the sighted agree: the thumb with radiating lines going outward is in pain; the thumb with dashed lines is numb. Because the blind participants had not ever been exposed to these kinds of line drawings before, they could not have learned these associations—another point in favor of "naturalness."

These findings allow us to conclude that the blind and the sighted have the same kind of recognition of the connotations of forms. If these connections were just social conventions, we would not find this kind of agreement. These findings provide more points in favor of Arnheim's position that there is a structural similarity between the forces that shape our physical behavior and the forces that shape our mental states. This

FIGURE 5.7 Blind people agreed that the thumb on the lower left with radiating lines going outwards is in pain and the thumb on the lower right outlined with dashed lines is numb.

Figure 8.9, p. 280 from Kennedy, J. (1993). Reprinted with permission of Yale University Press.

similarity allows us to perceive expression in inanimate objects *directly*, without learning, without association, without projection. And thus a weeping willow tree expresses sadness because it is structurally similar to the passive posture of sadness. And flames express striving because their dynamic upward motion is structurally similar to the reaching feeling of striving toward a goal.[31] This is a form of "embodied cognition"—we can feel the willow tree as sad because when we feel sad our body feels like it is heavy and hanging.

William James apparently had the same intuition as Arnheim about isomorphism between physical and mental states. Arnheim[32] cites these words from James' *Principles of Psychology:* "such attributes as intensity, volume, simplicity, or complication, smooth or impeded change, rest or agitation, are habitually predicated by both physical facts and mental facts." This principle of isomorphism between physical and mental life also parallels Susanne Langer's theory that music expresses by showing us the structure of emotional life.

The strong agreement across cultures and languages about the affective connotations of concepts, visual forms, and colors suggests that, for the most part, Goodman was wrong and Arnheim was right. These connotations form the basis for verbal metaphors—black rage, fiery courage, and so on. If poetry in some languages spoke of pink rage and watery courage, translations of such poetry would make little sense. And these connotations are what make it possible for non-representational images to express emotion.

However, it is a mistake to think of visual forms and colors and compositions as having a deterministic relationship to expressive properties. Context can shift our perceptions. Art historian Ernst Gombrich pointed this out when he noted that we perceive Piet Mondrian's final painting, *Broadway Boogie Woogie,* as expressing restless motion (as its name implies) when we are implicitly comparing it to earlier, simpler, more stable Mondrians. But if we were instead to compare *Broadway Boogie Woogie* to a painting by Italian futurist Gino Severini painted in similar colors but filled with diagonal broken lines and forms, the story changes. Now Mondrian's painting seems calm and ordered, while Severini's seems agitated.[33] Thus, to assume that a painting has a fixed and stable affective tone is to oversimplify how art conveys emotion. And this is a point for Goodman—yes, we can perceive similarity, but context can affect the matches we make.

In Sum: Perceiving Emotion in Abstract Visual Art Works Naturally and Inescapably

Nelson Goodman's argument that everything is similar to everything else may be logically sound. No matter what two items I put together (e.g., diamond and hammer), I can find points of similarity between them. They may appear in the same sentence; they both have two syllables; they are both hard. But what is logically sound may not be psychologically sound. Rudolf Arnheim's view that there is a natural similarity between certain forms and certain feelings turns out to be supported by the evidence—people from different cultures, and young children as well as adults, agree on what visual forms symbolize in terms of expressive properties. Arnheim's view is the one that makes psychological sense, at least on a very basic level. But these natural similarities can easily become entangled with culturally specific experiences, as Gombrich's example suggests, making adult responses to art a complex amalgam of both natural and cultural factors.

Paintings express emotions in part through their formal properties, and our ability to perceive these linkages is part of a broader human ability. Seeing expressive qualities in visual patterns is a general aspect of perception not limited to art. We see expressive properties in rocks, trees, columns, cracks, drapery, and the like. We find expression even in the most mundane and neutral of objects. We cannot help but perceive emotion when we look at inanimate objects (draped blankets, budding flowers, weeping willows), and we can even perceive expressive properties in stripped-down visual stimuli—a bright color, a dark color, a jagged line, a softly curving line. If Nelson Goodman were correct, then it would be as easy to learn an association between a bent-over tree and happiness, or to see a flaming fire as passive and devoid of energy. But John Kennedy cleverly showed that when associations are reversed (pairing the word *happy* with a square and *sad* with a circle), these matches feel wrong—as evidenced by the fact that they are harder to remember than the ones that feel right.

In this chapter I considered our natural tendency to perceive emotions in paintings. In an earlier chapter I showed how readily we perceive emotions in music. And similar arguments could be made about how we perceive the expressive connotations of the sounds of words. For example, we perceive the nonsense syllable *mal* as big, *mil* as little[34]; and we

correctly perceive that the Chinese words *ch'ung* and *ch'ing* are translations of *heavy* and *light,* respectively, and not the reverse.[35] This phenomenon, analyzed by the linguist Roman Jakobson, is called *phonetic symbolism,* and it is clearly cousin to the kind of visual form symbolism I have been talking about here.[36]

What about emotions in the viewer? Can paintings evoke these? Rothko said that many people cry when confronted with his pictures. How common is this? Can looking at non-representational visual art elicit strong emotional reactions? And if so, are these responses as strong as those that people report from listening to music? It is to this question that I now turn.

| Emotions in the Art Museum
Why Don't We Feel Like Crying?

PEOPLE HAVE REPORTED EXTREMELY powerful emotional responses while standing in front of paintings—shaking, dizziness, and tears. How common are such experiences? There is far less philosophizing about emotional responses to visual art than to music, and there are fewer studies from psychologists about this as well. Extant studies do not provide a strong basis from which to conclude that people shake and weep in front of paintings. But the visual arts (like all arts) can move us strongly, and there is fascinating evidence about the areas of the brain that are activated when paintings move us. I conclude this discussion by reflecting on why it is that people seem to be more willing to report feeling specific emotions in response to music than to the visual arts.

The Stendhal Syndrome

Nineteenth-century French novelists were obsessed with visual art and artists.[1] All of the major French novelists of that century—Honoré de Balzac, Émile Zola, Stendhal, Gustave Flaubert, and others—have a painter as a character in their works. Stendhal (the pen name of Marie-Henri Beyle) was so affected by certain works of art that he has an illness named in his honor: the Stendhal syndrome. How did this come about?

While in a chapel in Florence filled with beautiful frescoes—the chapel where Machiavelli, Michelangelo, and Galileo were buried—34-year-old Stendhal had a powerful emotional experience accompanied by strange physical symptoms. When standing alone in front of frescoes by Volterrano, he wrote:

I underwent, through the medium of Volterrano's *Sybils*, the profoundest ex-perience of ecstasy that, as far as I am aware, I ever encountered through the painter's art...Absorbed in the contemplation of *sublime beauty*, I could perceive its very essence close at hand...I was seized with a fierce palpitation of the heart (that same symptom which, in Berlin, is referred to as an *attack of nerves*); the well-spring of life was dried up within me, and I walked in constant fear of falling to the ground.[2]

Apparently Russian novelist Fyodor Dostoyevsky also had these kinds of intense emotional experiences from paintings. According to his wife, Anna Grigorievna, he reacted strangely when looking at Hans Holbein's *The Body of the Dead Christ in the Tomb* in the Kunstmuseum in Basel. This is a shocking painting showing a corpse at eye level on the museum wall. The painting is the size of a coffin and Christ is lying inside this claustrophobic space. Anna Grigorievna described leading Dostoyevsky away from the painting, where he had stood for almost 20 minutes in an agitated state with a fearful expres-sion on his face. Dostoyevsky also wrote about his experience viewing the classical sculpture *Apollo of the Belvedere*, saying that it caused "a sensation of the divine" and could effect a lasting internal change in the souls of those who viewed it.[3]

A psychiatrist in Florence, Graziella Magherini, noticed many similar cases of excessively intense and physiological reactions when viewing great works of art.[4] She reported that many visitors to Florence experienced strange physiological symptoms—rapid heartbeat, dizziness, confusion, fainting, and a feeling of disorientation—as they looked at a work of art. Magherini suggested that this syndrome happens most often in Florence because this city has the greatest density of Renaissance art in the world, and because Renaissance art has a particularly powerful appeal. She insisted to an inter-viewer that far from being a pathological state, the Stendhal syndrome can be experienced by anyone who looks at works of art with an open mind and a desire to experience strong feelings.[5]

Maria Barnas, the interviewer, was skeptical. She wondered why she, her-self an artist, had no memory of ever feeling strong emotions or having such physiological reactions when looking at a work of visual art, even one that she found impressive. Was she abnormal or were these Stendhal syndrome tourists abnormal? Perhaps these tourists had heard about the syndrome and were highly suggestible, making this a self-fulfilling prophecy. Indeed, psychiatrists have clashed with one another over the status and meaning of this syndrome. Elliot Wineburg, a psychiatrist at Mount Sinai Hospital in New York, has argued that these people were already "sick." But Reed

Moskowitz, a psychiatrist at New York University Medical Center, disagreed. "These are people who have a great appreciation of beauty, and you're putting them in the Mecca of art," he said.[6]

The story of the Stendhal syndrome is seductive. But let's deconstruct it. Could this reaction be due to the subject matter of the art—the religious figures in the frescoes that Stendhal was overcome by, the image of the dead and decaying body of Christ for Dostoyevsky? Could it be due to place—knowing that Florence was the home of the greatest painters and scholars of all time? In his book, Stendhal wrote that, upon realizing he was in the presence of the tombs of Michelangelo, Machiavelli, and Galileo, "the tide of emotion which overwhelmed me flowed so deep that it scarce was to be distinguished from religious awe." There is apparently also a Jerusalem syndrome (just Google it) whereby travelers to Jerusalem become overwhelmed by being in such a religious site. So maybe this response is due to more than the artworks. Stendhal's experience may be overdetermined, or restricted to certain sites at certain times.

An American Version of the Stendhal Syndrome

The Mark Rothko Chapel, in Houston, Texas, designed by architect Philip Johnson, contains 14 large murals by the abstract expressionist painter Mark Rothko, commissioned especially for this space. Unlike a typical art museum, the chapel is designed as a spiritual place. People often come and sit in a meditative attitude surrounded by the paintings, perhaps seeking a religious experience. This is a chapel—a hushed and sacred space, like the chapel where Stendhal was overcome.

The paintings in the chapel are darkly colored—with blacks, maroons, and purples predominating. They are illuminated by natural light so that the subtleties of the color can be clearly seen. Figure 5.1 (in the previous chapter) shows three of the paintings in the chapel.

James Elkins, an art historian at the School of the Art Institute in Chicago, describes Rothko's paintings in his 2004 book, *Pictures and Tears: A History of People Who Have Cried in Front of Paintings*:

[I]f you step too close to a Rothko, you may find yourself inside it. It is not hard to see why people say they are overwhelmed. Everything conspires to overload the senses: the empty incandescent rectangles of color, entirely encompassing your field of vision; the sheer glowing silence; the lack of footing or anything solid in the world of the canvas; the weird sense that the color is very far away, yet suffocatingly close.[7]

Elkins set out to research the experience of weeping in front of paintings. In response to a request for personal accounts, Elkins reports receiving 400 letters or phone calls from people describing experiences of crying in front of paintings. Most have no idea why they cried. Some of the reports of crying were during visits to the Rothko Chapel. The Rothko Chapel visitor's book includes comments like this:

"I can't help but leave this place with tears in my eyes."
"Was moved to tears but feel like some change in a good direction will happen."
"My first visit moved me to tears of sadness."
"Thank you for creating a place for my heart to cry."
"Probably the most moving experience I have had with art."
"A religious experience that moves one to tears."[8]

Elkins tells us that many of the comments said something about the loneliness and emptiness of the paintings, reminding them of death and loss.

Rothko would have approved of these powerful reactions. Recall the quote from Rothko in the previous chapter:

I'm interested only in expressing basic human emotions—tragedy, ecstasy, doom and so on—and the fact that lots of people break down and cry when confronted with my pictures shows that I communicate those basic human emotions. . . . The people who weep before my pictures are having the same religious experience I had when I painted them.[9]

And so we have reports, albeit anecdotal ones, of powerful responses to visual art—the sense of ecstasy and loss of reality that Stendhal reported, Dostoyevsky's sensation of the divine, and the tears of Rothko Chapel visitors. These reports cry out for psychologists to enter the arena and determine the circumstances that lead to these kinds of reactions.

Searching for Evidence

Feeling Like Crying?

One psychologist has developed a model of how and why people have strong emotional reactions to paintings, and his work has focused on reactions to paintings by Rothko. Matthew Pelowski began with a theory that tears from art occur at the end of a three-step experience.[10] First, a viewer experiences a

discrepancy—a feeling that something profound is going on, but something she does not understand. This creates tension and anxiety, which in turn leads to a desire to escape. But if the viewer persists, and keeps looking, she will experience an understanding, a sense of self-awareness and a feeling of relief that the initial discrepancy is resolved. This looking inward, and accompanying feeling of relief, can lead either to actual tears or to "feeling like crying," according to the theory.

In the first study Pelowski carried out to test this model, he interviewed 21 people who came to the Rothko Chapel. People were asked to rate their emotional experience after viewing the paintings, using a series of scales. Here are some of them: "While I was inside the room I experienced anxiety, confusion, tension" (these assessed the hypothesized first stage of the viewing experience). "While I was inside the room I experienced the need to leave" (which assessed the hypothesized second stage). And "While I was inside the room I experienced epiphany, self-awareness, relief" (which assessed the hypothesized final stage). Viewers were also asked to rate how strongly they agreed with "I cried or felt like crying." About one third of the interviewees said that they had felt like crying to some extent. Compared to the other viewers, this group reported higher levels of confusion, need for escape, self-awareness, and epiphany.

Would people show this same cluster of responses if they viewed Rothko paintings in a museum rather than a chapel? In two further studies, Pelowski interviewed 30 people viewing Rothko paintings (more brightly colored than those in Houston) (see Figure 6.1) in the Kawamura Memorial DIC Museum in Japan and 28 people viewing Rothko paintings at an exhibit at the Tate Modern in London, using the same measures. In both studies, again about one third of the viewers said they experienced some level of feeling like crying (about 3.5 points on a scale of zero to nine). This feeling correlated with ratings of self-awareness, epiphany, and a feeling of understanding the artist's intention.

These findings are consistent with the three-stage model. But they don't tell us for sure about the sequence in which these feelings were experienced. And there certainly could have been a "response demand" in favor of crying. Being asked about feeling like crying may have suggested to people that this was the sophisticated way to respond. Would people have mentioned feeling like crying if they had not been asked about it? We cannot know, but my guess is that fewer would have mentioned this spontaneously.

Clearly, some people do have strong emotional responses to visual art. But how common is this kind of experience? One study presented people with nine emotions (taken from the Geneva Emotional Music Scale

FIGURE 6.1 One of the paintings (in rich red and brown) by Mark Rothko used in Pelowski's (2015) study.

Untitled, 1958. Collection of Kawamura Memorial DIC Museum of Art, Sakura, Japan. © 1998 Kate Rothko Prizel & Christopher Rothko/Artists Rights Society (ARS), New York.

described in Chapter 4) and asked people to rate how often they experienced each emotion in response to painting and music.[11] While the findings looked fairly similar for both art forms, participants reported more often feeling wonder from paintings, and more often feeling nostalgia, peacefulness, power, joyful activation, and sadness from music. But this study did not specify that the paintings should be abstract, or that the music should be without lyrics. Nor did this study ask people to rate the intensity of their emotions, and that is the question we are after here. Recently, in my seminar on the psychology of art, I conducted an informal study in which I asked my 15 students to each ask three people to list the three strongest emotional responses they had experienced from music without lyrics and from abstract (non-representational) art. I specified abstract art to make sure that any emotional responses were not to the content represented (e.g., responding to a painting of a death scene with sadness), but rather to the formal properties of the work. I also wanted to compare abstract art to

something similarly non-representational but not visual—so I asked about music without lyrics. While I received rich responses to the music question (e.g., they reported bliss, peace, sadness, feeling energized), responses to the abstract art question were sparse, and mostly included responses such as "irritated," "annoyed," and "confused." Certainly no one mentioned weeping!

Perhaps asking people to note their emotional reactions to abstract paintings is akin to asking them to note their reactions to 12-tone music. Both kinds of art are unfamiliar to most people and hard to make sense of. Any study of emotional responses to paintings should perhaps, after all, include not only abstract works but also representational paintings of people (showing emotions, or in situations that are emotion arousing), and representational paintings without people, but representing scenes that we associate metaphorically with emotional reactions (barren landscapes and churning seas, etc.).

Feeling Moved?

Perhaps weeping is the wrong thing to be looking for. What people usually mean when they say art affects them emotionally is that they feel strongly "moved." Feeling moved may not strictly be classified as an emotion, but this is certainly a kind of emotional state, one that is akin to feeling awe, admiration, amazement.

The feeling of being moved is not a clearly understood construct. Psychologist Winfried Menninghaus tried to clarify what we mean by this phrase.[12] He and his collaborators asked students to recall an emotionally moving (stirring or touching) event and to describe the event and their feelings. Sadness and joy were the most common emotions reported as experienced in moving situations; feeling moved was always rated as intense.

Not surprisingly, the most frequently listed causes of being moved were major life events—death, birth, marriage, separation, reunion. While art-related events were listed as one of six kinds of experiences that elicited the feeling of being moved, they were in the very distinct minority. The kinds of art experiences mentioned as moving were film and music, but no one mentioned the visual arts.[13] But when psychologists ask people to report on strong experiences from the visual arts, we get a different picture. I have only found one study on this, and it is an unpublished dissertation in Swedish directed by Alf Gabrielsson. The findings show that people commonly report feelings of amazement, astonishment, and surprise as they become absorbed by a work of visual art.[14]

Clearly, then, how the question is asked is key. If we ask people directly what emotions they feel from visual art, as in the music studies discussed in Chapter 3, people list wonder and astonishment, which sound to me like feeling moved. But if we ask people to list the experiences that have moved them, they are much more likely to mention interpersonal experiences than they are the visual arts. Our social world dominates our emotional life.

When we ask people to rate how strongly they are moved by specific works of visual art as they view them, people are also very willing to report feeling deeply moved. We know this from a collaboration between neuroscientists Edward Vessel and Nava Rubin and literary scholar Gabrielle Starr.[15] These researchers showed people 109 paintings, Western and Eastern, representational and abstract, from the fifteenth to the twentieth century. Respondents were asked to rate each one for how strongly the work moved them on a scale of 1 to 4. The instructions were as follows:

> Imagine that the images you see are of paintings that may be acquired by a museum of fine art. The curator needs to know which paintings are the most aesthetically pleasing based on how strongly you as an individual respond to them. Your job is to give your gut-level response, based on how much you find the painting beautiful, compelling, or powerful. Note: The paintings may cover the entire range from "beautiful" to "strange" or even "ugly." Respond on the basis of how much this image "moves" you. What is most important is for you to indicate what works you find powerful, pleasing, or profound.

Paintings were viewed while the observers lay in a functional magnetic resonance imaging (fMRI) brain scanner, which would detect which areas of the brain were most activated, and whether the areas activated by an individual painting were predicted by the rating the person had given that painting.

After the scanning session, the viewers saw all of the paintings again, in the same order, for six seconds each. They rated each one on the intensity with which the work evoked the following nine feelings: joy, pleasure, sadness, confusion, awe, fear, disgust, beauty, and the sublime.

Did people agree on which works were moving? Absolutely not. Agreement was very low. On average, each painting strongly rated by one person was given a low rating for another. There was also very low agreement in completing the nine rating scales. What moves people is thus deeply idiosyncratic. While there seems to be clear consensus on what a picture expresses, as discussed in Chapter 5, there is enormous variability in the emotions a viewer actually experiences.

The interesting finding was that the researchers discovered specific brain areas that were most activated when people felt highly moved by the works of art—for the works of art they rated as 4's compared to all the others (rated as 1's, 2's, and 3's). The area activated when viewing the paintings rated as 4's was part of the default mode network. This area of the brain is associated with self-reflection, looking inward, and thinking about oneself.[16] The intriguing finding was that only those artworks experienced as most moving led to this kind of activation, though remember that what was most moving for one person was not most moving for another. Activation increased linearly as paintings moved from levels 1 to 3, and then there was a steep jump in activation as paintings moved to level 4. This study expands our understanding of the experience of being moved in response to visual art. What these findings suggest is that works of art that move us most are works that prompt us to reflect about ourselves. Of course, to be certain of this we would need evidence that people are actually reflecting about themselves when their default mode network activates as they view works of art they find highly moving.

One might consider a weakness of this study the finding that there was so little agreement about which paintings moved people. But in fact, this was a strength. Because the artworks that people found moving differed so much across people, the pattern of brain activation could not be chalked up to any visual aspect of the works (brighter colors, sharper edges, more contrast, etc.). Instead, we have to interpret the brain activation pattern as predicted entirely by how strongly moved people felt.

In Sum: Visual Art May be Less Emotion-Arousing than Music

Are the visual arts less emotion-arousing than music or film or literature, including being less moving overall for the average person? We really cannot say at this point. From a scientific standpoint, we know far more about emotional responses to music than those to the visual arts. We need to do more of the same kinds of studies with the visual arts that people have carried out with music, asking people to report their strongest feelings while looking at works of art. Either we will find that reported experiences with the visual arts are as strongly emotional as those with music, or we will find them much less so. My intuition is that we will find them less so.

Why might a painting evoke fewer reports of specific emotions like sadness, nostalgia, or joy than music? Here are the aspects of an art experience that I suggest allow us to feel powerfully moved and experience strong

emotions. First, there is solitude. We need to be experiencing the work without being distracted by others having conversations around us. When we visit an art museum, we often come with others and we talk to our friends as we pass from painting to painting. Pelowski and his colleagues found that people are unlikely to experience strong emotions in a crowded museum, or when chatting with the viewer next to them.[17] We should study people visiting museums at empty, odd hours.

When we listen to music with others present, we do not chat; we listen. But when we look at art with others, we are tempted to converse.[18] People report stronger emotional responses to music when listening with a close friend than when listening alone. Thus, being with others may strengthen emotional responses to music, but weaken such responses to visual art.

Second, we need to feel enveloped by the work—surrounded so that we cannot easily escape it. Music surrounds us more than visual art does. Music feels more "inside our head" than a painting does.[19] After all, the visual object that is causing a visual percept is external to us; sound has no external analogue to see or touch. And we can always look away from a painting, or see something else in our peripheral vision, but we cannot turn our ears off to music. Perhaps the importance of feeling enveloped explains why, in comparison to viewing paintings, we may feel more powerful emotions when entering into certain kinds of architectural spaces—cathedrals or rooms constructed by the artist James Turrell. In one such Turrell construction, *Space that Sees,* one sits and looks up at a rectangular opening in the ceiling, through which one sees the intense blue sky and the passing clouds. It is at first hard to tell whether the square is a painting of a sky or the real sky. The illusion is strange and powerful.

Third, we need to spend time with the work, not just the average 28.63 seconds (at most!) that viewers spend with paintings at a museum.[20]

I recall two exhibits at the Museum of Modern Art in New York which took place over time that I found very moving. One was a film by Rodney Graham, called *Rheinmetal/Victoria 8,* showing snow slowly covering up an old typewriter. The other was a sound installation by Janet Cardiff, called *The Forty Part Motet,* where 40 different speakers each played the voice of a different singer from a choir—more like a concert that a visual art installation. People did not just walk past these exhibits; they stayed for the duration because each unfolded over time. Harvard art history professor Jennifer Roberts requires her students to sit in front of a painting for three hours, taking notes as they look.[21] I ask my students to sit for an hour and write about their experience as they look. My students say they expected to be bored, but instead found that they lost track of time and began to see more

and more things in their painting as they looked. Still no one wrote about having a powerful emotion.

And finally there is the dimension of movement. Music makes us feel like moving—we move in synchrony to the beat—swaying, dancing, marching, moving our heads, tapping our feet.[22] Moving in these ways (called "entrainment" to music) may intensify the emotions we feel. My intuition is that we do not feel like moving when looking at art—certainly we do not see people swaying and clapping as they look at paintings!

Surprisingly, humans are not the only species to move to music. One hypothesis is that moving to music's beat is a by-product of our tendency to mimic with our voice: both vocal mimicry and moving to music involve a motor response to something we hear. A fascinating finding is consistent with this hypothesis: animals that mimic vocally (like parrots) also move to music by bobbing their heads or moving their feet; those who do not mimic vocally (like dogs, who certainly hear a lot of music) do not move to music.[23]

While it is intriguing to compare the kinds of emotional responses to different forms of art, this comparison should not be taken as an evaluative comparison. There is no reason to assume that all forms of art will have the same effects on us. The greatness of a form of art is not measured only by the emotions it arouses in us. Artworks also open our eyes and our minds.

The arts do something else—they can transform negative experiences into positive ones. This is why we can enjoy reading as tragic a novel as *Anna Karenina*, looking at Goya's horrifying painting of a firing squad, *The Third of May 1808*, and listening to sad music. It is to this paradoxical finding that I next turn.

| Drawn to Pain
*The Paradoxical Enjoyment of Negative
Emotion in Art*

IN THE *POETICS,* ARISTOTLE wrote that "we enjoy contemplating the most precise images of things whose actual sight is painful to us, such as the forms of the vilest animals and of corpses. The explanation of this . . . is that understanding gives great pleasure."[1] French philosopher Charles Batteux wrote, "Artists succeed much more easily with unpleasant objects in the arts than with pleasant ones."[2] This sentiment rings true. Paintings by Lucian Freud depict faces and bodies that are deformed, distorted, often grotesque. Picasso's *Head of a Woman,* shown in Figure 7.1, presents us with a face we would consider grotesque if encountered in real life. The right triptych of Hieronymus Bosch's painting, *The Garden of Earthly Delights,* displays the tortures of hell. Goya's *The Third of May 1808* depicts terrified men about to be shot by a firing squad. Despite their negative content, we line up to view these works. And this phenomenon is true for the other arts as well. People report stronger aesthetic appreciation of sad than of happy poems.[3] In a review of Elizabeth Strout's collection of stories, *Anything Is Possible,* a *The New York Times* reviewer wrote, "You read Strout, really, for the same reason you listen to a requiem: to experience the beauty in sadness."[4]

This is the paradox of the enjoyment of negative emotion in art—a paradox that has been noted for all art forms: enjoyment of tragedy in film, theater, literature, visual art; enjoyment of music that expresses grief. In this chapter I ask two questions. First, given that in our actual lives we do our best to avoid pain, suffering, and disgust, why are we drawn to works of art with negative emotional valence? And second, can we account for the appeal of art with negative content with the same kind of explanation across art forms?

FIGURE 7.1 Sculpture by Pablo Picasso.
Pablo Picasso (1881–1973) © ARS, New York. *Head of a Woman*. Boisgeloup, 1931. Right profile. Wood, plaster, 128.5 × 54.5 × 62.5 cm. MP301. Photo: Mathieu Rabeau. Musée National Picasso © RMN-Grand Palais/Art Resource, New York. © 2018 Estate of Pablo Picasso/Artists Rights Society (ARS), New York.

Pictures of the Grotesque

Why do we enjoy looking at visual art depicting murder, suffering, rotting meat, or ships in a storm with terrified people on board? Over 2,000 years after Aristotle wrote the words quoted at the opening of this chapter, psychologists have put this to the test. Their method is to show people images with negative content presented either as art or as non-art. If we believe it's art, do we react more positively?

German researchers Valentin Wagner, Winfried Menninghaus, Julian Hanich, and Thomas Jacobsen asked participants to look at 60 pictures of things most people find disgusting—for example, rotting food, feces, and mold,[5] as in Figure 7.2. Those participants in the *art condition* were told they were looking at photos from an exhibition of contemporary photographers at

FIGURE 7.2 Close-up image of worms (a) and horse manure (b) presented to participants by Wagner, Menninghaus, Hanich, and Jacobsen (2014), either as works of art or as pictures used for hygiene instruction.

a: From deutsch.istockphoto.com/stock-photo-3471110-worms-up-close.php. b: From deutsch. istockphoto.com/stock-photo-1937853-horse-poop-with-flies.php.

a famous museum; those in the *non-art condition* were told they were looking at pictures to be used to teach people about hygiene. Thus, the intended function of the images but not the images themselves differed for the two groups.

Viewers rated each image for how positive and how negative they felt as they looked at them. Then the pictures were shown again and people were asked to rate how beautiful each picture was and how disgusting the depicted object was.

Aristotle's observation might lead us to predict that when viewed as art, ratings of positive feeling and beauty would be higher, and ratings

of negative feeling and disgust lower. But this is not what was found. Negative ratings were unaffected: both groups of viewers had equally negative responses to the images; both found the pictures equally ugly and the objects depicted equally disgusting. However, the surprising finding was that those who viewed the images as instances of art also reported significantly higher positive feeling.

So Aristotle's delight was there. But this delight existed comfortably alongside very negative ratings. The art group experienced a combination of both positive and negative emotions. This outcome shows something very interesting: experiencing a negative image as art does not lessen the negative feelings evoked; rather, it just allows a positive emotional reaction to occur at the same time. This may be how nitrous oxide (laughing gas) affects us—leaving intact the sensation that we would normally think of as pain but removing the aversiveness—and thus making the pain something to observe with detachment, perhaps even with aesthetic interest.[6]

Other studies reveal that people have less intense emotional reactions to photographic images of unpleasant things (like mutilation) when they are presented as art rather than as documents of real scenes (e.g., press photographs). Emotional response to the images is measured physiologically—by electrical brain activity, brain imaging, heart rate, or by facial muscles involved in frowning and smiling. The consistent finding: people respond less intensely (as well as more positively) to images they consider art than to ones they consider non-art.[7] Thus, for example, people show more heart rate deceleration—a defensive response to danger detection—when they believe they are looking at unpleasant images taken from real scenes than when they believe the images were taken from movies (and hence from fictional scenes).[8]

Did participants respond less intensely to the images in the art context because they believed these were fictional? If so, this would not explain why we are drawn to paintings by Lucian Freud, which are often portraits (distorted and made somewhat grotesque) of *actual* people. It seems more likely that the lowered intensity occurs simply because we are looking at an image that we believe is art, whether the object it represents exists in the world (a portrait of a known individual) or not (a portrait from the artist's imagination). When these images are experienced as art, we can savor their forms, and savor our responses to these forms, however distorted.

Terror at the Movies

The same questions can be asked about terror and suspense at the movies. Think of Alfred Hitchcock's shower scene in *Psycho*. The scene—perhaps

the most famous horror scene from a movie ever—is set up to shock and to terrify. And it does. Marion Crane, played by the actor Janet Leigh, undresses and steps into the shower. She closes the translucent shower curtain and begins to soap herself under the stream of water. Suddenly, from inside the shower looking out through the translucent curtain, we see what we think is a man approaching. Marion has her back turned and is luxuriating in the hot shower. After a few seconds of slow approach, the man rips the shower curtain open and we see him holding up the knife. At the noise from the curtain opening, Marion turns, sees him, and screams. At this point, terrifying screeching music that sounds like screaming begins and we know she is being stabbed over and over again. We watch the murderer (whose face we never see) go away and Marion falls to the bottom of the tub, the water running with blood. The camera zeros in on her open, dead eye.

Why is it a lure to publicize this film as one of the most terrifying movies ever? Why do we watch this film, knowing we are going to be terrified? Perhaps people who seek out horror movies do not actually experience intense negative affect during the experience. But it is hard to believe that one could watch the shower scene and not feel terror. Another view—the aftermath explanation—is that people seek out these experiences because of the relief felt at the end, which is pleasurable.[9] Though Marion Crane dies, at least we get to stop watching her being stabbed over and over again as she screams and as the music blares. And there is the resolution at the end of the movie when Norman Bates (the killer) is seen in the holding cell.

Actually, studies support neither of these explanations. Instead, they provide an answer that is surprisingly consistent with the findings for visual art. It's not that we don't feel negative emotions as we watch. It's that positive ones come right along with the negative ones.

This dual-emotion explanation was demonstrated in a series of experiments by two professors of marketing and consumer behavior, Eduardo Andrade and Joel Cohen.[10] These researchers compared the emotional response of people who choose to watch horror movies at least once a month and can thus be assumed to like them (approachers) and people who choose to watch such movies at most once a year, and thus can be assumed to avoid them (avoiders). They then showed these participants an intensely frightening scene from one of two horror films—*The Exorcist* or *Salem's Lot*.

The Exorcist is a horror movie that involves the supernatural: it tells the story of the demonic possession of a 12-year-old girl who spews out green vomit, and whose voice has changed to a terrifying male voice that

shouts out violent and obscene commands. *Salem's Lot* is the name of a town in Maine where something is terribly wrong. People begin to disappear or become suddenly ill. We see a child, Ralphie, transformed into a vampire, with glowing face and sharp teeth. We see him bite his brother Danny, who dies. At the funeral, we see another character, Mike, open the coffin. We see Danny's body with eyes open and face glowing rise up to bite Mike. And the movie does not end with the defeat of the vampires. They remain.

Before and after watching a ten minute clip from one of these two movies, participants filled out an emotion scale measuring positive and negative affect. After watching the clip, approachers and avoiders both showed a similar increase in negative emotion. Thus, we can rule out both the possibility that people who like horror movies like them because they don't feel much negative affect when watching them, and that they like them because of a reduction of negative affect at the end.

It was the next finding that was telling: only the approachers showed an increase in positive emotion after the viewing. In fact, the graphs show that at the end of the viewing, for the approachers, positive affect was higher than negative. But for the avoiders, negative affect was higher than positive. Approachers were also shown to be lower in empathy and higher in aggressiveness and sensation seeking than avoiders.[11]

In short, horror movie approachers felt both negative and positive affect after watching. Negative and positive emotions were coactivated. "It may seem masochistic, but the more scared I feel watching a horror movie, the more I enjoy it!" said one participant. Clearly, fear and enjoyment can exist together. The increase in positive affect that the horror movie likers felt did not come at the expense of negative affect. Those who liked horror movies showed a positive correlation between happiness and fear; those who avoided them showed a negative correlation.

In another experiment, these same researchers tried to measure the correlation between fear and happiness directly. As participants watched one of these terrifying clips, they were asked to move a mouse along a grid continuously, with *afraid, scared, alarmed* on the x-axis and *happy, joyful,* and *glad* on the y-axis. Each axis had a five-point scale from "not at all" to "extremely." Feelings were recorded every three seconds.

One might expect that happiness and fear would be negatively correlated: when people saw the glowing vampire face of the once-innocent child, they should have felt fear, not happiness. But this is not what all participants showed. For the avoiders, there was a negative correlation

between fear and happiness. For the approachers, there was a positive correlation: the more scared they felt, the happier they felt.

The aftermath model would predict that the approachers would feel greater relief at the end—and this pleasure could then explain why they seek out such movies. But, in fact, it was the avoiders who reported more relief at the end.

Does this coactivation of fear and pleasure occur because viewers know they are in a make-believe world in which they themselves are safe? Is it because they know that this movie is fictional and that vampires do not exist? And can reminding avoiders that they are in a make-believe world cause them to show the same coactivation of fear and pleasure that the approachers show?

That question was addressed in yet another experiment, by Andrade and Cohen.[12] The reminder of make-believe was accomplished by providing biographies of the actors before the viewing and by putting normal-looking pictures of the two main actors next to the screen; this way participants would be continually aware that what they were watching was enacted, not real.

Now the two kinds of individuals responded identically: like the approachers, the avoiders showed an increase in positive affect at the end of the movie, indeed, just as high as that reported by the approachers. In addition, both groups now showed the same positive correlation between fear-related and happiness-related feelings.

These studies help us understand why people seek out experiences in fictional worlds that cause terror. According to the lower-intensity explanation, people seek out such aversive experiences because they do not actually experience much negative affect during the experience. Not so. Approachers reported levels of negative affect equivalent to those reported by avoiders. According to the aftermath model, people seek out these experiences because of the pleasure from the relief at the end. Not so. Approachers experienced an increase in negative affect after the film, in addition to an increase in positive affect. The fact that they did not experience a reduction in negative affect speaks against the aftermath model.

Instead, what these studies show is that for approachers, positive and negative affect were experienced as co-occurring during this experience: the more fear they felt, the more positive they felt. They enjoyed the negative affect. This phenomenon is consistent with what we find with the visual arts—people feel both negative and positive responses at the same time, but only when they believe they are viewing images that are art rather than reality.

Most telling is the finding that even avoiders experience this co-occurrence of positive and negative affect when they are continually reminded that they

are in a fictional world. The make-believe art frame provides psychological detachment, or distance, so that we can enjoy the experience of what we would avoid at all costs in our actual non-fictional lives.

Tragedy at the Movies

What about witnessing tragedy at the movies? Clearly we are drawn to very sad films. Ads for movies (as well as plays and novels) lure the public by describing the film as intensely moving. Spoiler alert: I recently saw *Manchester by the Sea*, a 2016 film where we witness a house burn down, knowing that three beautiful young children are inside and cannot be saved. The parents, Lee and Randi, watch from outside, helplessly. The fire was accidentally caused by Lee, the father, and Randi blames him. Randi and Lee divorce. Lee cannot recover, and even when he is given a second chance at parenthood when his brother dies, leaving him custody of his teenage son Patrick, Lee cannot take on this new role. The movie has no positive ending: Lee arranges for Patrick to be adopted by family friends, and instead of becoming Patrick's father, he offers to have Patrick visit him in Boston whenever he would like. This movie is immensely popular, but people must leave the movie theater heavy-hearted, as I did, and not uplifted one bit. Why do we subject ourselves to this emotional rollercoaster?

In the eighteenth century, philosopher David Hume suspected that we enjoy sadness in art because it moves us, and we like feeling moved. Of spectators at a tragedy, he writes, "The more they are touched and affected, the more are they delighted with the spectacle. . . . The heart likes naturally to be moved and affected."[13]

A study tested Hume's claim. Does sadness in art move us, and is the feeling of being moved pleasurable? Menninghaus and his colleagues selected 38 movies that contained a scene in which a character is confronted with the death of someone deeply loved.[14] In *Mystic River*, a father learns that his 19-year-old daughter Katie has been murdered. Oliver, the young husband in *Love Story*, embraces his wife Jenny as she dies of leukemia. Theresa, the female lead in *Message in a Bottle*, learns that her estranged lover Garrett has died at sea. There was a bottle inside his wrecked boat containing a message espousing Garrett's love for her. These are movies designed to make you cry or at least to feel like crying. But they are not unvaryingly sad. Rather, they have a positive quality as well, such as love or courage in the face of tragedy.

Brief one- to two-minute clips were made of each death news scene and participants watched these clips in an actual movie theater (over two

sessions). After each clip, viewers rated both how sad and how moved they felt. The concept of feeling moved was not defined, but people seem to know what this feels like—the key ingredients being a balance of both joy and sadness, with low degrees of arousal.[15] Enjoyment of the experience was also measured by asking people to indicate on the same kind of scale how much they would like to see the entire film based on the short clip they saw.

The results were striking. The sadder people felt, the more they wanted to see the entire movie. And this correlation was almost completely explained by the feeling of being moved. When the feeling of being moved was statistically subtracted from the equation, the correlation between sadness and enjoyment disappeared. Thus, we like sadness in fiction because sadness intensifies the feeling of being moved, and being moved feels good. In a follow-up study, sad and happy films were compared.[16] It was only during sad films that participants' pleasure resulted from the feeling of being moved. When watching the joyful films, pleasure was directly predicted by feeling joy. Thus, the pleasure we feel from watching grief-filled scenes is really the pleasure from feeling moved; the pleasure we feel from joyful narratives is simply the pleasure of happiness.

We would not feel so moved if the tragedy on screen happened to us in real life. The key is that we know it's fiction, not reality. Knowing this diminishes the pain, creates psychic distance, and allows disinterested contemplation. Whether this same kind of distance would occur when watching suffering in a film we knew to be a non-fictional documentary of true events is not known. Perhaps the results would be somewhere in between the pain of real life and the diminished pain from fiction.

Grief in Music

In 2013, the British Broadcasting Company asked people to nominate the saddest music they knew. They received 400 nominations. The top five were Henry Purcell's *Dido and Aeneas*, Samuel Barber's *Adagio for Strings*, the fourth movement of Gustav Mahler's *Symphony No. 5* (Adagietto), *Gloomy Sunday* sung by Billie Holiday, and Richard Strauss's *Metamorphosen*. If you doubt that these are sad, try listening to them, and if you enjoy them, ask yourself why.

People report profound and beautiful aesthetic experiences when listening to sad music.[17] In Chapters 4 and 5, I provided evidence that when we perceive music as sad we actually experience sadness. To be sure, some philosophers like Peter Kivy disagree. "The most unpleasant emotions

imaginable are perceived in music; and if that meant our feeling these emotions, it would be utterly inexplicable why anyone would willfully submit himself to the music," he wrote.[18] But philosopher Jerrold Levinson takes issue with this, arguing that while we do not feel full-fledged sadness from sad music, "something *very much like* the arousal of negative emotions is accomplished by some music, and so there is indeed something to explain in our avidity for such experience."[19] Further evidence that we actually experience sadness is that listening to sad (but not happy) music activates areas of the brain known to be activated by looking at sad faces.[20]

But even though brain imaging suggests that people are feeling sad from sad music, if we listen to what they say about how they feel when listening to sad music, we get a more nuanced picture. Music researchers Liila Taruffi and Stephan Koelsch conducted a survey of over 700 people (both Eastern and Western participants, and including both musicians and nonmusicians); their findings will show you why you may have not wanted to turn off the pieces nominated as the top five saddest of all time.[21] The most commonly reported emotion felt from sad music was nostalgia, not sadness. Given that people rated memory as the strongest reason for feeling sad from music, we can conclude that the nostalgia comes from the evocation of sad memories. Many positive emotions were also reported: peacefulness, tenderness, wonder, transcendence, and these reports are consistent with a number of other studies on this question.

It is thus misleading to infer that music expressing sadness *evokes* sadness as the primary emotion. The finding that sad music evokes positive emotion in addition to sorrow has now been replicated in many studies. It has also been shown that sad music can make us feel calmer—as if there is some kind of a cathartic effect.[22]

The fact that sad music evokes positive emotions lessens the paradox of enjoying sad music. But of course, sad music does evoke sadness in addition to positive emotions. The question then becomes, why do we like to do something that evokes sad feelings even if this activity also evokes positive ones? Why not just go for the joyful music? To get at this question, Taruffi and Koelsch also asked people to respond to a checklist of possible reasons for liking sad music. The results were revealing. Many participants agreed with this statement: "I can enjoy the pure feeing of sadness in a balanced fashion, neither too violent, nor as intense as in real-life." They also agreed with this one: "By contemplating this feeling in the music, I can get a better understanding of my own feelings, without negative life consequences."

How does this connect to why we enjoy sad films (or other forms of narrative art)? I argued that people are moved by and enjoy sadness in the narrative

arts such as film because they know it's art, not reality. Knowing the events are not really happening to *you* mutes the sorrow. In music it seems something similar is happening. People enjoy the feeling of sadness from music because they feel it is not as negative and intense and violent as sadness in their actual lives. Participants in Taruffi and Koelsch's survey said that one of the rewards of listening to sad music was the fact that there were no real-life implications to the sadness. This statement is consistent with what philosophers have noted. Philosopher John Hospers put it crisply: "Sadness in music is depersonalised; it is taken out, or abstracted from, the particular personal situation in which we ordinarily feel it, such as the death of a loved one or the shattering of one's hopes. In music we get what is sometimes called the "essence" of sadness without all the accompanying accidents, or causal conditions which usually bring it into being."[23]

In Sum: The More Negative the Content, the More We Are Moved

Negative emotions from art are not the exception but the rule. Psychologist Menninghaus and colleagues have posited that compared to positive emotions induced by art, negative emotions result in our paying more attention, feeling more emotionally engaged, and coming away with a more strongly encoded memory of the experience.[24] Experiencing painful emotions likely also motivates us to construct meaning—as a way of giving the painful experience a positive role.

Another important conclusion is that art that conveys painful or disgusting content does not induce negative emotions only. The visual-arts, film, and music studies converge on this takeaway message: we experience positive emotions alongside negative ones when we immerse ourselves in art with negative content. This is puzzling, and we must ask how it is that positive emotions can be experienced when we look at ugly or disgusting pictures, watch terrifying or sad films, or listen to sad music.

The visual-arts studies tell us that it is something about the art frame— believing that an image was created as art changes our reactions. And what is art but a form of make-believe virtual reality? We can experience positive reactions because we know that the depicted world we are responding to is not reality—it is not something we must confront and act upon. This has a "distancing" effect, allowing the kind of disinterested contemplation that Kant wrote about. This concept was discussed in the early twentieth

century by aesthetician Edward Bullough.[25] Psychologist Paul Rozin and his colleagues refer to this as "benign masochism" in a safe context.[26]

The horror-film studies tell us the same story. When we remind viewers that they are entering a make-believe, fictional world (by posting pictures of the actors out of role next to the movie screen), positive emotions are elevated. The tragic-film studies tell us that our positive emotions are due to the feeling of being moved. While we may be moved by tragedy in a make-believe world, when tragedy strikes us personally our strongest emotion is more likely to be grief than being moved. And the music studies tell us that one of the main reasons people say they experience positive emotions from very sad music is that they know this is not sadness being experienced in real life.

All of this is consistent with a leading emotion theory called *appraisal theory*: how we interpret a situation affects how we respond. The fact that we know we have entered virtual reality is at the heart of the matter. We know that we do not have to react in any actual way to a negative situation.

Key to why we seek negative emotions in art, yet avoid them in life, is that art provides a safe space to experience these emotions and to turn inward to savor them—safe because we know it is art, not reality. This knowledge allows us to observe the art and our negative reactions with a kind of disinterestedness, to use the words of Kant.[27]

Art with negative content invites us to introspect about our negative emotions, and to imagine how these responses are shared by others responding to the same work of art. While it's appropriate to focus on how moved and empathetic and horrified we feel looking at a tragedy on stage, responding this way when witnessing an actual tragedy would be inappropriate—indeed, narcissistic.

The explanation for our attraction to negative themes in art applies across art forms. Knowing that it's art and not reality makes all the difference. Is this effect specific to the arts? Certainly there is evidence outside of the arts that our beliefs affect our perceptual experiences. Just as believing that an image was intended as art makes us respond more positively, believing that a smell is from cheddar cheese (rather than body odor) makes us respond more positively—and these labels actually affect brain activation differentially.[28] Similarly, beer tasters told that beer had balsamic vinegar in it rate the taste lower than those who taste the same beer without that information.[29]

But the arts tell a more complicated story. First of all, when we respond to visual art, narrative art, or music with negative emotional content, we

experience a combination of negative and positive emotions. The beer and cheese studies just show people experiencing more positive responses. It is that combination of positive and negative, and their fascinating inverse correlation—the more negative the content, the more positive and moved people feel—that is special to the arts.

PART III | Art and Judgment

Part II of this book took up the puzzle of emotion and art. We often describe works of art as sad or happy. Of course, non-sentient objects like music and visual art cannot really have emotions. So the question becomes whether human artifacts like pieces of music or paintings somehow reflect our emotional lives. Clearly they must, if only in a metaphorical sense, since both music and visual art convey emotions. And these can be detected (with consensus) by people from different cultures and by young children. One of the primary ways that music shows emotions is by exploiting the emotional cues we all recognize in speech prosody— things like speed, loudness, and pitch. Because many speech prosodic cues to emotion are universal, we can now understand why it is that we readily perceive the emotions expressed in culturally unfamiliar music. And one of the primary ways that visual art shows emotion is by tapping into our unlearned, natural tendency to perceive connotational meanings of simple visual forms, whether these are part of works of art or just cracks in a sidewalk.

Both music and visual art also evoke emotion in the listener and viewer. While some people report powerful emotional reactions to visual art, including art that is entirely non-representational, strong emotional reactions are more commonly reported from music. I suggested that this is likely due to the fact that music

takes place over time and envelops us—so we cannot just pass by like we so often do in an art museum, and to the fact that music makes us feel like moving.

The final chapter in Part II considered why it is that we are drawn to painful emotions in art—whether this be sad music, paintings representing tragic or horrifying events, or terrifying movies. I concluded that we can best explain this phenomenon through the concept of aesthetic distance, which softens the intensity of our reactions and, because we do not have to do something (like fight or flee) to resolve the painful emotions, we have the opportunity to savor them and learn from them. As Aristotle said, understanding gives great pleasure.

In Part III I move from the heart to the head—turning away from emotional response to the question of how we evaluate art, deciding what we like and think is good, and what we do not like and think is of lesser quality. Part III uses studies examining visual arts to address these issues. Do we consider that our aesthetic evaluations rest on anything objective, or do we view them simply as matters of opinion that cannot be explained? Given how fiercely we argue about what we like and don't like, we might expect people to believe in the objectivity of their evaluations. But do they? When we look at a work of art, do we base our judgments only on the perceptual properties of the works, or does the factor of familiarity bias us toward liking a work—even when we do not consciously remember having seen the work before? Does what we believe about the artist's process affect our judgment—like how much effort was put into the making of the work, how intentional (as opposed to random) we perceive the work to be, and whether the work was originated by the artist or copied? The questions about the head are as puzzling as those about the heart.

CHAPTER 8 | Is It Good? Or Just Familiar?

THE CHIEF MUSIC CRITIC for *The New York Times*, Anthony Tommasini, tried to defend against classical music elitism when he wrote, " 'Eleanor Rigby,' I'd argue, is just as profound as Mahler's "Resurrection" Symphony.[1] This comment resulted in numerous letters of outrage several days later. His comment and the responses are attempts to confront what it means to value a work of art. If we prefer Rembrandt to Thomas Kinkade, a mass-market popular artist derided by art critics as sentimental, do we actually appreciate Rembrandt more, or are we just being snobs? Are paintings by abstract expressionist artist Mark Rothko great, or just decorative? Is Pablo Picasso the greatest painter since Vermeer, or not? Is country music star Johnny Cash as good as Mozart? Is Frank Gehry a great architect, or just a zany one?

Snobbery is particularly rampant in the art world, as well as in other domains where first-person judgments are key (e.g., wine tasting, designer fashion brands). Assuming we *really* appreciate that which we say we like, we still have to confront another big question: are aesthetic judgments simply matters of personal taste, or do they have truth value, in which case they are either right or wrong irrespective of a particular judge's assessment. Unlike the veridicality of mathematical proofs, aesthetic judgments are reports of first-hand experience, and thus the question of whether they have truth value gets complicated.[2]

Art experts and novices alike behave as if they believe that judgments of aesthetic value are objective. Museum curators and art critics can offer plenty of reasons why one work is better than another. When we argue with someone who dislikes a work that we think is great, we try to explain why we're right. And we feel disappointed and puzzled when someone we feel close to hates what we love. This behavior suggests that we believe that there

are universal standards of aesthetic taste. This is very unlike how we talk about food: when someone says she hates olives, the olive lovers among us do not try to justify why olives are good. We just assume the other person has different taste sensitivity. When we insist Shakespeare is greater than Agatha Christie, are we saying anything more than olives are good? Are we deluding ourselves if we think that our aesthetic judgments are anything more than subjective opinions?

The philosopher David Hume wrestled with the objectivist and subjectivist view. Here he describes how we often dismiss the subjectivist view:

> Whoever would assert an equality of genius and elegance between Ogilby and Milton, or Bunyan and Addison, would be thought to defend no less an extravagance, than if he had maintained a mole-hill to be as high as Teneriffe, or a pond as extensive as the ocean. Though there may be found persons, who give the preference to the former authors; no one pays attention to such a taste; and we pronounce, without scruple, the sentiment of these pretended critics to be absurd and ridiculous. The principle of the natural equality of tastes is then totally forgot, and while we admit it on some occasions, where the objects seem near an equality, it appears an extravagant paradox, or rather a palpable absurdity, where objects so disproportioned are compared together.[3]

Literary critic Helen Vendler explicitly defends the objectivist position:

> Why was Milton's "L'Allegro" more satisfactory than his "On the Death of a Fair Infant Dying of a Cough?" I believed, and still do, that anyone literate in poetry could see that the one was superior to the other. (Those who suppose there are no criteria for such judgments merely expose their own incapacity.)

But she goes on to say how difficult it is to demonstrate this:

> Still, to clarify to oneself and then to others, in a reasonable and explicit way, the imaginative novelty of a poem and to give evidence of its technical skill isn't an easy task. I've been brought to mute frustration by it when I know intuitively that something is present in the poem that I haven't yet been able to isolate or name or describe or solve. In chapter 12 of Lord Jim, Joseph Conrad remarks on that "mysterious, almost miraculous power of producing striking effects by means impossible of detection which is the last word of the highest art."[4]

What Vendler says about aesthetic judgments is similar to what philosopher Bertrand Russell said about moral judgments: "I cannot see how to refute

the arguments for the subjectivity of ethical values, but I feel myself inca-
pable of believing that all that is wrong with wanton cruelty is that I don't
like it."⁵

Hume suggested that a criterion for the objective greatness of a work
of art is its having stood the test of time: "The same Homer who pleased
at Athens or Rome two thousand years ago, is still admired at Paris and at
London. All the changes of climate, religion, and language, have not been
able to obscure his glory."⁶ He went on to say that contrary to what one might
think, scientific beliefs are more likely to be overthrown than are our beliefs
about greatness in the arts. "Nothing has been experienced more liable to
the revolutions of chance and fashion than these pretended decisions of sci-
ence. The case is not the same with the beauties of eloquence and poetry. Just
expressions of passion and nature are sure, after a little time, to gain public
applause, which they maintain forever."⁷

The view that aesthetic judgments can be right or wrong is an objectivist
view: aesthetic properties inhere in works of art in some objective way. If
you eavesdrop on people disagreeing about a movie, a painting, or a musical
performance, it certainly appears as if they think they are arguing about ob-
jective characteristics of the work. These arguments can be vehement, with
each person trying to persuade the other of his or her point of view. We argue
passionately as if we believe that there is a correct answer, and it is ours.

Hume's contemporary, Kant, believed that most people behave as if they
were objectivists:

> . . . if [someone] pronounces that something is beautiful, then he expects the
> very same satisfaction of others: he judges not merely for himself, but for eve-
> ryone, and speaks of beauty as if it were a property of things. Hence he says that
> the *thing* is beautiful, and does not count on the agreement of others . . . but
> rather *demands* it from them. He rebukes them if they judge otherwise . . . and
> to this extent one cannot say, "Everyone has his special taste." This would be as
> much as to say that there is no taste at all, i.e., no aesthetic judgment that could
> make a rightful claim to the assent of everyone.⁸

The alternative to aesthetic objectivism is the view that aesthetic judgments
are purely subjective. What is good for you can be bad for me. We don't argue
about whether vanilla ice cream is better than chocolate. We just accept that
I may like vanilla and you may like chocolate and thus we have different
tastes. For the subjectivist, aesthetic judgments are no different.

The world-renowned art connoisseur Kenneth Clark seems to have grown
into a subjectivist position. In his 1974 autobiography he wrote the following:

At the age of nine or ten I said with perfect confidence "this is a good picture, that is a bad one.". . . This almost insane self-confidence lasted till a few years ago, and the odd thing is how many people have accepted my judgements. My whole life might be described as a long, harmless confidence trick.[9]

Psychologists Weigh In

We see that philosophers and art experts disagree about the extent to which aesthetic judgments are objectively verifiable. What about non-philosophers? Two philosophers who were also psychological experimenters—Florian Cova and Nicolas Pain—addressed this issue in an experiment.[10] Their question was a psychological one, not a philosophical one: not *are* aesthetic judgments objective, but do ordinary people *believe* they are objective. They created short vignettes about two people (said to be friends but from different cultures) disagreeing about whether or not something was beautiful. There were three vignettes about works of art (Leonardo da Vinci's *Mona Lisa*, Beethoven's *Für Elise*, and the "castle of the Loire"—note this study was conducted in France), three about natural objects (a nightingale's song, a snow crystal, Niagara Falls), and three about photos of people (a man, a woman, and a baby). They also threw in three factual statements (e.g., that Proust was the author of *In Search of Lost Time*) and three fairly indisputably subjective statements (e.g., that Brussels sprouts are good). Here is one of their vignettes in which two people disagree about the beauty of something in nature:

> Agathe and Ulrich are on holiday in the country. While having a walk in the field, they hear a nightingale singing. Agathe says: "What beautiful singing!" But Ulrich answers: "No. It's definitely not beautiful."

They asked 30 students (non-philosophers) to say which of the following statements they agree with:

1. One of them is right and the other is not.
2. Both are right.
3. Both are wrong.
4. Neither is right or wrong. It makes no sense to speak in terms of correctness in this situation. Everyone is entitled to his own opinion.

Those who endorse #1 are objectivists. Those who endorse any of the others are subjectivists.

The question was whether people respond to the aesthetic disagreements as they do to the factual ones (such as the one about Proust), or whether they respond as they do to the subjective ones (such as the one about Brussels sprouts). The results were striking. Students were clearly objectivists about factual disagreements—they believed there was a right answer—and they were clearly subjectivists about all of the other kinds of disagreements—they believed there was no right answer. Thus, disagreements about the beauty of a work of art (or nature, or a person's looks) were responded to no differently from disagreements of the Brussels sprouts variety. Their beliefs accorded with the Latin expression, likely of medieval origin, "De gustibus non est disputandum": about matters of taste there is no disputing.

Perhaps people responded as subjectivists in this study because these vignettes did not involve their own views but just those of hypothetical others. But when the researchers repeated the study asking people to imagine that their *own* aesthetic judgments were being challenged, they readily admitted that there was no right and wrong even about their own aesthetic judgments.

What if the study had used comparative judgments, like the comparison between Milton and Ogilby mentioned by Hume? This is what psychologists Geoffrey Goodwin and John Darley did when they used comparative statements about art as controls in a study about ethics.[11] They presented people with statements such as Shakespeare was a better writer than is Dan Brown, Miles Davis was a better musician than is Britney Spears, *Schindler's List* is a better film than *Police Academy*, or classical music is better than rock music, and asked people to say if the statement was true, false, or just an opinion or an attitude. Again, almost all people were subjectivists, choosing the third possibility—even for the statement I want to insist has to be correct(!)—ranking Shakespeare above Dan Brown, the author of the best seller, *The Da Vinci Code*. A striking 84% said that this ranking was just a matter of opinion or an attitude. In studies like this, people rate factual statements as the most objectively verifiable, and evaluative statements about specific works of art and kinds of food as least verifiable, with evaluative statements about moral violations somewhere in between.[12]

In the Arts and Mind Lab, we carried out a series of studies to see whether we could get people to rate aesthetic judgments as objective.[13] We thought perhaps we could if we asked them to evaluate comparisons between "widely acclaimed" paintings from several centuries ago and relatively unknown recent paintings. Here is what people heard, and note that these painters were entirely fictitious, and these statements were presented without accompanying images:

Consider two paintings: Carramonde's widely acclaimed *Twelve Windows* (1793) and DeMantis' relatively unknown *City Wall* (1991). To what extent does the following statement express a matter of taste or a matter of fact?

"Carramonde's *Twelve Windows* is a better painting than DeMantis' *City Wall*."

We wondered whether manipulating the age and acclaim of the paintings would trick people into rating aesthetic comparisons as more objective.

The comparative statement here is phrased in the "normative" order—with the one people might think is better (because it has been widely acclaimed for centuries) presented before the one people might think is worse (because it is unknown and recent). We also presented the comparison in the "non-normative" order:

"DeMantis' *City Wall* is a better painting than Carramonde's *Twelve Windows*."

From other research, we know that people rate evaluative statements they agree with as more objective than those they disagree with.[14] We thought people might be more likely to agree with a statement saying that a widely acclaimed painting that had stood the test of time was better than a new and unknown one than a statement in the reverse order. So we manipulated order of comparison to test for this kind of order effect. Maybe in this case we could up their objectivity ratings.

As control items, we also presented people with comparative statements about facts (Jupiter is larger than Mercury), morals (robbing a bank to pay for a life-saving operation is a better action than robbing a bank to pay for drugs), and taste (butter pecan pie is a better food than ice cream with ketchup).

We found, again, that aesthetic judgments were ranked low in objectivity along with taste and moral judgments (though moral judgments were rated reliably higher than aesthetic ones) as shown in the graph in Figure 8.1. And aesthetic judgments were the only ones that remained immune to presenting the comparison in the non-normative order. Thus people could be tricked into rating the statement "Butter pecan pie is better than ice cream with ketchup" as more objective than "Ice cream with ketchup is better than butter pecan pie," but a statement that an old and revered painting was better than a new and unknown one was seen as no more objectively verifiable than this statement in the reverse order.

Some philosophers argue that aesthetic evaluations differ from other kinds of judgments because they must be made in the presence of the work

FIGURE 8.1 Graph showing judgments about taste (food, colors), art, and morality rated as equally subjective and as significantly more subjective than judgments about matters of fact.
Research by Rabb, Hann, & Winner (2017).

of art and not in the abstract (the so-called acquaintance principle).[15] That is, we cannot *know* whether a painting is beautiful unless we can look at the painting, whereas the knowledge that a planet is large or an action is immoral can be achieved by means of inference or reliable testimony. If allowed to look at two paintings, particularly ones they feel are very different in aesthetic value, people may feel that they can "just see" that one painting is better than the other one. Under this kind of condition they might just admit to objectivism.

So in one last attempt to elicit a belief in the truth value of aesthetic judgments, we showed people two paintings, one that they had personally rated on a prior task as highly liked and one as highly disliked. In the presence of these two images, they then rated the objectivity of a statement that one painting was better than the other (with order of paintings varied). But still, no evidence for a belief in the truth value of aesthetic judgments.

Might the insistence on there being no objective truth to aesthetic judgments be a contemporary Western view, one shaped by postmodernism and the liberal view that we should not impose our values on others? Contemporary, perhaps. But when a similar study was carried out in China (as well as in Poland and Ecuador), aesthetic judgments were still rated as subjective.[16] Might these findings be a product of political correctness and education, with those with less education more likely to be aesthetic

objectivists? There is evidence against this: our studies were carried out on-line with a sample of adults varying widely in level of education, and there was no correlation between education levels and ratings of the objectivity of aesthetic judgments.[17]

These studies of "folk aesthetics" leave us with a puzzle. If we are really subjectivists at heart, then why do we argue so fiercely with those who disagree with us about works of art? Why do we want to change their minds? Perhaps it is because we view aesthetic taste as part of our identity (far more so that our gustatory taste), and we feel impelled to try to convince others of what is so important to us. An attack on an artist or a work of art that we love feels like an attack on our self. Another possibility is that people are confused: when asked explicitly, they endorse subjectivism. But deep down (perhaps unconsciously), they cling to objectivism.

We do not know anything about how art connoisseurs would respond to the questions posed in these studies. I suspect that they would be more explicitly objectivist than the person on the street. After all, they have spent their lives doing scholarship on art and thus are likely to believe that they can *see* quality. And I would bet that those museum board members debating which artworks the museum should acquire or sell off believe that they are not just expressing a subjective taste, but are arguing for some kind of objective quality. Most likely art historians and art museum curators believe that the artistic canon—the works we house in our major museums and in our art history textbooks—has been formed and maintained by objective judgments of aesthetic quality.

The Search for Consensus

Whether people believe aesthetic judgments are objective or subjective does not tell us whether there is *in fact* some objective verifiability to these judgments. Maybe people just do not know that there is! What if we can show that ordinary people shown works of art they have never seen before and never heard of agree on which ones are the better ones? Suppose that people everywhere reach consensus when they cannot fall back on what they have learned that they are supposed to think. If we could show that there is a universal aesthetic sense leading us all to agree on *some* aesthetic judgments, I would count this as evidence that *some* aesthetic judgments have truth value.

British psychologist Hans Eysenck developed the Visual Aesthetic Sensitivity Test and provided evidence that he felt showed universals in aesthetic evaluation.[18] His test, created by German artist, K.O. Götz, consisted

of 42 pairs of non-representational forms. The pair members were identical except that one member had been altered by the artist in a way that eight other artists agreed made it inferior in design. Figure 8.2 shows three pairs, with the left member of each pair judged superior by those who created the test. Participants were not asked which member of each pair they liked best, or found most beautiful or most moving. Instead they were asked to select the design they felt was more harmonious. They were told, "Look carefully at the two designs, and you will see that the less harmonious design contains errors and faults."

This test was given to children and adults in England and Japan, and Eysenck reported minimal cultural disagreement.[19] This led Eysenck to conclude that there must be a single innate aesthetic ability (good taste) with

FIGURE 8.2 Figures from Hans J. Eysenck's Visual Aesthetic Sensitivity Test. The right member of the top pair and left members of the middle and bottom pairs were judged superior by the test creators.

From Eysenck, H. J. (1983). A new measure of "good taste" in visual art. *Leonardo*, 16(3), 229–231. © 1983 by the International Society for the Arts, Sciences and Technology ISAST. Reprinted by permission of MIT Press Journals.

large-scale agreement across age and culture, across personality and gender, and across people with different personality profiles.

Doesn't this finding conflict with the study by Vessel, Starr, and Rubin,[20] described in Chapter 5, showing strong disagreement among individuals in selecting the painting they preferred and felt most moving? Actually, not at all. Eysenck's test asks people to find the more *harmonious* design, not the one they like most. Alas, all that we can conclude from the Visual Aesthetic Sensitivity Test is that we have a shared ability to detect irregularity in forms. We certainly cannot conclude, from the finding that people agree on which forms are more regular, that aesthetic judgments have an objective basis. To do so would be to confuse perceptual discrimination with evaluative judgment: the fact that one pattern is more regular than another does not indicate that it is *better* than the other.

Once we start asking for preferences, individual differences loom large, as the Vessel study showed. And one very important factor in shaping preferences in the visual arts (and likely in all of the arts) is expertise. The most extensive research showing the importance of knowledge about the arts in shaping what we consider good was conducted by Irvin Child at Yale in the middle of the twentieth century.[21] He showed people pairs of reproductions of superficially similar paintings or drawings with one member of each pair considered higher in aesthetic merit by 12 specialists. For example, Hans Holbein's portrait of a lady of the Cromwell family was paired with Hans Krell's portrait of Queen Mary of Hungary, as shown in Figure 8.3. The two paintings were both sixteenth-century German paintings, and both portraits of a seated woman with a hat, shown in three-quarter view. But the 12 specialists viewed the Holbein as the better work.

When this test was given to people who said they were familiar with art, there was strong agreement that the ones the test designers thought was better was indeed better. And these art "connoisseurs" came from many different cultures: the United States, Fiji, Japan, Pakistan, and Greece.[22] But when the test was given to individuals with no art expertise, they often chose the "wrong" painting. We can conclude that what people believe is good in visual art is shaped by expertise in the domain of visual art.

If art experts across cultures agree that Holbein is better than Krell, this really does not show that their aesthetic judgments have truth value. After all, Holbein is famous, Krell is not, and fame is likely to influence judgments. Only if we can show that art experts across cultures agree on the comparative aesthetic merit of works they have never seen before and never heard of can we conclude there is consensus independent of cultural learning. This kind of study has not been done.

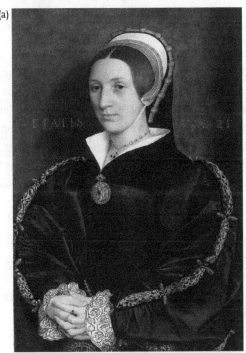

FIGURE 8.3 People familiar with art preferred the painting by Hans Holbein (a) to
the painting by Hans Krell (b) in Child's (1962) study of aesthetic taste.

a: Hans Holbein the Younger (German, 1497/98–1543), *Portrait of a Lady, Probably a Member
of the Cromwell Family*, ca. 1535–40, oil on wood panel, 28 3/8 × 19 Yi in. (72 × 49.5 cm),
Toledo Museum of Art (Toledo, Ohio), Gift of Edward Drummond Libbey, 1926.57. Photo
Credit: Photography Incorporated, Toledo. b: Hans Krell (+ um 1586), *Maria, Königin von
Ungarn (1505–1558)*. Bayerische Staatsgemäldesammlungen – Staatsgalerie in der Neuen
Residenz Bamberg (Inv.-Nr. 3564).

James Cutting's Challenge: Consensus Arises from Familiarity

Psychologist James Cutting set out to show something bound to irritate philosophers of art and art historians. His hypothesis was that aesthetic canons—what we consider to be the great works of art—sometimes get their start via chance (a bequest to a museum, for example) and are maintained by familiarity rather than by some works actually being objectively better than others.[23] He has thrown down the gauntlet to art experts, demonstrating, he believes, that we confuse quality in art with familiarity. We like what we are used to, even as we consciously continue to justify what we like with statements that sound objective, like "this work is better because of the line quality, the colors, the atmosphere," and so forth.

Cutting developed this view because of a well-established phenomenon in psychology called the *mere exposure effect*—just a chance encounter with something predisposes us to like it when we encounter it again—even when we do not recall having previously encountered it. The name most famously associated with this effect is that of the social psychologist Robert Zajonc. But this effect was known before Zajonc demonstrated it experimentally, and has certainly been a staple of the advertising industry. The more times we have seen an ad for Campbell's soup, the more we are likely to bypass the other soup brands and pick the Campbell's can off the supermarket shelf.

Zajonc demonstrated experimentally that repeated exposure to various kinds of unfamiliar stimuli (including completely meaningless ones, like foreign words and nonsense syllables) shapes our preferences.[24] For example, in one experiment participants heard (and tried to pronounce) 12 seven-letter Turkish words (meaningless to English speakers) read aloud. Participants heard these words repeated either 1, 2, 5, 10, or 25 times; some participants did not hear them at all. Participants then had to guess whether the stimulus meant good or bad using a scale from 0 to 6.

Without knowing about the mere exposure effect, anyone's expectation would be that goodness ratings for these words would be randomly distributed across the words. But this was not the finding. Instead, a very strong frequency effect was found: the more people had seen and said a word, the more positive they thought its meaning was. When Zajonc repeated this procedure with Chinese characters that could not be pronounced but only seen, he got the same finding. He dubbed this the "mere exposure" effect, with the word *mere* indicating that the images were passively viewed, and they were not positively reinforced in any way. This effect has been replicated hundreds of times for all kinds of stimuli, and it is one of psychology's robust findings.

James Cutting wondered whether the mere exposure effect could explain our preferences for specific works of art. Is taste in art just a function of sociocultural factors, as the French sociologist Pierre Bourdieu claimed?[25] Could it be that the more we see a new work of art, the more we like it? Do we think we like it because we believe it to be a great work, when in fact we just like it because it is what we are used to?

To find out, Cutting conducted a number of experiments using paintings by seven French impressionists: Paul Cézanne, Edgar Degas, Édouard Manet, Claude Monet, Camille Pissarro, Auguste Renoir, and Alfred Sisley. He showed people pairs of paintings by each of these artists, with similar subject matter (e.g., landscape, portrait, etc.) and made within two years of one another. But—and here is the rub—they differed in the frequency with which each had appeared in art history books. The idea was to recreate the experiments of Zajonc using revered works of art. The assumption was that the paintings reprinted more often would be ones that people had seen more. And the prediction was that the more frequently reprinted paintings would be preferred.

Cutting first had to figure out each work's frequency count. He did this by conducting a painstaking search for the number of times each painting occurred in the over six million volumes in Cornell University's libraries. He examined about 6,000 books falling into three categories: books dedicated to each artist; books about more than one impressionist; and general art history textbooks and encyclopedias covering art across time. He gave each painting a number for the frequency with which it appeared in these texts (and were thus likely to have been seen more not only by art historians but also by the general public). Frequencies ranged from over 100 (those impressionist works we are most familiar with and that are considered to be central in the impressionist canon) to under 10 (works on the borders of the canon).

Cutting showed slides of 66 pairs of paintings by his impressionist artists (one painting high, the other low in frequency) to Cornell University undergraduate participants. They looked at each pair for about eight seconds. Then they indicated which painting they preferred and whether they recognized either of the two paintings in the pair. Preference was used here as a stand-in for a judgment of quality, with the assumption that if I prefer X to Y, then I think X is the better work of art. The prediction was that people would prefer the paintings that had appeared more often in print, even if they did not consciously remember having seen the paintings before. A separate group of participants rated each painting for how prototypical it was of impressionism (on a seven-point scale) and indicated whether they remembered having seen it before.

Before I reveal the results, let's consider two pairs created by Cutting. The painting shown in Figure 8.4a is Renoir's *The Swing (La Balançoire)*, painted in 1876, depicting a young woman in a white dress with blue ribbons. She is holding the ropes of a swing that she appears about to step onto, conversing with a man in a straw hat; another man leans against a tree while a little girl looks on. The painting in Figure 8.4b is Renoir's *The Bower, Galette* (also called *In the Garden*, or *In the Garden Bower of Moulin de la Galette*), painted

FIGURE 8.4 Two pairs of paintings from Cutting's (2003) study of aesthetic judgment. a: Pierre-Auguste Renoir (1981–1919), *The Swing (La Balançoire)*, 1876. b: Pierre-Auguste Renoir (1841–1919). *The Bower, Galette*, 1876. Oil on canvas 81 × 65 cm. c: Paul Cézanne, *Bay of L'Estaque*. d: Paul Cézanne, *View of Mt. Marseilleveyre and the Isle of Maire (L'Estaque)*, ca. 1878–1882. Oil on canvas. 21 1/4 × 25 5/8 in. (54 × 65.1 cm).

Credits: a: RF2738. Musee D'Orsay, Paris. Photo Credit: Scala/Art Resource, New York. b: Pushkin Museum of Fine Arts. Photo Credit: Scala/Art Resource, New York. Reprinted by permission of the Pushkin Museum of Fine Arts, Russia. c: Philadelphia Museum of Art, The Mr. and Mrs. Carroll S. Tyson, Jr., Collection, 1963-116-21. d: Reprinted by permission of the Memorial Art Gallery of the University of Rochester: Anonymous Gift in tribute to Edward Harris and in memory of H. R. Stirlin of Switzerland.

one year earlier, in 1875. This painting depicts a young woman in a blue and white striped dress holding an unopened parasol and approaching several people sitting at a table. Both paintings are set in a sunlit-dappled lush garden with trees. The season in both appears to be summer.

At the bottom of Figure 8.4 are two paintings by Cézanne. Figure 8.4c is *Bay of L'Estaque*, painted between 1879 and 1883—a bay of blue water surrounded by mountains and a small town. There are trees in the foreground, and the predominant colors of the sea, the sky, and the land are muted blues and greens. Figure 8.4d is *View of Mt. Marseilleveyre and the Isle of Maire (L'Estaque)*, painted in 1882, with a vantage point closer to the bay and the town, in the midst of the trees. The colors are much brighter—the sea is bluer, the roofs on the houses are more orange, the ground under the trees is a golden color, and the shadows from the trees tell us that the sun is shining.

Now, before you read further and find their respective frequency counts, think about which one of each pair you prefer. (Of course Cutting's participants were shown these in color projected onto a screen.) Perhaps you think you prefer *The Swing* because it shows the full face of the young woman, while *The Bower, Galette* only shows the woman's ear and cheek. Perhaps you think you prefer *Bay of L'Estaque* because it is more majestic than the more close-up view in *View of Mt. Marseilleveyre and the Isle of Maire (L'Estaque)*.

Now check whether the paintings you prefer are the more frequently reprinted ones. Both of the images on the left were the preferred ones as well as the more frequently reprinted ones (though, of course, Cutting randomly varied the side of presentation of the most frequent image). *The Swing* was more frequent than *The Bower, Galette* (with frequency ratings of 94 and 18, respectively). And *Bay of L'Estaque* was more frequent than *View of Mt. Marseilleveyre and the Isle of Maire (L'Estaque)* (with frequency ratings of 86 and 27, respectively). If you preferred the more frequently reprinted painting, your preferences aligned with Cutting's findings. Renoir's more frequently reprinted *The Swing* was preferred 72% of the time; Cézanne more frequently reprinted *Bay of L'Estaque* was preferred 87% of the time. And overall, participants preferred the more frequently published image of each pair on 59% of the trials—a rate significantly above chance.

Those who resist the idea that mere frequency shapes our aesthetic judgments might argue that this holds just for people with no knowledge about art. Perhaps participants with more art knowledge would not choose on the basis of frequency—shouldn't they be able instead to choose on the basis of some kind of objective sense of quality? But Cutting's research

argues against this: preference for the most frequently reprinted images held true just as much for those who had taken an art history course as for those who had never taken one. Though of course, one art history course does not make you an art expert.

Surprisingly, preferences were not even due to consciously recognizing the images, since preferences did not correlate with whether participants remembered having seen the paintings before. However, because only 2.7% of the paintings were recognized by his Cornell University under-graduate participants, Cutting realized that perhaps he did not really demonstrate the independence of conscious recognition and preference. He thus repeated this procedure with older participants—faculty and graduate students at Cornell—who should be likely to recognize more of the works. And indeed, this older group recognized 18.6% of the paintings, allowing a stronger test of whether preferences were just due to frequency of occurrence in print independent of actual recognition. The results did not change: people preferred the paintings with the higher frequency counts, and there still was no relationship between conscious recognition and preference.

If unconscious exposure to reproductions of artworks really accounts for preferences, we should see no effect of frequency on young children, who presumably have not been exposed to books about art. When Cutting repeated his study with children ages six through nine, he indeed found no relationship between preference and frequency count.

Why might people prefer images they have seen before even if they do not know they have seen them before? Perhaps this is because artworks take time to understand, and thus ones we have seen more seem more understandable to us. If this is true, then we would expect works that are more complex to show a stronger frequency effect than less complex works. But how to measure complexity? Cutting decided just to rely on people's own subjective ratings of complexity. He presented his image pairs again and asked people to indicate not only which member of each pair they preferred but also which member was "more complex." Results did not shift. There was no effect of judged complexity: the only predictor was frequency count.

Of course, it is possible that people did not know how to judge complexity. Perhaps they just used the number of people in a painting as the metric of complexity. But it is most likely that these painting pairs did not differ at all in complexity (whatever that is) since each pair was by the same artist and had the same subject matter. If so, complexity judgments would not be reliable.

Could preferences be a function of what people thought was the most prototypical impressionist painting of the pair? Cutting tested this in the same way he tested for complexity, by asking people to rate each image for how representative it was of impressionist paintings. Frequency count remained the only predictor. But again I would add that the pairs are very unlikely to differ in prototypicality given the careful way in which they were matched.

Of course, the obvious criticism of the claim that preference is shaped by frequency is to reverse the causal direction. Maybe frequency is driven by quality: "better" works of art are the ones editors and art historians—those with a keen eye for "objective" quality—decide to feature in books. And there is another problem, too: who is to say that people actually saw the more frequently reprinted images more than the less frequently reprinted images? Most people do not look at art history books.

Cutting realized that there is no objective way to assess quality, and so we can't adjudicate between these two positions. Instead of the impossible task of proving that quality plays no role, he took another tack. Using a similar participant pool—other undergraduates at Cornell—could he erase preference for the more frequently reprinted paintings by showing the less frequently reprinted paintings more often over the course of a semester-long psychology class?

During 21 class periods of his introductory course on perception, Cutting presented a subset of paintings from his original 66 pairs singly for two seconds without comment. High–frequency count paintings were shown only once during the semester. Low–frequency count paintings were shown four times. At the end of the semester, the images were presented in pairs and students indicated their preferences. One member of each pair had a high frequency count but had been seen only once in class; the other member had a low frequency count but had been seen four times.

We could expect three possible findings. One might be that people still preferred the images with the higher print frequency. In that case, this experiment would not have answered the objections of those who say that frequency in print is a function of quality. A second finding might be that high classroom frequency could override low print frequency. In this case, preferences shown in the original study would be reversed: people would prefer the images they had seen more in class. This would count against the claim that the more frequently reprinted paintings are the ones with more objective quality. A final possibility is that the two kinds of frequency might cancel each other out, and thus preferences would be unrelated to either kind of frequency.

What Cutting found was the third pattern. Preferences were predicted neither by frequency in print nor by frequency of exposure in class. Can we then conclude that frequency is the driver of our aesthetic preferences? Cutting certainly thinks so—believing that he has shown the power of one kind of frequency to wipe out the other kind. But a critic could easily say that this final experiment is simply a failure to replicate the original finding that images with higher print frequencies are preferred. We cannot really conclude anything about such a null result. One would need many studies with this method, with different artists, to prove Cutting right . . . or wrong. Again, an entire grant application's worth of studies waiting to be done!

Cutting's research leaves us with the unsettling feeling that he is suggesting that the artistic canon has been shaped entirely by chance exposure to works of art, and that aesthetic quality plays no role in determining what we think is good art. But note that Cutting did not study art experts, true connoisseurs. As I said earlier, having taken one art history course certainly does not an expert make! Might connoisseurs have preferences unrelated to print frequency? Of course, such a study would have to be done with paintings the participants had never seen before, perhaps from a different culture. If we could show that Western art experts' preferences for Asian artworks align with works most frequently reprinted in Asian art history books, we could then more comfortably conclude that it is the art experts of the world who, with their nose for aesthetic quality, decide on which works get reprinted in art history books. And then lay preferences for the print-frequent images could just as well be due to quality as to frequency as the two would be inextricably confounded.

Another weakness of Cutting's study is that he included only paintings by master impressionists—all of whom are considered great. Maybe familiarity makes a difference only when you have pairs of paintings that really do not differ in quality. What would happen if Cutting had included work that many people might consider "bad" art?

Four experimental philosophers (acting much like psychologists), Aaron Meskin, Mark Phelan, Margaret Moore, and Matthew Kieran, devised a study to answer this question.[26] They asked whether the effect of exposure is sensitive to value. Suppose that the mere exposure effect that Cutting found is due not to mere exposure but to what exposure leads to—more exposure could help us to see what is good in works of art, and thus more exposure means we see more good art. But if we see bad art over and over, we might begin to like it less.

These philosopher-experimenters selected 48 landscape paintings by the twentieth-century American painter William Thomas Kinkade—art they

asserted, at the outset, to be bad. They also selected 12 landscape paintings by nineteenth-century British painter John Everett Millais—art they asserted, at the outset, to be good. Kinkade's paintings depict idyllic and sentimentally sweet bucolic scenes. One of the Kinkade paintings used in the Meskin study was *Stepping Stone Cottage*, depicting a cozy cottage whose windows glow with lights (though it is daytime). You can view Kinkade's works, including this one, on his website, at https://thomaskinkade.com/. (I was not able to get permission to reprint *Stepping Stone Cottage* in this book because the work would have had to be presented in a manner complimentary to Kinkade.) The cottage, surrounded by green lawn and bright flowers, is next to a small stream that reflects the lights from the cottage; horses graze peacefully in the background. Compare these to *Chill October*, one of the Millais paintings used (Figure 8.5).

Meskin and colleagues chose Kinkade as their "bad" artist on the basis of their own judgments, as well as on those of cultural critics who consistently deride his paintings as kitsch. It is easy to find disparagement and ridicule of Kinkade's work by art critics in the media. In a 2012 online obituary for Kinkade, art critic Jerry Saltz wrote that "Kinkade's paintings are worthless schmaltz, and the lamestream media that love him are wrong."[27] The online publication *The Daily Beast* dubbed him "America's most popular—and the art establishment's most hated—artist.[28] Yet, according to this same article,

FIGURE 8.5 Landscape by Millais used in study by Meskin, Phelan, Moore, and Kieran (2013).

John Everett Millais, *Chill October* (private collection).

a reproduction of some Kinkade painting (sold by the Thomas Kinkade Company) hangs in twenty million homes around the world.

What the educated elite considers kitsch always seems to have mass appeal. Hallmark cards and calendar art are perennially popular. When the Russian artists Vitaly Komar and Alexander Melamid commissioned an international poll on what colors and subject matter people preferred in paintings, they put the data together to create a "most" and "least" wanted painting for each country (undoubtedly they were being tongue in cheek).[29] The most wanted paintings across the world were remarkably similar—they depicted a peaceful and inviting nature scene, always with blue water and blue sky and peaceful wildlife—not entirely different from calendar art or a Kinkade painting.

In contrast to Kinkade, Millais is considered by critics to be a major painter. While his works are not deemed to be on the level of our greatest masterpieces, they are seen in major museums such as the Tate Britain, where there is certainly no chance of encountering a painting by Thomas Kinkade!

In Meskin's study, a class of 57 students sat in a philosophy of literature course over a seven-week period, and during a break in the middle of the lecture they were shown a set of images for two seconds each, with no evaluative comments made. Twenty-four of the Kinkade paintings were shown five times and 24 only once. The same procedure was used for Millais' works—half shown five times, half just once. A control group of 57 students (taking a course in philosophy) was exposed to none of the images. After this period, students in both the experimental and control groups saw all the images presented one at a time for six seconds each as they rated their liking on a 10-point scale.

The best result for these researchers would have been to show that exposure to Kinkade lowered liking scores, while exposure to Millais elevated liking scores. The first comparison of interest is between the Kinkade and Millais liking scores of the experimental and control groups. The Kinkade score was significantly lower (4.92) for the experimental than the control group (5.8). But the reverse was not found for Millais: these liking scores were not reliably different for the two groups. These results suggest (though do not prove) that exposure lowers liking for Kinkade but not for Millais—and hence, if we can take a small leap, that exposure lowers liking for bad art. However, liking for Millais should have been significantly higher in the experimental group in order to replicate the mere exposure effect.

A more revealing look at the data examined the "dosage" effect: do the more frequently exposed Millais paintings get higher scores than the less frequently exposed ones, and does the opposite result hold for the

Kinkade paintings? For the Kinkade paintings, liking scores for the ones seen only once were reliably higher (5.11) than for those seen five times (4.74). But for the Millais paintings, there was no effect of exposure. So the researchers failed to replicate the mere exposure effect for "good" art, but they did show that mere exposure for "bad" art reduces rather than increases liking.

How can we understand the finding that increased exposure to Kinkade paintings lowers liking? Meskin and his colleagues argue that repeated exposure enhances our ability to detect the badness in bad art. The more we look, the more garish Kinkade's colors may seem, and the more clichéd the imagery may look to us. And so, they suggest, we could actually use this kind of procedure to test for objective quality in art. If repeated exposure lowers liking, the work is likely of bad quality. If it increases liking, the work is likely of good quality (even though increased exposure to Millais did not increase liking, at least it did not lower it).

There is a logical problem here, however. Why don't the millions of Americans who own a Kinkade reproduction start to dislike it? Well, perhaps they do like it less than when they first bought it, but this has certainly not been shown. But let's not give up yet on the attempt to show differential effects of exposure for what critics consider good versus bad art. In the next section I suggest ways we might proceed.

In Sum: Art Works on Us but We Don't Know Why

What are we to conclude about the aesthetic judgments of ordinary people? First of all, we argue, often ferociously, with people whose tastes in art we disagree with. We do not do the same when we disagree with people about tastes in food. We care mightily that people agree with us on aesthetic preferences, less so on culinary preferences. But when pressed, we admit that our aesthetic judgments are just matters of subjective opinion.

Second, Cutting urges us to conclude that (at least when all else is equal) familiarity plays a powerful role in shaping our aesthetic tastes. He believes we are unaware of the power of familiarity, but that it clearly works on us. But this conclusion only holds if, and only if, we can be sure that the students in Cutting's studies really were exposed to the more frequently reprinted images more than the less frequently reprinted ones. And I am not convinced.

Third, familiarity can have two effects: it can increase our liking of some works (this was shown by Cutting in his final study, in which he showed some images more frequently, though not replicated by Meskin) and decrease our

liking of others. However, this has only been shown for one artist—Thomas Kinkade—in one experiment and does not explain why millions of people who own Kinkades continue to keep them on their walls.

Perhaps cultural learning and snobbery explain why we think some works of art are great and others are bad. But I favor the alternative, that works considered great and that stand the test of time are objectively higher in quality than works failing the test of time. Greatness in art is not an objective property of the world that all normal people agree about (like whether something is a liquid or a solid). Greatness in art is something that the human mind perceives, and some judgments about aesthetic value are objective ones in the sense that most (never all) human minds across time and place agree. Standing the test of time will not help us decide whether *King Lear* is a better play than *Hamlet*—when works are too close in quality, preferences are subjective. But time has helped us know that *King Lear* is great. And in a few centuries, time may help us discern that Rothko is a greater painter than Josef Albers (another painter of squares of color—serious, certainly, but not as powerful as Rothko). This view is consistent with one put forth by neuroscientist V. S. Ramachandran, who asserted that no theory of art can be complete until we figure out the principles that differentiate kitsch from high art.[30]

I would dearly like to be able to reject Bourdieu, who argued that aesthetic taste is *just* a function of our subculture. But we do not know how to prove this, and we may never be able to do so.

If there are any objective criteria for aesthetic "betterness," I would vote for polysemy (many layers of meaning), complexity, non-predictability, and non-sentimental (kitschy) subject matter. Psychologists should try to demonstrate that people can move from liking what critics consider kitsch (such as Kinkade) to appreciating what critics consider "high art," but that they are less likely to move in the opposite direction. That would be powerful evidence for some kind of objective "betterness" of quality in some works over others.

In this chapter I discussed the claim that, unbeknownst to us, familiarity is the basis of our aesthetic judgments. And I concluded that I remain unconvinced, though no one has yet demonstrated empirically that there is an objective basis to aesthetic judgments. In the next three chapters on aesthetic judgment, I show how beliefs about the process by which a work of art was made—with effort, with originality, and with intention—strongly affect our aesthetic judgments.

| Too Easy to Be Good?
The Effort Bias

THE RENOWNED BRITISH PAINTER David Hockney came up with an idea that has proven very controversial. He was struck by the sudden rise in realism in fifteenth century Northern European painting, and he wanted to explain this dramatic change.[1]

To see what struck Hockney, look at the faces in Figure 9.1. The painting in Figure 9.1a is by Giotto, who lived in Italy between 1266 (or 1267) and 1337. The face is relatively flat. Compare this to the face in Figure 9.1b painted by the Flemish painter Robert Campin, a century later. The face in Campin's painting is almost photographic in its realism—dramatically different from the flatter face in Giotto's painting. You can see the light and the shadow, the sag of flesh under the chin, the creases in the face, the natural-looking folds of the man's turban, and you can almost feel the texture of the fur around the man's neck. Hockney pinpointed the location and time of the sudden rise in realism to Flanders in the late 1420s and early 1430s—noting paintings by artists such as Robert Campin, Jan van Eyck, and Rogier van der Weyden.

In collaboration with Charles Falco, a physicist from the University of Arizona specializing in optics, Hockney made a radical proposition: this sudden shift toward realism in Flanders was due to the introduction of optical tools. These artists, they argued, were technologists as well as painters. The artists had figured out how to use mirrors as lenses, holding them up to the image they wanted to capture and projecting that image, upside down, onto a white canvas. This would allow them to trace the flat projected image—thus getting the folds of the drapery and the resultant changes in patterning just right. So it was not that these artists had so much more talent

 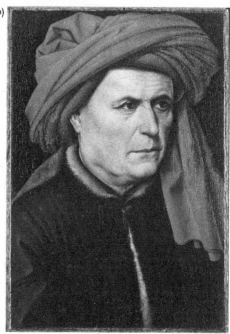

(a) (b)

FIGURE 9.1 The painting by Giotto (a) is far less realistic than the painting by Robert Campin (b), which is almost photographic in its realism.

Giotto, *San Lorenzo* (St. Lawrence) (1320–1325). Photo: J-M Vasseur, Institut de France, Abbaye Royale de Chaalis, Fontaine Chaalis, France.

Robert Campin. *A Man.* © The National Gallery, London. About 1435. Oil with egg tempera on oak, 40.7 × 28.1 cm. Bought, 1860 (NG653.1). National Gallery © The National Gallery, London/Art Resource, New York.

than those who came before them. Rather, they had different kinds of tools— tools that rendered their task so much easier.

Anyone can try what Hockney and Falco suggested the Flemish artists did. Suppose you want to paint someone's portrait. Tack up a white sheet of paper on the wall. Take a concave shaving mirror. Hold the mirror up at just the right angle with respect to wall and portrait. When you get it right, you will see that the person's image has been projected onto your sheet of paper, but upside down. You can trace this image directly onto the paper. Once you have the basic lines in place, you can turn the paper right side up and keep drawing. Something very difficult was just made a lot easier. Here is how Hockney described what he did:

> To make the projected images even clearer, I cut a hole in a piece of board to make a little window like those I had seen in Netherlandish portraits.

I then placed this board in a doorway and blacked out the room. I pinned a piece of paper next to the hole, inside the darkened room, and set up the mirror opposite the window and turned it slightly towards the paper. Then a friend sat outside the hole in the bright sunlight. Inside the room I could see his face on the paper, upside down but right way round and very clear.[2]

Surprising and powerful evidence that this is what these artists actually did was provided by Falco.[3] There were errors in linear perspective discovered in some of the realistic paintings Hockney wrote about. These errors were mathematically predicted by the use of a mirror focused on a certain area, then moved to an adjacent area and refocused. The chances of these errors being due to other causes is vanishingly slim. Errors are a kind of fingerprint—just what a detective relies on. Psychologists, too, have seen the information value of errors: Freud used errors as windows on unconscious motivation; Piaget used errors as clues to the forms of quasi-logic underlying children's thought; Daniel Kahneman and Amos Tversky used errors in reasoning about probability to understand how we make decisions.[4]

The most widely discussed error discovered by Falco is in Lorenzo Lotto's painting shown in Figure 9.2, called *Portrait of a Couple*, depicting a carpet with a complex geometric design covering a table. With two rulers, you will see that two borders (one along the octagonal pattern in the center of the carpet, one along the right side) recede into space but do not meet at one vanishing point, as linear perspective dictates.

Falco explains that Lotto's mirror could not have projected the entire image at once onto his canvas. After a part of the receding border was traced, Lotto would have had to move the mirror slightly to project the next part, resulting in this perspectival error—so subtle that the typical viewer (perhaps even the artist) would never notice, but clear enough to be captured by the measurements of an optical scientist.

Falco pointed out another error in the same painting. Inside the borders of the octagon pattern is a triangular pattern. Take a magnifying glass and you will see that the back part is blurry. Our eyes automatically refocus as they move around a scene. We do not see things out of focus. Why then would Lotto paint something blurry? According to Falco, when Lotto exceeded the depth of field of his mirror-lens and refocused it further in, the resultant image would have to be smaller. This change would have made it difficult to make the geometrical pattern on the back of the octagon match that on the front. The solution must have been to fudge it by blurring it. One final clue

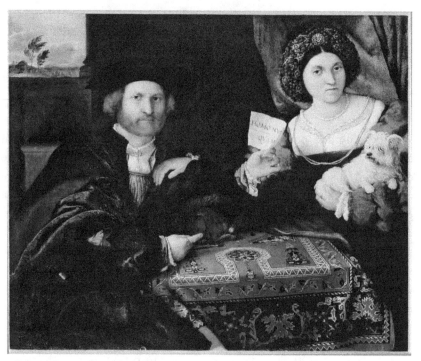

FIGURE 9.2 Painting by Lorenzo Lotto showing a perspectival error predicted by artist's use of a lens.

Lorenzo Lotto (1480–1556). *Portrait of a Couple*, 1523-1524. Hermitage Museum, St. Petersburg, Russia. Photo Credit: Erich Lessing/ Art Resource, New York.

seems to nail the argument: the triangular pattern becomes blurry at just the same depth that the vanishing point shifts.

Hockney's proposition has been roundly attacked by art historians. At a conference I attended at New York University in 2001 where Hockney first presented his thesis, art historians were bent on showing how Hockney could not be right.[5] One theme was that artists did not need to "cheat" like this because they were talented enough to draw without optical aids. Cultural critic and writer Susan Sontag made this point when she said, "If David Hockney's thesis is correct, it would be a bit like finding out that all the great lovers of history have been using Viagra."[6] Another theme was that there are no written records to support the use of optics before the seventeenth century—to which Hockney replied that artists kept their tricks secret. A third theme was that artists could have used a technique invented in the Renaissance—viewing (with one eye) what they were drawing through a grid on a window, and copying what they saw in each square onto the canvas. This is a way of getting the perspective right. The only problem was that

Falco was explaining how they got the perspective wrong! Art historian Jane Partner sums up the discomfort felt by her fellow art historians in a review as follows: "What then, if the "Mona Lisa" was an early Polaroid? It would require quite some rethinking of the conception of realism, which we think of as the formal embodiment of Humanism, if it were in fact part of a highly mechanized procedure. It is therefore hardly surprising that this book had caused so much discomfiture."[7]

Oddly, while art historians railed against Hockney, the evidence for optical aids has been widely accepted for some seventeenth-century artists. Architect Philip Steadman noticed that many of Vermeer's paintings depict the same room from different viewpoints, all on same-sized canvases.[8] Through precise calculation he was able to determine that this was because Vermeer used a camera obscura—a box or room with a hole in one side letting light in. This works much like the lens I described earlier. As light from outside the camera obscura enters the hole, it reproduces an upside-down image. This image can then be traced to form the beginning of a painting. Another study reported evidence that Rembrandt used mirrors to project his own image onto a flat surface within reach of his hand—thus allowing him to trace the projected image.[9] And if Rembrandt did this, it is likely other seventeenth-century painters did as well.

Whether or not these claims hold up, they do offer psychologists a road into an investigation of the role of perceived effort in evaluating a work of art. Suppose the great masters did project images using mirrors and traced them to begin their paintings. Certainly we would have to admit that such an optical aid makes the task of realistic painting far easier than painting with the naked eye alone. Does this devalue their works in our eyes? Is this like watching a sprinter break an Olympic record, only to find out that he was on steroids and thus did not do it "on his own?"

There is reason to believe that we value artworks more when we believe greater effort was involved. Early critics of Jackson Pollock's drip paintings dismissed them as something anyone could do.[10] But these critics were countered by others who pointed out the enormous amount of effort these paintings actually took. An article in *ARTnews* described Pollock's process as effortful:

> He has found that what he has to say is best accomplished by laying the canvas on the floor, walking around it and applying the paint from all sides. . . . The feverish intensity of the actual painting process could not be kept up indefinitely, but long periods of contemplation and thought must aid in the preparation for renewed work. . . . The final work on the painting was slow and deliberate. The

design had become exceedingly complex and had to be brought to a state of complete organization.[11]

This kind of evidence led art critic Leo Steinberg to write, "Questions as to the validity of Pollock's work, though they remain perfectly good in theory, are simply blasted out of relevance by these manifestations of Herculean effort, this evidence of mortal struggle between the man and his art."[12]

Psychologists Test the Role of Perceived Effort

Social psychologists have often demonstrated that the harder we work at something, the better we feel we have done. Students believe that if they have worked hard on a paper it must be good. This can be considered a form of cognitive dissonance reduction.[13] It is internally inconsistent to believe that you have worked hard and done a poor job. To reduce this inconsistency between effort and outcome, we inflate the outcome to match the effort. Of course equating effort with quality is not a perfect rule and it can lead to error.

Psychologist Justin Kruger and his colleagues[14] have directly addressed the issue of this chapter. They investigated the influence of perceived effort on people's aesthetic evaluations by showing them works of art and telling some that the works took a great deal of time to create, others that these same works took only a short time. Do people use the effort-equals-quality rule for evaluating art? The researchers reasoned that use of this rule would be especially likely in domains like art where it is difficult to make a clear determination of merit, and where people often disagree wildly.

Note that Kruger did not manipulate whether the works were made with technological aids, as Hockney and Falco claimed for artists like Jan van Eyck. Thus, the results could go either way. One might imagine that participants would rate the less effortful ones as greater—seeing the ability to do something quickly and easily as a mark of greater genius (much as we marvel over how Mozart wrote out his scores with very little editing, unlike the laborious editing of Beethoven). Or, following Susan Sontag, participants might use effort as a way to judge quality, assuming that more effort equals better art.

An initial experiment involved two groups of participants. They all read the same poem along with some facts about the poem—its title, author, age of poet, and time the poet spent writing the poem. Participants were told either that the poem took 4 hours to write (low effort condition) or 18 hours (high effort condition). Information about time spent was mixed in with

other information to reduce the likelihood that participants would become aware of the hypothesis and respond according to what they thought the experiment was after.

After reading the poem, participants were asked to recall all of the information about the poem (as a check that they remembered how long it took to write) and then to rate how much they liked the poem (from "hate it" to "love it"), its overall quality (from "terrible" to "excellent"), and how much money a poetry magazine would pay for it. Because liking and quality judgments were highly correlated, they were averaged together to create a single evaluation index. The average evaluation rating for the poem in the low-effort condition was 5.84, compared to 6.43 in the high-effort condition (out of 11, a statistically significant difference, thus unlikely to be due to chance). Participants estimated that a poetry magazine would offer $50 for the low-effort poem, and $95 for the high-effort poem, again a statistically significant difference.

Next the researchers turned to paintings and included art students (both undergraduate and graduate) as participants to see whether they, too, fall back on the effort heuristic. The art students were considered "art experts." This time, participants were shown two paintings by the same artist. One group was told that painting A took 4 hours, and that painting B took 26 hours. The other group was told the reverse and thus each painting was judged in a low- and a high-effort context. Participants rated each painting on a number of measures of quality, as well as on how much effort they believed went into each one.

The painting results replicated the poetry results. When painting A was said to have taken 4 hours it was rated 6.14 in quality (again out of 11); when it was said to have taken 26 hours, its rating rose to 6.69. Similar results were reported for painting B. Both experts and non-experts preferred painting A when they thought it had taken longer time to make, and painting B when they thought it had taken the longer time. And each painting was estimated to cost more when it was presented as having taken the longer amount of time to create. A statistical test called structural equation modeling allowed the researchers to show that the relationship between time spent on the painting and judged quality of the painting was fully explained by respondents' effort ratings (with more time equated with more effort, and more effort equated with higher quality). But when effort was held constant, the relationship between time and quality became non-significant. This means there was no direct relationship between time and quality. The relationship is only due to the fact that we infer more effort if we hear that more time was spent.

Is it surprising that the art experts were as misled by the effort-equals-quality rule as were the non-experts? Perhaps, but if you recall that the art

experts were just students studying art at either the undergraduate or grad-uate level, perhaps it is less surprising. It would be particularly interesting (and surprising) to show that true connoisseurs, those who have spent their lives looking at art—curators and art historians—could also be lured into using the effort heuristic.

Quality is of course a subjective judgment, and *time spent* is an objec-tive one. It seems easier to fall back on time spent, the objective measure, than to figure out which work of art is "better," whatever that means—es-pecially when works look very similar and hence seem similar in quality. Is this reliance on the objective measure of time spent even more likely to be used when quality is even more difficult to judge? To find out, Kruger gave people images of medieval arms and armor to judge, varying the number of hours it took a blacksmith to complete (110 or 15) and varying whether the images were presented in high or low resolution. Would people rely more on number of hours when the images were fuzzier and thus harder to judge? The answer was yes. Thus, we fall back on the effort-equals-quality rule be-cause of the difficulty of judging quality.

Kruger's experiments show that, *all else being equal*, time spent is translated into perceived effort, which in turn is translated into perceived liking and quality. But perhaps Kruger's experiment had a subtle "response demand": when people read that a work took many hours, this may have suggested to them that the researcher was expecting them to give this work higher ratings.

A subtler way of getting at how much we rely on effort was devised by Jean-Luc Jucker and colleagues.[15] And this study is more directly relevant to the Hockney controversy because Jucker manipulated whether a technological aid—a camera—was used. Using only non-experts, he showed participants nine optically realistic paintings that presumably require a great deal of effort and skill. One of these is shown in Figure 9.3. When pretested, these images were rated equally likely to be a painting or a photograph. One group of participants saw these images labeled "Painting by XXX"; another group saw these images labeled "Photograph by XXX." Capturing reality perfectly in a photograph requires only the pressing of a button; the same image painted is clearly far harder to produce. Half of the participants in each condition were asked to rate their liking of the works and the rest were asked to rate the amount of effort and skill they thought went into the works. Images were given significantly higher liking ratings when they were believed to be paintings. "Paintings" were also given significantly higher effort and skill ratings than "photographs."

A study using yet another method also avoided a response demand by asking participants to judge the quality of paintings and poems said to have been created either by one artist working alone or by two, three, or five artists

FIGURE 9.3 Photographically realistic painting by Robert Bechtle used in study by Jucker, Barrett, and Wlodarski (2014).

Robert Bechtle (1932–). *Agua Caliente Nova* (1975). Oil on canvas, 48 × 69 ½ inches. Courtesy of the artist and Anglim Gilbert Gallery. High Museum of Art, Atlanta, purchased with funds from the National Endowment for the Arts and the Ray M. and Mary Elizabeth Lee Foundation, 1978.1. © Robert Bechtle. Courtesy of the artist and Anglim Gilbert Gallery.

working together. Participants were also asked to judge the amount of effort of each creator. The fewer creators there were, the higher in quality the works were judged to be. And judged quality was related to the perceptions of effort from each individual creator (and with more creators, each individual's effort was perceived to be lower).[16]

These studies confirmed what Kruger showed: we esteem works of art more when we believe that more effort was invested in their making. A bias toward equating effort with a positive achievement has even been reported in 10-month-old infants![17] Here's how this was shown. Infants saw animated scenes involving a red protagonist (a circle with eyes) and two targets (a blue square and a yellow triangle, both with eyes). The agent is shown jumping over a low bar (low effort) to reach a blue square with eyes, and jumping over a high bar (high effort) to reach a yellow triangle with eyes. The question was whether infants would think that the red agent would prefer the blue square (reached with little effort) or the yellow triangle (reached with much effort). This was tested by showing infants the red agent approaching either the square or the triangle and measuring how long they looked at each event. Longer looking is taken as an indication of surprise. Infants looked longer when the red agent

approached the low-effort goal (blue square), allowing the inference that they had expected the agent to prefer the high-effort goal (yellow triangle).

Two studies challenge the idea that we always use the effort heuristic in judging art. In one of these studies, people used the effort heuristic when primed with the statement "Good art takes effort." They judged works said to have taken one year to complete as better than works said to have taken two to three days to complete. However, when primed with the statement "Good art takes talent," use of the effort heuristic disappeared. And when they presented paintings without priming, and asked people to evaluate the works either first for talent or first for quality, people who thought first about talent did not use the effort heuristic; and they also estimated the low-effort painting as worth more on the market.[18] The second of these studies showed that professional musicians attribute greater talent to a pianist said to have shown early high innate ability in comparison to a pianist said to have shown perseverance and hard work. This occurred even though—unbeknownst to the participants—the two musical excerpts they evaluated for talent were actually from the same musician.[19] The findings of these two "challenging" studies show that people do not always rely on the naïve theory (seen even in infants) that effort equals quality and can be nudged to rely instead on their beliefs about the artist's talent.

In Sum: Belief About Process Shapes How We Evaluate Art

Studies showing our reliance on the effort heuristic help us understand why critics like Susan Sontag were so offended by Hockney's suggestion that the old masters used tricks to make their job easier. Clearly easier meant less talent was needed—hence the art must be less great.

But other studies show that when talent is pitted against effort, people judge the work of the talented artist as higher in quality. My guess is that we could also dissolve the effort heuristic by showing people a film of the artist's process. I've seen film clips of Picasso painting quickly and getting it "right" on the first attempt. If participants were allowed to witness two processes, one effortless and one effortful, both yielding the same end product, they would most likely rate the work created effortlessly as better. Why? Because the effortless one will be seen as the product of the greater mind. Show them just the end product and they may again fall back on the effort heuristic. In both cases, we are judging the end product by how it was made.

Clearly we do not assess works of art just on the basis of their visual qualities. Visual qualities of works can be overshadowed by what we know about how the work was made (how effortful) and the nature of the mind that made

it (how innately talented). The process and the mind behind the work are part and parcel of the work. All too often this is forgotten by psychologists studying aesthetic reactions—when they present works out of context to people and simply ask for ratings.[20] Just think about how you would react to the discovery of a cave painting with accurate linear perspective as compared to how you would react to an eighteenth-century painting with such accuracy—painted long after the rules of linear perspective had been articulated by Renaissance masters. I am confident that you would evaluate the achievement of the cave painting as greater since it would have represented a genuine invention rather than the learning of passed on rules.

And this brings us to the question of forgery—the topic of the next chapter. Just as the same artwork changes in our assessment depending on our belief about the effort and the talent required, so the same artwork changes in our assessment when we discover that that it was not made by a great artist. The study of forgery provides further evidence that our evaluation of art is deeply affected by context: the perceptual qualities of a work are overshadowed by what we know about how it was made and the kind of mind that made it.

| Identical!

What's Wrong with a Perfect Fake?

WOULD YOU CARE IF you went to see the giant redwoods in California and discovered that you were looking not at living trees but at perfect plastic replicas that not only looked the same but felt and smelled the same as the living trees?[1] Would you care if you went to see an exhibit of Van Gogh paintings and discovered that you were looking at the Van Gogh Museum's Relievo Collection of perfect 3-D print replicas of the original paintings? If the answer to either of these questions is yes, then I challenge you to come up with a good reason why you care.

For much of history and prehistory, individuals admired or disdained artistic creations without knowing or caring who produced the works and under what circumstances. In the Renaissance, perfect copies were admired. When a painting said to have been by Raphael was discovered to be a copy indistinguishable from the original, an artist who had worked on the original with Raphael said this:

> I value it no less than if it were by the hand of Raffaello – nay, even more, for it is something out of the course of nature that a man of excellence should imitate the manner of another so well.[2]

Our time is different. In the West, at least since the Renaissance, originality and authenticity in art have been prized.[3] The individual artist is often revered as a genius, and works known to be forgeries are devalued, both aesthetically and monetarily, either because we know that they were not made by a great artist or because we believe them to exhibit a lower level of skill than the originals, or both. Whenever societies value originality in art, and where there is a commercial art market, forgers step in.[4]

A forgery is the theft of a signature with the intention to deceive. A forger creates a work and presents it as having been made by a more famous artist, typically with the motive of financial gain. The forger cannot gain fame, but must be invisible. Forgery differs from plagiarism, which is the theft of the work itself with the motive of deceptively demonstrating one's own skill.[5] Unlike the forger, the plagiarist attaches his or her own name to the stolen work. Discovering a forgery requires discovery of difference; discovery of plagiarism requires discovery of similarity or sameness.

No one knows how many forgeries hang on our museum walls, but it's likely a high number.[6] Most art forgeries are novel works created in the style of a famous artist. But some are attempts at exact duplicates, referred to as "fakes." The latter kind of forgery is less common because the forger will never succeed in fooling the art market if the original is well known. A copy of the *Mona Lisa* is not going to convince anyone that it is the original since everyone knows that the original hangs in the Louvre in Paris.

Forgeries disrupt our understanding of art history,[7] and also defraud museums and private collectors. Forgeries also pose a problem for philosophers. Consider this: when *Christ and the Disciples at Emmaus* (shown in Figure 10.1) was unveiled in 1937 to be Dutch master Johannes Vermeer's yet undiscovered great masterpiece, critics reveled in the masterful work of a genius.[8] Imagine yourself there, standing in front of the painting, admiring its formal properties, praising Vermeer's skill. Now imagine you learn eight years later, as the critics and public did, that this painting was not an authentic Vermeer after all. Rather, it was a forgery painted in the Netherlands in 1936 by the forger, Han van Meegeren. You return to the same spot, directly in front of the painting, and you look again; this time, not at an original Vermeer, but instead at a sham.

The painting's pictorial features are exactly as they were before. By these criteria, it should remain a masterpiece. However, the very critics who once praised the work for its skill then condemned and ridiculed the forgery for its flaws. Do a work's aesthetic properties change for us when we discover that a work is a forgery? That is the philosophical question. And the answer tells us a lot about the bases of our aesthetic judgments.

The Radical Aestheticism View

Some critics and philosophers argue that everything relevant to appreciation ought to be determined only by pictorial properties.[9] And thus if two

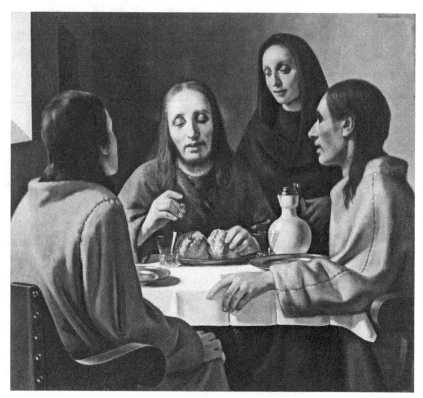

FIGURE 10.1 Forgery in the style of seventeenth-century Dutch master, Johannes Vermeer, by Dutch forger, Han van Meegeren (1889–1947).
Museum Boijmans Van Beuningen, Rotterdam/Photograph by Studio Tromp, Rotterdam.

pictures look identical there can be no aesthetic difference between them. In the words of critic Monroe Beardsley, "I reject the idea that there can be two indistinguishable paintings very different in value."[10] Any disparagement of a forgery, some argue, is simply due to snobbery. This was the position taken by philosopher Alfred Lessing[11] and author Arthur Koestler.[12] Like Beardsley, they take the formalist/empiricist approach that the aesthetic value of a work of art has to do only with its perceptual features and, hence, forgeries are devalued only because they have lost the prestige they enjoyed when considered works by great artists.

The Symbolic View

Other thinkers disagree. We don't appreciate a work of art for how it *looks* but for the sort of thing we believe that it *is*, for what we associate with it. In

short, a work of art is not just a physical object. It is an object with symbolic value because of who made it and how it was made and when it was made.

This view is consistent with the view put forth by psychologists that we are all essentialists—we have a basic tendency to think of certain special objects as having underlying, unobservable "essences."[13] If I lose my wedding ring, I am not content with a replacement. The replacement would lack the essence of the actual one. Similarly, works made by a famous artist contain something of the artist's essence, because of their association with the artist, and this is communicated to the viewer.[14] When Léon Hanssen, biographer of artist Piet Mondrian, believed that he had discovered that a painting thought to be by Theo van Doesburg was actually by Mondrian, he said when looking at it, "It was as if you could shake hands with Mondrian."[15] Unfortunately, the painting turned out not to have been by Mondrian, but I quote Hanssen here to show his belief that a painting contains a piece of the artist. A forgery does not. This view is not entirely rational: we know there is no physical essence of the artist on the canvas. But then who says that humans are entirely rational?

Numerous philosophers have taken the position that a perfect fake is *aesthetically* worse than the original.[16] Dutton's[17] position is that our response to and evaluation of an artwork cannot be separated from the kind of achievement it represents. A painting is the end product of certain actions on the part of the artist, carried out to solve certain problems. When we look at a painting by the fifteenth-century Italian painter Masaccio, it makes a difference if we know that he was one of the first artists to use linear perspective. The painting represents a greater achievement in terms of solving the problem of depth than do paintings by later painters, who did not have to discover perspective but simply had to master its already invented rules. Forgeries misrepresent the artist's achievement. This importance attributed to history can be heard in philosopher Walter Benjamin's words, and Benjamin's use of the term *aura* echoes psychology's use of the term *essence*:[18]

> In even the most perfect reproduction, one thing is lacking: the here and now of the work of art—its unique existence in a particular place. It is this unique existence—and nothing else—that bears the mark of the history to which the work has been subject. . . . The here and now of the original underlies the concept of its authenticity . . . what withers in the age of the technological reproducibility of the work of art is the latter's aura.

Philosopher Nelson Goodman offers another explanation for why the aesthetics of a perfect copy differ from that of the original. He points out that

the way we look at a painting is altered by knowing it is a forgery. We start to scrutinize the painting more carefully, looking for flaws. Hence the experience of looking at the same painting first assuming it to be the original and then knowing it to be a forgery is qualitatively different. We search for differences because we assume that if we keep looking, we may perceive a difference. In short, "since the exercise, training, and development of our powers of discriminating among works of art are plainly aesthetic activities, the aesthetic properties of a picture include not only those found by looking at it but also those that determine how it is to be looked at."[19]

What Experiments Can Tell Us

We can speculate about why forgeries should be devalued, but psychologists think experiments are more informative. Psychologists step into the picture when they devise experiments to figure out how we respond to a work of art when we find out it is a forgery, and why. Are we radical aestheticists who would admit no aesthetic difference between an original and an indistinguishable fake? Or do we insist on an aesthetic difference between two such works? And if we insist on the fake being lesser in some way, is this due to essentialism? Or is this due to the fake being tainted by the immorality of its maker? How could we design experiments to answer such questions?

Evidence That Just Believing a Work Is a Forgery or a Copy Matters

First, there is clear evidence that just telling people that a work is a copy causes people to rate the work less positively on a wide range of dimensions. Stefanie Wolz and Claus-Christian Carbon[20] presented the same 16 paintings to participants, telling some that the paintings were originals by famous artists such as Leonardo, and telling others that they were copies made, for example, by a disciple of the artist or, in another case, by a contemporary artist skilled at making copies of famous artworks on order. The researchers deliberately avoided the label "forgery" because of a possible response demand— participants might assume they were expected to rate a forgery lower because of the pejorative connotation of the term. Participants judged each painting on a host of dimensions: quality, positive emotional value, pleasure of inspecting, desire for possession, familiarity, extraordinariness, and visual rightness. They also rated the artist in terms of talent, perceived popularity, and personal appreciation. On every single scale except familiarity, ratings were significantly lower when the works were presented as copies. Another

experiment asked viewers to respond to a high quality reproduction of a por-trait by van Gogh under one of two conditions: they were told either that the painting represented one of van Gogh's greatest achievements or that it was a fake.[21] When the work was believed to be a fake it was rated as less good aesthetically, and was also perceived as smaller!

This devaluation of works presented as copies is reflected in brain activa-tion. In one study, viewers looked at 50 Rembrandt portraits while in a func-tional magnetic resonance imaging machine that measured blood flow to the brain.[22] Paintings were viewed for 15 seconds each. Just prior to the image appearing, viewers heard either "This is authentic" or "This is a copy." They had been told that copies were defined as works made by pupils, followers, or forgers (thus mixing deceptive and non-deceptive intent). Participants were given no other task than to look at the images.

Half of the paintings had actually been authenticated as copies. But true status and label were crossed so that each of the actual originals was labeled either "authentic" or "copy," and each of the actual copies was also labeled ei-ther "authentic" or "copy." What would make a difference in brain activity—whether the work was *really* a copy (irrespective of label) or *presented* as a copy (irrespective of actual status)?

There was no difference in brain activity when viewing the actual genuine Rembrandts versus the actual copies. This makes sense: of course viewers could not tell the difference, since these were works about which experts often disagreed. What did make a difference were the labels. When the image was presented as "authentic," there was greater activation in an area of the brain associated with reward and monetary gain, the orbitofrontal cortex. Many people also said that they actively tried to find flaws in images labeled as copies—providing support for Goodman's view that we look differently at paintings we believe to be forgeries than at ones we believe to be originals.

Another study using sculptures reported the same kind of findings, using a different brain measure. People with no professional art experience were shown classical Greek and Renaissance sculptures described either as genuine masterpieces from these periods or (falsely) as fakes that were imitations by art students.[23] The body proportions of half of the sculptures were deformed through photo editing, resulting in four kinds of items: gen-uine-original, genuine-deformed, fake-original, fake-deformed. Participants rated each sculpture on a scale from very unappealing to very appealing. Ratings were significantly lower both for the deformed images and for the images presented as imitations. Thus, participants were responding both visually, to actual flaws in the works, and cognitively to the *belief* that the work was not an original. In addition, electrical brain activity of the participants

differed depending on whether they were looking at what they believed to be an original or a copy. Our belief that a work is made from the artist's imagination rather than by copying another work clearly matters.

Psychologists George Newman and Paul Bloom addressed the role played by the fact that a copy is not seen as a creative performance by showing people two very similar (but not identical) landscape paintings.[24] One group was told that Painting A was made first, and Painting B was an intentional copy. Another group was told that the two painters created these paintings without knowledge of the other—coincidentally. Participants rated the financial value of each painting. When Painting B was an intentional copy of Painting A it was valued lower than A. But when Painting B was created independently of A, and hence both were creative performances, the two works were equal in value. Thus *how* the work was made mattered—effort matters, as shown in the previous chapter, as does whether the work is created from scratch rather than copied from a model, as shown here.

Is This Devaluation Specific to Artworks?

Does our devaluing of copies occur specifically for works of art, or for other kinds of artifacts as well? Newman and Bloom addressed this in another experiment.[25] They gave people stories to read about either paintings or prototype cars. Both the painting and the car were said to be valued at $100,000 and then duplicated exactly. Participants were asked how much they would value the duplicate, on a scale ranging from a lot less than $100,000 to a lot more. Would duplicate paintings lose their value relative to the original more so than duplicate cars?

The answer was clear. Duplicate artworks were rated as worth significantly less than the original. But duplicate cars did not lose value. Apparently, there is something special about originals when we are talking about artworks, but not ordinary kinds of artifacts. Unlike cars, art is not meant to be duplicated. Now the question is why. Why is a copy of an artwork worth so little, when copies of other things are worth just as much as the original? Newman and Bloom speculate that authenticity is particularly important for objects that have no clear utilitarian function. Perhaps the more useful an object is, the less its history of production matters. We value a car because of what it allows us to do. Since a work of art does not have a practical function, we value it for other reasons, and we think about how it was made, and who made it. But I would also add that we value a work of art for the mind that made it. The work is seen as an expression of the artist's individuality (remember this was one of Dutton's features, described in Chapter 1) and the artist's worldview.

We do not usually think of a prototype of a new car as an expression of the designer's worldview.[26]

Does the Physical Touch of the Master Matter?

A forgery is not touched physically by the master. Do we value originals over forgeries because we believe (irrationally) that as a result of having touched the original, something of the master's essence remains? Newman and Bloom showed that this kind of "positive contagion" is in fact part of the reason we value originals over copies.[27] They had people read stories about either a piece of sculpture or a piece of furniture (a dresser) that was duplicated. These objects were said to have been made either by hand or primarily via machine. Objects that were touched by the hand of the master were estimated to be worth more money, and this mattered far more for a work of art than for a non-art artifact. This kind of superstitious "contagion" has, however, also been reported for non-art objects: people pay handsomely for ordinary objects previously owned by celebrities and refuse to wear a sweater once worn by a murderer.[28]

Disentangling Moral from Immoral Copies, and Distinguishing Kinds of Aesthetic Judgments: A Study from the Arts and Mind Lab

The studies I have described thus far all displayed works of art one at a time, each presented either as an original or as a copy or a forgery. Not surprisingly, the labels "copy" and "forgery" negatively influenced participants' judgments. Both labels have a pejorative connotation. Even small children regard copying, regardless of intent, to be objectionable.[29] But this kind of design has a limitation: it does not capture a key component of the forgery puzzle—that our evaluation of the same artwork changes abruptly from one point in time to another. In the real world, we first come to know a painting like *Christ and the Disciples at Emmaus* believing it to be a Vermeer, and subsequently find out the work is a forgery. Our evaluation of the work then plummets.

What if we confronted participants with the fact that the properties have not changed by presenting two identical works side by side, labeling one the original, and one the forgery? Would participants still devalue the forgery? And if so, would they rate the forgery as less beautiful, less good, and less appealing than the original? Or would they have to admit no difference in these dimensions, and instead devalue the forgery only on what

I would call historical dimensions—originality, creativity, and influence? These are historical dimensions because what is original, creative, and influential when invented for the first time is no longer so when produced later in time.

And if forgery is still devalued when the identicality of the two images is made obvious, we still need to find out why. One possibility is that a forgery is immoral. Note that even children as young as five believe that what's wrong with a forgery is that it is cheating.[30] We could test the role of immorality by comparing ratings of forgeries (immoral) with ratings of sanctioned copies by the artist's assistant (not immoral). A second possibility is simply that a forgery was not made by a great master. The role of association with the master artist (with copy status held constant) can be seen by comparing ratings of a copy by the assistant to ratings of a copy by the master him- or herself.

We carried out just such a study in the Arts and Mind Lab, presenting participants with two identical images side by side, either two paintings or two photographs.[31] They were chosen so that the viewer could not tell whether the images were paintings or photographs. Here is how we introduced two identical paintings. [32]

Here are two images of "Light before Heat," a planned series of ten perfectly identical paintings attributed to the famous artist April Gornik. On the left is the first painting that Gornik made.

There were three conditions. In the forgery condition, the description continued as follows.

On the right is a second painting, which in fact was made by an art forger who copied Gornik's composition. Gornik relies on a team of assistants to make her work, which is common among contemporary and classical artists. The official Gornik studio stamp is on each painting, so each one is equally valued on the art market. In August, 2007, an art historian noticed the poorly copied stamp and exposed the forgery in a report for the magazine *Artforum*.

In the non-deceptive copy condition, the description continued this way:

On the right is the second painting, which was made by Gornik's assistant. Gornik relies on a team of assistants to make her work, which is common among contemporary and classical artists. The official Gornik studio stamp is on each painting, so each one is equally valued on the art market.

And in the artist copy condition, the description continued this way:

> On the right is the second painting, also made by Gornik. Gornik relies on a team of assistants to make her work, which is common among contemporary and classical artists. The official Gornik studio stamp is on each painting, so each one is equally valued on the art market.

We deliberately stated that Gornik relies on a team of assistants, and that this is common, in order to stress that there was nothing duplicitous about this practice. Underneath each image we stated the estimated price at auction. The estimated price for all images was identical except for that of the forgery, which was strikingly lower. Thus the artist's copy and the assistant's copy were both valued equally to the original on the art market so that any lower rating of the artist's or assistant's copy could not be due to assumed lower market value. Note that we also did not use the pejorative word "copy" but instead said that the first and second paintings were part of a planned series of identical works. We also had a photography group, with near-identical wording. These participants saw the image pair in Figure 10.2—a photograph by Andreas Gursky.

Participants compared the pair of images on a set of scales, with a rating far to the left indicating a strong preference for the original (the first), and a rating in the middle indicating no preference. Participants compared the images on the following, randomly ordered scales: beauty, liking, quality, influence, creativity, and originality.

Because responses clustered statistically into two groups, we were able to create two composite ratings, one we called "historically evaluative" (averaging influence, creativity, and originality) and the other we called "broadly evaluative" (averaging beauty, liking, and quality). Our findings for

FIGURE 10.2 Photograph by Andreas Gursky used in Rabb, Brownell, and Winner's (2018) study of response to forgery.
Rhein II, Photograph by Andreas Gursky (1955–). 190 cm × 360 cm (73 in × 143 in). © Andreas Gursky/[1999] Artists Rights Society (ARS), New York/VG Bild-Kunst, Bonn/Courtesy Sprüth Magers, Berlin, London.

paintings and photographs did not differ and so I will just talk about the painting findings here.

Figure 10.3 presents a graph showing our findings: the higher the bar, the more disfavored the copy was relative to the original. Consider first the composite historical-evaluative rating (on the left). The artist's copy (that is, the artist's second painting or photograph in the series) was devalued significantly less relative to the original than the assistant's copy, which was devalued significantly less than the forgery. For the broadly evaluative ratings, the artist and assistant's copy did not differ and both were devalued significantly less than the forgery.

We know that forgeries are fraudulent (hence immoral) in intent. That's why we introduced the artist assistant condition—which was identical to the forgery condition except for intent. We thought this would rule out the influence of perceived immorality. But when we saw that the copy by the assistant was rated lower on the historical-evaluative scale than the copy by the artist, we worried that participants might have viewed it as immoral for the assistant to make a work with the artist's stamp on it—despite the fact that we stated that this was a common practice. Fortunately, we had asked participants to rate how moral it was for the artist, the assistant, and the forger to make the second painting. Not surprisingly, participants rated the forged duplicate to be more immoral than the assistant's duplicate; but they also found the assistant duplicate to be more immoral than the artist's

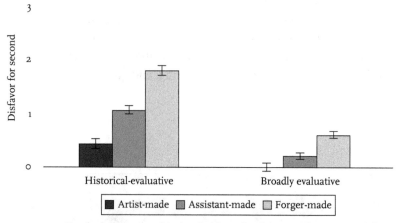

FIGURE 10.3 Graph showing two kinds of ratings for the second in a series of 10 identical paintings. The higher the bar, the more disfavored the copy. The second painting was made either by the artist, the artist's assistant, or a forger and was always a copy of the first painting made by the artist. From Rabb, Brownell, and Winner (2018).

duplicate. And so we had to statistically control for immorality. We did so with a linear regression analysis, which revealed that immorality did, in fact, predict the lower ratings for assistant over the artist duplicate. However, the regression analysis allowed us to examine separately the roles of who made the duplicate and whether the duplication was perceived as immoral. The key finding was this: even when immorality was statistically accounted for, just knowing that the second work was by the assistant led to its devaluation. This lowered evaluation is perhaps most puzzling for photographs, for why should the second print of a photograph be devalued by virtue of having been made by an assistant?

And so, when an original and an identical sanctioned copy are presented side by side, forcing acknowledgment of their visual similarity, the lowered evaluations of beauty and other broadly evaluative dimensions that have previously been reported for forgeries[33] and sanctioned copies[34] disappear. Instead, the lowered ratings we see have to do with participants' assessments of the historical context of the work. The fact that the lower ratings on historical-evaluative dimensions were seen for duplicates by sanctioned assistants as well as by forgers shows that we have a preference for authenticity independent of any moral disapproval. Remarkably, even copies by the same artist who made the original were devalued on these historical dimensions, suggesting a role for temporal priority (which one was made first) as well as for who did the duplicating (artist or assistant).

This study shows that when making an aesthetic evaluation of a work of art, it is not only the pictorial properties of the work (how beautiful it is, how good it is, how much you like it) that matter. What also matters is what we believe about a work's history and the process by which it was made.

In Sum: Art Works on Us by Bringing Us into Contact with the Artist's Essence

Our study tells us that we cannot explain our dislike of forgeries simply in terms of their immorality, nor just in terms of their lowered financial value. Recall that the price of the duplicate by the assistant was equal to the price of the artist's original, yet the duplicate was devalued on historical-evaluative dimensions even after immorality ratings were statistically controlled.

And so I come to the conclusion that a perfect fake is devalued for another reason. When we removed lowered monetary worth and immorality by creating the artist assistant condition, we found that the perfect copy by the artist assistant was still devalued—but only on the historical-evaluative

dimension. And this appears to be because the copy was not made by (and hence not touched by or associated with) the master. This conclusion is consistent with another study by Newman and his colleagues who reported that participants said that duplicate artworks made by someone other than the artist lacked the creator's "heart" or "soul."[35]

What about the broadly-evaluative dimension? We really should expect there to be no difference across our four kinds of images in terms of beauty, liking, and quality. And indeed, there was no difference on this dimension when comparing artist original, artist copy, and assistant copy. But not so for the forgery, which was rated lower on this dimension. The known immorality of the forgery somehow rubs off on the beauty-liking-quality dimension, as does the known lowered price, however irrational this may be.

These findings point to magical beliefs about artworks that are no different from our magical beliefs about objects owned by celebrities. People see artworks as imbued by the artist with a special essence. The idea that a work is genuine has aesthetic appeal. Philosopher Carolyn Korsmeyer talks of the shiver of contact with something real and historical.[36] When we buy a Picasso, we are buying a piece of Picasso's mind or soul. And here is something equally irrational. When people are given a choice between lower and higher edition numbers of the copies of Andy Warhol's screen prints of his *Campbell's Tomato Soup Can*, and between copies of the Beatles' *White Album* with lower and higher serial numbers, people choose the earlier numbers.[37] This preference appears to rule out physical contagion since there is no way that people could have believed that Warhol was more likely to have touched number 10,000 than number 9,000.

This finding just buttresses our conclusion that the most surprising thing we dislike about forgeries is the fact that they lack that special quality imbued by the artist at the moment of making. Consistent with our conclusion, when George Newman and colleagues asked participants to rate the extent to which a copy of a painting entitled *Dawn* that was made by the artist's assistant was or was not *Dawn*, most believed the copy was not the same painting as the original.[38] And when asked why, their explanations say something about the special quality that comes from the original artist. Here are some of the explanations given: "It wasn't touched by [the artist's] hands, seen by his eyes," "It is a copy, not the original which [the artist] poured his heart and soul into. A copy may be identical, but it is truly never the original," "It is a copy, it has no soul," "The identity of a painting (what it 'is' or 'is not') must consist of more than just its visual qualities. Art is a manifestation of the soul."

We used to make a clear distinction between forgeries and reproductions. Forgeries could fool people. Reproductions were obviously reproductions. Reproductions were cheap, and people who framed reproductions of famous paintings printed on canvas in their living room might be considered just a little bit "déclassé." Better to own an original by an unknown than to hang a copy of Van Gogh's *Sunflowers*, since everyone would know this was just a copy.

But now high-fidelity reproductions of paintings are being made with 3-D printers that capture the artist's brushwork and texture exactly. Of course, such fancy reproductions are no longer cheap (though they are far more affordable than the originals). According to the website of the Van Gogh Museum Relievo Collection, "The reproductions are of such high quality they are almost indistinguishable from the originals." And they are being advertised as ways to "enjoy the brightness of Vincent van Gogh's masterpieces and the energy of his brushstrokes in your own environment."[39]

But our findings predict that these reproductions will not be desirable. Despite their near indistinguishability from the original, they will hold little appeal because they lack something important about a work of art— Van Gogh's essence. In fact, I predict that poster reproductions will be preferred to these because the 3-D printed copies are pretending to be originals, whereas the posters are honest. I know that I would feel this way.

I titled this chapter with a question: Is there anything wrong with a perfect forgery? And the answer is yes—we believe that there is something wrong here. What is wrong applies not just to fakes made with the intent to deceive but with duplicates of any kind as long as they were not made by the master. What is wrong is over and above the fact that forgeries lose their monetary value when they are outed, and over and above the fact that we see forgers as immoral actors deceiving buyers to line their own pockets. What is wrong with a forgery is what is wrong with a duplicate, no matter how perfect the copy is. When I buy a painting, I own a piece of the artist who made it. If the painting I buy is a copy made by a sanctioned assistant or a devious forger, I do not own a piece of the artist. I own only a piece of the duplicator—and this is far less symbolically meaningful to me than owning a piece of the master. As art historian David Rosand put it, "the brush stroke is a mark of the painter's presence in the work."[40]

Musicologist Frederick Reece made a similar point about musical forgery. He describes a piece of music once attributed to Haydn but later discovered to have been written by a contemporary music teacher living in Germany.[41] People find the music teacher's work (which sounds so much like Haydn) to be beautiful. But sounding good is not enough,

Reece argued, just as beauty was not enough in our study of paintings and photographs. For what we value in a work of art is also symbolic: what moves us is knowing the connection of the work to history and to a particular creator.

In the next chapter, I take another perspective on quality judgments by considering the resemblance between paintings by abstract expressionist masters and superficially similar paintings by preschool children and animals like monkeys and elephants who have been handed brushes laden with paint. Can we see the higher quality in the works by the masters, or is the claim that "my kid could have done that" true? And if we can see the higher quality, what is it that gives it away?

CHAPTER 11 | "But My Kid Could Have Done That!"

I RECENTLY CAME ACROSS a brief video produced by artist Robert Florczak called "Why Is Modern Art So Bad?"[1] His answer was that modern art is created without any standards of skill and excellence. He recounts amusingly how he shows his graduate students a painting, tells them it is by Jackson Pollock, and asks them to explain why it is good. Students comply with complex answers. But then he shows them that the painting is not a painting at all—it is a close-up of Florczak's studio apron.

Tension between those who revere and those who deride abstract art can be seen even among the most highly regarded art historians. Gombrich[2] focused on representational art as a great human achievement, and disparaged abstract art as a display of the artist's personality rather than skill. Contrast this to the writings of Kirk Varnedoe, chief curator of painting and sculpture at the Museum of Modern Art from 1988 to 2001. In his book about abstract art, tellingly titled *Pictures of Nothing*,[3] he helps us understand how to make sense of pictures that refer to nothing in the world—that just are. Varnedoe wrote that abstract art is a signal human achievement created in a new language and filled with symbolic meaning. The "mind-boggling range of drips, stains, blobs, blocks, bricks, and blank canvases"[4] seen in museums of modern art are not random spills, he wrote. Rather, like all works of art, they are "vessels of human intention"[5] and they "generate meaning ahead of naming."[6] They represent a series of deliberate choices by the artist; they involve invention, and they evoke meanings—for example, energy, space, depth, repetition, serenity, discord.

Varnedoe also made another very important point. No one can really understand abstract art without knowing that the artists involved constituted a vibrant community, commenting, in images as well as in words, on one

another's works. This was particularly true of the abstract expressionists in New York—who all knew one another, and who were reacting to one another's works as they painted. Understanding of abstract art, Varnedoe argued, required more than just careful looking—it also required familiarity with this verbal and graphic conversation.

An analogy might be helpful. Our understanding of impressionist painting is likely enhanced when we realize that these painters were reacting to the invention of photography and, like the abstract expressionists, were in constant touch with one another in the middle to late nineteenth century in France. Of course, understanding how artists were reacting to other artists will deepen our understanding of any work of art, but this point may be particularly crucial for "pictures of nothing," where there is nothing representational to latch on to.

As aptly stated by art education researcher Elliot Eisner,[7] we evaluate art in the absence of rule, meaning there is no objective metric for us to use. Evaluating non-representational art seems particularly difficult because we cannot fall back on degree of realism or on how pleasing or meaningful the subject matter is. What metric do we use when we look at a Pollock painting, or one by Cy Twombly that looks somewhat like a scribble? The superficial similarity between works of abstract expressionism and easel paintings by preschool children is sometimes striking.[8] In 2007, works by Freddie Linsky were sold online at the Saatchi Online Gallery, and critics praised his "spot and blotch" primitivism.[9] It turned out, however, that Freddie was only two years old, and his work, made with ketchup, was put up for auction by his freelance art critic mother as a joke.

Chimps, monkeys, and elephants have all been given paints, brushes and paper on which they make marks. And their paintings, like those of preschoolers, bear a superficial resemblance to abstract expressionist paintings. Works by chimpanzees were once sneaked into a museum and mistaken for art that belonged there.[10]

While these examples show how we can confuse accidental or childish markings with abstract expressionism, the opposite situation is also common: we look at abstract expressionism and, like Robert Florczak, think this is something a child could have done. I have heard highly educated people deride abstract art, particularly abstract expressionism, as requiring no skill at all—often saying, "My kid could have done that!"[11]

In this chapter I focus on work coming out of my research group—the Arts and Mind Lab at Boston College. I hope this chapter gives you a slice of what I do and what a "program of research" on a single topic looks like. We began to wonder how we could disprove the statement, "My kid could

have done that." We decided on the simplest of paradigms: just show adult participants works by children or animals alongside works by famous abstract expressionists and see whether our participants could distinguish these two classes of art works. We realized we could measure this ability in a number of ways.

1. We could present participants with these kinds of pairs and ask them which one they preferred or thought was a better work of art.
2. We could track their eyes as they made this judgment to see whether they looked at these two classes of images in any different way.
3. We could ask them to guess which member of the pair was by the artist rather than the child or animal.
4. We could unpair the images and show them one at a time, randomly intermixed, and ask people which was by the artist.

And if people could pass our tests, we realized we would then need to figure out the basis on which they passed.

It would be of little interest to show that the Kirk Varnedoes of the world could succeed. We wanted to find out whether people with no special knowledge of abstract art could tell the difference. We also wanted to know if young children could pass these tests—for if they could, this would suggest that this kind of discrimination does not depend much on cultural learning.

In our first study, Angelina Hawley, a former doctoral student of mine, created pairs of images that looked eerily alike at first glance.[12] Each pair consisted of a painting by a famous abstract expressionist whose works were found in at least one major art history textbook (e.g., Mark Rothko, Hans Hofmann, Sam Francis) and a painting either by a child or a non-human animal—chimp, gorilla, monkey, or elephant. Angelina pored through online databases of art in museums as well as art by children and animals, seeking the perfect pairings. Her rule was that the pairs be superficially similar in terms of at least two attributes—color, line quality, brushstroke quality, or medium. She did not use any kind of mechanistic rubric, but matched holistically. She ended up with 30 pairs that looked strikingly similar—as I hope you will agree when you look at the painting by an artist and the painting by a four-year old in Figure 11.1. But first, please cover up the information at the bottom of the figure (and the spoiler alert below) telling you who did each painting. Can you tell which one is by the four-year-old?

Spoiler alert: The one of the left is by a four-year-old; the one on the right is by abstract expressionist Hans Hofmann. Did you guess correctly?

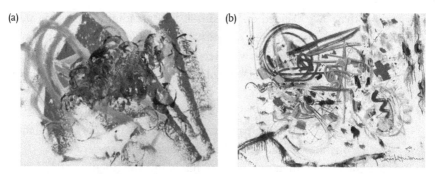

(a) (b)

FIGURE 11.1 Sample painting pair (with similar colors) used by Hawley and Winner (2011) testing whether people can discriminate works by famous abstract expressionists from those by preschoolers and animals.

a: "Abstract expressionist" painting by four-year-old Jack Pezanosky. Reprinted by permission of Jack's father, Stephen M. Pezanosky. b: Hans Hofmann (1880–1966), *Laburnum* (1954). Oil on linen, 40 × 50 inches (101.6 × 127 cm). With permission of the Renate, Hans & Maria Hofmann Trust/Artists Rights Society (ARS), New York.

Our participants were 40 psychology students with no art background, and we compared their responses to those of 32 studio art students. The question we asked was whether people would prefer, and judge as better, works by artists compared to works by children and animals. If people showed a leaning one way or the other, that would tell us that they perceived a difference.

We decided to look not only at whether people could make a discrimination when confronted with these pairs with no information that one member was by an artist, one by a non-artist, but also at the influence of attribution labels. We set up the study so that people would first see 10 pairs (on a computer screen, images side by side, as in Figure 11.1) without any labels revealing who made the paintings. It was important to present these first so that participants would not know that there was a possibility that some were made by children and animals. Next, they saw 20 more pairs, and these had labels under each image: one labelled artist and the other labelled child, chimp, gorilla, monkey, or elephant. It would not be particularly interesting to show that people choose according to label, knowing that the "right" answer would be to pick the works by artists. What would happen, we wondered, if we slyly reversed half of the attributions, labeling a Mark Rothko as "child" and a four-year-old's work as "artist?" Would correct and reversed labels have the same influence? Or would the influence of reversed labels be weaker? When the labels are wrong, we can test whether people choose according to the label (always choosing the work labeled artist) or according to something they see in the work (choosing the works actually by artists, even though mislabeled).

We designed the study so that every image was seen by some people in each of the labeling conditions. That way, any differences associated with labeling condition could not be attributed to the particular image pairs in particular conditions. If people really can't distinguish works by artists and untrained children and animals, we should expect chance responding to the first 10 unlabeled pairs, which would mean choosing the works by artists as liked more and as better only 50% of the time. This did not happen. For both the *like* and *better* question, both the art students (as expected) and the untrained-in-art psychology students selected the works by artists at an above-chance level. So if Robert Florczak had presented his graduate students with a photograph of a Pollock painting next to a blow-up of his studio apron (both unlabeled) and asked which was better, they would have chosen the Pollock.

What effect did the labels have? Of course, when the labels were correct, people chose the artist works at an above-chance rate. The critical test was the effect of the *wrong* label. To our surprise (and delight), art students as well as psychology students chose the works by artists at a rate above chance when the images were wrongly labeled (as shown in the graph in Figure 11.2). In other words, participants were likely to choose a work labeled "child" or "animal" (but actually by an artist) as better than a work labeled "artist" (but actually by a child or animal). They were ignoring the labels and responding on the basis of what they saw.

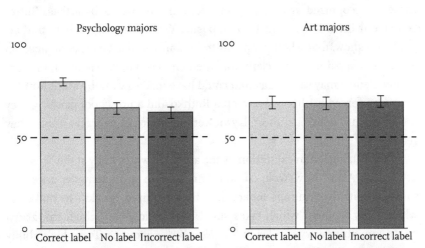

FIGURE 11.2 In a study by Hawley and Winner (2011), participants chose paintings by abstract expressionist artists as better than paintings by children and animals at a rate significantly above chance in all three labelling conditions. The dotted line represents where chance responding (50%) would fall.
Graph created by Nathaniel Rabb.

To be sure, people did not choose the artists' works 100% of the time. But the average percentage of times the artists' works were selected in response to "Which is the better work of art?" (in my view the most important question) was 79% in the correct-label condition (to be expected, given the label), 65% in the no-label condition, and 62% in the wrong-label condition. It is the above-chance performance in the no-label and unlabeled condition that is striking. I now refer to this as the two-thirds rule. So is the glass two-thirds full or one-third empty? You can spin the argument either way. Full, we know that people can make this discrimination. Empty, we admit that people are not always right. Sometimes they do confuse the two kinds of works.

The reasons people gave for their selections were informative. Both art and psychology students offered more "mentalistic" justifications when they selected artist than child or animal works—saying things like this one showed more planning, more skill, or more intention. Thus, people were seeing something of the artist's mind behind the work. Does this mirror your own thinking when you chose one of the two paintings in Figure 11.1?

When we presented these findings to a group of art historians, we were surprised at their irritation. They showed a kind of religious view, treating works by masters as so sacrosanct that one should not even raise the possibility that they might be confused with children's and animals' paintings. They seemed to think that by pairing works by animals or children with those by recognized artists, we were deriding the works by artists. But of course our intention was just the opposite. We had hoped to show, and actually did show, that when people untrained in visual art gaze at an abstract expressionist painting and claim that their child could have made it, they are wrong. People may say that a child could have made a work by Mark Rothko, but when forced to choose between a Rothko and a preschool painting they know which is which. In short, lay viewers see more in abstract art than they realize.

In the catalog for an exhibition by the artist Ellsworth Kelly at the Museum of Modern Art in New York, curator Ann Temkin wrote that she once said to Kelly that his paintings looked like they required no skill to make. To which Kelly replied, "which takes skill."[13] Art critic Peter Schjeldahl (2005) wrote something very similar in *The New Yorker* about Cy Twombly's ability to make meaningless images. "Twombly's works of the fifties remain his most exciting, for me. Those in the show, beginning in 1954, are flurries of impulsive line in pencil, crayon, or paint—sometimes mostly erased or overlapped with white house paint—which seem barbarically formless, yet are perversely graced with sensitive touch and texture. Like Zen koans, these

drawings not only defy comprehension but stop it dead. To make a persuasively meaningless mark is harder than it looks. Your little kid can't do it."[14] Our research shows that we can even recognize skill when the artist may be trying to make his works look unskilled.

Might people be even better at choosing the works by artists if instead of asking which one they thought was better we asked them to guess which one was by the artist (as I asked you to do for Figure 11.1)? We redid the study using the same pairs, this time with no labels.[15] We told people that in each pair, one painting was by a famous abstract artist and the other was by a child or animal (we specified that it might be by an elephant, a chimp, a gorilla, or a monkey). Their job was to pick the one by the famous artist. So that we could determine whether modern art knowledge made a difference, we asked each person how familiar they were with abstract art (very, a little, or not at all). Only one person was very familiar, some were a little familiar, and the majority (77 of them) were not at all familiar.

Since we gave a score of 1 for each "correct" answer (choosing the artist), scores could range from 0 to 30. Selecting at chance would yield a score of around 15. The average score was 19, and with our 103 participants, this score was significantly above chance. That's 63%—our two-thirds rule! Which replicates pretty exactly the average score obtained by people in our first study when they were asked which painting they thought was better.

Why, then, do some museum visitors scoff at abstract art, insisting that a child could have done as well? Perhaps by presenting images in contrasting pairs, we were inadvertently giving viewers an advantage they would not have had in a museum. Maybe if museumgoers viewed abstract art paired with works by children or animals they would recognize the difference. To find out whether people can still tell whether an abstract painting is by a master, without the clue of a contrasting paired image, we tried presenting each image individually.[16] This move meant presenting 60 images, in random order. We told people that each painting was either by a famous abstract artist or by a child or animal (again specifying elephant, chimp, gorilla, or monkey). Their job was to decide, for each painting, whether it was by an artist.

To determine how well people did, we had to take into account the number they got correct and the number they got wrong (since otherwise, those who said all 60 were by artists would have received a perfect score). Calculating a score called a *d*-prime score and testing that against zero showed us that people succeeded in picking out the artists at a rate significantly above zero. Sixty-one percent of the artist images were correctly classified on average—significantly above chance, and again conforming to our two-thirds rule. And

this finding held up as well when we included only those participants (the majority) who said they had no familiarity with abstract art.

How are people succeeding on these tasks? What cues are they using? The reasons people gave in our first study suggested that they were using some kind of cue to intentionality. We sat down with art historian Claude Cernuschi, a colleague of mine at Boston College specializing in abstract expressionism,[17] to talk about this. We brainstormed with him about what people might be seeing in the works that allow them to distinguish those by artists from those by children and non-humans. Together we came up with six "higher order" characteristics. In addition to intentionality, we hypothesized the following: (1) degree of visual structure; (2) relative importance of the negative space; (3) a sense of either conflict or harmony conveyed; (4) degree to which the work inspires and elevates the viewer; and (5) extent to which viewers feel that the work communicates with them.

We considered the expression of conflict or of harmony to be a form of metaphorical meaning, consistent with Varnedoe's[18] view discussed earlier. An abstract work of art, like music, is by definition non-representational. Nothing in the work stands for, or denotes, anything in the world. Nonetheless, abstract art, like music, conveys meanings (e.g., softness, loudness, harshness, struggle, resolution). Such meanings are conveyed through color, line, texture, composition, etc. Clashing colors do not *represent* harshness, but they can *express* harshness—in the same way the paintings express emotions, as discussed in Chapter 5.

We showed people our 60 images, one at a time. This time we said nothing about these works having been done by either artists or children and animals. We divided people into six groups, and gave each group a seven-point rating scale, asking them to rate each painting in terms of one of our six hypothesized distinguishing features.[19] Here is the actual wording we used:

1. Intentionality: As I interact with this painting, I start to see the artist's intentionality: it looks like it was composed very intentionally.
2. Structure: As I interact with this painting, I start to see a structure emerging.
3. Negative space: As I interact with this painting, I begin to notice that the negative space is as important as the positive space.
4. Metaphorical meaning: (1) As I interact with this painting, I can grasp a metaphorical meaning. The painting conveys tension and opposition. (2) As I interact with this painting, I can grasp a metaphorical meaning. The painting conveys balance and equilibrium.

5. Communication: As I interact with this painting, I feel that it is communicating with me.

6. Inspiration: As I interact with this painting, I feel inspired and elevated.

Our hypothesis was that the ratings on each of these scales would be higher for paintings by artists than paintings by children and animals. But ratings were higher on only two of the scales, intentionality and visual structure. And these two properties correlated.[20] This finding is consistent with the work by Jean-Luc Jucker[21] described in Chapter 2: people are more likely to judge something as art if they believe it was intentionally crafted rather than the product of an accident. The importance of structure is also consistent with the idea, discussed in earlier chapters, that non-representational art evokes emotion through some kind of structural isomorphism (as in a line that appears to be striving upward, expressing striving). It would be hard to imagine a structural isomorphism in art that would be perceived to be lacking in structure.[22]

Recall that in all of our studies, people correctly selected the works by artists only about two-thirds of the time. We decided to exploit this variability. If intentionality and structure are the guiding cues, we should expect works by artists that are very easy to classify correctly (as shown by the number of times they were correctly chosen) to have higher ratings on these two dimensions compared to artist works that are very difficult to classify correctly. We should also expect works by children and animals that are very easy to classify correctly to have lower ratings on these dimensions compared to child and animal works that get incorrectly chosen as being by artists.

How to decide which works were easy and which were hard to classify? We looked at the average correct score when the images were presented one at a time. That score was 61%. We decided to call paintings that received a score above 61% "easy" ones and those chosen at a rate of 50% or below as "hard." As a result, we had to eliminate 10 paintings that received scores in between these two numbers—resulting in four groups of paintings: easy and hard artist works; and easy and hard non-artist works. Figure 11.3 shows an example of each of these four kinds.

Of the six rating scales, again intentionality and visual structure emerged as important. Easy artist paintings received higher scores on these two scales than did hard artist paintings. And just the opposite occurred for the child or animal works: easy ones (those typically identified as by non-artists) received lower scores than did the hard ones (those typically misidentified as by artists).

FIGURE 11.3 Top row: Easy to classify (a) and hard to classify (b) artist paintings; Bottom row: Easy to classify (a) and hard to classify (b) child paintings. From Snapper, Oranç, Hawley-Dolan, Nissel, and Winner (2015).

(a) Sam Francis, *Untitled*, 1989. © 2017 Sam Francis Foundation, California/Artists Rights Society (ARS), New York. (b) Hans Hofmann, *Laburnum*, 1954. With permission of the Renate, Hans, and Maria Hofmann Trust/Artists Rights Society (ARS), New York. (c) Brice Haedge at age three. Reprinted with permission of Brice's mother, Dana Haedge. (d) Ronan Scott at age four. Reprinted with permission of Ronan's parents, Jennifer Danley-Scott and Graham Scott.

One final analysis showed that intentionality was the overall winner. We included all 60 images, and disregarded whether they had been correctly classified. We just asked whether any of the rating scales predicted selecting that work as by an artist. And now intentionality alone emerged. Paintings with high intentionality scores, whether or not they were by artists or elephants or chimps or monkeys or gorillas, were the ones most likely to be classified (correctly or incorrectly) as by an artist.

I draw four conclusions from this series of studies. First, people can tell the difference between abstract expressionist paintings and superficially similar ones by children and animals—when they are shown in carefully matched pairs. Second, even when these paintings are presented singly rather than in matched pairs, people succeed at correctly identifying those

by artists. Third, correct classifications of both kinds of works are based on perceived intentionality and perceived visual structure. These two characteristics are related: these works have structure because they are created with planning and forethought and are a result of a series of deliberate choices. And fourth, people use perceived intentionality to decide whether they believe a work is by a master or by a child or animal, and this can lead to error in classification.

It will not surprise art experts to hear that works by great abstract expressionists are not random markings and that they are seen as having structure. However, what is surprising is that people who know nothing about abstract expressionism—and thus may be among those puzzling over whether abstract expressionism is a hoax—can, if asked, discern these two characteristics. People see more than they think they see when looking at non-representational art. These findings show that abstract expressionist art reveals skill even to the untrained eye. Our findings support Varnedoe's[23] claim that these "mind-boggling" works are "vessels of human intention." One does not need to be initiated into an understanding of abstract art to perceive how—at least in terms of intentionality and structure—these works stand apart from works by children and animals. People staring, perhaps for the first time, at apparently random blobs and drips can see human intentionality shaping these markings, and can perceive a structure in the whole image.

We do not always perceive intentionality and structure in these images. But when we do, we sense at some level that we are in the presence of an artist who has pondered what he or she is trying to achieve, rather than in the presence of a four-year-old or a chimp delighting in making marks without much fore-, or after-, thought. These findings reveal the human tendency to ferret out intentionality, as well as the importance of perceived intentionality in our evaluations of non-figurative art.

When we administered a shortened version of our original studies—the pairs with and without labels—to young children, we expected them to select at random.[24] But this is not what happened. The children ranged in age from 4 to 10, and we divided them into younger (4–7) and older (8–10) groups. Even the youngest group distinguished between the two classes of artworks when asked which painting they liked more. They demonstrated their ability to distinguish the two classes of artworks (either by artists or by children or animals) by selecting one class of artworks significantly more than the other class when asked which they preferred. But which class of works did they prefer? Not the ones the adults chose—those by the actual artists. Instead,

the children were drawn to the works by children and animals, whether they were unlabeled, correctly labeled, or incorrectly labeled.

What is significant is that children were able to perceive a difference between these two classes of works. We can only speculate why young children liked the child and animal works more. Perhaps they found them simpler or more readable; perhaps they noticed that these were somewhat messier and this appealed to them. Perhaps they were drawn to these works because they reminded them of ones they had made or could make. Perhaps they were drawn to them because they are more used to seeing works like this—on the refrigerator, on preschool walls—than they are to viewing Mark Rothko paintings in a museum.

If there is a perceivable difference to the untrained observer between abstract works by masters and those by children and animals, will this be reflected only in conscious, explicit choices or also in measures outside of people's conscious control? We investigated this in collaboration with Sergio Alvarez, a colleague of mine at Boston College in computer science.[25] We measured implicit responses using an eyetracker as participants viewed a subset of our original set of pairs, all presented without attribution labels.

As people looked at each pair, they decided which image they liked more and which was the better work of art. As they looked, a camera tracked how long they looked at each image and their pupil dilation. Longer looking time is an implicit measure of interest and greater pupil dilation is an implicit measure of pleasure[26] and mental effort.[27]

Pupil dilation was greater when looking at images by artists (suggesting these were more pleasing). Pupil dilation was also larger when thinking about which image was better than which was preferred (and the "better" question certainly seems to be a question requiring more mental effort). When deciding which image was the better work of art, people looked at the artist images, on average, for 9.17 seconds and at the child and animal images, on average, for 6.66 seconds. And the probability of looking longer at the artist member of a pair was shown to be statistically above chance for the quality question. Recall that according to our rating study, works by artists have more visual structure than works by children and animals, and thus may invite more exploration. Similar results were not found for the preference question.

This eye-tracking study shows that people respond differently on an implicit level to images by artists vs. by children and animals. It also shows that people respond differently when thinking about preference versus quality in visual art. The fact that people look longer (and thus more carefully) at artist than child or animal works when thinking about quality (but not

preference) shows that a distinction between these two types of judgment is being made. Longer looking when thinking about quality than about preference makes sense. A judgment of quality calls for a more careful look before a reasoned decision can be reached; preference judgments can be instantaneous.

After we had published these studies, I received a phone call from a computer scientist, Lior Shamir, who has developed an expertise in programming computers to be able to recognize artist styles.[28] He asked me whether I'd be interested in seeing whether a machine could distinguish our artist works from our child and animal works. I said yes, with enthusiasm, and this led to an interesting collaboration.[29]

Shamir subjected our images to his program—a program that contains content descriptions (reduced to numbers) of over 4,000 aspects of images— aspects such as contrast, texture, uniformity or variation of brightness, fractal features, and color distribution.[30] He first "trained" the computer on 25 of the 30 images of each type (artist versus child/animal) and then tested the computer on five of each type. The computer had to classify each of the 10 test images as belonging to one or the other type of image. He then reran this classification test 15 times, each time randomly determining which were the training images, which the test images. The machine was correct 68% of the time, which is statistically way above chance, and also eerily close to the mean correct score humans received in our studies. Many of the content descriptors in the program played a role in the machine's correct classification.

Did the computer's responses correlate with human ones? When the computer classified an image as by an artist, had our human participants also done so?[31] Weirdly again, the images the computer program classified as by artists were also those that our human participants had been most likely to classify as artist-made.

The fact that a machine can learn to discriminate abstract expressionist paintings by great artists from superficially similar ones by children and non-humans tells us that there are perceptible, systematic, and quantifiable image properties that distinguish these two classes of paintings— even though these two kinds of works appear to the untrained eye to be strikingly similar.[32]

Kirk Varnedoe thought it necessary to defend Cy Twombly's seemingly random marks and splashes of paint against the criticism of "My kid could have done that." He wrote the following:[33]

> One could say that any child could make a drawing like Twombly only in the sense that any fool with a hammer could fragment sculptures as Rodin did, or

any house painter could spatter paint as well as Pollock. In none of these cases would it be true. In each case the art lies not so much in the finesse of the individual mark, but in the orchestration of a previously uncodified set of personal "rules" about where to act and where not, how far to go and when to stop, in such a way as the cumulative courtship of seeming chaos defines an original, hybrid kind of order, which in turn illuminates a complex sense of human experience not voiced or left marginal in previous art.

In Sum: Art Works on Us by Showing the Mind Behind the Art

In this chapter I presented a series of studies, all designed by my lab to address a focused question—whether, and if so, how untrained viewers discriminate between works by abstract expressionists and children and animals, and whether viewers value works by artists over works by children and animals, despite their surface similarity.

We may find it amusing to think that people are paying millions of dollars for works indistinguishable from four-year-olds' paintings. But the truth is that people untutored in the ways of art, and knowing nothing about modern and contemporary art, see more in abstract expressionism than they think they see. We know this from their explicit responses to our questions and their implicit responses picked up by our eye tracker. We know that even young children can see the difference. And the difference has to be seeable because a computer can learn to classify these two bodies of work into two distinct classes—those by artists and those by non-artists.

We may prize works by children and animals as fresh, spontaneous, and delightful. Artists may even be inspired at times by the markings of children.[34] But even the uninitiated can often distinguish such works from superficially similar works by artists. The traces left by artists differ from those left by children and animals. Artists' traces are perceived to be more intentional than traces by children and animals, which appear more random. Sometimes this leads us astray, when an artist's work looks random and a child's work looks intentional. But most of the time we perceive works by artists as the more intentional ones. Thus, we see the mind behind the art.

PART IV | What Art Does—and Does Not—Do for Us

In Part IV I take a close look at bold claims that involvement in an art form leads to improvement in some area outside of the arts. In Chapter 12, I ask whether the arts make us smarter, reviewing the evidence that arts education of any kind boosts children's grades, verbal and math test scores, and IQ. In Chapter 13, I ask whether engagement in fiction, either by reading or by enacting roles on stage, makes us better human beings—more able to understand others and more apt to behave altruistically. In Chapter 14, I ask whether making art improves well-being, and if so, how this works. Throughout these chapters I strive to distinguish real from bogus claims, and plausible from implausible arguments.

| Silver Bullets
Does Art Make Us Smarter?

NEARLY EVERYONE NOWADAYS—WHETHER PARENTS, teachers, or the general public, and especially in the United States—believes without question that children must learn reading, writing, mathematics, science, and perhaps some history. These, particularly reading and math, are considered the core academic literacies on which all other learning rests, and on which success in life depends.

Where does arts literacy stand in the hierarchy of what we consider important to teach? Far less time is spent on the arts in our schools than on subject areas considered to be the core of the academic curriculum. The arts are treated as a luxury—an arena for self-expression, perhaps, but not a necessary part of schooling. This attitude has been exacerbated by the proliferation of standardized testing in the United States required in mathematics and language arts. As a result, schools spend more and more time preparing their students for these tests, especially because schools face sanctions if scores are not at acceptable levels.

In the elementary school years, children may have music and/or art class once a week. After that, the arts are typically electives, meaning that not all students take an art class.[1] Theater and dance are almost nonexistent; what arts education we do have is in the visual arts and in music.[2] Sometimes the arts are considered extracurricular activities and thus are seen only in after-school programs—like playing on a sports team. A 2006 report by the National Assembly of State Arts Agencies in the United States reported that "study of the arts is quietly disappearing from our schools . . . the result of shifting priorities and budget cuts."[3] And

a 2004 report from the Council for Basic Education reported that the greatest erosion of arts education is occurring in schools with high minority populations.[4] Schools focus their attentions on training academic literacies.

What are the arts educator and the arts advocate to do? The most common response to the devaluation of the arts in our schools has been to insist on instrumental justifications claiming value for the arts because of what they can do for the basic literacies (or for the economy, though I am not discussing the monetary claims here).[5]

For years the President's Committee on the Arts and Humanities and similar organizations have been issuing reports declaring that the arts raise academic achievement.[6] When I checked this committee's most recent website, I read about the Turnaround Arts initiative, a wonderful movement to put the arts back into schools.[7] But rather than talk about the values inherent to the arts, the site goes on to explain that the reason for the reinvestment in the arts is to boost academic achievement.

The *Boston Globe Magazine* had a story recently in which the first paragraph read:

> Arts and culture make up a $704 billion industry in the United States—that's more than 4 percent of our nation's gross domestic product—and business leaders say that creativity is among the top skills they look for when hiring, as well as one of the most important traits for success. Research also shows that a solid arts education in school enhances student outcomes in multiple ways: Motivation and attendance improve, standardized test scores go up, dropout rates go down. Musical instruction can boost brain development in young children, with effects lasting into adulthood.[8]

And in a video posted on the Lincoln Center website, Chelsea Clinton tells us there is research showing that arts make kids better at reading and math (the topic of this chapter) as well as kinder, more compassionate, and more cooperative (the topic of the next chapter).[9]

This kind of instrumental reasoning is not new. The nineteenth-century educator and education reformer, Horace Mann, believed that drawing develops "moral uplift"[10] and music educators used to defend the teaching of music for its ability to improve memory and pronunciation.[11] The reasoning behind all of this is clear: perhaps schools under pressure will value the arts if we convince their leaders and funders that the arts strengthen skills in areas we don't need to justify. But is there truth to these claims?

The Old (and Vexed) Question of Transfer of Learning

The claim that arts education results in stronger non-arts skills is fundamentally a claim about transfer. Transfer of learning from one domain to another, much studied by psychologists, turns out to be exceedingly difficult to demonstrate. It used to be thought that studying Latin would improve general intelligence. But at the turn of the last century, pioneering psychologists Edward Thorndike and Robert Sessions Woodworth examined this question in a sample of over 8,000 high school students and could find no evidence for this claim. In 1901, in an influential paper entitled "The Influence of Improvement in One Mental Function Upon the Efficiency of Other Functions," they were led to the conclusion that transfer is rare:

> The mind is . . . a machine for making particular reactions to particular situations. It works in great detail, adapting itself to the special data of which it has had experience. . . . Improvement in any single mental function rarely brings about equal improvement in any other function, no matter how similar, for the working of every mental function group is conditioned by the nature of the data of each particular case.[12]

Reflecting back on this work later, Thorndike concluded:

> By any reasonable interpretation of the results, the intellectual values of studies should be determined largely by the special information, habits, interests, attitudes, and ideals which they demonstrably produce. . . . The chief reason why good thinkers seem superficially to have been made such by having taken certain school studies, is that good thinkers have taken such studies.[13]

In a volume entitled *Transfer on Trial*, psychologists Daniel Detterman and Robert J. Sternberg conclude that "transfer is rare and its likelihood of occurrence is directly related to the similarity between two situations."[14] Enter *near* and *far* transfer. Near transfer occurs when learning in one area improves learning in another very similar area. If learning to play the piano makes it easier to learn to play the organ or the accordion, this would be a case of near transfer. Hardly surprising. Far transfer occurs when learning in one area improves learning in a very different kind of area. If learning to play the piano improves mathematical skills, or if learning Latin improves the ability to play the piano, we would have cases of far transfer. Far more surprising. And far less likely!

Enter as well the *high road* and the *low road* to transfer. Low road transfer is transfer that occurs automatically—I study music and, lo and behold, my math scores go up. High road transfer occurs only when students are explicitly taught some kind of abstract principle which they learn can be taken from one domain and applied to another—I learn about the mathematical basis of musical scales and am taught that these principles can be used in math class.[15] The most elusive kind of transfer is far, low road transfer—yet nearly all of the claims that we hear for transfer of learning from arts education are of this kind.

Let's look at the evidence.

Does Arts Education Raise Academic Performance?

The evidence used to claim that the arts boost academic performance is based on numerous correlational studies.[16] But as everyone knows, we cannot infer causality from correlation. Correlational studies about arts education and academic performance have been badly misinterpreted and used erroneously to buttress the claim of transfer—which is an inherently causal idea.

Correlational studies about arts and academics compare the academic profile of students who do and do not study the arts either in school or in after-school programs. A study by education researcher James Catterall is one of the most often cited studies in support of the position that arts education boosts academic performance.[17] He analyzed data from over 25,000 eighth, ninth, and tenth graders participating in a 10-year National Educational Longitudinal Study. He classified each child in terms of extent of arts involvement both in and out of school, including attendance at museums. He then compared the top and bottom quartile of students (as measured by arts involvement) in terms of academic outcomes such as grades, test scores, school dropout rate, and boredom in school.

A strong positive correlation was found: compared to "low arts involved" students, "high arts involved" students had stronger academic achievement, performed more community service, watched fewer hours of television, and reported less boredom in school. This effect could not be explained away as a function of social class, with upper middle–class kids going to academically strong schools that have not cut the arts: the same positive relationship held for a sub-analysis of the top and bottom socioeconomic quartile of students (which totaled 6,500 students). This study is cited again and again as showing that arts education *causes* academic skills to grow.

Another highly cited study comes from Stanford anthropologist Shirley Brice Heath.[18] She reported that at-risk students who participate in after-school arts organizations for at least nine hours a week over the course of at least a year are ahead of a random national sample of students on a wide range of academic indicators: their school attendance is higher, they read more, and they win more academic awards. Again, a correlational, not a causal, study.

And perhaps *the* most widely cited bit of correlational data comes from the College Board. Every year the College Board releases data on the correlates of scores on the verbal and mathematics SAT, the tests most colleges and universities in the United States require as part of an entrance application. Their findings consistently show that the more years of high school arts classes students take, the higher their verbal and math SAT scores.

These are the kinds of findings that are cited by arts advocates as proof that arts education raises test scores. But all that these three bodies of data show is that students in the United States who choose to study the arts are students who are also high academic achievers. While this could mean that studying art causes students to gain academically, it could also mean that the students who choose to take art classes are high achieving to begin with. This is what we call a selection effect: high achievers are, for whatever reason, selecting themselves into art classes. Recall Thorndike's shrewd observation that the reason we think good thinkers are made by certain kinds of courses is that good thinkers take these courses.[19]

Take a look at how studies such as these have been used erroneously to support the claim that studying the arts *causes* test scores to rise. Here is how Catterall's findings are described in a 2006 report prepared by the National Assembly of State Arts Agencies in the United States:

> Students who participate in arts learning experiences often improve their achievement in other realms of learning and life. In a well-documented national study using a federal database of over 25,000 middle and high school students, researchers from the University of California at Los Angeles found students with high arts involvement performed better on standardized achievement tests than students with low arts involvement. Moreover, the high arts-involved students also watched fewer hours of TV, participated in more community service, and reported less boredom in school.[20]

While this quote does not directly claim causality, the first sentence certainly implies it (note the use of the verb *improve*). But another explanation of the correlation could be that arts involvement leads to fewer hours of

TV watching because students are busy doing art, and it is the lesser TV watching that is boosting academic performance.

What is most probable, however, is that selection effects are at the root of these kinds of correlations. Here are some possible reasons why high academic achievers (no matter what their socioeconomic status) may be more likely to choose to study the arts than low academic achievers—that is, to select into the arts. First, high academic achievers may attend schools strong in both academics and the arts. Second, they may come from families that value both academics and the arts. Third, they may have high energy and thus have time for and interest in both academics and the arts. And fourth, as our most selective colleges become more competitive each year, students may feel they need to build resumes showing strength in a non-academic area, such as one or another art form.

There is some intriguing evidence for the high-energy hypothesis in the study by Heath mentioned earlier.[21] Her study included not only students involved in after-school arts organizations but also those in two other kinds of after-school organizations—those focusing on sports, and those focusing on community service. All three groups were intensively involved in their choice of organization. Heath allowed us access to her unpublished data, and we compared the likelihood of winning an academic award among the arts and the sports students. While both groups were significantly more likely to win an academic award than a random national sample of students, the two groups did not differ in proportion of awards. Eighty-three percent of the group of arts-involved students and 81% of the sports-involved students won an academic award, compared to 64% of the national sample. The finding that both intensively involved arts and sports students did well academically is consistent with the possibility (though does not prove it) that these are highly motivated students to begin with. Perhaps their drive is what impels these students both to involve themselves in an after-school activity in a serious way and to do well in school.

Further support for the energy hypothesis comes from a point made by arts educator Elliot Eisner.[22] He compared the SAT advantage of students taking four versus one year of arts to that of students taking four versus one year of an elective academic subject such as a science or a foreign language. He found that students who specialized in *any* subject, whether arts or an academic elective, had higher SATs than those who had only one year in that subject (with academic specialization yielding a far greater advantage than arts specialization)! For example, in 1998, while students with four years of arts had verbal SAT scores that were 40 points higher than scores of those with only one year of arts, those with four years of a foreign language had

verbal SAT scores that were 121 points higher than scores of those with only one year of foreign language. Similarly, while students with four years of arts had mathematics SAT scores that were 23 points higher than scores of those with only one year of arts, those with four years of science had mathematics SAT scores that were 57 points higher than scores of those with only one year of science. Students who specialize or focus might have higher energy than those who do not specialize, and this higher drive could account for their higher academic achievement. A causal explanation is also possible (though not demonstrated by these data): the very process of sticking to something and getting better at it (whether art or an academic subject) might spill over into other areas—by virtue of the student having developed grit[23] or a belief that intelligence is malleable through hard work[24] (or both).

As noted, another reason for the strong correlation between arts study and SAT scores could be that our highest achievers study the arts in order to enhance their chances of admission to selective colleges. The academic profile of students choosing to take the arts has risen consistently over the last decade. When we plotted the relationship between SAT score and taking four years of arts in high school (compared to taking no arts), we found that this relationship grew stronger each year, beginning with the first year in which the data are available, 1988, and continuing through 1999 (the last year of data we examined).[25] The comparative advantage for students with four years of arts grew greater each year.

Using a large national database and sophisticated data analyses, two policy researchers, E. Michael Foster and Jade V. Marcus Jenkins, demonstrated that selection factors do indeed explain the association between arts involvement and academic achievement.[26] They showed that children who participate in the arts come from families with more resources, and children who participate in music and performing arts have higher IQ scores before choosing to participate. When the researchers adjusted for these and other kinds of factors, there was no association between participating in the arts and cognitive outcomes.

An examination of the relationship between arts study and academic achievement in other countries proves extremely instructive and casts doubt on all of the American hoopla. In the Netherlands, students who take arts electives in high school attain the same educational level as those with no arts electives.[27] This study, which controlled for students' socioeconomic status, shows that in the Netherlands, taking the arts in high school does not predict ultimate educational level attained.

Most tellingly, in the UK, the more arts courses taken in high school, the *poorer* the performance on national exams at the end of secondary school.[28]

The authors explained this finding by noting that in the UK, the only students who are permitted to prepare for more than one arts subject for their secondary school exams are those who choose an arts over an academic track (making it likely that many who choose this track will be academically weak). This stance contrasts sharply with educational policy in the United States. Academically weak students in the United States are steered into remedial academic courses, not into the arts. The comparison between the findings in the United States and those in the Netherlands and the UK suggest that the relationship between arts study and academic achievement is not a causal one but instead reflects different cultural values about who should study the arts and why. Would someone in the UK or the Netherlands say that one should avoid the arts because they destroy the mind?

Even if self-selection (high achievers choosing to study arts) explains the correlation in the United States, there might still be some causal force at work. Might it not be that once high achievers self-select into the arts, the arts then foster cognitive skills which translate into even higher academic performance? Lois Hetland, Monica Cooper, and I put this idea to the test by examining the data in James Catterall's study.[29] Catterall reported longitudinal data on students who self-selected into the arts in eighth grade and remained highly involved in the arts through twelfth grade. If both factors were at work, we would expect the strength of the relationship between arts involvement and academic performance to grow stronger over the years. But not so. The statistical effect size showing the relationship between studying the arts and academic achievement remained unchanged from eighth to tenth to twelfth grade. Although these data come from only one study, they come from a very large-scale study: there were 3,720 students who were highly involved in the arts from the eighth through twelfth grades, and the same number not particularly involved in the arts over that time period. The data fail to support the view that the arts are causing the academic achievement of these students to be higher than that of students relatively uninvolved in the arts.

So how can we figure out whether the arts are having some kind of causal influence on academic performance? Studies can compare students who get a rich versus a lean arts education; they must assess academic performance on some measure (such as an achievement or aptitude test) prior to their experience in the arts, showing that the two groups are equivalent, and then look at whether performance on that measure rises significantly more for those in the arts education group after a significant amount of time has elapsed. These are experimental designs and they are far more difficult to carry out than correlational studies.

In addition, one really needs a true experimental design—which means randomly assigning students and teachers to arts versus non-arts groups. Since this kind of study is nearly impossible to carry out in the messy world of schools, and might not get approval by a university's Institutional Review Board owing to the ethics of assigning students to groups, researchers usually rely on quasi-experimental designs. That means students are not randomly assigned to art and non-art, but instead self-select (or not) into the arts.

A key issue in experimental and quasi-experimental studies is the nature of the control group. For any conclusion to be drawn, the arts and control group must have students matched at pretest on the outcome in question, and must have teachers of similar quality. Of course, matching teachers is extremely hard to do since schools that are strong in the arts might attract different kinds of teachers (maybe more progressive ones) than schools that cut the arts.

Ideally, the arts students should be compared to a control group of students getting some other new kind of specialized program, like chess or fencing. This is because any new program is likely to have positive initial effects. The energizing effect of a new program on both teachers and students is called the "Hawthorne effect."[30]

In the late 1990s, Lois Hetland and I decided to take a close look at all of the experimental studies from 1950 to 1999 (published and unpublished, and appearing in English) that had tested the claim that studying the arts leads to some form of academic improvement.[31] We called our project the REAP project (for Reviewing Education and the Arts). In one analysis, we combined studies that compared children before and after getting high and low exposure to the arts in their schools. When these studies were combined statistically, yielding one large study (called a "meta-analysis"), the students in the high arts groups gained no more than those in the low arts groups on verbal or mathematics skills. We were not surprised because we could see no theoretical reason to expect learning in the arts to improve academic achievement. The ways of thinking learned in the arts are really very different from the skills assessed by verbal and math multiple-choice tests or by grades in traditional academic subjects. The arts are not a magic wand. Alas, we enraged the arts advocacy community, who felt that we were providing ammunition to those who wanted to cut the arts by revealing that the arts do not boost test scores. Instead, we wanted to change the conversation about the reason to have arts education. More on that later in the "In Sum" conclusion to this chapter.

But Doesn't Music Make You Smarter?

Maybe the problem is that we were looking at studies that compared students getting "the arts" to those not getting the arts. We can't tell whether these students were taking classes in visual arts, music, theater, dance, or some combination. Maybe this matters. And so we also looked at studies that tested the effects of specific art forms.

When I give talks on this topic, I often show a slide of a guitar store with a sign in front saying "Playing Music Makes You Smarter." Doesn't this feel right? After all, learning to play an instrument requires discipline, attention, memory, and listening skills. Might these skills then transfer to other areas of learning?

While this claim seems plausible, it remains very difficult to prove. To be sure, there is a positive correlation between taking music classes and SAT scores.[32] But with sophisticated statistical analysis, the correlational findings on music and SATs fall by the way side. When Kenneth Elpus compared the scores of over one million students who had taken at least one high school music course to scores of students without such a course, he controlled for socioeconomic status, time use, prior academic achievement, and school attitude.[33] With these factors held constant, there was no SAT advantage for the music students. What this shows is that it is selection effects that explain positive correlational findings: students who are academic achievers to begin with are those who select into music classes. But this should not be taken to mean that musicians are smarter than the rest of us, for when adults with and without music training are compared on overall IQ, there is no advantage for the musicians[34] though there may be a correlation between music *aptitude* and IQ, as discussed later on. And of course, high achievers not only select into music but also into other kinds of academic classes.

One study can be interpreted as showing either that music training raises academic achievement and standardized test scores or that children with high cognitive ability are those who persist at music.[35] This study showed a strong correlation between persistence at music lessons from age 8 to 17 and various cognitive outcomes. The researchers used a statistical method called "propensity scoring," by which each participant in the music group is matched with an individual in a control group on a variety of variables that might explain this link (e.g., socioeconomic status, parents' personality, parents' involvement with the child's school success). Those who persisted for nine years in music outperformed those who persisted in either sports, theater, or dance for that same amount of time. But for us to be certain that the music training is causing the achievement outcomes, we would have to

be certain that all of the variables on which children were matched were the relevant ones and no other important ones were left out. Children in the music and other groups were not matched on IQ, for example. And how could they be, since cognitive achievement was the outcome of interest? If children with higher IQ are those who gravitate to music lessons, and especially are those who persist over many years, then we have a selection effect, not a causal finding!

Here is a potentially complicating fact: psychologist Glenn Schellenberg of the University of Toronto conducted a widely cited study (using a true experimental design) of the effects of music education on IQ.[36] He took 144 six-year-olds and randomly assigned them to either keyboard music lessons, vocal music lessons, drama lessons, or no lessons at all. Lessons were given in groups of six and spanned 36 weeks. He administered an IQ test (the Wechsler Intelligence Scale for Children) before the lessons began and after they ended. When the two music groups were combined, they gained nearly (but not quite) three points more in IQ than the non-music group. This small difference proved statistically significant! Schellenberg suggested that this improvement could be due to music training being very "school-like"— it involves sitting still, reading notation, and homework (practicing).[37] And we know that school attendance is associated with IQ gains.[38]

A few subsequent studies have also asked whether music training boosts either IQ or other kinds of cognitive tests, some of these true experiments with random assignment, some quasi-experimental, simply following children who do and do not self-select into music lessons. One experimental study found that children assigned to music training gained significantly more in reading than others assigned to a painting condition.[39] However, another experimental study reported no effects of music (versus visual arts) training on spatial-navigational reasoning, visual form analysis, numerical discrimination, or receptive vocabulary.[40] A recent meta-analysis of experimental studies (totaling 3085 participants) showed a very small relationship between music training and cognitive outcomes; most importantly, the more rigorously designed the study, the smaller the relationship, leading the researchers to conclude that previously reported positive relationships are probably due to either placebo or selection effects.[41] Hence, there is no firm and consistent finding that music training enhances non-music cognition.

Schellenberg has gone on to demonstrate that the link found in correlational studies between duration of music training and IQ is actually explained by music aptitude.[42] He gave musically trained and untrained adults a nonverbal intelligence measure, the Raven's Advanced Progressive Matrices, which involves completing visual patterns in a logical manner), as

well as a musical aptitude test (the Musical Ear Test). Yes, music training did correlate with IQ. But music aptitude also correlated with IQ. Here are the two important findings: when he controlled (statistically) for music aptitude, the relationship between training and IQ disappeared. But when he did the reverse—controlling for training—the relationship between music aptitude and IQ remained. What this shows is the reason behind the relationship between taking music lessons and higher IQ. Children with higher musical aptitude are the ones who persist at music lessons, and music aptitude and IQ are correlated.

Surely Music and Math!

During the 2010 Macy's Thanksgiving Day Parade, a *Sesame Street* float promoting the value of music was accompanied by an announcement that "Studies show that kids who play music learn math and science even better." Doesn't everyone know that music improves math? Correlational findings between music training and math achievement are not relevant since we can't know whether the positive associations between music and math found are due to music training or self-selection into music by individuals with math skills. What about the experimental studies?

A few experimental studies (assigning children to music training or non-music training) have tested the claim that training in music improves mathematics achievement. The findings are a mixed bag. Some show a positive relationship. One found that children assigned to music lessons did better on math tests compared to control groups—but only when the music training began before age seven.[43] Another showed that a spatial program led to more growth in math when that program was combined with music keyboard training than when it was combined with English-language training.[44] But other studies show either a negative effect (the musically trained kids do worse), inconsistent findings, or no relationship at all.[45]

It has also been claimed that music and math *aptitude* are correlated—that musical people are also mathematical, and mathematicians are more musical than the rest of us. To investigate this, we surveyed two groups of individuals—those with doctorates in mathematics and those with doctorates in either literature or a language.[46] The mathematicians reported no higher levels of either musicality or musicianship than the humanists. Moreover, even among those who reported high levels of facility with an instrument and/or sight-reading abilities, mathematicians did not report

significantly greater levels of musicality than did the literature or language scholars.

Given the lack of evidence for mathematicians being unusually musical, one must ask why the belief in the "musical mathematician" is so prevalent. Likely this comes from the mathematical structure of music and from the ancient tradition of treating the study of music as a mathematical discipline. Because music has underlying mathematical properties, it easily lends itself to being a subject of mathematical analysis. However, despite music's mathematical structure, the ability to create music may not require particularly high levels of mathematical thinking.

The belief in the "musical mathematician" may also be strengthened by a confirmation bias.[47] We notice mathematically talented people who are musical but fail to notice those who are not. For example, it is well known that Einstein was a reasonably accomplished violinist. The New York Times published a story about the musical talents of Harvard mathematician Noam Elkies.[48] But how many of us know that physicist Richard Feynman "found music almost painful"[49] despite his proclivity with the bongo drum? Similarly, non-mathematicians who are musical may fail to attract our attention. Compared to the number of people knowing that Einstein was a musician, my guess is that far fewer people know that the writer James Joyce was highly musical[50] and that the philosopher Jean-Jacques Rousseau wrote an opera.[51]

How About the Mozart Effect?

We also hear hype about a special relationship between music and spatial abilities—particularly the ability to look at a visual form or pattern and imagine moving that form or pattern around in space (by folding it or rotating it). This is the kind of ability we might rely on in order to decide how best to rearrange the furniture in our living room. The original Mozart effect studies showed that adults who just *listened* to brief segments of Mozart and other classical music temporarily improved their spatial reasoning skills. Later came studies testing whether engaging in *making* music improves spatial reasoning in children.

The "Mozart effect" entered into our lexicon after the prestigious journal, Nature, published a letter by Frances Rauscher, Gordon Shaw, and Katherine Ky.[52] These researchers reported that college students who listened to 10 minutes of Mozart scored significantly higher on a spatial reasoning test than control groups who listened to a 10-minute relaxation tape, or who

just sat in silence for 10 minutes. Of course, this report led many labs to carry out similar studies in an attempt to replicate these surprising findings. And the media went wild, making claims like listening to Mozart will get you into Harvard, and the like.

Our REAP team conducted a meta-analysis of the many Mozart effect studies that followed and reported an overall significant positive effect on certain kinds of spatial tasks (but not others)—just on those that required transforming visual images mentally.[53] But it was not clear what conclusion could be drawn because another researcher, Christopher Chabris, carried out his own meta-analysis using a somewhat different group of studies and found no significant effect.[54]

Glenn Schellenberg offered his own clarification on the matter by demonstrating that while the Mozart effect can be replicated, it really has nothing specifically to do with music. Rather, it has to do with being in a state of positive arousal. We know that people perform worse on tests when in a negative mood or when bored and perform better when in a positive mood.[55] The initial Mozart effect study compared people after listening to Mozart versus after sitting in silence or listening to a relaxation tape. Could the Mozart listening have put these participants in a state of positive arousal—ideal for taking a cognitive test? Consistent with this explanation, Schellenberg and his colleagues found that after hearing an energetic Mozart piece participants scored higher on a spatial test than after a slow and sad Albinoni piece.[56]

While there have been many attempts to replicate the original Mozart effect studies, with some reporting positive results, others null effects, the overall view that I have come to is that we cannot conclude that listening to Mozart raises spatial reasoning scores. There is just no good theoretical explanation for why Mozart should improve our ability to manipulate visual images. Moreover, the effect reported in the original study lasted only 10 minutes. Thus, even if there were such an effect, it could not have any educational implications (like getting you into Harvard).

The psychologist who carried out the original Mozart effect study, Frances Rauscher, went on to conduct a series of studies with young children, concluding that the experience of *making* music improved spatial abilities, and this effect was not restricted to ten minutes. Our REAP team, led by Lois Hetland, carried out meta-analyses on three groups of these studies, divided by their outcome measure.[57] The studies that looked at the effect of music training on the ability to transform visual images showed a positive relationship. However, there has been one study that looked at long-term music instruction's effects on spatial abilities. Eugenia Costa-Giomi randomly

assigned children either to piano instruction for three years or to no music lessons.[58] At the onset of the study, the two groups did not differ in any cognitive skills. After one and again after two years of study, results looked promising for those rooting for music to improve spatial skills: the music group scored significantly higher than the control group at the end of both of these years. But after the third and final year of music instruction, the control group had caught up to the music group. There were no longer any significant differences. We must be cautious, therefore, in assuming that music training has the power to strengthen visual spatial skills in any lasting way.

Two Promising Cases of Near Transfer

I don't want to leave this topic on a negative note. All of the tests of transfer I have discussed thus far have been tests of far transfer—where the original domain of learning (an art form) appears quite unrelated to the transfer domain (verbal, math, spatial, and IQ tests). There are, I am glad to report, two areas where the original and transfer domains seem more plausibly related and where there is indeed some respectable evidence for transfer: music and phonological skill (both involve sound), and drama and verbal skill (both involve words). I like to say, "Don't look for transfer if you can't explain it when you find it." You need a plausible rather than a contrived rationale for any transfer found. Here are two cases where near transfer was found and where we can provide a plausible rationale.

Music Learning and Phonological Skills That Underlie Reading

Music learning is associated with phonological awareness—a skill that may be an important precursor and predictor of reading skills.[59] Phonological awareness refers to conscious awareness of the sound structure of words, and is measured by responses to questions like these: Can you say the word *toothbrush* without the "br" sound? How many sounds can you hear in the word *cat*? Which word begins with the same sound as cat?—*car, bus*, or *boy*? Can you think of a word that rhymes with *store*?

Correlational studies with young children show that music skills and music aptitude are associated with phonological awareness.[60] Musicians have phonological awareness superior to that of non-musicians, and music aptitude in children correlates with phonological awareness and accounts for over 40% of the variance in reading in 8- to 13-year-olds without any musical training.[61] A meta-analysis of experimental studies on this question compared one group of children getting music instruction to a control group

not getting music instruction, with both groups getting the same amount of reading instruction.[62] While this study found no significant effect of music training on reading fluency, it did show a small but statistically significant effect of music training on phonological awareness. When the researchers broke phonological awareness down into rhyming versus other phonological outcomes, they discovered that it was the ability to rhyme that was affected by musical training, but only after at least 40 hours of instruction.

How can this finding be explained? Neuroscientist Nina Kraus has pioneered studies showing that music training in childhood strengthens auditory pathways in the brain.[63] This is referred to as training-related plasticity of the brain. She has gone on to show that two years of music training in childhood results in a stronger subcortical differentiation of the contrasting sounds of the stop consonants *ba* versus *ga*. This is a response that is linked to reading skill: better readers show stronger brain responses to contrasting speech sounds. Kraus's study is the first experimental demonstration of brain changes in auditory processing causally linked to music training.

Classroom Drama and Verbal Skills

Classroom drama refers to using acting techniques in the regular classroom rather than acting on stage. Studies have compared the effect of enacting stories versus just listening to the stories. When our REAP team, led by Ann Podlozny, synthesized a large number of studies on this topic, we found strong effects.[64] First, understanding of the stories was stronger when they were enacted. This makes perfect sense. When you take an active role in what you are learning, you process it more deeply and learn it better. Somewhat more surprising was that those in the drama group also performed better on understanding new stories, not just the story they had enacted. Perhaps acting out stories helped them to learn how to make sense of new ones. Most surprising of all was that those in the story enactment groups achieved higher reading readiness scores, higher reading achievement scores, higher oral language development, and higher writing scores. In short, acting out texts rather than just reading them did appear to strengthen children's verbal skills. This is a clear case of near transfer.

Another Approach: The Search for Broad Habits of Mind

Most studies examining transfer from the arts fail to do something very important: they neglect to analyze what is being taught in the arts classes

studied. Any plausible theory of transfer needs to be based on an under-standing of the kinds of thinking skills being taught in the "parent" domain (art). Only then does it make sense to ask whether one or more of these skills might transfer to learning in another domain of cognition.

If you ask someone what students learn in visual arts classes, you are likely to hear that they learn how to paint, or draw, or use a potter's wheel. Of course students learn arts techniques in arts classes. But what else do they learn? Are there any kinds of general thinking dispositions (we call them "studio habits of mind") that are instilled as students study arts techniques? If so, perhaps here is where to look for transfer.

Lois Hetland and I, along with arts teacher and artist Shirley Veenema and arts researcher Kimberly Sheridan, undertook a qualitative, ethnographic study of "serious" visual arts classrooms. This resulted in a book called *Studio Thinking: The Real Benefits of Visual Arts Education,* which has been adopted by many teachers in the United States and abroad as an organizing framework for their teaching.[65] Our goal was to shift the conversation about the utility of arts education away from test scores and toward broad habits of mind. And teachers have told us that this framework proves to be a powerful advocacy tool.

Here is what we did. We studied high school visual arts classes in two schools where students could concentrate in an art form. We picked these schools because we wanted to start with the best kinds of arts teaching. These are schools for students with interest and talent in an art form, where students spend at least three hours a day working in their chosen art form, and where teachers are practicing artists.

After coding what we filmed in the arts classes, we concluded that we had found the following potentially generalizable habits of mind being taught at the same time as students were learning the *craft* of painting and drawing.

Engage and persist. The teachers presented their students with projects that engaged them, and they insisted that the students stick to a task for a sustained period of time. Thus they were teaching their students to focus and develop inner-directedness. As one of our teachers said, she teaches them to learn "how to work through frustration."

A reasonable transfer hypothesis: Art students who learn to stick to art projects in a disciplined manner over long periods of time may become more focused and persistent in other areas of the school curriculum.

Envision (mental imagery). Students were constantly asked to envision what they could not observe directly with their eyes. Sometimes students were asked to generate a work of art from imagination rather than from observation. Sometimes they were asked to imagine possibilities in their

works. Sometimes they were asked to imagine forms in their drawings that could not be seen because they were partially occluded. And sometimes they were asked to detect the underlying structure of a form they were drawing and then envision how that structure could be shown in their work.

A reasonable transfer hypothesis: If art students in fact become better at envisioning in art class, they may transfer this skill to a scientific area where envisioning is required, such as reading radiographic images or examining archeological ruins.

Express (personal voice). Students were taught to go beyond craft to *convey a personal vision* in their work. As one of our drawing teachers said, "Art is beyond technique. . . . I think a drawing that is done honestly and directly always expresses feeling."

A reasonable transfer hypothesis: Art students who become better at conveying a personal vision (going beyond technique) may bring this skill to essay writing.

Observe (notice). "Looking is the real stuff about drawing," one of our teachers told us. The skill of careful observation is taught all the time in visual arts classes and is not restricted to drawing classes where students draw from the model. Students are taught to look more closely than they ordinarily do and to see with new eyes.

A reasonable transfer hypothesis: Art students who learn to look more closely at the world and at works of art may bring these improved observational skills to a scientific area such as medical diagnosis (and see later discussion here for just such a finding!).

Reflect (meta-cognition/critical judgment). Students were asked to become reflective about their art making and we saw this reflection take two forms. One we called "question and explain." Teachers often asked students to step back and focus on what they had produced, or how they had produced it. Their open-ended questions prompted students to reflect and explain, whether aloud or even silently to themselves. Students were thus stimulated to develop meta-cognitive awareness about both product and process. The other we called "evaluate." Students got continual practice in evaluating their own and others' creations. Teachers frequently evaluated student art informally as they moved about the room, as well as more formally in regular critique sessions. Students were also asked to make evaluations themselves—they were asked to talk about what works and what does not work in their own pieces and in ones by their peers. Thus students were trained to make critical judgments and to justify these judgments.

A reasonable transfer hypothesis: Art students who develop meta-cognitive awareness about their artworks and about their working process may show more meta-cognitive awareness in other areas of the curriculum—for example, improving in their ability to revise their writing.

Stretch and explore. Students were asked to try new things—to explore and take risks. As one of our teachers said, "You ask kids to play, and then in one-on-one conversation you name what they've stumbled on."

A reasonable transfer hypothesis: Art students who become comfortable with making mistakes and being playful may be willing to take creative risks in other areas of the curriculum.

These habits are important in a wide range of disciplines, not only in the visual arts. But while I listed one or more reasonable transfer hypotheses for each habit we saw being taught, transfer cannot be assumed to occur without experimental evidence. There is some evidence now that the habits of observation and of envisioning may transfer from the arts to more "scientific" domains.

Observe as a General Habit

In 2001, a paper published in the *Journal of the American Medical Association,* a premier medical journal, reported that when medical students were taught to look closely at works of art, they became better medical observers.[66] Students at Yale Medical School were randomly assigned to one of three groups. Those assigned to the art group each studied a preselected painting at an art museum featuring a human figure. They were instructed to look for 10 minutes and then to describe the person in the painting in detail to four other students. It was not enough to say that someone looked sad. Instead, students were to talk in detail about the person's facial features. A control group was taught how to take a patient's history and conduct a physical examination. And a lecture group listened to lectures about abdominal X-ray images.

Before and after this intervention, students were given a test related to medical diagnostic skill. They were shown photographs of people with medical disorders and were given three minutes to describe what they saw (but not to diagnose). The more features relevant to a diagnosis they noted, the higher their score.

The findings were quite striking. Groups did not differ at pretest, but the art group had significantly higher scores at post-test. Students in the other two groups were more likely to describe the photographs in very general

terms. Clearly looking closely at works of art depicting faces strengthened these students' observational skills in a way highly relevant for medical diagnosis. As a result of this study, medical schools around the country have begun to offer similar art observation programs extending over longer periods of time to train diagnostic skills.[67]

One might ask whether this intervention was specific to the arts. Students could just as well have been trained to look at one another's faces closely. Perhaps this would have worked as well. But the arts provide a very easy way to train looking skills given a very wide variety of faces—different ages, ethnicities, and in all sorts of intimate settings that one would not normally be privy to. This is a bonus effect of the arts, and could have the added payoff of getting students interested in the visual arts.

Envision as a General Habit

My colleagues and I have some evidence that learning to envision in visual arts classes fosters geometry performance, at least when it comes to purely spatial reasoning divorced from the learning of theorems.[68] We compared students majoring in either visual art or theater in an arts high school, examining their performance on the kind of spatial reasoning that geometers use. For example, we showed them two overlapping squares along with a list of shapes and asked them to identify the one shape that could not be formed by the overlap. Another question showed two triangles: the task was to draw a four-sided shape that combined both triangles, with the stipulation that the triangles could not overlap and no two sides could be parallel. These kinds of questions require imagining (envisioning) shapes mentally. We tested the students at the beginning of high school, as they entered ninth grade, and then at the end of their tenth-grade year. Students majoring in art entered ninth grade with superior spatial skills (a selection effect, likely), but also grew significantly more in these skills than did those majoring in theater (a training effect, we think).

These two habits of mind—observe and envision—are not the kinds of skills picked up by SAT tests, but my doctoral student Jillian Hogan is hard at work developing reliable measures of these habits. These habits of mind are very important ways of thinking that will stand students in good stead for just about anything they may choose to do. It is my hope that other researchers will look at some of the other habits of mind we describe, develop measures of learning of these habits, and test for their transfer to a plausible domain.

In Sum: Let's Look to Habits of Mind, Not Academic Test Scores

In this chapter I have reviewed claims about the effects of arts education on cognition, pointing out mistaken interpretations of findings leading to bogus and implausible claims. The clear conclusion is that students in arts-centered schools do not perform better academically than do those in more traditional schools. And music does not make kids smarter, more mathematical, or more spatial.

But if we focus on just what arts teachers are actually trying to teach, we can see other kinds of outcomes that we might look at as potential transfer outcomes. These are the broad habits of mind that are used in each art form. If we want to go that route, we need to figure out the habits of mind that are central to each art form, and then we need to develop ways to measure how well such habits are learned in the art form, and whether they transfer to other domains. Jillian Hogan is now analyzing habits of mind taught in music classes,[69] and Thalia Goldstein, a former doctoral student of mine, is doing the same thing with theater classes.

Suppose we find that the habits of mind learned in the arts do not transfer? Should we then eliminate the arts from our schools? To counter this possibility, we need to distinguish core from instrumental justifications for teaching the arts. Core justifications should always be the most important: acquiring an understanding of the arts is intrinsically important, just as is acquiring an understanding of the sciences. This is of course a value judgment, not something that can be proven or disproven. But to justify this value judgment, I would point out that the arts are ubiquitous; no human society has been without them; and the arts offer a way of understanding unavailable in other disciplines.

We could also argue that athletics is intrinsically important for our children—another value judgment. Now, suppose coaches began to claim that playing baseball increased students' mathematical ability because of the complex score-keeping involved. Then suppose researchers set out to test this and found that the claim did not hold up. Would school boards react by cutting the budget for baseball? Of course not. Because whatever positive academic side effects baseball might or might not have, schools believe sports are inherently good for kids. We can and should make the same argument for the arts: the arts are good for our children, over and above any non-arts benefits that the arts may in some cases have. Just as a well-rounded education requires education of the body through physical education, a balanced education requires study of the arts.

Moreover, the study by Foster and Jenkins discussed earlier did demonstrate one important positive outcome of involvement in the arts in childhood.[70] Children who took music lessons were 22 percentage points more likely to participate in the arts in young adulthood compared to those who did not take music lessons. And children who were involved in dance and drama were 26 percentage points more likely to participate in the arts in young adulthood, and to participate more frequently, compared to those not involved. If we believe that the arts contribute positively to quality of life, then here is one strong intrinsic justification for our schools spending money on arts education. As philosopher Nelson Goodman quipped, "Education should not be half-brained."

| The Lives of Others
Fiction and Empathy

I HOPE TO HAVE convinced you that claims about arts education raising our IQs and elevating our children's verbal and math test scores are overblown and wrong-headed. Far transfer is exceedingly difficult to demonstrate, probably because it rarely occurs. I hope I have also convinced you that lack of such far transfer "side effects" should have no bearing on the value we place on the arts in our lives, and on the value we place on the arts as a fundamental part of every child's education.

Is empathy a more plausible arts education outcome to consider than test scores? Many seem to think so. Bill English, Artistic Director for San Francisco Playhouse, says about his theater, "We like to think of ourselves as our community's empathy gym. It's a place where we come to work out our powers of compassion." Read what Stanford neuroscientist Jamil Zaki, empathy researcher, has to say: "I think of lots of different forms of art as empathy boot camp. . . . The arts . . . provide you with a very low risk way of entering worlds and lives and minds that are far from what you would normally experience."[1]

It is the narrative art forms—fiction (or nonfiction biographies), theater, and film—that most clearly invite us to do this. And so it is that claims about art and empathy are made most often for the narrative arts. Cases in point: psychologists Raymond Mar and Keith Oatley postulate that "consumers of literary stories experience thoughts and emotions congruent with the events represented by these narratives."[2] Referring to the characters in the novels of Charles Dickens and George Eliot, philosopher Martha Nussbaum remarked, "It is impossible to care about the characters and their well-being in the way the text invites, without having some very

definite political and moral interests awakened in oneself."³ Nussbaum's position is that reading literature helps us practice empathy—we put ourselves into the shoes of another—often of others very different from ourselves, and this transport humanizes the other.⁴

Fundamental here is the concept of simulation. On this argument, when we see human beings represented in literature, we project ourselves into their bodies and minds and simulate what they are experiencing. And when we enact characters on stage, we do the same thing—simulate what our fictional character is experiencing. This is empathy as it is commonly construed—stepping into the shoes of another. Where better to have this kind of experience than with works of literature, either read or enacted? Of course, we can do this in "real life," by interacting with actual others. And perhaps immediate interaction with others builds empathy more so than does interaction with imaginary characters. But in fiction we are offered rich descriptions of a person's hidden motivations and secret wishes, while in real life we just have to guess without the benefit of a tell-all narrator. In addition, in fiction we can simulate others' inner lives in a low-cost way: a *mistaken* simulation of someone's experiences in order to determine her motives or beliefs does not lead to bad consequences with fictional characters but can in real-world interactions. And where else but in literature do we get to encounter such a wide variety of human types, from Captain Ahab in *Moby Dick* to King Lear, from Jane Eyre to Emma Bovary, often so different from ourselves in time, space, and mind? And where else but in literature can we try out such a wide variety of roles safely because we are only in an imaginary world—whether between the covers of a book, or watching a drama on film or on stage?

In this chapter, I examine the evidence that reading literature inspires empathy.⁵ I then turn to the question of whether the experience of acting out literature might have an even stronger effect. But first, let me disentangle what we mean by the term *empathy*.

Three Kinds of Empathy

Empathy has several senses. It can mean knowing what someone is feeling: I see your mouth turn down and I guess that you are feeling sad. I call this *cognitive empathy.*⁶ It goes without saying that this ability to grasp what others are feeling is a critically important social skill. Most investigations into the effects of the arts on empathy have focused on cognitive empathy—perhaps because this is the easiest one to measure.

Empathy can also mean *feeling* what that person is feeling: I see tears in your eyes and I feel your sorrow. This is a kind of vicarious mirroring of another's internal state and I call this *emotional empathy*.[7]

And finally, empathy can mean acting to help someone else: I risk my life to hide a Jewish family in Nazi-occupied Europe; I send money to alleviate starvation halfway around the world; I see tears in your eyes and I try to comfort you. I call this *compassionate empathy*, but others have called this *sympathy*[8] or *altruistic* or *prosocial behavior*.[9]

Individuals differ in their empathic abilities. Those on the autistic spectrum have difficulty reading other people's thoughts and emotions from facial expressions and tone of voice; sociopaths may be able to read others' internal states but do not care about the suffering of others.[10] If the narrative arts can strengthen empathy, findings could thus have clinical uses.

Most people would agree that empathy is a good thing. And if the narrative arts can build empathy, that could be one reason why these forms have always had such power over us, ever since stories began to be told . . . and retold. However, empathy is not always good. Psychologist Paul Bloom[11] has pointed to some of its pitfalls, leading us to feel for people who are near us and who are like us, and to be insensitive to the suffering of those far away and very different from ourselves. But my question here is not the value of empathy; it is whether engaging in fictional worlds with fictional others increases one or more forms of empathy.

Literature: Projecting Ourselves into the Lives of Others

When well and convincingly crafted, fictional characters almost come alive for us. We know they are fictional but we cannot help but think of them as living outside of the covers of the book. We ask authors to tell us what happened to the characters after the book ended, as if they have gone on living and have some kind of independent agency. In her book, *Why We Read Fiction*, literary theorist Lisa Zunshine[12] says that when her students read Jane Austen's *Pride and Prejudice*, they argue about whether Elizabeth Bennet slept with Mr. Darcy before marriage, as if this were something that could be factually resolved. We love our fictional characters and want to keep living with them. That's why many people were in a frenzy every time a new *Harry Potter* book was released. Sick of Sherlock Holmes, Arthur Conan Doyle murdered his creation in the 1893 story, "The Final Problem." But the public was not sick of Holmes. They mourned for him and begged Doyle to revive him. He gave in when he published "The Empty House," in 1903. And fans were livid

when George R. R. Martin (whose book, *A Song of Ice and Fire* inspired the TV series *Game of Thrones*) failed to write a new volume within what they considered an acceptable time frame: they wanted to know "what happened."[13]

The fictional characters we love are very different from ourselves. As mentioned, Martha Nussbaum thinks that reading about "the other" builds empathy—literature can "wrest from our frequently obtuse and blunted imaginations an acknowledgment of those who are other than ourselves, both in concrete circumstance and even in thought and emotion."[14] Philosopher Richard Rorty[15] concurs. He points to books about injustice—Harriet Beecher Stowe's *Uncle Tom's Cabin* and Victor Hugo's *Les Misérables*—and suggests that by learning about the destructive effects of cruelty, readers will become less cruel in their own behavior. It is said that when Harriet Beecher Stowe met President Abraham Lincoln in 1862 he said to her, "So you're the little woman who wrote the book that made this great war." Whether or not this story is actually true, and it is disputed, it nicely captures the belief that literature can change minds and change behaviors.[16]

The belief that reading fiction makes us better, more empathetic human beings sounds right. But is it so? Philosopher Gregory Currie is skeptical:[17] "Many who enjoy the hard-won pleasures of literature are not content to reap aesthetic rewards from their reading; they want to insist that the effort makes them more morally enlightened as well. And that's just what we don't know yet." We do know, however, that great writers are not always morally good. Poet Ezra Pound was a fascist, T. S. Eliot was an anti-Semite.

Suzanne Keen, author of *Empathy and the Novel*,[18] wanted to find out whether reading made people act more compassionately, and so she examined 411 responses to Rohinton Mistry's *A Fine Balance*, a novel depicting the suffering of characters trapped by poverty and injustice in India, responses readers had submitted to Oprah Winfrey's website.[19] The majority of respondents stressed the emotional experience of reading, including feelings of empathy for the characters and crying. Not one person mentioned actually *doing* something to combat poverty and injustice as a result of reading the novel. Instead, the most common action reported was to recommend the novel to others. But psychologists would not count this as evidence against the claim that fiction makes us more compassionate. Readers of this book may not have realized how this book had changed them and may not have connected later actions and attitudes to having read this book. They may also have failed to act because they felt powerless to combat poverty and injustice. I do know of one reader who knew how a book made her more compassionate: a sensitive child who stopped eating pork after reading *Charlotte's Web*, E. B. White's novel about a cherished pet pig rescued from the slaughter house. This behavior has persisted into her adult years.

Could we turn to brain evidence to resolve the debate about whether fiction reading makes us better at empathy? We know that when we read fiction, brain areas used in theory-of-mind tasks are activated.[20] Does fiction reading improve cognitive empathy by continuously activating the brain area involved in social simulation?

Psychologists have tried to resolve this debate. They have asked whether fiction reading improves any or all three kinds of empathy after we close the pages of a book and step back into the actual world. They have done this in two ways: by comparing fiction to nonfiction readers on some measure of empathy (correlational studies); and by randomly assigning some people to read fiction, others to read nonfiction or not to read at all, and then measuring how this affects some kind of empathy (experimental studies).

Cognitive Empathy

Correlational studies have asked whether fiction readers are particularly skilled at inferring other people's inner states of mind. There is a test for this, called the "Reading the Mind in the Eyes Test," developed by British autism researcher Simon Baron-Cohen.[21] In this test, which you can try out on the Internet,[22] people are presented with pictures of faces with only the eyes showing, like the ones in Figure 13.1.

The eyes are surrounded by four verbal names of mental states. For the top image, the four words are *serious, ashamed, alarmed,* and *bewildered.* Which word best describes what this person is feeling? The test developers determined the correct choice by determining how most people respond. In this case, the right (majority) answer is *serious.*[23] For the bottom image, your choices are *reflective, aghast, irritated,* and *impatient.* And the correct response here is *reflective.*

Individuals on the autism spectrum, known to have deficient theory of mind skills, fare poorly on this test.[24] Even typical adults also have some difficulty, and thus this test detects subtle individual differences in the ability to read emotions. This is a test of cognitive empathy.

Let's take a close look at the findings of one of the initial studies asking whether fiction readers are particularly good at the Eyes test—conducted by psychologists Raymond Mar, Keith Oatley, and their colleagues.[25] A group of adults from a university community were recruited. To find out the extent to which each person was a fiction reader, an adapted version of a test called the Author Recognition Test was given.[26] Participants see a list containing names of fiction writers, names of nonfiction writers, and made-up names (these were the "foils"). Biographies can contain the same rich psychological information

FIGURE 13.1 Two images from the Reading the Mind in the Eyes Test.
Reprinted with permission from Simon Baron-Cohen at the Autism Research Center at
Cambridge University in the UK. Information on test development can be found in Baron-
Cohen, S., Wheelwright, S., Hill, J., & Plumb, I. (2001). The "Reading the Mind in the Eyes"
test revised version: A study with normal adults, and adults with Asperger syndrome or high-
functioning autism. *Journal of Child Psychology and Psychiatry, 42*, 241–252; and Baron-Cohen,
S., Jolliffe, T., Mortimore, C., & Robertson, M. (1997). Another advanced test of theory of
mind: Evidence from very high functioning adults with autism or Asperger syndrome. *Journal
of Child Psychology and Psychiatry, 38*, 813–822.

as fiction, and so the researchers made sure that the names on their nonfic-
tion list were not biographers but instead wrote on such non-social topics
as economics or science. The task for participants was to select the names
recognized as authors. They were told not to guess, and were also told that
some of the names were not author names at all. Participants ended up with
a fiction and nonfiction author recognition score for the number of accurately
identified names in each category, corrected for guessing (by subtracting the
number of non-author names selected). The more fiction/nonfiction authors
a participant correctly identifies, the more we can assume that this participant
has been a fiction/nonfiction reader throughout his or her lifetime.

Fiction and nonfiction author recognition scores were highly correlated.
And yet they did not show the same associations with the Eyes test. Fiction
scores were positively (and significantly) related to the Eyes test—the higher

the fiction score, the better the Eyes score. Nonfiction scores were negatively (and significantly) related to the Eyes test—the higher the nonfiction score, the lower the Eyes score.

These findings do not tell us whether the kind of cognitive empathy measured by the Eyes test was *developed* by the act of readng fiction. It may have been. But it could also be the other way around: people with strong cognitive empathy may be drawn to fiction because of their preexisting interest in other people's minds.

To discover whether there is a causal link between reading fiction and cognitive empathy, we need an experimental study. In 2013, a publication appeared in the highly selective and prestigious journal *Science* with the provocative title "Reading Literary Fiction Improves Theory of Mind."[27] The researchers, David Kidd and Emanuele Castano, randomly assigned participants to read literary texts, and then assessed their theory of mind performance (as measured by the Eyes test) compared to that of individuals who read different types of texts or did not read anything. They found that reading short excerpts of what they called literary fiction improved performance on the Eyes test to a greater extent than did reading nothing, reading nonfiction, or reading what they called popular fiction.

This study struck a chord with journalists and led to an article in *The New York Times* with the provocative headline, "For Better Social Skills, Scientists Recommend a Little Chekhov."[28] To my students and me, this finding seemed implausible. How could reading just a few pages of fiction in one sitting immediately translate into making us better at identifying emotions from people's eyes? So my doctoral student Maria Eugenia Panero and I decided to see if we could repeat the finding. We carried out an exact replication of the original study, but failed to find any effect of reading fiction, whether literary or popular. Then we discovered that two other research teams were also trying to replicate this study. We ended up combining the data from our three replication attempts and publishing a failure-to-replicate paper.[29] Though we found no advantage on the Eyes test after reading fiction, we did find a very strong and positive *correlation* between having a history of fiction reading (as measured by the author recognition test I mentioned earlier) and a high score on the Eyes test. At almost the same time, another failed replication of the original Kidd and Castano study was published.[30] This study also found a correlation between scores on the author recognition test and scores on the Eyes test, but no causal link between reading fiction and performance on the Eyes test. I have empathy for Kidd and Castano, but science must attempt to replicate findings, especially highly unpredictable ones.

The correlation we find takes us no further than the correlational findings reported earlier. Either it's the selection effect again—the kind of person who is interested in others' emotions (and hence good at that Eyes test) is the kind of person also drawn to reading fiction (likely!), or years of reading fiction strengthens a person's ability to identify others' emotions on that test. Of course, these are not mutually exclusive: people interested in other people's interior lives may be drawn to fiction, and then reading fiction may strengthen that interest. The rich may then get richer.

The idea that fiction reading makes you better at reading emotions in the eyes is a far transfer claim. It's not as if fiction is all about describing the ways people's eyes look when they feel each kind of emotion. So it's a leap to think that reading *Anna Karenina* makes you better able to make connections between visual details of a face and the emotions inside that face. To find causal evidence that reading fiction actually makes the reader more empathetic, it would be a safer bet to turn to studies that look for near transfer. These kinds of studies have asked whether reading a story about compassionate empathy makes readers behave with more compassion. These studies have received far less press coverage than the Kidd and Castano paper, perhaps because they are actually far more plausible—hence less jazzy and surprising.

Compassionate Empathy

Some studies show that reading fiction can increase compassionate empathy. When psychologist Dan Johnson gave participants a fictional story to read, the more emotionally transported into the story people said they felt, the greater the compassion and sympathy and tenderness they said they felt toward the character.[31] In another study, participants read a story about an Arab-Muslim woman who is assaulted in a subway station and stands up to her attackers. Participants in a control condition read a factual synopsis of the events in the story, without any dialogue or inner monologue. Compared to those who read a synopsis, those who read the full story showed a reduced "perceptual race bias" when shown ambiguous-race Arab-Caucasian faces. That is, they were less likely to categorize angry faces as Arab.[32] This seems indirectly linked to empathy—less bias might lead to kinder behavior.

Something similar happened when children read an excerpt from *Harry Potter*.[33] The researchers chose *Harry Potter* because Harry is a character who fights for a world without inequities and who befriends stigmatized groups like the "Mudbloods," witches and wizards born to parents without magic abilities. Children in the experimental group read a passage in which a member of a stigmatized group is insulted and humiliated, while those in a

control group read a passage not related to the theme of prejudice. And the students in both groups not only read but also discussed the reading with their teacher.

It would not be interesting to show that children in the experimental group developed a better attitude about Mudbloods! One must show that they develop better attitudes toward stigmatized groups *not* mentioned in the book. And so the researchers assessed attitudes toward immigrant children at the participants' schools. These attitudes did improve more in the experimental group, though only for those who identified with Harry (as measured by a self-report questionnaire asking children how much they agreed with statements like "I would like to be more like Harry"). But remember, children not only read but also discussed the passage. Thus, whether reading alone could have changed attitudes was not actually tested. That should qualify the interpretation of these findings. Another concern is the extent to which these findings were due to suggestibility. The experiment may well have conveyed an implicit message to respond in a certain way. It would be more convincing if the same findings obtained when the post-test occurred on another day, in different circumstances, with different experimenters.

Yet *Harry Potter* readers have been turned on to compassionate empathy by the Harry Potter Alliance, a nonprofit organization inspired by the activist organization in the *Harry Potter* books, Dumbledore's Army. Those who join become part of "Dumbledore's Army of the real world" and engage in social activism around human rights and fairness. One such campaign, "Not in Harry's Name," pushed Warner Brothers to use fair trade chocolate in its manufacture of Harry Potter Chocolates. Author J. K. Rowling is quoted on the alliance website as saying, "I am honoured and humbled that Harry's name has been given to such an extraordinary campaign, which really does exemplify the values for which Dumbledore's Army fought in the books."[34] But these behaviors do not come about by a single reading of *Harry Potter*. This is just the jumping-off point. The behaviors are brought about by joining an inspiring organization of like-minded peers.[35]

Dan Johnson has also looked to see whether readers are more willing to help someone after reading a story featuring a character behaving prosocially.[36] The answer is yes, but only if readers reported being "transported" into the story (as measured by agreement with statements like "I wanted to learn more about [a character]," or "I had a vivid mental picture of [a character]"). Those who were highly transported were more likely to help the experimenter pick up pens that were "accidentally" dropped. They were also more likely to say that they felt compassion (or similar feelings) while reading the story. And in another study by Johnson, those prompted to generate mental imagery as

they read were more likely to help out a researcher by participating in a study that paid only five cents.

We can conclude that when children and adults read about a prosocial hero doing kind and empathetic things, they are likely to help a person in need outside of the pages of the book immediately after reading it. This is certainly a case of near transfer—from reading stories about helping to engaging in helping behavior—though the kind of help differed from story to transfer behavior. These studies only showed changes in behavior immediately after reading. It would be important to show that changes in behavior are lasting. One experiment did show that self-reported feelings of compassion actually grew stronger over one week—again, just for those who were transported into the story.[37]

None of these studies compared the effects of reading a story about fictional characters to that of reading a non-fictional story about people who actually lived. Thus, the studies have confounded fiction with story. Is there any reason to believe that a fictional story about suffering is more likely to inspire compassion than a non-fictional story about the same theme? It might well be the reverse: reading a story about a real victim might make us more likely to act; knowing one is reading fiction might make us less likely to act. To find out, Eva Maria Koopman gave people excerpts from two texts to read at two different time points one week apart, one text about depression and one about grief.[38] Participants were randomly assigned to one of three genre conditions: literary narrative (by award winning fiction writers), life narrative (much like a memoir), and expository (they read scientific descriptions of depression and grief). The literary narratives and life narratives were introduced either as fiction or as based on true events. After reading, participants had the chance to donate to a charity related to depression or grief all or some of the money they had received for participating. Only a small number of participants donated (31 out of 210 participants); however, those in the depression condition were significantly more likely to donate when they had read the life narrative than when they read the literary text (or the expository text). But whether the life narrative and literary texts were believed to be fiction or non-fiction made no difference to donating behavior. And prior exposure to fiction proved unrelated to whether people donated. Thus, if reading fiction does affect prosocial behavior, this study suggests that such an effect is not due to entering a fictional world—rather it is due to the fact that the information about people in need is presented in narrative form.

There remains the problem of suggestibility alluded to earlier. Did the participants figure out that the point of these studies was to see whether they behaved prosocially, as did one of the story characters? And it's too bad that

the only measures of compassion we have thus far from reading literature are low cost behaviors like helping someone pick up some dropped items or volunteering to give up time to be in a study. I'd like to know whether, after reading literature about people in pain and in need, readers are more likely to sacrifice hard-earned money to alleviate the suffering of those far away and very unlike themselves. And we need all studies to include the variable of time in these studies—to see how long any empathy effects, if they occur, last.

I offer here four notes of caution. First, some studies have used simple stories written by psychologists, and we cannot use such stories to test the effects of "real" literature. Second, literature does not typically offer us overt moral lessons or express clear moral norms and protagonists are certainly not always prosocial. The novelist Howard Jacobson wrote an opinion piece for *The New York Times* about a recent uproar over a New York City production of Shakespeare's *Julius Caesar*, in which Caesar, who is of course assassinated in the play, was made to look like Donald Trump. Some people took this as incitement against Trump. In an opinion piece in *The New York Times*, Jacobson reminded us, "Plays don't tell you what to think, let alone how to act. A good play won't even tell you what the playwright thinks."[39]

Third, we need to consider what happens when we read fiction about evil. When we read Dostoyevsky's *Crime and Punishment*, most of us cannot help but identify with and feel for Raskolnikov, the character who commits a senseless murder. Would this kind of reading lead jurors to be less likely to find someone guilty, or lead judges to grant more lenient sentences? Perhaps. Such a study has not been done, but a recent op-ed in *The New York Times* noted that defense lawyers in Czarist Russia sometimes invoked Raskolnikov to seek sympathy from the jury.[40]

And finally, there is ample reason to believe that cognitive empathy does not always lead to compassionate, altruistic behavior. The ability to detect others' beliefs and intentions could just as well lead someone to manipulate others as to help them. The philosopher Gregory Currie speculates provocatively that when we feel empathy for fictional characters, it depletes our empathy for actual people, making us *less* empathic. William James describes what psychologists call moral self-licensing when he asks us to imagine "the weeping of the Russian lady over the fictitious personages in the play, while her coachman is freezing to death on his seat outside." After leaving the fictional world, we feel that we have paid our empathy dues.[41]

Literary theorists would not be surprised at the weakness of the evidence that reading literature improves empathy. In her book, Lisa Zunshine provides many rich examples of the kinds of complex mental-state attribution that all

kinds of fiction require the reader to make.[42] Novels often cause us to keep in mind how one person mistakenly thinks that another person does not know what another person is feeling about yet another person, and so on. This is cognitive empathy. But Zunshine cautions against assuming that engaging in a certain kind of thinking make us better at this kind of thinking: "Theory of mind makes reading fiction possible, but reading fiction does not make us into better mind-readers."[43]

Suzanne Keen is on the same page as Zunshine. She argues that while we feel empathy for fictional characters (both in "great" literature and mass market novels), the evidence that this spills over into becoming a more empathetic person is just not there.[44] She argues that the idea that reading makes us behave better toward others is at odds with the fact that reading is an isolating activity by which we shut out those around us. When I was a child, my family took long road trips and I loved to immerse myself in a novel in the back seat. I remember a trip to Florida from Michigan during which I devoured a good portion of Margaret Mitchell's 1936 saga of the South during the American Civil War, *Gone with the Wind*. Because my younger sister got carsick from reading in the car, I was made to stop reading and play with her. I was not happy, nor generous. However, the isolating quality of reading need not mean that readers do not have friends and that they are less generous and less empathetic in general. In fact, there is evidence that readers of fiction score high on social connectedness and do not score high on loneliness.[45] Nonetheless, the evidence that readers of fiction are better people than non-readers is not strong. Keen quotes literary theorist Harold Bloom as saying: "The pleasures of reading indeed are selfish rather than social. You cannot directly improve anyone else's life by reading better or more deeply.[46]

If we just go by the studies carried out so far, I would have to come down on the side of the skeptics—Gregory Currie, William James, Suzanne Keen, Liza Zunshine, and Harold Bloom. Despite the plausibility of the claim that literature improves empathy because of how powerfully we project ourselves into and empathize with fictional characters, we do not yet have strong evidence to support this claim. The evidence is only there for very near transfer claims—prosocial stories written by experimenters make us think and act more prosocially (often quite similarly to how the characters thought and acted) immediately after reading, and in one case, also after discussing the story's themes. These near transfer connections are not particularly generalizable to actual literature, since most literature does not carry a moral lesson. And remember that the Germany that led to Hitler was one of the most literate societies, reading Goethe and listening to Beethoven's "Ode to Joy" by night.

And yet . . . I am not ready to conclude that there is no link between literature and compassionate empathy. I make here a plea for more and better research on the effects of literature on compassion. Great literature allows us to get inside the lives of people we would never meet in real life. I would wager that if we could do the study right, we could show that reading Dickens not only makes us feel what it is like to be a penniless, hungry, and unjustly treated child but also makes us more likely to help children in such conditions—if the opportunity to help presents itself to us. Similarly, what might be the effect of reading Victor Hugo's *Les Misérables*—especially the scene where Jean Valjean, just released from years of hard labor for stealing food to feed his sister's child, steals two silver candlesticks owned by the bishop who has taken him in—and when he is caught, the bishop gives the candlesticks to him as a gift? Here we see the cruel effects of injustice and the potential life-giving results of kindness. Might this not make a judge more likely to be lenient in sentencing certain kinds of crimes? Certainly, there would be cases of people who do not react this way. No one would claim that there is a necessary link between reading Dickens and Hugo and compassion for the poor and outrage at injustice. But reading Dickens and Hugo just might nudge some of us to be more compassionate, and that is all we would need in order to make the case that literature has the power to induce compassion.

For now, we have to conclude that the evidence shows the following: people who read a great deal of fiction also have high cognitive empathy skills. But there is no reliable evidence yet to allow us to choose whether the causal arrow flows from fiction reading to empathy, from empathy to fiction reading, or in both directions. In terms of compassionate empathy, we can conclude that people who read prosocial stories and who get transported into them are likely to behave more prosocially immediately after reading, but thus far this has been shown only for behaviors that involve little cost or sacrifice.

Acting: Enacting the Lives of Others

What about the effects of acting—where we don't just read about the other, but temporarily *become* the other? Acting is a strange thing. An actor pretends to be someone else but without any intent to deceive. While monkeys (and elephants and chimpanzees) paint if handed a brush dipped in paint, and parrots dance to the beat of music,[47] acting is a uniquely human behavior.

We could not act on stage without the ability to imitate and to pretend—abilities that emerge in the second year of life, as we have learned from Jean

Piaget's meticulous observations.[48] While limited examples of pretense and imitation have been reported in non-human primates,[49] no evidence of the kind of extended pretense involved in dramatic acting has ever been reported in non-humans. Just imagine dogs or even chimpanzees acting out a pretend love scene or a pretend battle and you will realize how unusual, indeed odd, is the human behavior we call acting.

What does acting entail? In the film *The Iron Lady*, we see Meryl Streep "become" Margaret Thatcher. In *Julie and Julia*, we see her "become" Julia Child. Streep seems to take on not only her characters' bodies but also their inner states—their feelings, beliefs, attitudes, joys, and sorrows. What does the continual practice of stepping into another person's shoes (whether that person is an actual or fictional person) do to the actor?

Because acting requires us to analyze characters, perhaps more intensely than reading about them, acting training might help students become more psychologically astute, and more able to understand the minds of others— that is, better at cognitive empathy. Because acting typically requires students to actually *feel* the emotions of the characters they enact, acting training might help develop emotional empathy. And if actors become more cognitively and emotionally empathetic on stage, might they demonstrate these skills off stage? And might such heightened cognitive and emotional empathy lead to compassionate empathy off stage?

Psychologists have approached the question of acting and empathy not by studying great actors (though this would be fascinating to do) but by studying children learning to role play. Developmental psychologist Michael Chandler[50] was a pioneer here, the first researcher (to my knowledge) to test whether the simple act of role playing improved children's ability to grasp the feelings and thoughts of another (that is, to become more cognitively empathetic). He asked this question of children and adolescents classified as "serious and chronic delinquents" because they had long police and court records due to antisocial, criminal behavior—just the kind of individuals known to have difficulties adopting others' perspectives.[51] Would teaching these youths to practice role playing make them better able to discern the thoughts and feelings of others (and hence, perhaps, to become better able to integrate into society)? Chandler worked with a group of 45 of these boys, ages 11–13. The first step of the research was to demonstrate that their perspective-taking abilities were indeed deficient. He showed the boys five cartoon sequences depicting a character going through a series of events and then displaying an emotion. This emotion was witnessed by someone who had no knowledge of the preceding events. For example, in one sequence a boy accidentally broke a window with a baseball and then

ran home. When he heard a knock on the door, he reacted with alarm. His father saw his reaction, but did not know about the broken window and so could not know why the boy was afraid. The task was to imagine what the ignorant bystander would think, explaining, in this case, what the father would think about why the boy was afraid. Suppose you reply that the father would say the son was afraid because he had broken a window. You would receive a low perspective-taking score—the father could not know this. But you would probably reply that the father would say that he did not know why the son was afraid. And then you would receive a high score on perspective taking. You would have shown the ability to differentiate your own (egocentric) knowledge of an event from what another person knew—or did not know.

When Chandler compared the perspective-taking scores of the delinquent boys to scores of a control group of non-delinquent boys, the difference was striking: the scores of the diagnosed boys were almost four times lower than those of the typical boys, a highly significant difference. The anti-social boys had difficulty differentiating what they knew from what the innocent bystander knew, reporting, for example, that the father knew the boy was scared because he had broken a window.

And now for the second step of the research program. Having established that the boys diagnosed as anti-social had difficulty understanding what someone else knew, Chandler tested whether he could improve this deficiency through acting training. The boys were randomly assigned to one of three conditions. The *acting* condition was engaged in making up skits (in groups of five) about real-life events. Each skit had to be performed over and over again until each child had enacted every role. These skits were filmed and were then reviewed by the group members so that they could think about how to improve them. There were two control conditions: in a *film* condition, children made animated cartoons and documentaries about their neighborhood (but they could not be actors in their films); the other condition received *no special intervention*. The acting and film groups met for a half -day a week over 10 weeks.

After the 10 weeks, all three groups were given another five cartoon sequences. The results were striking. While all groups improved from pretest to post-test (presumably because they now were more used to the cartoon test), those in the acting group improved significantly more than those in either control group in perspective taking. And amazingly, follow-up 18 months later indicated that the boys in the acting group showed significantly decreased levels of actual delinquent behavior than those in the other two groups.[52]

These findings are consistent with what has been reported about theater intervention programs designed to boost the social skills of children and adolescents with autism spectrum disorders.[53] They are also consistent with what has been reported about a prison theater program called *Shakespeare Behind Bars*, where prisoners—often incarcerated for the most violent of crimes—spend many months producing a Shakespeare play.[54] (I do not intend to in any way equate individuals with autism spectrum disorders with those who commit crimes; however, individuals who commit crimes can be assumed to have poor perspective-taking skills, as do those on the spectrum.) The website of the Shakespeare program describes the arts as having "healing power" and states as its mission to bring "theatrical encounters with personal and social issues to the incarcerated allowing them to develop life skills that will ensure their successful reintegration into society." One of the stated goals is to develop empathy and compassion. And the program reports recidivism rates of only 5.1%. Compare this to the national average rate of prisoners released in 2005 and rearrested within five years: 67.8%![55] According to one audience member quoted on the website, "These men cannot re-do the day that sealed their fate, but they have become better men while they are serving their time."

Of course, I realize that these are not the results of an experiment. The prisoners chose whether to participate, and hence there could be selection effects. It would be great to see a study comparing outcomes in prisoners randomly assigned to acting versus another activity. Would the results hold up? We have tried to do such a study but difficulties with getting approval from prison authorities have stymied us.

Thalia Goldstein and I have conducted similar studies with children and adolescents not diagnosed for any social difficulty. Our goal was to determine whether acting training develops cognitive and/or emotional empathy. We asked whether the abilities to *infer* what others are feeling, and to *feel* what others are feeling, are strengthened by engaging in acting classes. We asked these questions about non-professional actors—children and adolescents and young adults studying acting.

Our initial studies were correlational. In one study, we compared how two groups of adolescents aged 14–17 fared on a measure of cognitive empathy and a measure of emotional empathy.[56] Participants all attended one of two arts high schools where students could concentrate in an art form as a major. One group was concentrating intensively on acting; the other group had not been involved in acting but was concentrating equally intensively on another art form. We gave them a measure of cognitive empathy (the Eyes test) and a measure that to me seems to assess emotional empathy (a self-report

measure called the Index of Empathy for Adolescents).[57] In this measure, participants are asked to rate how strongly they agree with statements like "It makes me sad to see a girl who can't find anyone to play with," or "Kids who have no friends probably don't want any." Agreeing with the first statement adds to your empathy score; agreeing with the second one lowers your empathy score.

How did our two groups compare? The acting group performed significantly better on the Eyes test but they did not perform better on the Index of Empathy test. Thus, they proved better at inferring what others are feeling (from their eyes) but did not report any stronger tendency to feel what others are feeling. We called our resultant publication "Actors Are Skilled in Theory of Mind but Not Empathy." The Internet picked this up with a blog post called "Think Acting is About Emotional Empathy? Science Says No"[58]

Next, to find out whether we could replicate this finding with older participants who had more experience in acting, and with the use of different measures of empathy, we studied young adult actors involved in a theater education program and who had been acting since adolescence. We compared them to students majoring in psychology. To see whether the actors were higher on another kind of cognitive empathy scale besides the Eyes test, we showed them films of characters interacting and asked them to make inferences about the motivations of these characters.[59] For example, in one scene, Cliff arrives at Sandra's house for a dinner party, and they begin to discuss his vacation in Sweden, clearly enjoying themselves. Then another guest, Michael, arrives and immediately dominates the conversation, speaking only to Sandra. Sandra looks slightly annoyed, looks in Cliff's direction, and then asks Michael, "Tell me, have you ever been to Sweden?" The participant is asked to explain why Sandra posed this question. A correct answer might be to bring Cliff back into the conversation. An incorrect answer might be because she preferred talking about Sweden over discussing the topic Michael brought up.

To see whether the actors would again show no superior emotional empathy, we administered a self-report test appropriate for this age group—the empathic concern subscale of the Interpersonal Reactivity Index.[60] Participants had to rate their agreement with statements like, "I often have tender feelings for people less fortunate than me" or "Sometimes I don't feel very sorry for people when they are having problems."

The actors scored higher than the non-actors on the movie test—the measure of cognitive empathy.[61] But on the Interpersonal Reactivity Test—the measure of emotional empathy—there was no difference. Again, we had shown that actors outperform non-actors in cognitive empathy

but did not self-report higher emotional empathy than that reported by non-actors.[62]

Was cognitive empathy developed by the training these students received—training which continually prompted them to think about characters' mental states and about how to reveal these states through their facial expressions? That is one possibility. Another is that adolescents interested in the internal states of others are just the kind of individuals drawn to studying acting. The question of the "selection effect" rears up again! To determine which comes first, the superior empathy or the acting training, we had to do an experimental study.

A true experimental study requires random assignment of children to both acting and some other kind of training, as Michael Chandler did. We could not manage this: parents wanted their children to take acting lessons and were not interested in having them possibly randomly assigned to a visual arts or music group. And so, we fell back on a quasi-experimental study, one in which we followed students self-selecting into acting or some other kind of arts training.[63]

We compared two groups of 8- to 10-year-olds and two groups of 13- to 16-year-olds. In each case, one group received acting training over the course of a year and the other group received some other form of arts training, also over the course of a year. Participants were pretested on a series of empathy measures, and then post-tested on these same measures after the year of acting or other-arts instruction. Would those getting practice in stepping into others' shoes grow more in cognitive or emotional empathy than those getting training in another kind of art form?

First, cognitive empathy. One of the measures was the Eyes test, with the younger group getting this test in a form adapted for children.[64] The younger acting group did not gain on this measure over time. Nor did the older group. However, we noticed something interesting. The younger actors were no different from the non-actors on the Eyes test at either pre- or post-test. Not so for the older ones, who outperformed the non-actors already at pre-test.

We can build two stories from these findings. The causal story goes as follows: to become good at the Eyes test requires at least several years of acting training. The 8- to 10-year-olds had not had much acting experience. But the 13- to 16-year-olds certainly had. The scores of the older children were way below those of the adults we had tested in our initial correlational study, but perhaps it takes more than 10 months of weekly acting lessons for these scores to develop.

But here is the non-causal story: the younger children chose acting because their parents liked the idea. The older children were more likely drawn

to acting through their own desire—and hence, perhaps, because of their cognitive empathy skills. Thus, they scored high on the Eyes test. The selection effect again.

A second measure of cognitive empathy was used only with the older children—a measure in which the participant must guess what a character in a film is thinking and feeling, called the Empathic Accuracy Paradigm.[65] This test assesses the ability to infer a person's mental state from moment to moment as that person interacts with another. The acting group started out no different from non-actors at pretest, but they grew significantly better over the year, outperforming the control group at post-test. This finding suggests that their acting training developed their ability to infer others' inner states.[66]

Self-report scales of emotional empathy were also administered. At both ages, the acting and control groups were equivalent at pre-test; and at both ages, the acting group gained significantly more on self-report empathy than did the control group. This result is not consistent with our earlier correlational findings showing actors were not higher on emotional empathy, and the next finding I report on emotional empathy (using our own measure) lends further support to the view that actors (including children drawn to acting) do have above-average emotional empathy.

Because self-report scales have problems (who knows whether people are honest), we developed our own measure of emotional empathy—which we named the Fiction Emotion-Matching task. This task was used to assess whether our participants reported feeling the same emotion as a fictional character they watched on film. The younger group watched four 30-second segments from two children's movies (*Charlie and the Chocolate Factory* and *Willy Wonka and the Chocolate Factory*) in which the protagonist was either sad or scared. The older group watched four 30-second segments from films that would appeal to adolescents (*Love Story, Dawson's Creek, Kramer v. Kramer,* and *The Laramie Project*). After watching the clip, participants reported what they themselves felt and what the character in the clip felt. At both ages, the acting group scored higher than the controls at pretest: they were more likely to say they felt the same emotion at the same intensity as the character in the film. However, this effect was stronger for the younger group; for the older group, the effect only neared significance. In neither group did scores grow over time. I conclude that children and adolescents who show sufficient interest in acting to sign up for acting classes are likely to be strong in the ability to mirror others' emotion (certainly an important skill for an actor to have). This skill appears to lead to acting lessons, but is not an outcome of acting lessons.

In Sum: The Acting-Empathy Link May Be Stronger than The Reading-Empathy Link

Colson Whitehead won the 2017 Pulitzer prize for *The Underground Railroad*, a powerful novel about slavery. He reported that one of the most meaningful responses he received was from a stranger in a bookstore who told him, "Your book made me a more empathetic person."[67] This reader had imagined the suffering of slaves, and had felt their suffering. This is clearly an act of empathy. The question, though, is what this experience does for the reader once the book is finished. Is this person more able to recognize or experience the sufferings of actual people, and does this person behave in any way differently after reading this book?

I have presented a complex, often inconsistent set of findings on the relation between reading and empathy, and then between acting and empathy. What are we to conclude from the empirical evidence?

With respect to whether reading literature improves empathy of any kind, and given the state of the research at this point, I remain skeptical. Despite the fact that we certainly empathize with fictional characters—thinking about their mental states and feeling their emotions—we do not (yet) have the evidence to say that after we close the book we have more skill than nonfiction readers or non-readers at inferring the mental states of others or experiencing the emotions of others. The evidence we do have for this is only there for very near transfer claims—prosocial stories making us think and act more prosocially immediately after reading. But these near transfer connections are not particularly generalizable to much of literature, since most literature does not try to convey a prosocial lesson.

We can say with some certainty that people attuned to thinking about others' mental states (at least as measured by the Eyes test) are drawn to fiction. But, no matter how ardently we argue that literature makes us more psychologically astute, we still don't know whether there is any kind of causal relationship here.

When I tell people that there is scant evidence that reading great literature makes us better people, they look at me as if I am attacking literature. It is so easy to make beautiful, plausible claims about the empathetic benefits of entering narrative worlds—and so hard to back up these claims with evidence. It is also easy to criticize the tools that psychologists use. Critics may think the Eyes test is too narrow to gauge what one gets from literature. They may think that on self-report empathy scales people would be too likely to make themselves sound better than they are. But psychologists Dan Johnson and

Eva Koopman are making inroads toward better measures—such as willingness to give time and money, or racial bias in categorization of faces. Such outcomes are consequential and much more convincing than performance on the Eyes test, or willingness to pick up pens. Still, it is too early in this research program to say anything with certainty about whether literature really makes us behave better toward others.

One promising new measure of cognitive empathy has been developed by Dodell-Feder and colleagues.[68] Participants read "The End of Something," a short story by Hemingway. The mental states of these characters are never explicitly described and must be inferred to make sense of what is going on. How skilled participants are in inferring these mental states is assessed in an interview after reading. Participants are first asked to summarize the story to see whether they mention mental states without being asked for them. Then they are given excerpts from the text and are asked to explain the underlying motivations and intentions and beliefs of the characters. We already know that people differ in how well they perform on this measure. Now we need to find out whether perhaps a year's worth of taking literature classes, compared to a year's worth of taking no literature classes (if only we could assign people randomly!), affects how people do on this measure. And because this is a measure of cognitive empathy with *fictional characters*, we would need to test whether improvement on this kind of task actually entails greater cognitive empathy toward "real" people.

We could also look at how skilled people are at explaining the motivations of others that we hear about. Since literature exposes us to an enormous variety of human types, perhaps those who read fiction are more likely to be able to come up with plausible yet non-obvious explanations for why people behave the way they do—why Donald Trump tweets (what is he actually trying to achieve?), what motivated different groups of people to vote for him, what Putin really thought when he was being interviewed by Oliver Stone, why people go to horror movies, and the like.

We will need to come up with other qualitative measures for emotional empathy. Instead of self-report scales, we need in-depth interviews asking people to introspect about how they felt at different points in their lives when they were witnesses to other people feeling strong negative or positive emotions. We will need to look at the quality of responses given. As for compassionate empathy, we need to assess these behaviors after some kind of meaningfully long exposure to fiction and compare these outcomes to a control condition. And participants must not be able to self-select into these conditions: random assignment is needed if we are to make any kind of causal claims.

With respect to *enacting* fictional characters, my conclusions are more positive. Like fiction readers, acting students (adult and adolescent) are superior at reading emotions in the eyes; but as with fiction readers, there is no evidence that actors grow stronger at this skill over time. The most parsimonious conclusion for actors is the same as that for fiction readers: individuals good at this kind of skill are the kind drawn to acting and to fiction.

As for emotional empathy and acting, we have inconsistent results. We have two findings showing that adolescent and young acting students score equivalently on these scales to non-actors; and we have two findings showing that child and adolescent acting students grow more on these scales after a year of acting than do non-actors. What are we to believe? These inconsistent results show how hard it is to get reliable, consistent evidence for acting training's effects on emotional empathy. Especially when one relies on the kinds of self-report measures that psychologists have developed thus far for assessing the tendency to feel the feelings of others.

But we do have some evidence for the direction of the causal arrow when it comes to the practice of acting and other measures of cognitive empathy—and these findings permit me to be less skeptical about acting and empathy than about reading and empathy. The experience of acting training did strengthen perspective-taking skills in boys diagnosed as anti-social. And the experience of acting also strengthened the ability to infer the thoughts and feelings of an actor on film in adolescents intensively involved in acting.

Whether actors are particularly kind people is a question I leave up to the reader. Certainly, there are plenty who are not: Hollywood celebrities don't often make headlines for their altruistic behavior. And there could be psychological costs to acting. It is possible that being so able to "become" another makes it more difficult to have a clear and consistent identity.[69]

Psychologists will continue to try to create improved measures of capacities like empathy and may thereby gain more consistent evidence that the narrative arts are empathy builders both for readers and actors. But clear-cut evidence just may not be forthcoming, no matter what the measure. Does this matter? It matters for science, but it certainly does not matter for how we value literature and acting. In the words of Suzanne Keen at the conclusion of her book, *Empathy and the Novel* (and I would generalize these words to theater as well as literature), "A society that insists on receiving immediate ethical and political yields from the recreational reading of its citizens puts too great a burden on both empathy and the novel."[70]

CELLIST YO YO MA, an advocate for more arts in our schools, was recently quoted as saying that "art has the power to console, transform, welcome, and heal. It's what the world needs now."[1] A few days later I came across an article in *The New York Times* called "Using Shakespeare to Ease War's Trauma," about a veteran just back from combat who went to a performance of Shakespeare's *Richard III*.[2] He saw enacted there something that reminded him of his own wartime experience and he began to sob. This veteran, Stephan Wolfert, is now an actor who has created a solo show, "Cry Havoc!" (words taken from Mark Antony's speech in *Julius Caesar*). In this play he uses lines from Shakespeare to explore what it is like to be at war and then come back to civilian life. He also runs an acting class for veterans where the acting is meant to heal, by helping the veterans "deal" with what they have experienced.

In his wonderfully titled book, *The Uses of Enchantment*, the psychoanalyst Bruno Bettelheim made the case that fairy tales—which deal with universal human problems like the death of a parent, the cruelty of a step-parent, sibling rivalry—are far better for children than shallow stories whose goal is just to entertain or instruct.[3] Fairy tales have deep meaning (loss, abandonment, loneliness, fear) and allow children to recognize their own anxieties; in addition, fairy tales suggest solutions—in the end, good prevails. The child identifies with the hero's suffering and with the hero's ultimate triumph.

That involvement in the arts is therapeutic is a long-held view. In *The Poetics*, Aristotle argues that watching tragedies enacted on stage had a cathartic effect: the tragedy arouses pity and fear in the audience member, and these emotions are released at the end of the play, leaving the viewer feeling purged, and feeling relief. Freud believed that engagement in the

arts (whether as artist or audience member) was a means of coping with unconscious instinctual wishes that could not be consciously faced or fulfilled—a theory he applied to Leonardo da Vinci.[4] Noting that Leonardo was an illegitimate child who lived with his mother for the first few years of his life, but was then was taken to live with his father and his father's wife, Freud argued that Leonardo must have had a powerful Oedipal yearning for his lost mother. This unfulfilled wish was then fulfilled unconsciously in the subject matter of his paintings. In his painting *Madonna and Child with St. Anne*, for example, Christ as a child is lovingly nurtured by two young women, assumed by Freud to represent (unconsciously) his mother and step-mother. Leonardo had transformed the energy behind his forbidden libidinal feelings for his mother into the socially acceptable goal of creating art. This sublimation (seen in all artists, Freud believed) resulted in a release of tension from unfulfilled wishes. Like Aristotle's catharsis, sublimation provides relief.

The belief in the arts as cathartic has led to the practice of art therapy, in which art making is considered not only a tool for diagnosis but also as a way to improve mood and functioning.[5] Art therapy is considered a way to externalize and thereby resolve conflicting feelings and sublimate urges.[6]

In this chapter I first discuss physiological evidence that making art is stress relieving. I then review research with children either making drawings or engaging in pretend play (which is a toddler's form of theater) and consider how both of those activities aid in emotion regulation.

Arts Enrichment Program Lowers Cortisol in Children

Stress shows itself in elevated cortisol levels. Lowered cortisol levels along with reduced anxiety have been noted in adults engaged in playing the piano, working with clay, and practicing calligraphy, as well as during music listening when facing situations such as medical procedures.[7] Can we find the same effects in young children?

Developmental psychologist Eleanor Brown found that engagement in the arts lowers cortisol levels in children living with the stress of poverty.[8] She studied low-income 3- to 5-year-olds at a Head Start preschool with a daily 45-minute arts enrichment program taught by arts teachers that included music, dance, and visual arts. At several time points over a year, she measured children's salivary cortisol before and after participating in an arts class (music, dance, or visual arts) and a homeroom class. Scheduling was carefully arranged so that each arts class cortisol level could be compared to the child's homeroom class level at the same time of day (since cortisol can

be affected by time of day). Cortisol was lower after an arts class than after a homeroom class at the middle and end of the year but not at the start of the year. Again, we see that the arts result in some form of relief from tension. A small study investigating effects of visual art making on electrical activity in the brain provides supporting evidence: for both artists and non-artists, making an oil pastel painting for 20 minutes increased electrical activity in the brain in a pattern consistent with lower cortical arousal, relaxation, and self-regulation.[9]

Eleanor Brown's finding parallels one by my doctoral student Jillian Hogan. She found that low-income fourth-grade children report higher engagement in art class compared to non-low-income children—perhaps because school is their only opportunity to engage in the arts.[10] Higher engagement likely means greater enjoyment and, hence, lower stress.

Drawing Improves Mood in Children and Adults

Jennifer Drake, a former doctoral student in my lab, showed something consistent with these findings. She has demonstrated in repeated studies that the simple act of making a drawing improves mood in children. Art therapists might reply that they knew this all along, but they would have only case study evidence on which to base their hunch. Art therapists might also say that the reason making art boosts mood is because it allows for expression and working out of trauma. But Drake's research shows something different. Drawing, it turns out, boosts mood *less* when children use it to express their negative feelings and *more* when they use art making to escape—to distract themselves from negative feelings and enter into a fictional, more positive world.[11]

How does she show this? She brings children (and adults) into the lab and induces a negative mood—either by showing them a sad film clip or asking them to think of something that happened to them that was very disappointing. Mood is assessed prior to and after mood induction: children show how they feel by pointing to drawings of faces ranging from looking very happy to looking very sad; adults are asked to rate their mood using the Positive and Negative Affect Schedule, a mood scale consisting of a list of positive and negative mood terms (such as interested, jittery, upset, excited).[12]

After that, participants draw. Some are told to draw something about what they are feeling or about the sad film. We call this the "venting" or "expressing condition." Others are asked to draw a neutral object like a house. We call this the "distraction condition" because focusing on something neutral should

pull the child's attention away from negative thoughts. Several minutes later, children are given the same mood measure again. The key question is change in mood after drawing.

If art making improves well-being by allowing us to vent or express, which could lead to catharsis, the children asked to use the drawing to show how they felt should fare better than the ones invited to turn away from their sad memory or sad reaction to the film. But this was not the finding. For both children and adults, those in the distraction condition improved their mood more than did those in the venting condition. Note that the venting condition did not worsen mood; both conditions resulted in improved mood, but mood was improved more in the distraction condition.[13]

Drake has also demonstrated the greater mood benefit of distraction over venting for creative writing.[14] After participants were guided for three minutes to think about the saddest thing that ever happened to them, half were asked to write (either poetry or prose) about what they had recalled "as a way to focus on, feel, and make sense of the experience." The others were asked to write about their living room as a way to "focus, depict, and make sense of the setting." For both poetry and prose writing, those who wrote about their living room (which took them away from the sad memory) reported greater mood improvement than those who focused on the sad event.

Another group of researchers showed something similar for the alleviation of anger.[15] Participants watched films of people being mistreated—previously demonstrated to evoke anger in viewers. They were then asked to do one of four activities: a positive distraction condition (paint something that makes you happy), a neutral distraction condition (painting a still life from observation), a venting condition (paint something that expresses your feelings in reaction to the film clips), and a non-art activity as a control (a word search task). Mood improved the most in the positive and neutral distraction conditions and the least in the venting and non-art conditions. These findings converge to show that for non-artists, using art as a form of distraction from real-life problems improves mood more than using art to explore negative feelings.

Children Engaging in Pretend Play

The origins of theater are in dramatic pretend play, an activity in which typical children spontaneously engage beginning around the age of two. We have all seen children pretending to be a dog, feed a doll, be the mother, and

so forth. There is now evidence that when young children engage in dramatic play—acting out imaginary scenarios, "trying on" various emotional states—they develop stronger social skills. This was demonstrated by Thalia Goldstein and Matthew Lerner (2017) in an experimental study with low-income four- to five-year-olds in a Head Start program.[16]

The researchers randomly divided children into three groups. One group engaged in guided dramatic pretend play activities twice a week over eight weeks for 30 minutes a session—the kinds of drama games used in acting classes. The other two groups served as controls: one control group engaged in guided block building for the same amount of time, while the other engaged in guided story time, listening to stories about fictional characters and responding to questions, but never acting them out.

A battery of tests was given to the children before and after the eight-week intervention to assess the emotional effects potentially specific to engaging in pretend play. While the dramatic play group did not grow in theory of mind or in more generous sharing behavior, children in this group displayed two developments in the ability to control their emotions. First, when an experimenter pretended to be hurt, the dramatic-play children were less likely to become personally distressed and freeze or turn away. This lower personal distress on the experimenter–hurt test was associated with fewer neutral spontaneous peer interactions in the classroom (resulting in a larger proportion of positive interactions). And second, when given a self-report empathy scale, these children were less likely to agree with statements about mirroring the emotions of others (for example, less likely to agree with the statement "Seeing a boy who is crying makes me feel like crying"). Note that this finding seems in conflict with my conclusion in the previous chapter that children who self-select into acting show heightened ability to mirror others' feelings. But the authors argued that the lowered personal distress in response to the experimenter's injury and the lowered likelihood of emotion mirroring should be interpreted as signs of emotional control.

Emotional control is a form of self-regulation and is hence a key aspect of social competence. Why might dramatic pretend play teach young children the skill of emotional control? The answer may be that dramatic play is rule-governed, as the Russian psychologist Lev Vygotsky[17] pointed out, and requires control over oneself. When children embody characters and portray pretend emotions, they are learning to control their own emotional reactions—and this may be transferring to non-pretend play situations. Goldstein and Lerner cite much evidence that gaining control over one's personal distress is associated with the ability to respond more appropriately to another person's needs.

In Sum: The Healing Work of Art

Involvement in the arts is emotionally valuable for children: stress is lowered, negative affect is lowered, and social skills with peers improve.

The positive effect of drawing on mood is more powerful when drawing is used as a form of distraction than when it is used as a way to express one's negative affect. The opportunity to enter a world of imagination—and hence to escape, albeit briefly, from one's reality—is what seems to work best in terms of mood improvement, at least in the short term.

Distraction may have a bad reputation, but here we see that distraction can be beneficial. There is plenty of reason to want our children to feel better, and we can know that art experiences in school both relieve stress and enhance positive mood. And the findings discussed here lead me to believe that these effects occur because of the power of distraction. Witness the recent craze for adult coloring books, said to lower stress. Artist Paul Klee is reputed to have said, "The more horrifying this world becomes, the more art becomes abstract." Dancer Twyla Tharp is reputed to have said, "Art is the only way to run away without leaving home."

But I do not want to end this chapter without returning to Aristotle's catharsis, Freud's sublimation, and Bettelheim's fairy tales. Engagement with the arts (whether as maker or audience member) not only helps us escape our terrors but can also force us to confront these terrors. If humans did not gravitate toward art that upsets them, then such art would likely not exist. Recall the evidence discussed in Chapter 7: painful art is moving, and we enjoy the feeling of being moved. There is considerable evidence that art therapy for clinical populations improves emotional functioning, and art therapy often involves making art about trauma.[18] What we need now is evidence with non-clinical populations for the *healing power* of confronting our pain through either witnessing or creating works of art— asking people to talk about what gives them solace after watching a tragedy or making a work of art expressing a painful experience, and asking them about transformative arts experiences. We may well find that making art to explore emotional pain is a bit like psychotherapy: painful at first but eventually somewhat healing.

PART V | Making Art

The chapters in Part IV on transfer from the arts have shown that there is little evidence that engagement in an art form as a child makes us smarter academically or in terms of IQ. The chapters also showed that reading fiction by itself does not make us better, more empathetic human beings, though reading fiction could be used as a jumping-off place for engagement in compassionate behavior. But when I looked at the research on enacting roles in fictional worlds, the evidence, though preliminary, does suggest an empathy pay-off. Apparently, the continual practice of becoming another person helps us take the perspective of another person. How long that lasts, and how that translates into compassionate behavior, however, has not been demonstrated (or even investigated). Finally, I looked at the evidence for the claim that the arts can be therapeutic and found clear support. However, contrary to the Freudian concept of wish fulfillment and the Aristotelian concept of catharsis, making art works its magic most strongly not by allowing the maker to express negative emotions but instead by providing a form of escape into a world of the imagination.

In Part V, I take up the question of who becomes an artist. Is artistic talent inborn, or can anyone develop such talent through 10,000 hours of practice? What is the relationship between prodigious artistic talent at a young age and major creativity in the arts as an adult? And can we say anything definitive about *why* humans make art?

CHAPTER 15 | Who Makes Art and Why?

WHAT DOES IT TAKE to become an artist? Conventional wisdom would say that first and foremost it takes talent, and talent is something you are born with. Without talent, you cannot be great. But recently some psychologists have rejected this common-sense view, arguing that what it takes to become an artist is no different from what it takes to become great at anything: sheer hard work. With 10,000 hours of intensive, effortful practice, now dubbed "deliberate" practice, anyone can become excellent. It's just a matter of grit.

To explore the validity of these two positions, I need to first set the stage by contrasting the course of artistic development in the typical child to the course of artistic development in the "child prodigy" in art. In this chapter, I use the visual arts as my example domain, though I could just as well have used music. Both the visual arts and music are domains in which we know a great deal about typical and prodigious development.

The Course of Artistic Development in Typical Children

We do not hear parents praising their children as little doctors, lawyers, or teachers. But parents typically see their children as little artists. That is because, if given the chance and the materials, all children paint and draw. In the intensity and playfulness with which preschool children paint, they resemble artists. They create images that show no concern for the conventions of realistic representation. Suns can be green, grass can be purple. Their drawings are spontaneous, imaginative, appealing. At age five my son created the delightfully Picasso-esque non-realistic person in profile shown in Figure 15.1. And children draw often. As I mentioned at the outset of this

FIGURE 15.1 Picasso-esque drawing by my son, Benjamin Gardner, at age five. From the collection of the author.

book, by the age of two, my granddaughter Olivia made over 100 "abstract expressionist" paintings.

Despite the evidence presented in Chapter 11 showing that we can distinguish preschool art from abstract expressionism, there is also no denying the resemblance between the art of very young children and that of twentieth-century masters.[1] You can see this in the images shown in Chapter 11. After all, if there were not a strong resemblance between child and master twentieth-century art, there would have been no motivation for asking whether people can tell the difference.

After the productive preschool drawing years, at least in the West, as children move into middle childhood, they draw less often.[2] And when they do draw, they are motivated to draw things "the right way," and hence their drawings become more stereotyped and constrained. Figure 15.2 contrasts a whimsical preschool drawing with an older child's more stereotyped drawing.[3] Older children want to master the graphic conventions of their culture. In the West, this leads to an interest in the rules of realism (perspective, shading, neatness, and yellow rather than green suns). In their desire to do things the "right way," their works, while more realistic than those of preschoolers, seem also less aesthetically pleasing—at least to the Western eye trained in the modernism of Klee, Miro, Kandinsky, Picasso, and other twentieth-century Western painters. One could slip a five-year-old's painting into a modern art museum and fool some people, but one could not get away with this with a 10-year-old's painting. I have

FIGURE 15.2 (a) Preschool drawing; (b) Older child's "literal stage" drawing.
From the collection of the author.

come to call the shape of artistic development U-shaped—with high play-fulness and artistry in the preschool years, a decline in the middle child-hood years in the "literal stage," and a return to artistry, playfulness, and experimentation in those individuals who go on to become artists.[4]

The willingness to violate realism declines with age, even if this is at the cost of stylistic consistency. We showed this by asking children to complete

"incomplete" copies of drawings varying in realism.[5] For example, we gave them two Picasso drawings, one far more realistic than the other, each with an arm and hand erased. We pointed to the blank space and told children to try to add the arm and hand the way the artist would have done. We scored their completions in terms of whether the level of realism in the drawing was matched in the completion.

Six-year-olds performed better than both 8- and 10-year-olds and did as well as the 12-year-olds. Thus, for example, six-year-olds completed the schematic, non-realistic Picasso drawing by adding an arm with a non-realistic, schematic hand; they completed the realistic Picasso with a far more realistic hand. But the 8- and 10-year-olds completed all works in an equally realistic way. They appeared consumed with the goal of realism and were unwilling to draw non-realistically even when this would have resulted in more stylistic consistency. Because the 6- and 12-year-olds performed equally well and better than the 8- and 10-year-olds, the willingness to violate realism can be considered to follow a U-shaped curve.

The strongest evidence for U-shaped development in drawing has been provided by Jessica Davis.[6] She asked the following age groups to draw: 5-year-olds, presumed to be at the high end of the U-curve in aesthetic dimensions of their drawings; 8-, 11-, and 14-year-olds and non-artist adults, presumed to be in the literal, conventional stage; and 14-year-old self-declared artists and professional adult artists, presumed to have emerged from the literal stage. All Davis asked of her participants was to make three drawings: draw happy, draw sad, and draw angry. Then the drawings were scored (by judges who did not know the ages of the makers) for expression, balance, appropriate use of line as a means of expression (e.g., sharp, angled lines to express anger), and appropriate use of composition as a means of expression (e.g., an asymmetrical composition as more expressive of sadness than a symmetrical composition).

The results were striking: scores for the adult artists' drawings were significantly higher than scores for the works of children ages 8, 11, and 14 (non-artists) and adults (non-artists), but did not differ from the scores of two other groups—the youngest children (age five) and the adolescents who saw themselves as artists. Thus, only the five-year-olds' drawings were similar to those by adult and adolescent artists, revealing again that U-shaped developmental curve for aesthetic dimensions of drawing.

David Pariser and Axel van den Berg countered that the U-shaped curve is culturally determined—a product of the Western expressionist aesthetic.[7]

They repeated Davis' study with Chinese-Canadian children living in Montreal. Judges were instructed to use Davis' scoring method. Two judges were from the United States, and two were Chinese-Canadians in Montreal. The judges from the United States replicated the Davis U-shaped curve. But those from the Chinese community did not: the curve produced by their scores did not show any decline, revealing that the Chinese judges did not value the aesthetic qualities of the five-year-olds' drawings over those of the older children's. Their scores seemed to reflect greater valuing of technical skill than playfulness and expressivity. This cultural difference in the judging eye was even more pronounced when judges did not have to follow any scoring protocol and were simply asked to put the drawings into three piles: best, just OK, and poorest. The Chinese judges scored the youngest drawings below those of all others; the US judges scored these drawings as among the best.

This finding, if replicated, would allow the conclusion that the U-curve is a reflection of how we judge children's art and is a product of a Western modernist expressionist aesthetic. It is also likely that the loss of expressiveness in drawings that the Western judges perceived may not be inevitable. Arts education plays a very small role in our schools. It is certainly possible that if the visual arts were taught seriously throughout the school years, fewer children would experience a decline in interest or expressiveness. This could be tested in societies that valorize visual artistic expression.

The same decline of artistry is seen in the verbal arts—namely, in the creation of metaphors. I have found that two- and three-year-olds use words non-literally—a folded potato chip is labeled "cowboy hat," a yo-yo held up to the chin is a "beard," a peanut shell being pried open is a "crocodile's mouth," and freckles are called "cornflakes."[8] And there is plenty of evidence that these children were not making honest mistakes but were being deliberately playful. Either they had previously named these objects with their conventional names (demonstrating their knowledge of the literal name), or they smiled with delight as they named, or their non-literal namings were accompanied by pretend play (e.g., putting the yo-yo to the chin and laughing), showing these were not intended literally. But by the school years, these kinds of non-conventional labels become less common. Children now want to use words the way they are supposed to be used. Whether future poets showed this same decline in playful use of language in the school years has never been documented.

The Course of Artistic Development in Artistically Gifted Children

Some children show a striking gift for drawing realistically at a very young age. The drawings at the bottom of Figure 15.3 were made by a gifted three-year-old—a child we would call a precocious realist. Compare these drawings to a typical

(a)

(b) (c)

FIGURE 15.3 (a) Typical three-year-old "tadpole" human figure drawing. From the collection of the author. (b) and (c) More fully articulated figure drawings by gifted child artist, Gracie Pekrul, age three. Reprinted with permission of Gracie's mother, Jennifer Krumm.

"tadpole" human figure drawing at age three, shown at the top of Figure 15.3. Constance Milbrath demonstrated that gifted child artists use foreshortening by ages 7 or 8, while typical children only get there by ages 13 or 14.⁹ The drawing in Figure 15.4 is by a gifted child aged four years and seven months who represented depth by occlusion, and showed figures in motion.¹⁰ Note how skillfully he captures the twisting head of the dinosaur at the bottom left.

The ability to draw realistically at an early age can be seen in the child-hood drawings of adult artists including Pablo Picasso, John Everett Millais, Edwin Henry Landseer, John Singer Sargent, Paul Klee, and Henri de Toulouse-Lautrec. Artist and curator Ayala Gordon observed naturalism in

FIGURE 15.4 Drawing of dinosaurs by gifted child artist Arkin Rai at 4 years 7 months. Reprinted with permission of Arkin's father, Dinesh Rai.

the childhood compositions of 31 Israeli artists.[11] Picasso spoke of one of his childhood drawings in this way:

> I was perhaps six. . . . In my father's house there was a statue of Hercules with his club in the corridor, and I drew Hercules. But it wasn't a child's drawing. It was a real drawing, representing Hercules with his club.[12]

Drawings by artistic savants—individuals with autism and drawing talent—also show an early ability to draw very realistically. Drawings by Nadia, a low-functioning autistic child with a mental age of three at age six, show an astonishing realism. Her drawings of riders on horses are reminiscent of sketches by Leonardo.

In the West, realism has long been prized. From the Renaissance until the twentieth century, artists have created the illusion of space, volume, and depth on a two-dimensional surface.[13] Is it because children see so many realistic images that realism is a sign of precocity in drawing? A comparison to non-Western art prodigies shows the powerful role of culture in determining these early signs of artistic talent. Wang Yani was a child prodigy in painting in China.[14] But her paintings looked nothing like those by Western gifted children. Hers were painted in the allusionistic, impressionistic style of traditional Chinese brush painting, as shown in Figure 15.5.

But Yani does share something with Western art prodigies: what art prodigies in both the East and West show is the ability to master the pictorial conventions of their culture. In the West this means mastering the convention of perspective and realism. In China this means mastering the convention of capturing the spirit of objects, not their exact likeness.

Ten Thousand Hours versus Innate Talent: Four Arguments in Favor of Talent

Some children who are precocious at mastering the pictorial conventions of their culture will go on to become artists as adults. It is typically just children with this kind of talent who climb out of the conventional period and start to violate the rules mastered earlier—and hence, they move into the postconventional stage. While the preschooler lacks conventions, the adult modernist artist has mastered them and then rejected them. It is because neither preschool nor adult Western art is dominated by conventions that the two bodies of work seem superficially so similar.

But which children emerge from the dip in the U and become artists? Are they the talented few, or just those who work much harder than others

FIGURE 15.5 Paintings by Chinese painting prodigy Wang Yani at age three (a) and at age four (b). India ink on rice paper.

Reprinted by permission of Wang Yani via Galerie Jaspers, Munich, Germany.

at honing their skill? *Talent* is a word that upsets a lot of people. It has become fashionable today to believe that our greatest accomplishments, including in the arts, are the product not of talent but of hard work—namely 10,000 hours of hard work. This argument was developed by psychologist Anders Ericsson,[15] who used the term *deliberate practice* instead of hard work—practicing over and over again and with mindfulness what is most difficult—and was later popularized by Malcolm Gladwell.[16] But while deliberate practice is necessary for the achievement of high levels of expertise, it is simply not sufficient.[17] Talent—the innate proclivity to learn easily and quickly in a particular domain—is also a necessary ingredient and should not be lightly dismissed. Let's consider four pieces of evidence countering the "all it takes is practice" view: early high achievement, biological markers, motivation, and finally, some experimental evidence.

Early High Achievement

The indisputable fact of precocious achievement in drawing prior to much practice is one argument against the 10,000 hours claim.[18] The idea that these precocious realists have achieved mastery of graphic realism through practice makes little sense when we realize how advanced their drawings were from the start. Even if we have no evidence of their very earliest drawings, the idea that *any* child could engage in enough practice to make such drawings at such early ages does not seem plausible. And early signs of high ability are seen in other domains as well—for example in music, math, chess, and verbal reasoning.[19]

Biological Markers

A second argument against the all-it-takes-is-practice view is that precocious realists as well as adult visual artists show a pattern of strengths and deficits that are most parsimoniously explained as reflecting biological, innate characteristics, as explained next.

Non-Right-Handedness and Anomalous Dominance

A disproportionate number of adult artists and children who draw precociously are non-right-handed.[20] No environmental explanation can make sense of this finding: artists do not need to use both hands when drawing, and even very young precocious drawers show this tendency, often drawing interchangeably with both hands.[21] Non-right-handedness is an (imperfect) marker of anomalous brain dominance. About 70% of people have standard dominance—a strong left-hemisphere dominance for language and hand (yielding right-handedness)

and a strong right hemisphere dominance for other functions such as visual-spatial and musical processing.[22] Those thirty percent with anomalous dominance have more symmetrical brains (with language and visual-spatial functions represented to some degree on both sides of the brain).

Visual-Spatial Strengths

Anomalous dominance has been associated with strengths in visual-spatial, musical, and mathematical abilities.[23] How do gifted drawers stack up here? There are reports of unusually vivid and early visual memories in such children.[24] For example, they are better able to recognize non-representational shapes that they have seen before[25] and to recall shapes, colors, compositions, and forms in pictures.[26] They also excel at recognizing what is hinted at in incomplete drawings,[27] suggesting that they have a rich lexicon of mental images, and they are faster than typical drawers on an embedded figures task where they have to find shapes "hidden" in contexts.[28] In short, precocious realists show the kinds of right-hemisphere skills that would be predicted by anomalous dominance.

Language Weaknesses

What about weaknesses that might be biologically based? Anomalous dominance has also been argued to lead to deficits in areas for which the left hemisphere is important, resulting in language-related problems such as dyslexia.[29] When either adults or children who draw at high levels are examined for verbal problems, they show weaknesses. Artists score poorly on tests of verbal fluency,[30] they report more reading problems as children than do other college students,[31] and they make more spelling errors than do other students.[32] And the kinds of spelling errors they make are just those associated with poor reading skills—non-phonetically based errors that do not preserve letter–sound relationships (e.g., *physicain* rather than *fizishun* when spelling *physician*).[33]

This association of non-right-handedness, spatial skills, and linguistic problems has been called the "pathology of superiority" by neurologists Norman Geschwind and Albert Galaburda.[34] While the cause of this association remains controversial,[35] there is no denying the existence of this association. This fact lends support to the claim that children who draw precociously are different from the start.

Most children are language learning prodigies: they acquire the language of their culture rapidly and with no direct instruction. They have brains wired to acquire language. But only a small subset of children are

prodigies in other areas—typically seen in drawing, music, mathematics, or chess. Anthropologist Claude Lévi-Strauss had this to say about the kind of mind that could compose music: "we do not understand the difference between the very few minds that secrete music and the vast numbers in which the phenomenon does not take place, although they are usually sensitive to music. However, the difference is so obvious, and is noticeable at so early an age, that we cannot but suspect that it implies the existence of very special and deep-seated properties."[36] He certainly seems to come down on the side of innate talent rather than of deliberate practice.

Motivation: Rage to Master

A third argument against the practice position is that it does not explain what motivates these children to work so hard. One cannot bribe a typical child to draw all day, but the precocious children Jennifer Drake and I have studied insisted on spending their time in this way. Parents reported that these children sometimes had to be dragged away from drawing in order to eat, sleep, go to school, and be sociable. These children show a "rage to master" in the domain of drawing—a strong drive to figure out the rules of graphic representation. They draw constantly and compulsively. One child we studied drew his first face at age three—a circle with two eyes, and then went on to draw four hundred faces like this all in one sitting.[37] The interest, drive, and desire to work on something must be part and parcel of the talent. This desire to work so hard at something comes from within, not without, and occurs almost always when there is an ability to achieve at high levels with relative ease. This rage to master can be seen in autistic savants as well, but non-autistic gifted children show this drive, too—and we see this in all areas in which children show precocity—whether drawing or music or math or chess.

Occasionally we spot examples of a rage to master without particularly high ability. Gertrude Hildreth[38] documented the drawings of a child who made over 2,000 drawings of trains between the ages of 2 and 11. His drawings were better than average, but he never progressed to prodigy level. This child showed what can be achieved through hard work but no unusual talent.[39]

The drive to draw found in precocious drawers has its parallels in other domains. There are children who spend hours every day finding and solving math problems, and these children also are precocious at math and are able to think about mathematical concepts far beyond the reach of their peers.

The same kinds of children have been observed in the areas of instrumental music performance, chess, and reading.[40] We don't usually note examples of precocity in writing, but my husband, Howard Gardner, a writer of many nonfiction books, exhibited precocity in nonfiction writing when he put out a newspaper in second grade, using a mini printing press.

Experimental Evidence: Controlling for Deliberate Practice

When researchers control statistically for hours of deliberate practice, differences in levels of achievement remain. Researchers Elizabeth Meinz and David Hambrick[41] quantified the relative importance of deliberate practice and working-memory capacity in piano sight-reading skill. Deliberate practice was necessary, accounting for almost half of the variability in piano sight-reading skills. But working-memory capacity predicted skill level above and beyond deliberate practice. Thus, deliberate practice is not sufficient to become an expert sight-reader, and poor working-memory capacity may preclude achieving expertise no matter how hard you work. A meta-analysis pooling 28 findings on the relationship between music expertise and deliberate practice yielded this result: deliberate practice accounted only for 21% of the variance in musical achievement.[42] Twenty-one percent is not nothing, but clearly it's certainly not the whole story.

Research on chess masters tells a similar story.[43] It turns out that number of hours of deliberate chess practice does not perfectly predict level of chess achieved: there are wide individual differences in the number of hours needed to reach grandmaster level, and some people who put in huge amounts of chess time never attain master level. The most plausible explanation for these differences is an innate proclivity to pick up with rapidity the skills that chess requires. What is true of chess masters is bound to be true of all kinds of great achievers, whether in the arts, the sciences, or athletics, though comparable studies have not yet been conducted.[44]

Talent Plus Work Is Still Not Enough

I have tried to make the case for the necessity of inborn talent in becoming a visual artist—and I believe that what holds for the visual arts holds as well for the other art forms. Hard work is, of course, necessary; it is just not sufficient. But even talent plus hard work together cannot ensure that a child prodigy in an art form goes on to become an adult artist in that art form. The highest possible endpoint of artistic talent in childhood is creativity in the sense of domain-altering innovation—big-C creativity. Only a fraction of

children gifted in any domain eventually become revolutionary adult creators in that domain.[45] Why?

The answer is that the skill of being a prodigy is not the same as the skill of being a big-C creator—at least this is true in the West. A prodigy is someone who can easily and rapidly master an already-established domain. A creator is someone who disrupts and changes a domain.[46] All young children, whether typical or gifted, say charmingly creative things that no adult would say and engage in fantasy play.[47] However, this kind of universal creative thinking is quite different from the kind of big-C creativity that is involved in reshaping a domain. Personality and will play a significant role. Creators seek to shake things up. They are restless, rebellious, and dissatisfied with the status quo.[48] They are courageous[49] and independent.[50]

There is some evidence, though not definitive, that creators (again in the West) have disproportionately suffered childhoods of stress and trauma.[51] There is also clear evidence for a disproportionate incidence of bipolar disorder in creative individuals.[52] Of course, neither childhood trauma nor psychopathology are necessary predictors of major creativity, and there are many different life outcomes for gifted children. In addition, some major creators (Charles Darwin, for example) were not recognized as gifted in childhood, or early signs of giftedness were simply missed.

The bottom line is that we should never expect a prodigy to go on to become a creator. The ones who do make this transition are the exception, not the rule. Expecting a prodigy to become a major creator is unfair and psychologically damaging for those who do not have the mind and personality to become a creator.

What I have said here about the difficult transition from prodigy to major creator is likely culture-bound. In the West we valorize originality in the arts; talent without originality is of little interest. In Asian cultures, at least traditionally, originality in art is less important than skill. Artists were meant to spend most of their lives mastering the styles of their teachers, only very late moving on to a somewhat new style of their own.[53] Cultures' differing emphases on originality versus skill must affect the kind of individual who becomes an artist—an intriguing question that remains to be pursued.

In Sum: We Can't Live Without It But Who Knows Why Art Evolved

If high achievement in art requires some sort of inborn ability, then skill in art making would seem to be an adaptive trait. But while it is easy to speculate

on the survival value of language or tool use, it's not so easy to come up with a natural selection explanation for why art evolved in humans. Evolutionary psychologists have tried, of course. They have argued that fiction is a form of virtual reality that allows us to practice (in the safety of our imaginations) how to behave in different kinds of roles and social relationships.[54] And people who are more skilled at social relationships may be more likely to reproduce and spread their genes. Another commonly heard argument is that artistry is a form of sexual selection.[55] Just as Darwin noted that the peacock's tail attracts female mates,[56] certain valued human behaviors are also said to be able to attract mates and thus improve reproductive success. Evolutionary psychologist Geoffrey Miller argues that intelligence, humor, creativity, altruism, and artistic ability are all traits likely to improve reproductive success.[57] In his words:

> Applied to human art, beauty equals difficulty and high cost. We find attractive those things that could have been produced only by people with attractive, high-fitness qualities such as health, energy, endurance, hand-eye coordination, fine motor control, intelligence, creativity, access to rare materials, the ability to learn difficult skills, and lots of free time.[58]

Others like Steven Pinker[59] have argued that art is a spandrel—it evolved as a by-product of our complex brains, with no survival function of its own. In contrast, Semir Zeki sees the function of art as an extension of the function of the brain—"the seeking of knowledge in an ever-changing world.[60] If art making is a way of understanding the world (a position Nelson Goodman took), then art making is also not a spandrel, as knowledge of one's environment is absolutely foundational for survival.

Survival value arguments for art are extremely difficult to test: we can never test them with controlled experiments designed to show causation given the conditions under which evolution in fact occurred. While art serves many very important psychological functions from culture to culture, we cannot say that these functions are *why* art evolved, or that without art we would not have survived. Art making could well just be a product of our complex brains. With our brains comes the urge to make things, not just to notice them, and the capacity to get immense pleasure from making things that are just to be contemplated rather than to serve some instrumental purpose. Without art, Homo sapiens might have survived but we would be a very different kind of species.

PART VI | Conclusion

In the concluding chapter, I consider the relationship between the psychology of art and the philosophy of art while summarizing the key points I have tried to lay out. I hope to have shown that the relationship between these two disciplines is one of mutual enrichment, rather than a contest and a matter of either-or.

CHAPTER 16 | How Art Works

IN THESE PAGES I HAVE examined questions about the arts that have been debated—sometimes for centuries—by philosophers of art. To these questions philosophers have proposed answers based on reasoned argument, intuition, and introspection. Philosophers do not typically ask what ordinary people think about these questions. They care about getting the issues clear and straight and, if possible, approaching the truth of the matter.

Psychologists have asked different questions: not "What is art?" but rather "What do people think is art?"; not "Are aesthetic judgments objective? but rather "Do people believe aesthetic judgments have an objective basis?" My goal has been to show what psychologists, using the methods of social science, have revealed about how ordinary people (that is, not philosophers) reason about these questions—and to point out when ordinary discourse about the arts mirrors what some philosophers have said, and conflicts with what others have said.

In the sections that follow I have tried to capture the highlights of each chapter, contrasting philosophical positions (as well as common-sense views) with what social science has actually revealed.

Can Art Be Defined?

Whether art can be defined was the question with which I opened this book. Here the research clearly supports the philosophical position that art is not a concept with necessary and sufficient features. Art is also not a natural kind concept. It is a socially constructed concept, and this makes it possible for what counts as art to keep changing.

There is empirical support for Nelson Goodman's position that when an object functions as a work of art (because we believe it to be art), we attend to it and remember it (and our brains respond to it) in a manner qualitatively differently from when that object is not functioning as art. This conclusion brings us back to Kant's idea of the aesthetic attitude being a form of disinterested contemplation. We may not be able to pinpoint what is and is not art, but philosophers and psychologists together may be able to pinpoint the difference between observing something with or without an aesthetic attitude. In addition, our "meta-concept" of art differs from our "meta-concept" of other kinds of artifacts. Our linguistic hedges study showed that in contrast to non-art artifact concepts like tools, people believe that art is a kind of concept that is more loosely defined, and more dependent on expert determination of what is and is not a member of the category art. Taken together, these results support the dominant modern philosophical position that art cannot be tightly defined. Instead, we can loosely define art by listing the various possible characteristics of works of art, recognizing that this list must remain an open one.

Does Music Express Emotion to the Listener?

Though some music theorists have denied that music expresses emotions, most music philosophers believe it does. What psychological research shows us is that people, whether musically trained or not, typically report perceiving quite specific emotions from playing or listening to music. And these emotions go way beyond basic ones like happiness and sadness to include feelings like nostalgia, melancholy, tenderness, and amazement. While emotion theorists might debate whether all of these terms are actually names for emotions, these are clearly states restricted to sentient beings and thus can only be metaphorically but not literally conveyed by music.

What justification would there be to deny what so many people say they perceive in music? While I may incorrectly misclassify a dog as a cat, what sense does it make to say that I incorrectly misclassify music as expressing sorrow? After all, there is no way to falsify this perception, because there is no way to test whether music objectively shows an emotion. This claim is an inherently psychological (subjective) one.

Accepting that people do hear emotional properties in music, the question then becomes *how* music manages to convey emotion. One clear finding from research is that certain structural features in music mirror how emotions are conveyed by the prosodic features of speech, such as speed, pitch level,

and loudness. When we are sad we speak more slowly, more softly, and in a lower register. Thus when music is slow and soft and low, we perceive it as sad. Other emotional properties (like the link between the minor mode and sadness, the major mode and happiness) may be learned, but as I pointed out, I do not believe this matter has been fully resolved. Research has also shown that people agree on which basic emotions are expressed by music even in a culturally unfamiliar form. The psychological research provides no support for the claim that music does not express emotions. I conclude that the conventional wisdom that music is the language of the emotions holds up very well.

Does Music Evoke Emotion in the Listener?

We know that music is pleasing and arousing. Music activates the reward areas of the brain, and also speeds up our heartbeat, respiration rate, and other symptoms of arousal. There is really no philosophical puzzle about this because pleasure and arousal are not technically emotions. The philosophical puzzle is how music can cause us to feel emotions. Emotions are about something. Yet when we hear sadness in music and thus feel sad ourselves, there is no object to our sadness. Nothing bad has happened to make us feel sad. This puzzle has led some philosophers to deny that we do feel emotions from music. They admit that we can feel pleasure and we can feel moved, but when we say we feel sad or happy, we are just wrong. We hear emotion in the music and mistakenly believe we are actually feeling that emotion. Other philosophers, however, see nothing incoherent about the idea of an objectless emotion. We mirror in ourselves the emotion we hear in the music and we feel that emotion.

Research clearly supports the position that music elicits emotions in the listener. It makes no sense to deny that music evokes actual emotions in us when everyone reports that it does. Could we all be wrong? And people are not simply confusing what they hear in the music from what they feel. They do not always directly mirror in themselves what they hear in the music because they can also distinguish what they hear from what they feel. For instance, people can hear music as sad yet report feeling nostalgic or dreamy. But I have suggested that the emotions we feel from music feel somewhat different from emotions that have objects and that are evoked outside of music. We know that the sadness that Elgar's cello concerto evokes is caused by the performance of music, and not by an actual tragedy. This cannot help but soften the sadness. Overall the research on this topic fails to provide support for the philosophical position that we cannot feel

emotion from music. We do, but these emotions are softened by aesthetic distance.

Do Pictures Express Emotion to the Viewer?

Nelson Goodman's argument that everything is similar to everything else on some dimension or other may be logically sound. But it is Rudolf Arnheim's argument for a natural similarity between forms and emotions that is supported by the research evidence. There is agreement across ages and across cultures about the expressive properties of visual forms. Moreover, our proclivity to see expressive qualities in visual forms is not limited to pictures functioning as art: we see the same kinds of expressive properties in rocks, trees, columns, cracks, drapery, and other mundane objects if we are predisposed to look at them in this way.

This general proclivity is also seen in the phonetic symbolism of language as we so readily perceive the expressive connotations of the sounds of words: *mal* is "big," *mil* is "little"; *ch'ung* and *ch'ing* are translated from Chinese as "heavy" and "light," respectively, and not the reverse.

Phonetic symbolism is akin to the kind of visual-form symbolism discussed in this chapter. Thus, when Kirk Varnedoe titled his book about abstract art *Pictures of Nothing*, he was alluding to what some say about abstract art—that it consists of meaningless blobs of paint—but he went on to describe how full of meaning, including emotional meaning, abstract art is. While both music and abstract pictures express emotions, they do so in very different ways. Yet both involve the relationship of resemblance. Our perception of emotion in music is made possible in part because of its resemblance to speech prosody; our perception of emotion in abstract art grows out of our ability to see expressive properties in all visual forms. Yet the mechanism by which we see expressive properties in visual forms is not fully understood and remains mysterious. While we know that people perceive emotion in art through some sort of formal isomorphism, we really do not know how this occurs, or in what this isomorphism really consists. These are yet unanswered questions.

Does Visual Art Evoke Emotion in the Viewer?

Mark Rothko said his paintings were meant to evoke powerful emotions in viewers. Some people have reported weeping as they stand in front of his entirely non-representational, abstract paintings. But there is little evidence

that this kind of emotional response is the norm. And emotional responses to visual art seem to be less powerful than emotional responses to music. I have suggested that this may be due to the fact that music envelops us, takes place over time, and makes us feel like moving far more than do other art forms. The way we normally interact with visual art is to glance briefly and move on, and this mode of interaction is guaranteed to not evoke strong emotions.

When people do report feeling like crying when looking at art, they are clearly feeling moved. And there is intriguing evidence that when we are powerfully moved by works of visual art, an area of the brain known to be associated with introspection, the default mode network, is activated. This finding suggests (but alone does not serve as proof) that visual art has the power to make us look inside ourselves. If this is true, then visual art that moves us can foster self-understanding.

Why Do We Enjoy Negative Emotions from Art?

Aristotle said we don't like to look at painful things in life but get pleasure from seeing these things in art. We like tragedy on stage because of its cathartic effect. We like sad music. We look at paintings of suffering, dying people, we go to horror movies, scary movies, suspenseful movies. Does this mean we are masochists? We can answer this in the negative, because the research shows that when we experience art with painful content we not only feel negative emotions but also feel positive ones. And that is primarily because of aesthetic distance. That is, we know that our emotions are caused by art, not "real life." In addition, the experience of negative emotions promotes meaning making as we try to make something positive out of a painful experience. And meaning making is one of the most important functions of art.

Are Aesthetic Judgments Based on Anything Objective?

Philosophers and art experts have disagreed about whether aesthetic judgments have truth value or are simply subjective, just matters of opinion. Whether or not these judgments do in fact have any objective basis, research shows that lay people *believe* that such judgments have no objective basis, classifying them as more like matters of opinion than matters of fact. Perhaps one reason for the belief that these judgments are just matters of opinion is that we find it exceedingly difficulty to come up with cogent reasons why one work is better than another. I am sure that Shakespeare is overall a superior

author compared to Agatha Christie, but how can I prove this to you? I can tell you his language is more beautiful, but you might tell me hers is more true to life. I can tell you his characters make me think more, but you can tell me that her characters make you think just as much—after all, figuring out "who did it" can be all-consuming.

If we conclude that aesthetic judgments have no objective basis, what would determine our aesthetic preferences? Could it simply be familiarity? This is what James Cutting purports to show, arguing that the artistic canon is maintained by a feedback loop involving mere exposure: the more familiar we become with a work, the more we value it, and the more we value it, the more we look at it, deepening our familiarity. I have pointed to an alternative interpretation of Cutting's research: works make it into the canon because they are of higher objective quality than works that did not make it into the canon. In other words, though we may not be able to define it, perhaps objective quality does exist and accounts for why some works have withstood the test of time, and have been valued for centuries by people from many different artistic cultures.

Do Our Beliefs About Effort Shape Our Aesthetic Judgments?

Do we judge a work of art just by its perceptible properties, or do our beliefs about how it was made also play a role? Philosopher Denis Dutton believed that we judge a work of art by the kind of achievement we think it represents. Something that could have been created without much effort constitutes a very different kind of achievement from something that required hard work and much effort. One might assume that a work completed without much effort would be most valued because such a work is evidence of a greater talent than one completed with greater effort. However, research shows just the opposite. All else being equal, more effort leads to a more positive judgment. The history behind the work is part and parcel of the work. We cannot help but allow our beliefs about the process to affect our evaluation of the product.

What Is Wrong with A Beautiful Perfect Fake?

Why we should care if a painting we find beautiful turns out to be a perfect fake is a profound question. The fake is just as beautiful as it always was. Yet research confirms that we do not like fakes. We do not want to go to a museum to look at a fake and we do not want one in our living room. The fact

that we devalue perfect copies even when we admit they remain beautiful shows that there is more to art's true value than just looking good. And that extra property is the work's connection to history, to the hand of the master, and to what we know about the mind that made it. Because of the mind that made it, we imbue a work of art with the essence of the artist—irrational, but apparently true. This conclusion is entirely consistent with Denis Dutton's position that we judge a work of art not just by what it looks like but by what kind of achievement it demonstrates.

Could a Child Have Made That Jackson Pollock?

There is a deep mistrust of abstract art. People do not know how to evaluate it. How can we tell if it is good when we can't use realism, subject matter, or narrative implications as a guide? In addition, abstract art looks superficially a lot like paintings by preschoolers. This is why people say, "My kid could have done that."

But your kid actually could *not* have done that. The untutored eye is able to distinguish works by children (and certain animals) from works by abstract expressionist painters. We can see the difference, and we also recognize the works by the master artists as better than those by children and animals. And it turns out that the way we make this discrimination is by perceiving intentionality. We perceive greater intentionality in works by artists than in superficially similar works by children and animals. This research leads me to conclude that we see more than we think we do in abstract art. When we evaluate a work of art, we are thinking about the mind that made it (consistent with what we know about our response to art forgeries).

Does Art Make Us Smarter?

Just as some people say that any kid could have made a work of abstract expressionism, they (or others) assert with confidence that art makes our kids smarter. Arts-infused schools, it is said, will raise academic achievement and standardized test scores. Music lessons will raise a child's IQ. Unfortunately, research does not provide much support for these instrumental claims. We will have to look elsewhere for the value of an arts education. I believe that we should be looking at the kinds of habits of mind and ways of working engendered by studying an art form seriously. In the case of the visual arts, this includes learning to observe closely, learning to envision, learning to explore and learn from mistakes, learning to stick

with something over time, and developing the habits of critique and evaluation and reflection on one's process.

Does Fiction Make Us More Empathetic?

Both philosophers and psychologists have claimed that fiction makes us more empathetic. We empathize with fictional characters, fearing for their safety, weeping at their suffering. Shouldn't this heighten our tendency to empathize with others once we close the pages of our novel? After all, literature introduces us to a much wider range of people than we could ever meet in real life, and thus it must help us to understand others, and empathize with them. I showed in this chapter that there is only the weakest of evidence for this rosy view of what reading fiction can do, but went on to suggest how we might look for such evidence. On the other hand, there is stronger evidence that *enacting* a fictional character (rather than reading about one) leads to greater understanding of others and more altruistic behavior toward others.

Can Art Be Therapeutic?

Many would agree that engaging in the arts makes us feel better. And I presented evidence that when young children living in poverty engage in art making, they show physiological indices of stress relief. What is it about the arts that relieves stress? Both Aristotle and Freud took the position that the arts are therapeutic because they are cathartic. For Aristotle, watching a tragedy arouses pity and fear, feelings which at the conclusion of the tragedy flood out of us, leaving us calm. For Freud, making art involves sublimating forbidden urges in a socially acceptable way, resulting in release of tension. But research shows another mechanism at work: making art pulls us away from negative affect and distracts us from our problems. And this fits what some artists tell us about how making art is a glorious escape. Whether more intensive and longer-term involvement in the arts can help to relieve stress not via distraction but through the process of venting and working through difficulties (like what goes on in art therapy) remains to be determined—but is a distinct possibility.

Who Makes Art and Why?

For a long time people assumed that artists (and other highly creative and accomplished people) are born, not made. More recently, it has become fashionable to reject this "nativist" view for the more egalitarian-flavored belief that we can all achieve extreme heights in any domain as long as we are willing to engage in countless (or rather, 10,000) hours of effortful practice beginning at a young age. It has become almost a religious dogma to adhere to this position, claiming that the onus is on the other side to *prove* there is such a thing as innate talent. But now we are beginning to see studies showing that while hard work is necessary for artistry, it is not sufficient. Individuals who have had the same intensity of practice over many years simply do not end up reaching the same level of artistry. The old view turns out to have truth to it after all.

Disciplines develop for a reason. They have methods and standards, but many of the most interesting and important questions and problems do not come stamped "Made for philosophy" or "Test only in the psychology lab." My goal in these pages has been to examine some of the most interesting questions and problems about the psychology of the arts, wherever they emanate, and to identify progress as well as false leads in our attempt to address these issues. My hope is that this effort helps to move their pursuit in positive directions.

NOTES

Chapter 1

1. Seiberling (1959), p. 82.
2. Balter (2009).
3. Conard, Malina, and Münzel (2009).
4. Valladas, Clottes, Geneste, Garcia, Arnold, and Tisnerat-Laborde (2001).
5. Lévi-Strauss (1964), p. 127.

Chapter 2

1. Bell (1914), p. 1.
2. Kostelanetz (1988).
3. Kant (1790/2000).
4. Tolstoy (1897/1930).
5. Bell (1914).
6. Dickie (1974).
7. Beardsley (1982).
8. Levinson (1990).
9. Bell (1914), p. 12.
10. Dutton (2009).
11. Ibid., p. 50.
12. Ibid., p. 51.
13. Noe (2016).
14. Kant (1790/2000).
15. Ortega y Gasset (1968), p. 28.
16. Watanabe (2001, 2011, 2013).
17. Cacchione, Mohring, and Bertin (2011).
18. Gardner (1970).
19. Shamir, Macura, Orlov, Eckley, and Goldberg (2010).
20. Schopenhauer (1966), § 36, p. 185.
21. Dissanayake (1988).
22. Wittgenstein (1953).

23. Weitz (1956).
24. Goodman (1978).
25. Ortega y Gasset (1968), p. 68.
26. Scruton (2007).
27. Scruton (1998), p. 148.
28. Scruton (2007), p. 245.
29. Kant (1790/2000).
30. Zwaan (1991).
31. Jakobson (1960).
32. Knobe and Nichols (2008).
33. Kamber (2011).
34. Jucker, Barrett, and Wlodarski (2014).
35. Rabb and Winner (2017b).
36. Malt (1990).
37. Rabb and Winner (2017a).

Part II

1. Rothko (2006).
2. Art Gallery of Ontario (2011), p. 15, cited in Melcher and Bacci (2013), p. 203.

Chapter 3

1. Blacking (1995).
2. Conard, Malina, and Münzel (2009).
3. Juslin, Liljeström, Västfjäll, Barradas, and Silva (2008).
4. Rentfrow and Gosling (2003).
5. Juslin and Isaksson (2014).
6. Hanslick (1891), p. 67.
7. Stravinsky (1936), pp. 53–54.
8. Davies (1980); Kivy (1980).
9. Allen (2017).
10. Yo-Yo Ma discusses music as storytelling in a clip from Live from Lincoln Center on December 31, 2013; this clip can be accessed at http://www.yo-yoma.com/culture-matters/storytelling-in-strings/.
11. Volkov and Shostakovich (1979), p. 141.
12. Langer (1957).
13. This quote from Jean Sibelius comes from an interview in the Danish newspaper *Berlingski Tidende*, June 10, 1919.
14. Langer (1957), p. 27.
15. See Gabrielsson and Juslin (2003) for a review.
16. Collier (2007).
17. Nielsen (1987).
18. Hevner (1935a, 1935b, 1936, 1937).
19. See Gabrielsson and Lindström (2001) for a review.
20. Kramer (1964).
21. Bezooijen, Otto, and Heenan (1983).
22. Scherer, Banse, and Wallbott (2001).
23. Juslin and Laukka (2003).

24. Coutinho and Dibben (2013).

25. Helmholtz (1863/1954), p. 371.

26. Dalla Bella, Peretz, Rousseau, and Gosselin (2001); Gagnon and Peretz (2003); Juslin and Lindström (2010).

27. Adachi and Trehub (1998).

28. The earlier study was by Kastner and Crowder (1990); the later study was by Dalla Bella, Peretz, Rousseau, and Gosselin (2001).

29. Kivy (1980).

30. Patel (2008), pp. 16–22.

31. Balkwill and Thompson (1999).

32. Balkwill, Thompson, and Matsunaga (2004).

33. Sievers, Polansky, Casey, and Wheatley (2013) created a computer program that could generate both melodies and animated sequences of a bouncing ball. Participants in the United Stated and Cambodia were asked to generate melodies and movement sequences to represent angry, happy, peaceful, sad, and scared. Results showed cross-cultural agreement about the properties of melodies and movement needed to convey specific emotions, and also revealed a cross-modal parallel between music and movement in terms of features that convey emotions (e.g., rate, direction, etc.).

34. Laukka, Eerola, Thingujam, Yamasaki, and Beller (2013).

35. Fritz et al. (2009).

36. Isabelle Peretz, personal communication, July 10, 2017.

37. Fritz et al. (2009), supplemental materials, Table S6.

38. Isabelle Peretz told me that the sad music clips in this study were also lower in average pitch. Personal communication, July 10, 2017.

39. Juslin and Laukka (2003).

Chapter 4

1. Kivy (1980).

2. For other philosophers who have taken this position see Howes (1958) and Pratt (1952). For a review see Davies (1994).

3. Davies (1994).

4. Blood and Zatorre (2001); Habibi and Damasio (2014); Koelsch (2014, 2015).

5. Blood and Zatorre (2001).

6. Salimpoor, Benovoy, Larcher, Dagher, and Zatorre (2011).

7. Sloboda (1991).

8. Koelsch (2014).

9. Fairhurst, Janata, and Keller (2013).

10. Blood and Zatorre (2001).

11. Gomez and Danuser (2007); Mursell (1937).

12. Egermann, Fernando, Chuen, and McAdams (2015).

13. Meyer (1956).

14. Koelsch (2015).

15. Meyer (1961).

16. This presentation by Koelsch (2017) can be accessed at http://www.fondazione-mariani.org/it/neuromusic/congressi/boston-june-2017.html. To view, register (free) by clicking on the register button top right side of page.

17. Juslin, Liljeström, Västfjäll, Barradas, and Silva (2008).

18. Baltes and Miu (2014); Eerola, Vuoskoski, and Kautiainen (2016).

19. Gosselin, Pacquette, and Peretz (2015); Griffiths, Warren, Dean, and Howard (2004); Mazzoni et al. (1993); Peretz, Gagnon, and Bouchard (1998); Satoh, Nakase, Nagata, and Tomimoto (2011).

20. Mas-Herrero, Zatorre, Rodriguez-Fornells, and Marco-Pallarés (2014).

21. Gosselin, Paquette, and Peretz (2015).

22. Langer (1957).

23. Ekman and Friesen (1971).

24. For an example, see Krumhansl (1997).

25. Posner, Russell, and Peterson (2005); Russell (1980, 2003).

26. Schubert (2004).

27. Scherer (2004); Zentner, Grandjean, and Scherer (2008).

28. Izard (1990).

29. Russell (2003).

30. Maslow (1968).

31. Gabrielsson (2010), pp. 553–554.

32. These reports are consistent with those of Goldstein (1980); Konečni, Wanic, and Brown (2007); Lowis (1998); Panksepp (1995); Scherer, Zentner and Schacht (2001–2002); and Sloboda (1991).

33. Juslin et al. (2015).

34. Meyer (1956), p. 8.

35. Schubert (2013).

36. Zentner, Grandjean, and Scherer (2008).

37. Kant (1790/2000).

38. Gurney (1880), pp. 316–317.

39. Scherer (2004).

40. Gabrielsson (2010).

41. Kawakami, Furukawa, Katahira, and Okanoya (2013).

42. Davies (2010), p. 38.

43. Konenči, Brown, and Wanic (2008).

44. Goldstein (2009).

45. Aniruddh Patel, personal communication, July 1, 2017.

46. Juslin, Liljeström, Laukka, Västfjäll, and Lundqvist (2011).

47. Bigand, Vieillard, Madurell, Marozeau, and Dacquet (2005).

48. Fritz et al. (2009).

49. Helmholtz (1863/1954).

50. McDermott, Schultz, Undurraga, and Godoy (2016).

51. Zatorre (2016).

52. Werker and Hensch (2015).

53. Masataka (2006).

54. Terhardt (1984).

55. Ross (2016).

56. Brown (1981), p. 240.

Chapter 5

1. Ives (1984); Jolley, Fenn, and Jones (2004).
2. Van Gogh (1882).
3. Rodman and Eliot (1961), p. 93.
4. Rothko (2006), p. 46.
5. Varnedoe (2006), pp. 40–41.
6. Bell (1914).
7. Arnheim (2004), p. 459.
8. Goodman (1972).
9. Dalla Bella, Peretz, Rousseau, and Gosselin (2001).
10. Melcher and Bacci (2013). Examples of positively and negative rated paintings can be seen in Figure 5 of Melcher and Bacci's article.
11. Murphy and Zajonc (1993).
12. Melcher and Bacci (2013).
13. Gerger, Pelowski, and Leder (2017).
14. Blank, Massey, Gardner, and Winner (1984).
15. Jolley and Thomas (1994).
16. Callaghan (1997).
17. Callaghan, 2000; Misailidi and Bonoti (2008).
18. Carothers and Gardner (1979).
19. Jolley and Thomas (1995).
20. Lundholm (1921).
21. Poffenberger and Barrows (1924).
22. Kimura (1950); Odbert, Karwoski, and Eckerson (1942); Osgood (1960); Wexner (1954).
23. Takahashi (1995).
24. Edwards (1986).
25. Hupka, Zaleski, Otto, Reidl, and Tarabrina (1997).
26. Osgood, Suci, and Tannenbaum (1957).
27. Osgood (1964).
28. Osgood (1960).
29. Liu and Kennedy (1994).
30. Kennedy (1993).
31. Arnheim (2004).
32. Ibid., p. 428.
33. Gombrich (1960); contrast effects on the perception of degree of abstraction in paintings were shown by Specht (2007).
34. Sapir (1929).
35. Brown, Black, and Horowitz (1955).
36. Jakobson (1960).

Chapter 6

1. Mulstein (2017).
2. Stendhal (1959), p. 302.

3. Amâncio (2005).

4. Magherini (1989).

5. Barnas (2008).

6. Haberman (1989).

7. Elkins (2004), pp. 13–14.

8. Ibid., p. 9.

9. Rodman and Eliot (1961), p. 93.

10. Pelowski (2015).

11. Miu, Pitur, and Szentágotai-Tătar (2016).

12. Menninghaus et al. (2015).

13. Kuehnast, Wagner, Wassiliwizky, Jacobsen, and Menninghaus (2014).

14. Gabrielsson (2011), describing the findings from Löfstedt (1999).

15. Vessel, Starr, and Rubin (2012).

16. Gusnard and Raichle (2001).

17. Pelowski, Liu, Palacios, and Akiba (2014).

18. Liljeström, Juslin, and Västfjäll (2013).

19. Thompson (2009).

20. Smith, Smith, and Tinio (2017).

21. Roberts (2013).

22. Janata, Tomic, and Haberman (2012); Trost, Ethofer, Zentner, and Vuilleumier (2012); Zatorre, Chen, and Penhune (2007).

23. Patel, Iversen, Bregman, and Shultz (2009); Schachner, Brady, Pepperberg, and Hauser (2009).

Chapter 7

1. Halliwell (Ed.) (1995). *Poetics*, 4, 1448b, IV, pp. 37–38.

2. Batteux (1746/2015).

3. Krazenberger and Menninghaus (2017).

4. Senior (2017).

5. Wagner, Menninghaus, Hanich, and Jacobsen (2014).

6. This comment was made to me by philosopher Naomi Scheman.

7. Gerger, Leder, and Kremer (2014); Mocaiber et al. (2010); Mocaiber, Perakakis, et al. (2011), Mocaiber, Sanchez, et al. (2011), Van Dongen, Van Strien, and Dijkstra (2016).

8. Mocaiber, Perakakis, et al. (2011).

9. Andrade and Cohen (2007).

10. Ibid.

11. Bartsch, Appel, and Storch (2010); Hoffner and Levine (2005); Tamborini, Stiff, and Heidel (1990).

12. Andrade and Cohen (2007).

13. Hume (1767). Of tragedy. In *Essays and treatises on several subjects, vol. 1*, pp. 243–245.

14. Hanich, Wagner, Shah, Jacobsen, and Menninghaus (2014).

15. Kuehnast, Wagner, Wassiliwizky, Jacobsen, and Menninghaus (2014).

16. Wassiliwizky, Wagner, Jacobsen, and Menninghaus (2015).

17. Gabrielsson and Wik (2003).

18. Kivy (1980), p. 3.

19. Levinson (1997), p. 217.

20. For a review see Sachs, Damasio, and Habibi (2015).

21. Taruffi and Koelsch (2014).

22. Mori and Iwanaga (2017); see also Sachs et al. (2015) for a discussion of how sad music may restore homeostasis.

23. Hospers (1954–1955), p. 327.

24. Menninghaus et al. (2017).

25. Bullough (1912).

26. Rozin, Guillot, Fincher, Rozin, and Tsukayama (2013).

27. Kant (1790/2000).

28. de Araujo, Rolls, Velazco, Margo, and Cayeux (2005).

29. Lee, Frederick, and Ariely (2006).

Chapter 8

1. "Eleanor Rigby" is a song by the Beatles. This comment by Tommasini appeared in *The New York Times* on July 30, 2017.

2. Kieran (2010).

3. Hume (1767), Of the standard of taste. In *Essays and treatises on several subjects, vol. 1*, p. 257.

4. Vendler (2002), p. 4.

5. Russell (1960), cited in Railton (2003), Chapter 4, p. 88.

6. This passage from Hume's "Of the standard of taste" (1757/2001) was cited in Railton (2003), Chapter 4, p. 92.

7. Hume (1767), Of the standard of taste. In *Essays and treatises on several subjects, vol. 1*, p. 271.

8. Kant (1790/2000), p. 98.

9. Clark (1974), p. 47.

10. Cova and Pain (2012).

11. Goodwin and Darley (2008).

12. For studies showing similar findings see Beebe, Qiaoan, Wysocki, and Endara (2015); Beebe and Sakris (2016).

13. Rabb, Han, Nebeker, and Winner (2018).

14. Beebe and Sakris (2016).

15. Pettit (1983); Wollheim (1980).

16. Beebe and Sakris (2016).

17. The study by Rabb, Han, Nedeker, and Winner (2018) was carried out on Amazon Mechanical Turk, an online marketplace for survey research.

18. Eysenck (1983).

19. Götz, Lynn, Borisy, and Eysenck (1979); Iwawaki, Eysenck, and Götz (1979).

20. Vessel, Starr, and Rubin (2012).

21. Child (1962).

22. Anwar and Child (1972); Child and Siroto (1965); Ford, Prothro, and Child (1966); Haritos-Fatouros and Child (1977); Iwao and Child (1966): Iwao, Child, and Garcia (1969).

23. Cutting (2003).

24. Zajonc (1968).

25. Bourdieu (2010).

26. Meskin, Phelan, Moore, and Kieran (2013).

27. The 2012 obituary of Thomas Kinkade by Jerry Saltz can be accessed at this website: http://www.artnet.com/magazineus/features/saltz/rip-thomas-kinkade-4-10-12.asp

28. Bissonette (2014).

29. Wypijewski (1997).

30. Ramachandran (2011).

Chapter 9

1. Hockney (2001).

2. Ibid., p.74.

3. Falco (2000).

4. Kahneman and Tversky (1972).

5. Winner (2004).

6. Lieberman (2001).

7. Partner (2002), p. 247.

8. Steadman (2002).

9. O'Neill and Corner (2016).

10. Davenport (1948), p. 62, cited in Kruger, Wirtz, Boven, and Altermatt (2004).

11. Goodnough (1951).

12. Steinberg (1955), p. 44.

13. Festinger (1957).

14. Kruger, Wirtz, Boven, and Altermatt (2004).

15. Jucker, Barrett, and Wlodarski (2014), Experiment 3.

16. Smith and Newman (2014).

17. Liu, Ullman, Tenenbaum, and Spelke (2017).

18. Cho and Schwartz (2008).

19. Tsay and Banaji (2011).

20. Bullot and Reber (2013) make this point.

Chapter 10

1. Philosopher Mark Sagoff (1976) raises this question in a discussion of art forgeries.

2. Lenain (2011), p. 187.

3. Burckhardt (1878/1990). For a detailed discussion of the history of responses to forgery, see Lenain (2011).

4. Bowden (1999).

5. Dutton (1998).

6. Barboza, Boley, and Cox (2013).

7. Philosopher Sherri Irvin (2007) takes this position.

8. Dutton (1983, 2003).

9. I owe the term *radical aestheticism* to Lenain (2011).

10. Beardsley (1982), p. 229.

11. Lessing (1965).

12. Koestler (1965).

13. Keil (1989).

14. Newman (2016).

15. Siegal (2017).

16. Danto (1973); Dutton (1979, 1983); Goodman (1976); Irvin (2007); Sagoff (1976); see Hick (2010) for discussion.

17. Dutton (1979).

18. Benjamin (2002), pp. 103–104.

19. Goodman (1976), pp. 111–112.

20. Wolz and Carbon (2014).

21. Seidel and Prinz (2017), Experiment 3.

22. Huang, Bridge, Kemp, and Parker (2011).

23. Noguchi and Murota (2013).

24. Newman and Bloom (2012), Experiment 4.

25. Newman and Bloom (2012), Experiment 1.

26. Interestingly, when a mass-produced non-art object is associated with a specific designer, we value it more than when it is associated with a company. This was shown by Smith, Newman, and Dhar (2015) in their fifth experiment. The non-art object they asked participants to think about was a piece of clothing. This explains why you might not be happy if you discovered that your Dior bag was a replica sold on a New York street corner.

27. Newman and Bloom (2012), Experiment 5.

28. Frazier, Gelman, Wilson, and Hood (2009); Nemeroff and Rozin (1994); Newman, Diesendruck, and Bloom (2011).

29. Olson and Shaw (2011).

30. Gilli, Ruggi, Gatti, and Freeman (2016).

31. Rabb, Brownell, and Winner (2018).

32. Unfortunately I was unable to obtain permission to reproduce the Gornik image in black and white. So you will have to imagine it. But we could have used any painting in this study—as long as we showed two identical images.

33. Noguchi and Murota (2013); Seidel and Prinz (2017).

34. Wolz and Carbon (2014).

35. Newman, Bartels, and Smith (2014).

36. For a discussion of the aesthetic dimension of genuineness, see Korsmeyer (2016).

37. Smith, Newman, and Dhar (2015).

38. Newman, Bartels, and Smith (2014).

39. The description of the Relievo Collection at the Van Gogh Museum can be accessed here: https://www.vangoghmuseum.nl/en/about-the-museum/relievo-collection.

40. Rosand (1988), p. 88, cited in Lenain (2017), p. 238.

41. Reece (2017).

Chapter 11

1. This video by Robert Florczak can be accessed at https://www.youtube.com/watch?v=lNIo7egoefc.

2. Gombrich (1960).

3. Varnedoe (2006).

4. Ibid. pp. 40–41.

5. Ibid. p. 31.

6. Ibid. p. 34.

7. Eisner (2002).

8. Gardner (1980).

9. Chittenden (2007).

10. Hussain (1965).

11. Vartanian (2013).

12. Hawley and Winner (2011).

13. Temkin and Kelly (2013).

14. Schjeldahl (2005). I am grateful to Nat Rabb for alerting me to this piece in *The New Yorker*.

15. Snapper, Oranç, Hawley-Dolan, Nissel, and Winner (2015).

16. Ibid.

17. Cernuschi (1997).

18. Varnedoe (2006).

19. Snapper, Oranç, Hawley-Dolan, Nissel, and Winner (2015).

20. We did not report this correlation in our paper, but Drake and José (2017) reanalyzed our data and reported a significant correlation.

21. Jucker, Barrett, and Wlodarski (2014).

22. I am grateful to Nat Rabb for this point.

23. Varnedoe (2006).

24. Nissel, Hawley-Dolan, and Winner (2016).

25. Alvarez, Winner, Hawley-Dolan, and Snapper (2015).

26. Hess (1965); Hess and Polt (1960); Johnson, Muday, and Schirillo (2010).

27. Beatty (1982); Johnson, Miller-Singley, Peckham, Johnson, and Bunge (2014); Just and Carpenter (1992); Kahneman (1971).

28. Shamir (2012); Shamir, Macura, Orlov, Eckley, and Goldberg (2010).

29. Shamir, Nissel, and Winner (2016).

30. Shamir et al. (2010).

31. I am referring here to Snapper, Oranç, Hawley-Dolan, Nissel, and Winner (2015).

32. We now know that we can build computer programs that behave pretty much like humans when asked to separate works by abstract expressionists from works by children and animals. But can we train computers to create abstract paintings that would be indistinguishable from abstract works by human artists? In a small recent experiment, Elgammal, Liu, Elhoseiny, and Mazzone (2017) exposed a computer system to a wide variety of styles of art and trained the system to generate new art in a style that *deviated* from the training image—just enough that the new art was not in any recognizable style, but not so much as to be too deviant. Participants were then asked to guess whether the image was created by a human or generated by a computer. Some of the images used in this experiment were from our study (Snapper et al. 2015). Some of the other images were from a contemporary art fair, Art Basel (2016). Participants were much more likely to classify as human-made the abstract expressionist works from our study than the computer-generated paintings. But they were actually *more* likely to classify the computer-generated art as by a human than

the works from the Art Basel fair. Thus a computer trained to learn from human art and trained to deviate from it a moderate amount may be able to generate paintings that look like they were made by human artists.

33. Varnedoe (1994).

34. Fineberg (1997); Gardner (1980); Winner (1982).

Chapter 12

1. Winner, Goldstein, and Vincent-Lancrin (2013).

2. National Center for Education Statistics (2012). But see Bloch and Taylor (2018) for a report on the decline of music in New York City public high schools.

3. Ruppert (2006), p. 1.

4. von Zastrow and Janc (2004).

5. Rabkin and Redmond, (2004); Wakeford (2004), p. 84.

6. Murfee (1995); Weitz (1996).

7. The Turnaround Arts initiative is described on the website of the President's Committee on the Arts and the Humanities: https://www.pcah.gov/education.

8. O'Neill (2017).

9. A video of Chelsea Clinton discussing the arts can be accessed here: http://www.lincolncenter.org/video/57dbb4a58a9a70e644b80b72.

10. Efland (1990).

11. Keene (1982).

12. Thorndike and Woodworth (1901), pp. 249–250; cited in Bransford and Schwartz (1999), p. 62.

13. Thorndike (1924), p. 98.

14. Detterman and Sternberg (1993), p. 15.

15. Salomon and Perkins (1989).

16. For a recent review of research on this topic, see Foster and Jenkins (2017).

17. Catterall (1997); Catterall, Chapleau, and Iwanaga (1999).

18. Heath (1998).

19. Thorndike (1924).

20. Ruppert (2006).

21. Heath (1998).

22. Eisner (2001).

23. Duckworth (2016) developed the concept of grit and showed its importance in academic achievement.

24. Dweck (2006) developed the concept of a growth mindset—the belief that intelligence can be improved by effort.

25. Vaughn and Winner (2000).

26. Foster and Jenkins (2017).

27. Haanstra (2000).

28. Harland, Kinder, Lord, Stott, and Schagen (2000).

29. Catterall (1998); Catterall, Chapleau, and Iwanaga (1999); Hetland and Winner (2002); Winner and Cooper (2000).

30. Mayo (1930).

31. Hetland and Winner (2002); Winner and Cooper (2000); Winner and Hetland (2000).

32. Vaughn and Winner (2000).

33. Elpus (2013).

34. Brandler and Rammsayer (2003); Helmbold, Rammsayer, and Altenmuller (2005); Schellenberg and Moreno (2010).

35. Hille and Schupp (2013).

36. Schellenberg (2004).

37. Schellenberg (2009).

38. Ceci and Williams (1997).

39. Moreno et al. (2009).

40. Mehr, Schachner, Katz, and Spelke (2013).

41. Sala and Gobet (2017).

42. Swaminathan, Schellenberg, and Khalil (2017).

43. Rauscher and Hinton (2011).

44. Graziano, Peterson, and Shaw (1999).

45. Friedman (1959); Neufeld (1986); Weeden (1971). A meta-analysis by Sala and Gobet (2017) showed no effect.

46. Haimson, Swain, and Winner (2011).

47. Kahneman and Tversky (1972).

48. McLain (2010).

49. Gleick (1992), p. 65.

50. Fargnoli and Gillespie (2006).

51. Strauss (1978).

52. Rauscher, Shaw, and Ky (1993).

53. Hetland (2000a).

54. Chabris (1999).

55. Ashby, Isen, and Turken (1999); O'Hanlon (1981).

56. Thompson, Schellenberg, and Husain (2001).

57. Hetland (2000b).

58. Costa-Giomi (1999).

59. Castles and Coltheart (2004).

60. Anvari, Trainor, Woodside, and Levy (2002); Lamb and Gregory (1993).

61. Strait, Hornickel, and Kraus (2011); Zuk et al. (2013).

62. Gordon, Fehd, and McCandliss (2015).

63. Kraus and Chandrasekaran (2010).

64. Podlozny (2000).

65. Hetland, Winner, Veenema, and Sheridan (2007, 2013); Hogan, Hetland, Jaquith, & Winner (2018).

66. Dolev, Friedlaender, and Braverman (2001).

67. Elder, Tobias, Lucero-Criswell, and Goldenhar (2006); Naghshineh et al (2008). See Perry, Maffuli, Willson, and Morrissey (2011) for a review of studies on this kind of intervention.

68. Goldsmith, Hetland, Hoyle, and Winner (2016).

69. Hogan and Winner (in press).

70. Foster and Jenkins (2017).

Chapter 13

1. The statements by Bill English and Jamil Zaki are reported in Musiker (2015).

2. Mar and Oatley (2014).

3. Nussbaum (1997a), p. 104.

4. Nussbaum (1997b).

5. It has also been argued by evolutionary psychologists Tooby and Cosmides (2001) that fiction has another function: it sharpens our counterfactual reasoning abilities in a safe environment. I do not consider the evidence for this claim here, and focus only on fiction's potential effect on empathy.

6. Cognitive empathy is variously referred to as theory of mind (Wellman, Cross, and Watson (2001), mentalising (Frith, Morton, and Leslie, 1991), mind reading (Whiten, 1991), perspective taking (Johnson, 2012), and social intelligence (Baron-Cohen, Jolliffe, Mortimore, and Robertson, 1997).

7. Sometimes this phenomenon is referred to as emotional contagion (Hatfield, Cacioppo, and Rapson (1993).

8. Coplan (2004).

9. Johnson (2012).

10. Ali and Chamorro-Premuzic (2010); Baron-Cohen and Wheelwright (2004).

11. Bloom (2016).

12. Zunshine (2006).

13. L. Miller (2011) wrote about this in *The New Yorker* magazine.

14. Nussbaum (1997a), pp. 111–112.

15. Rorty (1989).

16. Vollaro (2009).

17. Currie (2013).

18. Keen (2007).

19. Mistry (2010).

20. Mar (2011); Tamir, Bricker, Dodell-Feder, and Mitchell (2016).

21. Baron-Cohen, Wheelwright, Hill, Raste, and Plumb (2001).

22. The Reading the Mind in the Eyes Test can be accessed here: http://socialintelligence.labinthewild.org/mite/.

23. The four responses were determined during test development as follows: at least 50% of respondents had to chose a particular label (and this was considered the correct answer), and no more than 25% could select any of the foils.

24. Baron-Cohen, Jolliffe, Mortimore, and Robertson (1997); Baron-Cohen, Wheelwright, Hill, Raste, and Plumb (2001).

25. Mar, Oatley, Hirsh, dela Paz, and Peterson (2006).

26. The Author Recognition Test was originally developed by Stanovich and West (1989).

27. Kidd and Castano (2013).

28. Belluck (2013).

29. Panero, Weisberg, et al. (2016).

30. Samur, Tops, and Koole (2017).

31. Johnson (2012).

32. Johnson, Huffman, and Jasper (2014).

33. Vezzali, Stathi, Giovannini, Capozza, and Trifiletti (2015).

34. J. K. Rowlings' comments can be found on the Harry Potter Alliance website: http://www.thehpalliance.org/.

35. Other studies have also shown how literature about marginalized groups can make us see these people are like ourselves. Hakemulder (2000, Chapter 2) found six studies showing that reading stories with positive descriptions of outgroups led to reduction of social distance—that is, participants came to recognize outgroup members as more similar to themselves after reading.

36. Johnson (2012); Johnson, Cushman, Borden, and McCune (2013).

37. Bal and Veltkamp (2013).

38. Koopman (2015).

39. Jacobson (2017).

40. Wilson (2018) who reports finding this account in McReynolds (2013), p. 120.

41. Currie (2016); James (1963), p. 143.

42. Zunshine (2006).

43. Zunshine (2006), p. 35.

44. Keen (2007).

45. Mar, Oatley, and Peterson (2009).

46. Keen (2007), p. 119, citing H. Bloom (2000), p. 22.

47. Schachner, Brady, Pepperberg, and Hauser (2009).

48. Piaget (1951).

49. Whiten and Byrne (1988).

50. Chandler (1973).

51. For studies showing that lack of social competence is associated with difficulties adopting another's perspective, see Anthony (1959) and Feffer (1970).

52. These findings were later replicated in a group of 48 institutionalized children (ages 9 to 14) with an "anti-social" diagnosis, by Chandler, Greenspan, and Barenboim (1974).

53. Corbett et al. (2011, 2014, 2015); Lerner and Levine (2007); Lerner and Mikami (2012); Lerner, Mikami, and Levine (2011).

54. You can read about Shakespeare Behind Bars here: https://www.shakespearebehindbars.org/.

55. Durose, Cooper, and Snyder (2014).

56. Goldstein, Wu, and Winner (2009).

57. Bryant (1982).

58. This blog can be accessed here: https://peopletriggers.wordpress.com/2013/07/29/think-acting-is-about-emotional-empathy-science-says-no/.

59. We used a test called the Movie for the Assessment of Social Cognition (Dziobek et al., 2006).

60. Davis (1983).

61. If we use "p values" to determine whether this was a significant difference, we have to wobble: the p value was .057, and traditionally the cut-off for significance is lower than .05. However, the "Cohen's-d effect size" (which tells you the strength of the association between group and score) was .58, traditionally considered a medium effect size. So we can conclude tentatively that the actors again outperformed the non-actors on this measure of cognitive empathy.

62. Nettle (2006) reported that professional actors scored higher on another empathy test—the Empathy Quotient, developed by Baron-Cohen and Wheelwright (2004). However, this test combines both cognitive and emotional empathy statements. Thus we cannot know whether the actors' advantage was due to cognitive or emotional empathy (or both).

63. Goldstein and Winner (2012).

64. Baron-Cohen, Wheelwright, Hill, Raste, and Plumb (2001).

65. Ickes (2001).

66. To create the Empathic Paradigm measure, we filmed two actors playing husband and wife involved in a heated discussion that lasted 15 minutes. Only the woman was shown, but both voices could be heard. After filming, we replayed the film and asked the female actor to stop the film at every moment where she recalled having a specific thought or feeling and to tell us what that thought or feeling was. These became the "right answers." We played this film for the participants, stopping the film at each of these moments and asking, "What was she thinking of feeling underneath what she said?" Other cognitive empathy tests were also given to the younger group but are not discussed here, as the acting children were equivalent to controls on these at both testing time points.

67. Colson Whitehead's comment was reported in *The New York Times*, April 11, 2017, and can be accessed at https://www.nytimes.com/2017/04/10/business/media/pulitzer-prize-winners.html?_r=0.

68. Dodell-Feder, Lincoln, Coulson, and Hooker (2013).

69. For a discussion of boundary issues in actors, see Burgoyne and Poulin (1999).

70. Keen (2007), p. 168.

Chapter 14

1. Loth (2017).

2. Collins-Hughes (2017).

3. Bettelheim (1977).

4. Freud (1910/1990).

5. Dryden, Waller, and Gilroy (1992).

6. Kramer (2000); Levy (1995).

7. Toyoshima, Fukui, and Kuda (2011); Uedo et al. (2004).

8. Brown, Garnett, Anderson, and Laurenceau (2017).

9. Belkofer, Van Hecke, and Konopka (2014).

10. Hogan and Winner (2017).

11. Drake, Coleman, and Winner (2011); Drake, Hastedt, and James (2016); Drake and Winner (2012a, 2013).

12. Watson, Clark, and Tellegen (1988).

13. Similar kinds of findings have been reported by others: Curl (2008) showed that making drawings or collages about a positive event led to lowered ratings of state anxiety relative to pretest, whereas making art about a negative event led to higher ratings; Smolarski, Leone, and Robbins (2015) showed that making drawings after a negative affect induction improved all participants' reported moods, but the improvement was greater for those instructed to draw something "that makes you happy"

(positive instruction) than for those told to "draw your current feelings" (negative) or to trace another drawing (neutral).

14. Fink and Drake (2016).

15. Diliberto-Macaluso and Stubblefield (2015).

16. Goldstein and Lerner (2018).

17. Vygotsky (1967).

18. Lloyd, Wong, and Petchkovsky (2007); Slayton, D'Archer, and Kaplan (2010); Stuckey and Nobel (2010).

Chapter 15

1. Arnheim (2004); Gardner (1980); Schaefer-Simmern (1948); Winner and Gardner (1981).

2. Cox (1992).

3. Gardner (1980).

4. Gardner and Winner (1981); Rosenblatt and Winner (1988); Winner (2006).

5. Winner, Blank, Massey, and Gardner (1983).

6. Davis (1997).

7. Pariser and van den Berg (1997).

8. Winner (1979, 1988).

9. Milbrath (1998).

10. Drake and Winner (2012b).

11. Gordon (1987).

12. Richardson (1991), p. 29.

13. Gombrich (1960).

14. Goldsmith (1992); Zhensun and Low (1991). To view some of Wang Yani's early paintings, go to Wang Yani's website, https://myhero.com/w_yani, and click on images, or go to https://www.google.com/search?q=wang+yani&client=safari&rls= en&source=lnms&tbm=isch&sa=X&ved=0ahUKEwiMzIGcztfWAhWq34MKHf7qA hQQ_AUICigB&biw=1324&bih=881.

15. Ericsson (1996).

16. Gladwell (2008).

17. Drake and Winner (in press); Winner (1996).

18. Drake and Winner (in press).

19. Hulbert (2018); Winner (1996).

20. Mebert and Michel (1980); Peterson (1979); Rosenblatt and Winner (1988); Smith, Meyers, and Kline (1989).

21. Winner (1996).

22. Geschwind (1984); Geschwind and Galaburda (1987).

23. Geschwind and Galaburda (1985).

24. Hermelin and O'Connor (1986); Rosenblatt and Winner (1988, 1996); Winner and Casey (1992); Winner, Casey, DaSilva, and Hayes (1991).

25. Hermelin and O'Connor (1986).

26. Rosenblatt & Winner (1988).

27. O'Connor and Hermelin (1983).

28. Drake and Winner (2018).

29. Geschwind and Galaburda (1987).

30. Hassler (1990).

31. Winner, Casey, DaSilva, and Hayes (1991).

32. Ibid.

33. Frith (1980).

34. Geschwind and Galaburda (1985), p. 445.

35. Bryden, McManus, and Bulman-Fleming (1994).

36. Lévi-Strauss (1969), p. 18

37. Drake and Winner (2018).

38. Hildreth (1941).

39. Winner (1996).

40. Ibid.

41. Meinz and Hambrick (2010).

42. Macnamara, Hambrick, and Oswald (2014).

43. Gobet and Campitelli (2007); Howard (2009).

44. For a recent edited volume about the controversial issue of talent versus deliberate practice, see Hambrick, Campitelli, and Macnamara (2017).

45. Winner (1996).

46. Gardner (2011); Simonton (1994).

47. See Richards (1996) for a discussion of divergent thinking in typically developing children.

48. Csikszentmihalyi (1996); Gardner (2011); Simonton (1994); Sulloway (1996).

49. See Gruber (1981) for a discussion of Darwin's courage.

50. Albert and Runco (1986).

51. Goertzel and Goertzel (1962); Goertzel, Goertzel, and Goertzel (1978); Sulloway (1996).

52. Jamison (1993); Kyaga et al. (2013); Ludwig (1995).

53. The Chinese versus Western view of artistic creativity is discussed in Gardner (1989), chapter 12.

54. Tooby and Cosmidis (2001).

55. G. Miller (2011).

56. Darwin (1859, 1871).

57. Greengross and Miller (2011). For modest evidence in support of the sexual selection argument, see Beaussart, Kaufman, and Kaufman (2012); Charlton (2014); Clegg, Nettle, and Miell (2011); and Nettle and Clegg (2006).

58. G. Miller (2011), p. 281, cited in Seghers (2015).

59. Pinker (2009).

60. Zeki (1999), p.12.

REFERENCES

Adachi, M., & Trehub, S. E. (1998). Children's expression of emotion in song. *Psychology of Music, 26,* 133–153.

Albert, R. S., & Runco, M. A. (1986). The achievement of eminence: A model of exceptional boys and their parents. In R. J. Sternberg & J. E. Davidson (Eds.), *Conceptions of giftedness* (pp. 332–357). New York: Cambridge University Press.

Ali, F., & Chamorro-Premuzic, T. (2010). Investigating theory of mind deficits in non-clinical psychopathy and Machiavellianism. *Personality and Individual Differences, 49*(3), 169–174.

Allen, D. (2017, January 26). A protest against death. *New York Times,* C6. https://www.nytimes.com/2017/01/25/arts/music/my-favorite-page-semyon-bychkov-tchaikovsky-pathetique.html?_r=0

Alvarez, S., Winner, E., Hawley-Dolan, A., & Snapper, L. (2015). What eye gaze and pupil dilation can tell us about perceived differences between abstract art by artists vs. by children and animals. *Perception, 44*(11), 1310–1331.

Amâncio, E. J. (2005). Dostoevsky and Stendhal's syndrome. *Arquivos de Neuro-Psiquiatria, 63*(4), 1099–1103.

Andrade, E. G., & Cohen, J. B. (2007). On the consumption of negative feelings. *Journal of Consumer Research, 34,* 283–300.

Anthony, E. J. (1959). An experimental approach to the psychopathology of childhood autism. *British Journal of Medical Psychology, 32,* 18–37.

Anvari, S. H., Trainor, L. J., Woodside, J., & Levy, B. A. (2002). Relations among musical skills, phonological processing, and early reading ability in preschool children. *Journal of Experimental Child Psychology, 83,* 111–130.

Anwar, M. P., & Child, I. L. (1972). Personality and esthetic sensitivity in an Islamic culture. *Journal of Social Psychology, 87*(1), 21–28.

Arnheim, R. (2004). *Art and visual perception: A psychology of the creative eye. Fiftieth anniversary.* Berkeley: University of California Press.

Ashby, F. G., Isen, A. M., & Turken, A. U. (1999). A neuropsychological theory of positive affect and its influence on cognition. *Psychological Review, 106,* 529–550.

Art Gallery of Ontario (2011). *Abstract expressionist New York: Masterpieces from the Museum of Modern Art.* http://www.ago.net/assets/files/pdf/AbEx-CompleteText.pdf

Bal, P. M., &Veltkamp, M. (2013). How does fiction reading influence empathy? An experimental investigation on the role of emotional transportation. *PLoS ONE*, *8*(1), e55341.

Balkwill, L. L., & Thompson, W. F. (1999). A cross-cultural investigation of the perception of emotion in music: Psychophysical and cultural cues. *Music Perception*, *17*, 43–64.

Balkwill, L. L., Thompson, W. F., & Matsunaga, R. (2004). Recognition of emotion in Japanese, Western, and Hindustani music by Japanese listeners. *Japanese Psychological Research*, *46*, 337–349.

Balter, M. (2009). Early start for human art? Ochre may revise timeline. *Science*, *323*, 5914, 569.

Baltes, F. R., & Miu, A. C. (2014). Emotions during live music performance: Links with individual differences in empathy, visual imagery, and mood. *Psychomusicology: Music, Mind, and Brain*, 24(1), 58–65.

Barboza, D., Boley, G., & Cox, A. (2013, October 28). A culture of bidding: Forging an art market in China. *New York Times*. http://www.nytimes.com/projects/2013/china-art-fraud/

Barnas, M. (2008). Confrontations: An interview with Florentine psychiatrist Graziella Magherini. *Metropolis M*. Issue No. 4, August/September.

Baron-Cohen, S., Jolliffe, T., Mortimore, C., & Robertson, M. (1997). Another advanced test of theory of mind: Evidence from very high functioning adults with autism or Asperger syndrome. *Journal of Child Psychology and Psychiatry*, *38*(7), 813–822.

Baron-Cohen, S., & Wheelwright, S. (2004). The empathy quotient: An investigation of adults with Asperger syndrome or high functioning autism, and normal sex differences. *Journal of Autism and Developmental Disorders*, *34*(2), 163–175.

Baron-Cohen, S., Wheelwright, S., Hill, J., Raste, Y., & Plumb, I. (2001). The "Reading the Mind in the Eyes" test revised version: A study with normal adults, and adults with Asperger syndrome of high-functioning autism. *Journal of Child Psychology and Psychiatry*, *42*(2), 241–251.

Bartsch, A., Appel, M., & Storch, D. (2010). Predicting emotions and meta-emotions at the movies: The role of the need for affect in audiences' experience of horror and drama. *Communication Research*, *37* (2), 167–190.

Batteux, C. (1746/2015). *The fine arts reduced to a single principle*. (J. O. Young, Trans.). New York: Oxford University Press.

Beardsley, M. (1982) *The aesthetic point of view: Selected essays*. Ithaca, NY: Cornell University Press.

Beatty, J. (1982). Task-evoked pupillary responses, processing load, and the structure of processing resources. *Psychological Bulletin*, *91*, 276.

Beaussart, M. L., Kaufman, S. B., & Kaufman, J. C. (2012). Creative activity, personality, mental illness, and short-term mating success. *Journal of Creative Behavior*, *46*(3), 151–167.

Beebe, J., Qiaoan, R., Wysocki, T., & Endara, M. A. (2015). Moral objectivisim in cross-cultural perspective. *Journal of Cognition and Culture*, *15*, 386–401.

Beebe, J., & Sackris, D. (2016). Moral objectivism across the lifespan. *Philosophical Psychology*, *29*(6), 919–929.

Belkofer, C. M., Van Hecke, A. V., & Konopka, L. M. (2014). Effects of drawing on alpha activity: A quantitative EEG study with implications for art therapy. *Art Therapy: Journal of the American Art Therapy Association*, *31*(2), 61–68.

Bell, C. (1914). *Art*. London: Chatto & Windus.

Belluck, P. (2013, October 3). For better social skills, scientist recommend a little Chekhov. *New York Times*. https://well.blogs.nytimes.com/2013/10/03/i-know-how-youre-feeling-i-read-chekhov/

Benjamin, W. (2002). The work of art in the age of its technological reproducibility: Second version. In H. Eiland & M. W. Jennings (Eds.), *Walter Benjamin: Selected writings, 3: 1935–1938*. Cambridge, MA: Belknap Press.

Bettelheim, B. (1977). *The uses of enchantment: The meaning and importance of fairy tales*. New York: Knopf.

Bezooijen, R. V., Otto, S. A., & Heenan, T. A. (1983). Recognition of vocal expressions of emotion: A three-nation study to identify universal characteristics. *Journal of Cross-Cultural Psychology*, *14*(4), 387–406.

Bialystock, E., & De Pape, A.-M. (2009). Musical expertise, bilingualism, and executive functioning. *Journal of Experimental Psychology, Human Perception and Performance*, *35*(2), 565–574.

Bigand, E., Vieillard, S., Madurell, F., Marozeau, J., & Dacquet, A. (2005). Multidimensional scaling of emotional responses to music: The effect of musical expertise and of the duration of the excerpts. *Cognition and Emotion*, *27*, 1113–1139.

Bissonnette, Z. (2014). The drunken downfall of evangelical America's favorite painter. *The Daily Beast*. http://www.thedailybeast.com/articles/2014/06/08/the-drunken-downfall-of-evangelical-america-s-favorite-painter.html

Blacking, J. (1995). *Music, culture and experience: Selected papers of John Blacking*. Chicago: University of Chicago Press.

Blank, P., Massey, C., Gardner, H., & Winner, E. (1984). Perceiving what paintings express. In R. Crozier & A. Chapman (Eds.), *Cognitive processes in the perception of art*. Amsterdam: North Holland Press.

Bloch, S., & Taylor, K. (2018). Music class gets lost in the shuffle. *New York Times*, May 14, A16.

Blood, A., & Zatorre, R. (2001). Intensely pleasurable responses to music correlate with activity in brain regions implicated in reward and emotion. *Proceedings of the National Academy of Sciences of the United States of America*, *98*(20), 11818–11823.

Bloom, H. (2000). *How to read and why*. New York: Scribner.

Bloom, P. (2016). *Against empathy: The case for rational compassion*. New York: Ecco, Harper Collins.

Bourdieu, P. (2010). *Distinction: A social critique of the judgment of taste*. (R. Nice, Trans.). London: Routledge.

Bowden, R. (1999). What is wrong with an art forgery? An anthropological perspective. *Journal of Aesthetics and Art Criticism*, *57*(3), 333–343.

Brandler, S., & Rammsayer, T. H. (2003). Differences in mental abilities between musicians and non-musicians. *Psychology of Music*, *31*(2), 123–138.

Bransford, J., D., & Schwartz, D. L. (1999). Rethinking transfer: A simple proposal with multiple implications. *Review of Research in Education*, *24*, 61–100.

Brown, E. D., Garnett, M. L., Anderson, K. E., & Laurenceau, J. P. (2017). Can the arts get under the skin? Arts and cortisol for economically disadvantaged children. *Child Development, 88*(4), 1368–1381.

Brown, R. (1981). Music and language. In *Documentary report of the Ann Arbor symposium. National symposium on the applications of psychology to the teaching and learning of music* (pp. 233–265). Reston, VA: Music Educators National Conference.

Brown, R., Black, A., & Horowitz, A. (1955). Phonetic symbolism in natural langauges. *Journal of Abnormal and Social Psychology, 50*, 388–393.

Bryant, B. K. (1982). An index of empathy for children and adolescents. *Child Development*, 413–425.

Bryden, M. P., McManus, I. C., & Bulman-Fleming, M. B. (1994). Evaluating the empirical support for the Geschwind-Behan-Galaburda model of cerebral lateralization. *Brain and Cognition, 26*(2), 103–167.

Bullot, N., & Reber, R. (2013). The artful mind meets art history: Toward a psychohistorical framework for the science of art appreciation. *Behavioral and Brain Sciences, 36*, 123–180.

Bullough, E. (1912). "Psychical distance" as a factor in art and an aesthetic principle. *British Journal of Psychology, 5*, 87–118.

Burckhardt, J. (1878/1990). *The civilization of the Renaissance in Italy.* New York: Penguin.

Burgoyne, S., & Poulin, K., with Reardon, A. (1999). The impact of acting on student actors: Boundary blurring, growth, and emotional distress. *Theatre Topics, 9*(2), 157–179.

Cacchione, T., Mohring, W., & Bertin, E. (2011). What is it about Picasso? Infants' categorical and discriminatory abilities in the visual arts. *Psychology of Aesthetics, Creativity, and the Arts, 5*(4), 370–378.

Callaghan, T. (1997). Children's judgments of emotions portrayed in museum art. *British Journal of Developmental Psychology, 15*, 515–529.

Callaghan, T. (2000). The role of context in preschoolers' judgments of emotion in art. *British Journal of Developmental Psychology, 18*, 465–474.

Carothers, T., & Gardner, H. (1979). When children's drawings become art: The emergence of aesthetic production and perception. *Developmental Psychology, 15*, 570–580.

Castles, A., & Coltheart, M. (2004). Is there a causal link from phonological awareness to success in learning to read? *Cognition, 91*(1), 77–111.

Catterall, J. S. (1997). Involvement in the arts and success in the secondary school. *Americans for the Arts Monographs, 1*, No. 9.

Catterall, J., Chapleau, R., & Iwanaga, J. (1999). Involvement in the arts and human development: General involvement and intensive involvement in music and theater arts. In E. Fiske (Ed.), *Champions of change: The impact of the arts on learning* (pp. 1–18). Washington, DC: The Arts Education Partnership and the President's Committee on the Arts and the Humanities.

Ceci, S. J., & Williams, W. M. (1997). Schooling, intelligence and income. *American Psychologist, 52*(10), 1051–1058.

Cernuschi, C. (1997). *"Not an illustration but the equivalent:" A cognitive approach to abstract expressionism.* Cranbury, NJ: Associated University Presses.

Chabris C. F. (1999). Prelude or requiem for the "Mozart effect"? *Nature, 400,* 826–827.

Chandler, J. J. (1973). Egocentrism and antisocial behavior: The assessment and training of social perspective-taking skills. *Developmental Psychology, 9*(1), 326–332.

Chandler, M., J., Greenspan, S., & Barenboim, C. (1974). Assessment and training of role-taking and referential communication skills in institutionalized emotionally disturbed children. *Developmental Psychology, 10*(4), 546–553.

Charlton, B. D. (2014). Menstrual cycle phase alters women's sexual preferences for composers of more complex music. *Proceedings of the Royal Society B, 281:* 20140403.

Child, I. L. (1962). Personal preferences as an expression of aesthetic sensitivity. *Journal of Personality, 30*(3), 496–512.

Child, I. L., & Siroto, L. (1965). BaKwele and American esthetic evaluations compared. *Ethnology, 4*(4), 349–360.

Chittenden, M. (2007, December 2). Tiny-fingers Freddie dupes art world. *The Sunday Times.* https://www.thetimes.co.uk/article/tiny-fingers-freddie-dupes-art-world-f9z2hxcowgv

Cho, C., & Schwartz, N. (2008). Of great art and untalented artists: Effort information and the flexible construction of judgmental heuristics. *Journal of Consumer Psychology, 18,* 205–211.

Clark, K. (1974). *Another part of the wood.* London: John Murray.

Clegg, H., Nettle, D., & Miell, D. (2011). Status and mating success amongst visual artists. *Frontiers in Psychology, 2,* Article 310.

Collier, G. L. (2007). Beyond valence and activity in the emotional connotations of music. *Psychology of Music, 35,* 1, 110–131.

Collins-Hughes, L. (2017, March 9). Using Shakespeare to ease war's trauma. *New York Times.* https://www.nytimes.com/2017/03/09/theater/shakespeare-military-stephan-wolfert-cry-havoc.html?

Conard, N. J., Malina, M., & Münzel, S. C. (2009). New flutes document the earliest musical tradition in southwestern Germany. *Nature, 460,* 737–740.

Coplan, A. (2004). Engagement with narrative fictions. *Journal of Aesthetics and Art Criticism, 62*(2), 141–152.

Corbett, B. A., Gunther, J. R., Comins, D., Price, J., Ryan, N., Simon, D., & Rios, T. (2011). Brief report: Theatre as therapy for children with autism spectrum disorder. *Journal of Autism and Developmental Disorders, 41*(4), 505–511.

Corbett, B. A., Key, A. P., Qualls, L., Fecteau, S., Newsom, C., Coke, C., & Yoder, P. (2015). Improvement in social competence using a randomized trial of a theatre intervention for children with autism spectrum disorder. *Journal of Autism and Developmental Disorders, 46*(2), 658–672.

Corbett, B. A., Swain, D. M., Coke, C., Simon, D., Newsom, C., Houchins-Juarez, N., & Song, Y. (2014). Improvement in social deficits in autism spectrum disorders using a theatre-based, peer-mediated intervention. *Autism Research, 7*(1), 4–16.

Corrigall, K. A., Schellenberg, E. G., & Misura, N. M. (2013). Music training, cognition, and personality. *Frontiers in Psychology, 4,* 222.

Costa-Giomi, E. (1999). The effects of three years of piano instruction on children's cognitive development. *Journal of Research in Music Education, 47*(3), 198–212.

Coutinho, E., & Dibben, N. (2013). Psychoacoustic cues to emotion in speech prosody and music. *Cognition and Emotion*, 27(4), 1–27.

Cova, F., & Pain, N. (2012). Can folk aesthetics ground aesthetic realism? *The Monist*, 95(2), 241–263.

Cox, M. (1992). *Children's drawings*. London: Penguin.

Csikszentmihalyi, M. (1996). *Creativity*. New York: Harper Collins.

Curl, K. (2008). Assessing stress reduction as a function of artistic creation and cognitive focus. *Art Therapy: Journal of the American Art Therapy Association*, 25(4), 164–169.

Currie, G. P. (2013). Does great literature make us better? *New York Times*, Opinionator. https://opinionator.blogs.nytimes.com/2013/06/01/does-great-literature-make-us-better/ (Print version entitled "Does fiction civilize us?," June 2, 2013, p. SR12.)

Currie, G. P. (2016). Does fiction make us less empathic? *Teorema: Revista Internacional de Filosofía*, 35(3), 47–68.

Cutting, J. E. (2003). Gustave Caillebotte, French Impressionism, and mere exposure. *Psychonomic Bulletin & Review*, 10, 319–343.

Dalla Bella, S., Peretz, I., Rousseau, L., & Gosselin, N. (2001). A developmental study of the affective value of tempo and mode in music. *Cognition*, 80(3), B1–B10.

Danto, A. C. (1973). Artworks and real things. *Theoria*, 39(1-3), 1–17.

Darwin, C. (1859) *On the origin of species*. London: John Murray.

Darwin, C. (1871). *The descent of man and selection in relation to sex*. London: John Murray.

Davenport, R. W. (1948). A Life roundtable on modern art. *Life*, 25(2), 62.

Davies, S. (1980). The expression of emotion in music. *Mind*, 89, 67–86.

Davies, S. (1994). *Musical meaning and expression*. Ithaca, NY: Cornell University Press.

Davies, S. (2010). Emotions expressed and aroused by music: Philosophical perspectives. In P. N. Juslin & J. A. Sloboda (Eds.), *Handbook of music and emotion: theory, research, applications*. Oxford, UK: Oxford University Press.

Davis, J. (1997). Drawing's demise: U-shaped development in graphic symbolization. *Studies in Art Education*, 38(3), 132–157.

Davis, M. H. (1983). Measuring individual differences in empathy: Evidence for a multidimensional approach. *Journal of Personality and Social Psychology*, 44(1), 113–126.

de Araujo, I. E., Rolls, E. T., Velazco, M. I., Margot, C., & Cayeux, I. (2005). Cognitive modulation of olfactory processing. *Neuron*, 46, 671–679.

Detterman, D. K., & Sternberg, R. J. (1993). *Transfer on trial: Intelligence, cognition and instruction*. Westport, CT: Praeger.

Dickie, G. (1974). *Art and the aesthetic: An institutional analysis*, Ithaca, NY: Cornell University Press.

Diliberto-Macaluso, K., & Stubblefield, B. L. (2015). The use of painting for short-term mood and arousal improvement. *Psychology of Aesthetics, Creativity, and the Arts*, 9(3), 228–234.

Dissanayake, E. (1988). *What is art for?* Seattle: University of Washington Press.

Dodell-Feder, D., Lincoln, S. H., Coulson, J. P., & Hooker, C. I. (2013). Using fiction to assess mental state understanding: A new task for assessing theory of mind in adults. *PLoS ONE*, 8, 11.

Dolev, J. C., Friedlaender, L., K., & Braverman, I. M. (2001). Use of fine art to enhance visual diagnostic skills. *Journal of the American Medical Association, 186*(9), 1019.

Drake, J. E., Coleman, K., & Winner, E. (2011). Short-term mood repair through art: Effects of medium and strategy. *Art Therapy: Journal of the American Art Therapy Association, 28*(1), 26–30.

Drake, J. E., Hastedt, I., & James, C. (2016). Drawing to distract: Examining the psychological benefits of drawing over time. *Psychology of Aesthetics, Creativity, and the Arts, 10*(3), 325–331.

Drake, J. E., & José, A. (2017, August). Maybe your child could have painted that: Comparing the works of artists, prodigies, and children. Presented at the meeting of the American Psychological Association, Washington, DC.

Drake, J. E., & Winner, E. (2012a). Confronting sadness through art-making: Distraction is more beneficial than venting. *Psychology of Aesthetics, Creativity, and the Arts, 6,* 251–266.

Drake, J. E., & Winner, E. (2012b). Predicting artistic brilliance. *Scientific American Mind, 23*(5), 42–48.

Drake, J. E., & Winner, E. (2013). How children use drawing to regulate their emotions. *Cognition and Emotion, 27*(3), 512–520.

Drake, J. E., & Winner, E. (2017). Why deliberate practice is not enough: Evidence of talent in drawing. In D. Z. Hambrick, G. Campitelli, & B. N. Macnamara (Eds.), *The science of expertise: Behavioral, neural, and genetic approaches to complex skill.* Abington, UK: Routledge.

Drake, J. E., & Winner, E. (in press). Extreme drawing realism in childhood. *Roeper Review.*

Dryden, W., Waller, D., & Gilroy, A. (1992). *Art therapy: A handbook.* McGraw-Hill Education (UK).

Duckworth, A. (2016). *Grit: The power of passion and perseverance.* New York: Simon & Schuster.

Durose, M. R., Cooper, A. D., & Snyder, H. N. (2014). *Recidivism of prisoners released in 30 states in 2005: Patterns from 2005 to 2010.* Washington, DC: Bureau of Justice Statistics, *28.*

Dutton, D. (1979). Artistic crimes. *British Journal of Aesthetics, 19,* 302–341. http://www.denisdutton.com/artistic_crimes.htm

Dutton, D. (1983). *Forger's art: Forgery and the philosophy of art.* Berkeley: University of California Press.

Dutton, D. (1998). Forgery and plagiarism. In R. Chadwick (Ed.), *Encyclopedia of applied ethics.* http://www.denisdutton.com/forgery_and_plagiarism.htm

Dutton, D. (2003). Authenticity in art. In J. Levinson (Ed.). *The Oxford handbook of aesthetics.* New York: Oxford University Press.

Dutton, D. (2009). *The art instinct: Beauty, pleasure, and human evolution.* New York: Bloomsbury Press.

Dweck, C. (2006). *Mindset: The new psychology of success.* New York: Random House.

Dziobek, I., Fleck, S., Kalbe, E., Rogers, K., Hassenstab, J., Brand, M., . . . Convit, A. (2006). Introducing MASC: A movie for the assessment of social cognition. *Journal of Autism and Developmental Disorders, 36*(5), 623–636.

Edwards, B. (1986). *Drawing on the artist within: An inspirational and practical guide to increasing your creative powers.* New York: Simon & Schuster.

Eerola, T., Vuoskoski, J. K., & Kautiainen, H. (2016). Being moved by unfamiliar sad music is associated with high empathy. *Frontiers in Psychology, 7,* 1176.

Efland, A. (1990). *A history of art education: Intellectual and social currents in teaching the visual arts.* New York: Teachers College Press.

Egermann, H., Fernando, N., Chuen, L., & McAdams, S. (2015). Music induces universal emotion-related psychophysiological responses: Comparing Canadian listeners to Congolese Pygmies. *Frontiers in Psychology,* Article 1342, 1–9.

Eisner, E. (2001). What justifies arts education: What research does *not* say. In M. McCarthy (Ed.), *Enlightened advocacy: Implications of research for arts education policy practice* (pp. 19–29). The 1999 Charles Fowler Colloquium on Innovation in Arts Education. College Park: University of Maryland.

Eisner, E. W. (2002). *The arts and the creation of mind.* New Haven, CT: Yale University Press.

Ekman, P., & Friesen, W. V. (1971). Constants across cultures in the face and emotion. *Journal of Personality and Social Psychology 17,* 124129.

Elder, N. C., Tobias, B., Lucero-Criswell, A., & Goldenhar, L. (2006). The art of observation: Impact of a family medicine and art museum partnership on student education. *Medical Student Education, 38*(6), 393–398.

Elgammal, A., Liu, B., Elhoseiny, M., & Mazzone, M. (2017). CAN: Creative adversarial networks generating "art" by learning about styles and deviating from style norms. *arXiv,* Article 1706.07068. https://arxiv.org/pdf/1706.07068.pdf

Elkins, J. (2004). *Pictures and tears: A history of people who have cried in front of paintings.* New York: Routledge.

Elpus, K. (2013). Is it the music or is it selection bias? A nationwide analysis of music and non-music students' SAT scores. *Journal of Research in Music Education, 61*(2), 175–194.

Ericsson, K. A. (1996). The acquisition of expert performance: An introduction to some of the issues. In K. A. Ericsson (Ed.), *The road to excellence: The acquisition of expert performance in the arts and sciences, sports, and games* (pp. 1–50). Mahwah, NJ: Erlbaum.

Eysenck, H. J. (1983). A new measure of 'good taste' in visual art. *Leonardo, 16*(3), 229–231.

Fairhurst, M. T., Janata, P., & Keller, P. E. (2013). Being and feeling in sync with an adaptive virtual partner: Brain mechanisms underlying dynamic cooperativity. *Cerebral Cortex 23,* 2592–2600.

Falco, C. (2000). Optical insights into Renaissance art. *Optics & Photonics News,* July, 52–59.

Fargnoli, A. N., & Gillespie, M. P. (2006). *Critical companion to James Joyce: A literary reference to his life and work.* New York: Facts on File.

Feffer, M. H. (1970). A developmental analysis of interpersonal behavior. *Psychological Review, 77,* 197–214.

Festinger, L. (1957). *A theory of cognitive dissonance.* Evanston, Il: Row & Petserson.

Fineberg, J. (1997). *The innocent eye: Children's art and the modern artist.* Princeton, NJ: Princeton University Press.

Fink, L., & Drake, J. E. (2016). Mood and flow: Comparing the benefits of narrative versus poetry writing. *Empirical Studies of the Arts, 34*(2), 177–192.

Ford, C. S., Prothro, E. T., & Child, I. L. (1966). Some transcultural comparisons of esthetic judgment. *Journal of Social Psychology, 68*(1), 19–26.

Foster, E. M., & Jenkins, J. V. M. (2017). Does participation in music and performing arts influence child development? *American Educational Research Journal, 54*(3), 399–443.

Frazier, B. N., Gelman, S. A., Wilson, A., & Hood, B. M. (2009). Picasso paintings, moon rocks, and hand-written Beatles lyrics: Adults' evaluations of authentic objects. *Journal of Cognition and Culture, 9*(1), 1–14.

Freud, S. (1910/1990). *Leonardo da Vinci and a memory of his childhood.* In J. Strachey (Ed.), *The standard edition, complete psychological works of Sigmund Freud.* New York: W. W. Norton.

Friedman, B. (1959). *An evaluation of the achievement in reading and arithmetic of pupils in elementary school instrumental music classes* (Unpublished doctoral dissertation). New York University.

Frith, U. (Ed.). (1980). *Cognitive processes in spelling* (pp. 495–517). London: Academic Press.

Frith, U., Morton, J., & Leslie, A. M. (1991). The cognitive basis of a biological disorder—autism. *Trends in Neurosciences, 14*(10), 433–438.

Fritz, T., Jentschke, S., Gosselin, N., Sammler, D., Peretz, I., Turner, R., Friederici, A. D., & Koelsch, S. (2009). Universal recognition of three basic emotions in music. *Current Biology, 19*, 573–576.

Gabrielsson, A. (2010). Strong experiences with music. In P. N. Juslin & J.A. Sloboda (Eds.), *Handbook of music and emotion: Theory, research, applications* (pp. 547–574). Oxford, UK: Oxford University Press.

Gabrielsson, A. (2011). *Strong experiences with music: Music is much more than just music.* Oxford, UK: Oxford University Press.

Gabrielsson, A., & Juslin, P. N. (2003). Emotional expression in music. In R. J. Davidson, K. S. Scherer, & H. H. Goldsmith (Eds.), *Handbook of affective sciences* (pp. 503–434). Oxford, UK: Oxford University Press.

Gabrielsson, A., & Lindström, E. (2001). The influence of musical structure on emotional expression. In P. N. Juslin & J. A. Sloboda (Eds.), *Music and emotion: Theory and research* (pp. 223–248). Oxford, UK: Oxford University Press.

Gabrielsson, A., & Wik, S. L. (2003). Strong experiences related to music: A descriptive system. *Musicae Scientiae, 7*(2), 157–217.

Gagnon, L., & Peretz, I. (2003). Mode and tempo relative contributions to "happy-sad" judgments in equitone melodies. *Cognition and Emotion, 17*, 25–40.

Gardner, H. (1970). Children's sensitivity to painting styles. *Child Development, 41*, 813–821.

Gardner, H. (1980). *Artful scribbles: The significance of children's drawings.* New York: Basic Books.

Gardner, H. (1989). *To open minds.* New York: Basic Books.

Gardner, H. (2011). *Creating minds: An anatomy of creativity seen through the lives of Freud, Einstein, Picasso, Stravinsky, Eliot, Graham, and Gandhi.* New York: Basic Books.

Gardner, H., & Winner, E. (1981). First intimations of artistry. In S. Strauss (Ed.), *U-shaped behavioral growth*. New York: Academic Press.

Gerger, G., Leder, H., & Kremer, A. (2014). Context effects on emotional and aesthetic evaluations of artworks and IAPS pictures. *Acta Psychologica, 151*, 174–183.

Gerger, G., Pelowski, M., & Leder, H. (2017). Empathy, Einfühlung, and aesthetic experience: The effect of emotion contagion on appreciation of representational and abstract art using fEMG and SCR. *Cognitive Processing*, 1–19. https://doi.org/10.1007/s10339-017-0800-2

Geschwind, N. (1984). The biology of cerebral dominance: Implications for cognition. *Cognition, 17*(3), 193–208.

Geschwind, N., & Galaburda, A. M. (1985). Cerebral lateralization: Biological mechanisms, associations, and pathology: I. A hypothesis and a program for research. *Archives of Neurology, 42*(5), 428–459.

Geschwind, N., & Galburda, A. (1987). *Cerebral lateralization*. Cambridge, MA: MIT Press.

Gilli, G. M., Ruggi, S., Gatti, M., & Freeman, N. H. (2017). How children's mentalistic theory widens their conception of pictorial possibilities. *Frontiers in Psychology, 7*, Article 177.

Gladwell, M. (2008). *Outliers: The story of success*. New York: Little Brown & Co.

Gleick, J. (1992). *Richard Feynman and modern physics*. London: Little, Brown and Company.

Gobet, F., & Campitelli, G. (2007). The role of domain-specific practice, handedness, and starting age in chess. *Developmental Psychology, 43*, 159–172.

Goldsmith, L. T., Hetland, L., Hoyle, C., & Winner, E. (2016). Visual-spatial thinking in geometry and the visual arts. *Psychology of Aesthetics, Creativity, and the Arts, 10*(1), 56–71.

Goertzel, M. G., Goertzel, V., & Goertzel, T. G. (1978). *Three hundred eminent personalities*. San Francisco: Jossey-Bass.

Goertzel, V., & Goertzel, M. G. (1962). *Cradles of eminence* (pp. 301–349). Boston: Little, Brown.

Goldsmith, L. T. (1992). Stylistic development of a Chinese painting prodigy. *Creativity Research Journal, 5*(3), 281–293.

Goldsmith, L. T., Hetland, L., Hoyle, C., & Winner, E. (2016). Visual-spatial thinking in geometry and the visual arts. *Psychology of Aesthetics, Creativity, and the Arts, 10*(1), 56–71.

Goldstein, A. (1980). Thrills in response to music and other stimuli. *Physiological Psychology, 8*, 126–9.

Goldstein, T. R. (2009). The pleasure of unadulterated sadness: Experiencing sorrow in fiction, nonfiction, and "in person." *Psychology of Aesthetics, Creativity, and the Arts, 3*(4), 232–237.

Goldstein, T. R., & Lerner, M. D. (2018). Dramatic pretend play games uniquely improve emotional control in young children. *Developmental Science, 21*(4).

Goldstein, T. R., & Winner, E. (2012). Enhancing empathy and theory of mind. *Journal of Cognition and Development, 13*(1), 19–37.

Goldstein, T. R., Wu, K., & Winner, E. (2009). Actors are skilled in theory of mind but not empathy. *Imagination, Cognition and Personality, 29*(2), 115–133.

Gombrich, E. H. (1960). *Art and illusion: A study in the psychology of pictorial representation*. Princeton, NJ: Princeton University Press.

Gomez, P., & Danuser, B. (2007). Relationships between musical structure and psychophysiological measures of emotion. *Emotion, 7*(2), 377–387.

Goodman, N. (1972). Seven strictures on similarity. In N. Goodman (Ed.), *Problems and projects* (pp. 437–446). Indianapolis and New York: Bobbs-Merril.

Goodman, N. (1976). *Languages of art*. Indianapolis: Hackett.

Goodman, N. (1978). *Ways of worldmaking*. Indianapolis: Hackett.

Goodnough, R. (2012). Pollock paints a picture. *ARTnews*, November. (Originally appeared May 1951). http://www.artnews.com/2012/11/26/pollock-paints-a-picture/

Goodwin, G., & Darley, J. (2008). The psychology of meta-ethics: Exploring objectivism. *Cognition. 106*(3), 1339–1366.

Gordon, A. (1987). Childhood works of artists. *Israel Museum Journal, 6*, 75–82.

Gordon, R. L., Fehd, H. M., & McCandliss, B. D. (2015). Does music training enhance literacy skills? A meta-analysis. *Frontiers in Psychology, 6*, Article 1777.

Gosselin, N., Paquette, S., & Peretz, I. (2015). Sensitivity to musical emotions in congenital amusia. *Cortex, 71*, 171–182.

Götz, K. O., Lynn, R., Borisy, A. R., & Eysenck, H. J. (1979). A new visual aesthetic sensitivity test: I. Construction and psychometric properties. *Perceptual and Motor Skills, 49*(3), 795–802.

Graziano, A., Peterson, M., & Shaw, G. (1999). Enhanced learning of proportional math through music training and spatial-temporal training. *Neurological Research 21*(2), 139–152.

Greengross, G., & Miller, G. (2011). Humor ability reveals intelligence, predicts mating success, and is higher in males. *Intelligence, 39*, 188–192.

Griffiths, T. D., Warren, J. D., Dean, J. L., & Howard, D. J. (2004). When the feeling's gone": A selective loss of musical emotion. *Journal of Neurology, Neurosurgury & Psychiatry, 75*, 344–345.

Gruber, H. (1981). *Darwin on man*. Chicago: University of Chicago Press.

Gurney, E. (1880). *The power of sound*. London: Smith Elder.

Gusnard, D. A., & Raichle, M. E. (2001). Searching for a baseline: Functional imaging and the resting human brain. *Nature Reviews Neuroscience, 2*, 685–693.

Haanstra, F. (2000). Dutch studies of the effects of arts education on school success. *Studies in Art Education 41*(3), 19–33.

Haberman, C. (1989, May 15). Florence's art makes some do to pieces. *New York Times.* http://www.nytimes.com/1989/05/15/world/florence-s-art-makes-some-go-to-pieces.html

Habibi, A., & Damasio, A. (2014). Music, feelings, and the human brain. *Psychomusicology: Music, Mind, and Brain, 24*(1), 92–102.

Haimson, J., Swain, D., & Winner, E. (2011). Do mathematicians have above average musical skill? *Music Perception, 29*(2), 203–213.

Hakemulder, F. (2000). *The moral laboratory: Experiments examining the effects of reading literature on social perception and moral self-concept*. Amsterdam: John Benjamins.

Halliwell, S. (Ed. and Trans.) (1995). *Aristotle's Poetics*. Cambridge, MA: Harvard University Press.

Hambrick, D. Z., Campitelli, G., & Macnamara, B. N. (Eds.). (2017). *The science of expertise: Behavioral, neural, and genetic approaches to complex skill.* Abington, UK: Routledge.

Hanich, J., Wagner, V., Shah, M., Jacobsen, T., & Menninghaus, W. (2014). Why we like to watch sad films. The pleasure of being moved in aesthetic experiences. *Psychology of Aesthetics, Creativity, and the Arts, 8*(2), 130–143.

Hanslick, E. (1891). *The beautiful in music* (7th ed.). London and New York: Novello, Ewer & Co.

Haritos-Fatouros, M., & Child, I. L. (1977). Transcultural similarity in personal significance of esthetic interests. *Journal of Cross-Cultural Psychology, 8*(3), 285–298.

Harland, J., Kinder, K., Lord, Pl., Stott, A., Schagen, I., & Haynes, J. (2000). *Arts education in secondary schools: Effects and effectiveness.* York, UK: National Foundation for Educational Research.

Hassler, M. (1990). Functional cerebral asymmetries and cognitive abilities in musicians, painters, and controls. *Brain and Cognition, 13*(1), 1–17.

Hatfield, E., Cacioppo, J. T., & Rapson, R. L. (1993). Emotional contagion. *Current Directions in Psychological Science, 2*(3), 96–100.

Hawley, A., & Winner, E. (2011). Seeing the mind behind the art: We can distinguish abstract expressionist paintings from highly similar paintings by children, chimps, monkeys, and elephants. *Psychological Science, 22*(4), 435–441.

Heath, S. (1998). Living the arts through language and learning: A report on community based youth organizations. *Americans for the Arts Monographs, 2,* no. 7.

Helmbold, N., Rammsayer, T., & Altenmuller, E. (2005). Differences in primary mental abilities between musicians and nonmusicians. *Journal of Individual Differences, 26,* 74–85.

Helmholtz, H. von (1863/1954). *On the sensation of tone as a physiological basis for the theory of music.* New York: Dover.

Hermelin, B., & O'Connor, N. (1986). Spatial representations in mathematically and in artistically gifted children. *British Journal of Educational Psychology, 56,* 150–157.

Hess, E. H. (1965). Attitude and pupil size. *Scientific American, 212,* 46–54.

Hess, E. H., & Polt, J. M. (1960). Pupil size as related to interest value of visual stimuli. *Science, 132,* 349–350.

Hetland, L. (2000a). Listening to music enhances spatial-temporal reasoning: Evidence for the "Mozart effect." *Journal of Aesthetic Education, 34*(3-4), 105–148.

Hetland, L. (2000b). Learning to make music enhances spatial reasoning. *Journal of Aesthetic Education, 34,* 3-4,179–238.

Hetland, L., & Winner, E. (2002). Cognitive transfer from arts education to non-arts ourtomces: Research evidence and policy implications. In E. Eisner & M. Day (Eds.), *Handbook of research and policy in art education.* Alexandria, VA: National Art Education Association.

Hetland, L., Winner, E., Veenema, S., & Sheridan, K. (2007). *Studio thinking: The real benefits of visual arts education.* New York: Teachers College Press.

Hetland, L., Winner, E., Veenema, S., & Sheridan, K. (2013). *Studio thinking 2: The real benefits of visual arts education* (2nd ed.). New York: Teachers College Press.

Hevner, K. (1935a). The affective character of the major and minor modes in music. *American Journal of Psychology, 47*, 103–118.

Hevner, K. (1935b). Expression in music: A discussion of experimental studies and theories. *Psychological Review, 47*, 186–204.

Hevner, K. (1936). Experimental studies of the elements of expression in music. *American Journal of Psychology, 48*, 246–268.

Hevner, K. (1937). The affective value of pitch and tempo in music. *American Journal of Psychology, 49*, 621–630.

Hick, D. H. (2010). Forgery and appropriation in art. *Philosophy Compass, 5*(12), 1047–1056.

Higham, T., Basell, L., Jacobi, R., Wood, R., Bronk Ramsey, & Conard, N. J. (2012). Testing models for the beginnings of the Aurignacian and the advent of figurative art and music: The radiocarbon chronology of Geißenklösterle. *Journal of Human Evolution, 6*, 664–676.

Hildreth, G. (1941). *The child mind in evolution.* New York: Kings Crown Press.

Hille, A., & Schupp, J. (2013). How learning a musical instrument affects the development of skills. *SEOP Papers on Multidisciplinary Panel Data Research, 591.* ISSN: 1864-6689 (online). Soeppapers@diw.de. http://www.diw.de/documents/publikationen/73/diw_01.c.429221.de/diw_sp0591.pdf

Hockney, D. (2001). *Secret knowledge: Rediscovering the lost techniques of the old masters.* London: Thames and Hudson, Ltd.

Hoffner, C. A., & Levine, K. J. (2005). Enjoyment of mediated fright and violence: A meta-analysis. *Media Psychology, 7*, 207–237.

Hogan, J., Hetland, L., Jaquith, D., & Winner, E. (2018). *Studio thinking from the start: The K-8 Art Educator's Handbook.* New York: Teachers College Press.

Hogan, J., & Winner, E. (2017). Unpublished research.

Hogan, J., & Winner, E. (in press). Using habits of mind as tools for assessment in music. To appear in D. J. Elliott, G. McPherson, & M. Silverman (Eds.), *The Oxford Handbook of Philosophical and Qualitative Assessment in Music Education.*

Hospers, J. (1954-55). The concept of artistic expression. *Proceedings of the Aristotelian Society New Series, 55*, 313–344.

Howard, R. W. (2009). Individual differences in expertise development over decades in a complex intellectual domain. *Memory & Cognition, 37*(2), 194–209.

Howes, F. S. (1958). *Music and its meanings.* London: Athlone Press.

Huang, M., Bridge, H., Kemp, M. J., & Parker, A. J. (2011). Human cortical activity evoked by the assignment of authenticity when viewing works of art. *Frontiers in Human Neuroscience, 5*, 134.

Hulbert, A. (2018). *Off the charts: The hidden lives and lessons of American child prodigies.* New York: Knopf.

Hume, D. (1767). *Essays and treatises on several subjects.* In two volumes. London: Printed for A. Millar, in the Strand; and A. Kincaid, and A. Donaldson, at Edinburgh.

Hupka, R. B., Zaleski, Z., Otto, J., Reidl, L., & Tarabrina, N. (1997). The colors of anger, envy, fear, and jealousy: A cross-cultural study. *Journal of Cross-Cultural Psychology, 28*(2), 156–171.

Hussain, F. (1965). Quelques problèmes d'ésthetique expérimentale. *Sciencias de l'Art, 2*, 103–114.

Ickes, W. (2001). Measuring empathic accuracy. In J. A. Hall & F. J. Bernieri (Eds.), *Interpersonal sensitivity: Theory and measurement* (pp. 219–241). Mahwah, NJ: Lawrence Erlbaum.

Irvin, S. (2007). Forgery and the corruption of aesthetic understanding. *Canadian Journal of Philosophy, 37*(2), 283–304.

Ives, S. W. (1984). The development of expressivity in drawing. *British Journal of Educational Psychology, 54*(2), 152–159.

Iwao, S., & Child, I. L. (1966). Comparison of esthetic judgments by American experts and by Japanese potters. *Journal of Social Psychology, 68*(1), 27–33.

Iwao, S., Child, I. L., & García, M. (1969). Further evidence of agreement between Japanese and American esthetic evaluations. *Journal of Social Psychology, 78*(1), 11–15.

Iwawaki, S., Eysenck, H. J., & Götz, K. O. (1979). A new Visual Aesthetic Sensitivity Test (VAST): II. Cross-cultural comparison between England and Japan. *Perceptual and Motor Skills, 49*(3), 859–862.

Izard, C. (1990). Facial expressions and the regulation of emotions. *Journal of Personality and Social Psychology, 58*(3), 487–498.

Jacobson, H. (2017, June 24). Why we must make a mockery of Trump. *New York Times*, A19. https://www.nytimes.com/2017/06/23/opinion/donald-trump-shakespear-julius-caesar-howard-jacobson.html.

Jakobson, R. (1960). Closing statement: Linguistics and poetics. In T. A. Sebeok (Ed.), *Style in language* (pp. 350–377). Cambridge, MA: MIT Press.

James, W. (1963). *Psychology*. New York: Fawcette Publications.

Jamison, K. R. (1993). *Touched with fire: Manic depressive illness and the artistic temperament*. New York: Free Press.

Janata, P., Tomic, S. T., & Haberman, J. M. (2012). Sensorimotor coupling in music and the psychology of the groove. *Journal of Experimental Psychology: General, 141*, 54–75.

Johnson, D. R. (2012). Transportation into a story increases empathy, prosocial behavior, and perceptual bias toward fearful expressions. *Personality and Individual Differences, 52*(2), 150–155.

Johnson, D. R., Cushman, G. K., Borden, L. A., & McCune, M. S. (2013). Potentiating empathic growth: Generating imagery while reading fiction increases empathy and prosocial behavior. *Psychology of Aesthetics, Creativity, and the Arts, 7*(3), 306–312.

Johnson, D. R., Huffman, B. L., & Jasper, D. M. (2014). Changing race boundary perception by reading narrative fiction. *Basic and Applied Psychology, 36*, 83–90.

Johnson, E. L., Miller-Singley, A. T., Peckham, A. D., Johnson, S. L., & Bunge, S. A. (2014). Task evoked pupillometry provides a window into the development of short-term memory capacity. *Frontiers in Psychology, 13*, 218.

Johnson, M. G., Muday, J. A., & Schirillo, J. A. (2010). When viewing variations in paintings by Mondrian, aesthetic preferences correlate with pupil size. *Psychology of Aesthetics, Creativity, and the Arts, 4*(3), 161.

Jolley, R. P., Fenn, K., & Jones, L. (2004). The development of children's expressive drawing. *British Journal of Developmental Psychology, 22*, 545–567.

Jolley, R. P., & Thomas, G. V. (1994). The development of sensitivity to metaphorical expression of moods in abstract art. *Educational Psychology, 14*(4), 437–450.

Jolley, R. P., & Thomas, G. V. (1995). Children's sensitivity to metaphorical expression of mood in line drawings. *British Journal of Developmental Psychology, 13*(4), 335–346.

Jucker, J.-L., Barrett, J. L., & Wlodarski, R. (2014). "I just don't get it": Perceived artists' intentions affect art evaluations. *Empirical Studies of the Arts, 32*(2), 149–182.

Juslin, P. N., & Isaksson, S. (2014). Subjective criteria for choice and aesthetic judgment of music: A comparison of psychology and music students. *Research Studies in Music Education, 36*(2), 179–198.

Juslin, P. N., & Laukka, P. (2003). Communication of emotions in vocal expression and music performance: Different channels, same code? *Psychological Bulletin, 129*, 770–814.

Juslin, P. N., Baradas, G., & Eerola, T. (2015). From sound to significance: Exploring the mechanisms underlying emotional reactions to music. *The American Journal of Psychology, 128*, 3, 281–304.

Juslin, P. N., Liljeström, S. Laukka, P., Västfjäll, D., & Lundqvist, L.-O. (2011). Emotional reactions to music in a nationally representative sample of Swedish adults: Prevalence and causal influences. *Musicae Scientiae, 15*, 174–207.

Juslin, P. N., Liljeström, S., Västfjäll, D., Barradas, G., & Silva, A. (2008). An experience sampling study of emotional reactions to music: Listener, music, and situation. *Emotion, 8*(5), 668–683.

Juslin, P., & Lindström, E. (2010). Musical expression of emotions: Modelling listeners' judgements of composed and performed features. *Music Analysis, 29*, 334–364.

Just, M. A., & Carpenter, P. A. (1992). A capacity theory of comprehension: Individual differences in working memory. *Psychological Review, 99*, 122–149.

Kahneman, D. (1971). Changes in pupil size and visual discrimination during mental effort. In J. R. Pierce, & J. R. Levene (Eds.), *Visual science: Proceedings of the 1968 international symposium*. Bloomington: Indiana University Press.

Kahneman, D., & Tversky, A. (1972). *Judgment under uncertainty: Heuristics and biases.* Cambridge, UK: Cambridge University Press.

Kamber, R. (2011). Experimental philosophy of art. *Journal of Aesthetics and Art Criticism, 69*(2), 197–208.

Kant, I. (1790/2000). *Critique of the power of judgment* (P. Guyer, Ed., & P. Guyer & E. Matthews, Trans.). In *The Cambridge edition of the works of Immanuel Kant.* Cambridge, UK: Cambridge University Press.

Kastner, M. P., & Crowder, R. G. (1990). Perception of the major/minor distinction: IV. Emotional connotations in young children. *Music Perception, 8*(2), 189–201.

Kawakami, A., Furukawa, K., Katahira, K., & Okanoya, K. (2013). Relations between musical structures and perceived and felt emotion. *Music Perception, 30*, 407–418.

Keen, S. (2007). *Empathy and the novel*. Oxford, UK: Oxford University Press.

Keene, J. A. (1982). *A history of music education in the United States*. Hanover, NH: University Press of New England.

Keil, F. C. (1989). Concepts, kinds and development. Cambridge, MA: MIT Press.

Kennedy, J. M. (1993). *Drawing and the blind: Pictures to touch*. New Haven, CT: Yale University Press.

Kidd, D. C., & Castano. E. (2013). Reading literary fiction improves theory of mind. *Science, 342*(6156), 377–380.

Kieran, M. (2010). The vice of snobbery: Aesthetic knowledge, justification and virtue in art appreciation. *Philosophical Quarterly 60*, 243–63.

Kimura, R. (1950). Apparent warmth and heaviness of colors. *Japanese Journal of Psychology, 30*, 33–36.

Kivy, P. (1980). *The corded shell: Reflections on musical expression.* Princeton, NJ: Princeton University Press.

Knobe, J., & Nichols, S. (2008). An experimental philosophy manifesto. In Knobe, J., & Nichols, S. (Eds.), *Experimental philosophy* (pp. 3–14). Oxford, UK: Oxford University Press.

Koelsch, S. (2014). Brain correlates of music-evoked emotions. *Nature Reviews: Neurosciences, 15*, 170–180.

Koelsch, S. (2015). Music-evoked emotions: Principles, brain correlates and implications for therapy. *Annals of the New York Academy of Sciences, 1337*, 193–201.

Koelsch, S. (2017). Musical predictions and their impairment in children with atypical development. In R. Zatorre (Chair), Symposium, Predictive Processing in Music and Its Significance for Health. Neurosciences and Music IV Conference, Boston, June 15–18.

Koestler, A. (1965). The aesthetics of snobbery, *Horizon, 8*, 50–53.

Konečni, V. J., Brown, A., & Wanic, R. A. (2008). Comparative effects of music and recalle life-events on emotional state. *Psychology of Music, 36*(3), 289–308.

Konečni, V. J., Wanic, R. A., & Brown, A. (2007). Emotional and aesthetic antecedents and consequences of music-induced thrills. *American Journal of Psychology, 120*(4), 619–643.

Koopman, E. M. (2015). Empathic reactions after reading: The role of genre, personal factors and affective responses. *Poetics, 50*, 62–79.

Korsmeyer, C. (2016). Real old things. *British Journal of Aesthetics, 56*(3), 219–231.

Kostelanetz, R. (Ed.), (1988). *Conversting with Cage.* New York: Limelight Editions.

Kramer, E. (1964). Elimination of verbal cues in judgments of emotion from voice. *Journal of Abnormal and Social Psychology, 68*, 390–396.

Kramer, E. (2000). *Art as therapy: Collected papers.* London: Jessica Kingsley.

Kraus, N., & Chandrasekaran, G. (2010). Music training for the development of auditory skills. *Nature Reviews Neuroscience, 11*, 599–605.

Krazenberger, M., & Menninghaus, W. (2017). Affinity for poetry and aesthetic appreciation of joyful and sad poems. *Frontiers in Psychology, 7*.

Kruger, J., Wirtz, D., Boven, L. V., & Altermatt, T. W. (2004). The effort heuristic. *Journal of Experimental Social Psychology, 40*, 91–98.

Krumhansl, C. L. (1997). An exploratory study of musical emotions and psychophysiology. *Canadian Journal of Experimental Psychology/Revue Canadienne de Psychologie Expérimentale, 51*(4), 336–353.

Kuehnast, M., Wagner, V., Wassiliwizky, E., Jacobsen, T., & Menninghaus, W. (2014). Being moved: Linguistic representation and conceptual structure. *Frontiers in Psychology, 5*, 1242.

Kyaga, S., Landén, M., Boman, M., Hultman, C. M., Långström, N., & Lichtenstein, P. (2013). Mental illness, suicide and creativity: 40-Year prospective total population study. *Journal of Psychiatric Research, 47*(1), 83–90.

Lamb, S. J., & Gregory, A. H. (1993). The relationship between music and reading in beginning readers. *Educational Psychology, 13*(1), 19–27.

Langer, S. K. (1957). *Philosophy in a new key* (3rd ed.). Cambridge, MA: Harvard University Press.

Laukka, P., Eerola, T., Thingujam, N. S., Yamasaki, T., & Beller, G. (2013). Universal and culture-specific factors in the recognition and performance of musical affect expressions. *Emotion, 13,* 434–449.

Lee, L., Freferick, S., & Ariely, D. (2006). Try it, you'll like it: The influence of expectation, consumption, and revelation on preferences for beer. *Psychological Science, 17*(12), 1054–1058.

Lenain, T. (2011). *Art forgery: The history of a modern obsession.* London: Reaktion Books.

Lerner, M. D., & Levine, K. (2007). The Spotlight Program: An integrative approach to teaching social pragmatics using dramatic principles and techniques. *Journal of Developmental Processes, 2,* 91–102.

Lerner, M. D., & Mikami, A. Y. (2012). A preliminary randomized controlled trial of two social skills interventions for youth with high-functioning autism spectrum disorders. *Focus on Autism and Other Developmental Disabilities, 27*(3), 147–157.

Lerner, M. D., Mikami, A. Y., & Levine, K. (2011). Socio-dramatic affective-relational intervention for adolescents with Asperger syndrome and high functioning autism: Pilot study. *Autism: The International Journal of Research and Practice, 15*(1), 21–42.

Lessing, A. (1965). What is wrong with a forgery? *Journal of Aesthetics and Art Criticism, 23*(4), 461–471.

Levinson, J. (1990). *Music, art, and metaphysics,* Ithaca, NY: Cornell University Press.

Levinson, J. (1997). Music and negative emotion. In J. Robinson (Ed.), *Music and meaning* (pp. 215–241). Ithaca, NY: Cornell University Press.

Lévi-Strauss, C. (1964). *Tristes tropiques: An anthropological study of primitive societies in Brazil* (J. Russell, Trans.) New York: Atheneum.

Lévi-Strauss, C. (1969). *The raw and the cooked. Introduction to a science of mythology: I.* New York: Harper & Row.

Levy, F. J. (1995). *Dance and other expressive art therapies: When words are not enough.* New York: Routledge.

Lieberman, P. (2001, December 3). Artistic fact or optical illusion? *Los Angeles Times.* http://articles.latimes.com/2001/dec/03/news/mn-10977

Liljeström, S., Juslin, P. N., & Västfjäll, D. (2013). Experimental evidence of the roles of music choice, social context, and listener personality in emotional reactions to music. *Psychology of Music, 41*(5), 579–599.

Liu, C. H., & Kennedy, J. M. (1994). Symbolic forms can be mnemonics for recall. *Psychonomic Bulletin & Review, 1*(4), 494–498.

Liu, S., Ullman, T. D., Tenenbaum, J. B., & Spelke, E. S. (2017). What's worth the effort: Ten-month-old infants infer the value of goals from the costs of actions. *Science, 358*(6366), 1038–1041.

Lloyd, C., Wong, S. R., & Petchkovsky, L. (2007) Art and recovery in mental health: A qualitative investigation. *British Journal of Occupational Therapy, 70*(5), 207–214.

Loth, R. (2017, February 6). Case against the NEA is not about budgets. *Boston Globe.* https://www.bostonglobe.com/opinion/2017/02/06/trump-case-against-nea-has-nothing-with-budgets/19gNQCZNBMzepunx9GkfFM/story.html#comments

Lowis, M. J. (1998). Music and peak experiences. *Journal of Mankind Quarterly, 39*(2), 203–224.

Ludwig, A. M. (1995). *The price of greatness: Resolving the creativity and madness controversy.* New York: Guilford Press.

Lundholm, H. (1921). The affective tone of lines. *Psychological Review, 28*, 43–60.

Macnamara, B. N., Hambrick, D. Z., & Oswald, F. L. (2014). Deliberate practice and performance in music, games, sports, education, and professions. *Psychological Science, 25*(8), 1608–1618.

Magherini G. (1989). *La sindrome di Stendhal.* Firenze: Ponte Alle Grazie.

Malt, B. (1990). Features and beliefs in the mental representation of categories. *Journal of Memory and Language, 29*, 289–315.

Mar, R. A. (2011). The neural bases of social cognition. *Annual Review of Psychology, 62*, 103–134.

Mar, R. A., & Oatley, K. (2014). The function of fiction is the abstraction and simulation of social experience. *Perspectives on Psychological Science, 3*(3), 173–192.

Mar, R. A., Oatley, K., Hirsh, J., dela Paz, J., & Peterson, J. B. (2006). Bookworms versus nerds: Exposure to fiction versus non-fiction, divergent associations with social ability, and the simulation of fictional social worlds. *Journal of Research in Personality, 40*, 694–712.

Mar, R. A., Oatley, K., & Peterson, J. B. (2009). Exploring the link between reading fiction and empathy: Ruling out individual differences and examining outcomes. *Communications, 34*, 407–428.

Masataka, N. (2006). Preference for consonance over dissonance by hearing newborns of deaf parents and of hearing parents. *Developmental Science, 9*(1), 46–50.

Mas-Herrero, E., Zatorre, R. J., Rodriguez-Fornells, A., & Marco-Pallarés, J. (2014). Dissociation between musical and monetary reward responses in specific musical anhedonia, *Current Biology, 24*, 1–6.

Maslow, A. H. (1968). *Toward a psychology of being* (2nd ed.). New York: Van Nostrand Reinhold.

Mayo, E. (1930). The human effect of mechanization. *American Economic Review, 20*(1), 156–176.

Mazzoni, M., Moretti, P., Pardossi, L., Vista, M., Muratorio, A., & Puglioli, M. J. (1993). A case of music imperception. *Journal of Neurology, Neurosurgery, and Psychiatry, 56*, 322–324.

McDermott, J. H., Schultz, A. F., Undurraga, E. A., & Godoy, R. A. (2016). Indifference to dissonance in native Amazonians reveals cultural variation in music perception. *Nature, 535*(7613), 547–550.

McLain, D. L. (2010, August 28). Skilled at the chessboard, keyboard and blackboard. *New York Times.* http://www.nytimes.com/2010/08/29/crosswords/chess/29chess.html

McReynolds, L. (2013). *Murder most Russian: True crime and punishment in late imperial Russia*. Ithaca: Cornell University Press.

Mebert, C. J., & Michel, G. F. (1980). Handedness in artists. In J. Harron (Ed.), *Neuropsychology of Left-Handedness* (pp. 273–278). New York: Academic Press.

Mehr, S. A., Schachner, A., Katz R. C., & Spelke, E. S. (2013). Two randomized trials provide no consistent evidence for nonmusical cognitive benefits of brief preschool music enrichment. *PLoS ONE 8*(12), e82007.

Meinz, E. J., & Hambrick, D. Z. (2010). Deliberate practice is necessary but not sufficient to explain individual differences in piano sight-reading skill: The role of working memory capacity. *Psychological Science, 21*(7), 914–919.

Melcher, D., & Bacci, F. (2013). Perception of emotion in abstract artworks: A multidisciplinary approach. In S. Finger, D. Zaidel, F. Boller, & J. Bogousslavsky (Eds.), *The fine arts, neurology, and neuroscience. Progress in Brain Research, 204.* Elsevier.

Menninghaus, W., Wagner, V., Hanich, J., Wassiliwizky, E., Jacobsen, T., & Koeslch, S. (2017). The Distancing-Embracing model of the enjoyment of negative emotions in art reception. *Behavioral and Brain Sciences, 40*, 1–58.

Menninghaus, W., Wagner, V., Hanich, J., Wassiliwizky, E., Kuehnast, M., & Jacobsen, T. (2015). Towards a psychological construct of being moved. *PLOS One, 10*(6), 1–33.

Meskin, A., Phelan, M., Moore, M., & Kieran, M. (2013). Mere exposure to bad art. *British Journal of Aesthetics, 53*(2), 39–164.

Meyer, L. (1956). *Emotion and meaning in music*. Chicago: Chicago University Press.

Meyer, L. (1961). On rehearing music. *Journal of the American Musicological Association, 14*(2), 257–267.

Milbrath, C. (1998). *Patterns of artistic development in children: Comparative studies of talent*. Cambridge, UK: Cambridge University Press.

Miller, G. (2011). *The mating mind: How sexual choice shaped the evolution of human nature*. New York: Anchor Books.

Miller, L. (2011, April 11). Just write it! A fantasy author and his impatient fans. *The New Yorker.* http://www.newyorker.com/magazine/2011/04/11/just-write-it

Misailidi, P., & Bonoti, F. (2008). Emotion in children's art: Do young children understand the emotions expressed in other children's drawings? *Journal of Early Childhood Research, 6*(2), 189–200.

Mistry, R. (2010). *A fine balance*. New York: Random House.

Miu, A. C., Pitur, S., & Szentágotai-Tătar, A. (2016). Aesthetic emotions across arts: A comparison between painting and music. *Frontiers in Psychology, 6*, Article 1951.

Mocaiber, I., Perakakis, P., Pereira, M. G., Pinheiro, W. M., Volchan, E., de Oliveira, L., & Vila, J. (2011). Stimulus appraisal modulates cardiac reactivity to briefly presented mutilation pictures. *International Journal of Psychophysiology, 81*(3), 299–304.

Mocaiber, I., Pereira, M. G., Erthal, F. S., Machado-Pinheiro, W., David, I. A., Cagy, M., Volchan, E., & de Oliveira, L. (2010). Fact or fiction? An event-related potential study of implicit emotion regulation. *Neuroscience Letters, 476*, 84–88.

Mocaiber, I., Sanchez, T. A., Pereira, M. G., Erthal, F. S., Joffily, M., Araujo, D. B., Vochan, E., & de Oliveira, L. (2011). Antecedent descriptions change brain reactivity to emotional stimuli: a functional magnetic resonance imaging study of an extrinsic and incidental reappraisal strategy. *Neuroscience, 193*, 241–248.

Moreno, S., Marques, C., Santos, A., Santos, M., Castro, S. L., & Besson, M. (2009). Musical training influences linguistic abilities in 8-year-old children: More evidence for brain plasticity. *Cerebral Cortex, 19*(3), 712–723.

Mori, K., & Iwanaga, I. (2017). Two types of peak emotional responses to music: The psychophysiology of chills and tears. *Scientific Reports, 7*, Article No. 46063.

Mulstein, A. (2017). *The pen and the brush: How passion for art shaped nineteenth-century French novels* (A. Hunter, Trans.). New York: Other Press.

Murfee, E. (1995). Eloquent evidence: Arts at the core of learning. Report by the President's Committee on the Arts and the Humanities.

Murphy, S. T., & Zajonc, R. B. (1993). Affect, cognition and awareness: Affective priming with suboptimal and optimal stimulus. *Journal of Personality and Social Psychology, 64*, 723–729.

Mursell, J. L. (1937). *The psychology of music.* New York: W. W. Norton & Co.

Musiker, C. (2015, September 3). Fighting the empathy deficit: How the arts can make us more compassionate. KQED Arts. https://ww2.kqed.org/arts/2015/09/03/fighting-the-empathy-deficit-how-the-arts-can-make-us-more-compassionate/

Naghshineh, S., Hafler, J. P., Miller, A. R., Blanco, M. A., Lipsitz, S. R., Dubroff, R. P., Khoshbin, S., & Katz, J. T. (2008). Formal art observation training improves medical students' visual diagnostic skills. *Journal of General Internal Medicine, 23*(7), 991–997.

National Center for Education Statistics (NCES) (2012). *Arts Education in Public Elementary and Secondary Schools: 1999-2000 and 2009-10.* Washington DC.

Nemeroff, C., & Rozin, P. (1994). The contagion concept in adult thinking in the United States: Transmission of germs and of interpersonal influence. *Ethos, 22*(2), 158–186.

Nettle, D. (2006). Psychological profiles of professional actors. *Personality Individual Differences, 40*(2), 375–383.

Nettle, D., & Clegg, H. (2006). Schizotype, creativity and mating success in humans. *Proceedings of the Royal Society B, 273*, 611–615.

Neufeld, K. A. (1986). Understanding of selected pre-number concepts: Relationships to a formal music program. *Alberta Journal of Educational Research, 32*(2),134–139.

Newman, G. E. (2016). An essentialist account of authenticity. *Journal of Cognition and Culture, 16*(3-4), 294–321.

Newman, G. E., Bartels, D. M., & Smith, R. K. (2014). Are artworks more like people than artifacts? Individual concepts and their extensions. *Topics in Cognitive Science, 6*(4), 647–662.

Newman, G. E., & Bloom, P. (2012). Art and authenticity: The importance of originals in judgments of value. *Journal of Experimental Psychology: General, 141*(3), 558–569.

Newman, G. E., Diesendruck, G., & Bloom, P. (2011). Celebrity contagion and the value of objects. *Journal of Consumer Research, 38*(2), 215–228.

Nielsen, F. V. (1987). Musical "tension" and related concepts. In T. A. Sebeok & J. Umiker-Sebeok (Eds.), *The semiotic web '86. An international yearbook* (pp. 491–513). Berlin: Mouton de Gruyter.

Nissel, J., Hawley-Dolan, A., & Winner, E. (2016). Can young children distinguish abstract expressionist art from superficially similar works by preschoolers and animals? *Journal of Cognition and Development. 17*(1), 18–29.

Noe, A. (2016). *Strange tools: Art and human nature.* New York: Hill & Wang.

Noguchi, Y., & Murota, M. (2013). Temporal dynamics of neural activity in an integration of visual and contextual information in an esthetic preference task. *Neuropsychologia, 51*(6), 1077–1084.

Nussbaum, M. (1997a). *Cultivating humanity: A classical defense of reform in liberal education.* Cambridge, MA: Harvard University Press.

Nussbaum, M. (1997b). *Poetic justice: The literary imagination and public life.* Boston, MA: Beacon Press.

O'Connor, N., & Hermelin, B. (1983). The role of general ability and specific talents in information processing. *British Journal of Developmental Psychology, 1*(4), 389–403.

Odbert, H. S., Karwoski, T. R., & Eckerson, A. B. (1942). Studies in synesthetic thinking: I. Musical and verbal association of color and mood. *Journal of General Psychology, 26,* 153–173.

O'Hanlon, J. F. (1981). Boredom: Practical consequences and a theory. *Acta Psychologica, 49,* 52–82.

Olson, K. R., & Shaw, A. (2011). 'No fair, copycat!': What children's response to plagiarism tells us about their understanding of ideas. *Developmental Science, 14*(2), 431–439.

O'Neill, F., & Corner, S. F. (2016). Rembrandt's self-portraits. *Journal of Optics, 18,* 8.

O'Neill, M. (2017, February 24). Here's why you should send your kid to an arts camp this summer. *Boston Globe Magazine.* https://www.bostonglobe.com/magazine/2017/02/24/here-why-you-should-send-your-kid-arts-camp-this-summer/XaNEEo6lFxYkMlE8wu79tM/story.html.

Ortega y Gasset, J. (1968). *The dehumanization of art and other essays on art, culture, and literature.* Princeton, NJ: Princeton University Press.

Osgood, C. E. (1960). The cross-cultural generality of visual-verbal synesthetic tendencies. *Behavioral Science, 5*(2), 146–169.

Osgood, C. E. (1964). Semantic differential technique in the comparative study of cultures. *American Anthropologist, 66*(3), 171–200.

Osgood, C. E., Suci, G. J., & Tannenbaum, P. H. (1957). *The measurement of meaning.* Urbana: University of Illinois Press.

Panero, M. E., Goldstein, T. R., Rosenberg, R., Hughes, H., & Winner, E. (2016). Do actors possess traits associated with high hypnotizability? *Psychology of Aesthetics, Creativity, and the Arts, 10*(2), 233–239.

Panero, M. E., Michaels, L., & Winner, E. (in preparation). Becoming a character: Unpacking the link between dissociation and acting.

Panero, M. E., Weisberg, D.S., Black, J., Goldstein, T.R., Barnes, J. L.,Brownell, H., & Winner, E. (2016). Does reading a single passage of literary fiction really improve theory of mind? An attempt at replication. *Journal of Personality and Social Psychology, 111*(5), e46.

Panksepp, J. (1995). The emotional sources of "chills" induced by music. *Music Perception, 13*(2), 171–207.

Pariser, D., & van den Berg, A. (1997). The mind of the beholder: Some provisional doubts about the U-curved aesthetic development thesis. *Studies in Art Education, 38*(3), 158–178.

Partner, J. (2002). Review: Secret knowledge: Rediscovering the lost techniques of the old masters. *Cambridge Quarterly, 31*(4), 345–349.

Patel, A. D. (2008). *Music, language, and the brain.* Oxford, UK: Oxford University Press.

Patel, A. D., Iversen, J. R., Bregman, M. R., & Schulz, I. (2009). Experimental evidence for synchronization to a musical beat in a nonhuman animal. *Current Biology, 19*(10), 827–830.

Pelowski, M. (2015). Tears and transformation: Feeling like crying as an indicator of aesthetic or insightful experience with art. *Frontiers in Psychology, 6,* Article 10006, 1–23.

Pelowski, M., Liu, T., Palacios, V., & Akiba, F. (2014). When a body meets a body: An exploration of the negative impact of social interactions on museum experiences of art. *International Journal of Education and the Arts, 15*(14), 1–47.

Peretz I., Gagnon L., & Bouchard B. (1998). Music and emotion: Perceptual determinants, immediacy, and isolation after brain damage. *Cognition, 68,* 111–41.

Perry, M., Maffulli, N., Willson, S., & Morrissey, D. (2011). The effectiveness of arts-based interventions in medical education: A literature review. *Medical Education, 45*(2), 141–148.

Peterson, J. M. (1979). Left-handedness: Differences between student artists and scientists. *Perceptual and Motor Skills, 48*(3), 961–962.

Pettit, P. (1983). The possibility of aesthetic realism. In E. Shaper (Ed.), *Pleasure, preference and value: Studies in philosophical aesthetics* (pp. 17–38). Cambridge, UK: Cambridge University Press.

Piaget, J. (1951). *Play, dreams, and imitation in childhood.* New York: Routledge

Pinker, S. (2009). *How the mind works.* New York: Norton.

Podlozny, A. (2000). Strengthening verbal skills through the use of classroom drama: A clear link. *Journal of Aesthetic Education, 34*(3-4), 91–104.

Poffenberger, A. T., & Barrows, B. E. (1924). The feeling value of lines. *Journal of Applied Psychology, 8,* 187–205.

Posner, J., Russell, J. A., & Peterson, B. S. (2005). The circumplex model of affect: An integrative approach to affective neuroscience, cognitive development, and psychopathology. *Developmental Psychopathology, 17*(3), 715–734.

Pratt, C. (1952). *Music as the language of emotion.* Washington, DC: Library of Congress.

Rabb, N., Brownell, H., & Winner, E. (2018). Essentialist beliefs in aesthetic judgments of duplicate artworks. *Psychology of Aesthetics, Creativity, and the Arts.* Online First Publication, May 24.

Rabb, N., Han, Nebeker, & Winner, E. (2018). Unwavering metaaesthetic beliefs and the case for expressivism. Submitted for publication.

Rabb, N., & Winner, E. (2017a). Confronted with art: How children and adults classify visual art works and understand their purpose. Manuscript in preparation.

Rabb, N., & Winner, E. (2017b). Linguistic hedges may reveal what kind of category we think art is. Manuscript in preparation.

Rabkin, N., & Redmond, R. (Eds.). (2004). *Putting the arts in the picture: Reframing education in the 21st century.* Chicago: Columbia College.

Railton, P. (2003). *Facts, values, and norms: Essays toward a morality of consequence.* Cambridge, UK: Cambridge University Press.

Ramachandran, V. S. (2011). *The tell-tale brain: A neuroscientist's quest for what makes us human.* New York: Norton.

Rauscher, F. H., & Hinton, S. C. (2011). Music instruction and its diverse extra-musical benefits. *Music Perception, 29*(2), 215–226.

Rauscher, F. H., Shaw, G. L., & Ky, K. N. (1993). Music and spatial task performance. *Nature, 365*(6447): 611.

Reece, F. (2017). Music and truth. Talk presented at the fifth annual Harvard Horizons Symposium, April 12, 2017. https://www.youtube.com/watch?v=1PI9UFsTvgY

Rentfrow, P. J., & Gosling, S. D. (2003). The do re mi's of everyday life. The structure and personality correlates of music preferences. *Journal of Personality and Social Psychology, 84*, 1236–1256.

Richards, R. (1996). Beyond Piaget: Accepting divergent, chaotic, and creative thought. *New Directions for Child and Adolescent Development, 72*, 67–86.

Richardson J. (1991). *A life of Picasso.* New York: Random House.

Roberts, J. L. (2013). The power of patience: Teaching students the value of deceleration and immersive attention. *Harvard Magazine*, November-December, 40–43.

Rodman, S., & Eliot, A. (1961). *Conversations with artists.* New York: Capricorn.

Rorty, R. (1989). *Contingency, irony, and solidarity.* Cambridge, UK: Cambridge University Press.

Rosand, D. (1988). *The meaning of the mark: Leonardo and Titian.* Lawrence, KS: Spencer Museum of Art, University of Kansas.

Rosenblatt, E., & Winner, E. (1988). The art of children's drawing. *Journal of Aesthetic Education, 22*(1), 3–15.

Ross, A. (2016, July 4). When music is violence. *The New Yorker.* http://www.newyorker.com/magazine/2016/07/04/when-music-is-violence

Rothko, M. (2006). *Writings on art* (M. Lopez-Remiro, Ed.). New Haven, CT: Yale University Press.

Rozin, P., Guillot, L., Fincher, K., Rozin, A., & Tsukayama, E. (2013). Glad to be sad, and other examples of benign masochism. *Judgment and Decision Making, 8*(4), 439–447.

Ruppert, S. (2006). *Critical evidence: How the arts benefit student achievement.* National Assembly of State Arts Agencies.

Russell, B. (1960). Notes on philosophy, January 1960. *Philosophy, 35*, 146–7.

Russell, J. A. (1980). A circumplex model of affect. *Journal of Personality and Social Psychology, 39*, 1161–1178.

Russell, J. A. (2003). Core affect and the psychological construction of emotion. *Psychological Review, 110*, 145–172.

Sachs, M. E., Damasio, A., & Habibi, A. (2015). The pleasures of sad music: A systematic review. *Frontiers in Human Neuroscience, 9*, 404.

Sagoff, M. (1976). The aesthetic status of forgeries. *Journal of Aesthetics and Art Criticism, 35*(2), 169–180.

Sala, G., & Gobet, F. (2017). When the music's over. Does music skill transfer to chilren's and young adolescent's cognitive and academic skills? A meta-analysis. *Educational Research Review, 20*, 55–67.

Salimpoor, V. N., Benovoy, M., Larcher, K., Dagher, A., & Zatorre, R. J. (2011). Anatomically distinct dopamine release during anticipation and experience of peak emotion to music. *Nature Neuroscience, 14*(2), 257–264.

Salomon, G., & Perkins, D. N. (1989). Rocky roads to transfer: Rethinking mechanisms of a neglected phenomenon. *Educational Psychologist, 24*(2), 113–142.

Saltz, J. (2012). RIP Thomas Kinkade. http://www.artnet.com/magazineus/features/saltz/rip-thomas-kinkade-4-10-12.asp

Samur, D., Tops, M., & Koole, S. L. (2017). Does a single session of reading literary fiction prime enhanced mentalising performance? Four replication experiments of Kidd and Castano (2013). *Cognition and Emotion, 32*, 130–144.

Sapir, E. (1929). A study in phonetic symbolism. *Journal of Experimental Psychology, 12*, 225–239.

Satoh, M., Nakase, T., Nagata, K., & Tomimoto, H. (2011). Musical anhedonia: Selective loss of emotional experience in listening to music. *Neurocase: The Neural Basis of Cognition, 17*, 410–417.

Schachner, A., Brady, T. F., Pepperberg, I. M., & Hauser, M. D. (2009). Spontaneous motor entrainment to music in multiple vocal mimicking species. *Current Biology, 19*(10), 831–836.

Schaefer-Simmern, H. (1948). *The unfolding of artistic activity: Its basis, processes, and implications.* Berkeley: University of California Press.

Schellenberg, E. G. (2004). Music lessons enhance IQ. *Psychological Science, 15*, 511–514.

Schellenberg, E. G. (2009). Music training and nonmusical abilities: Commentary on Stoesz, Jakobson, Kilgour, and Lewycky (2007) and Jakobson, Lewycky, Kilgour, and Stoesz (2008). *Music Perception, 27*(2), 139–143.

Schellenberg, E. G., & Moreno, S. (2010). Music lessons, pitch processing, and g. *Psychology of Music, 38*, 209–221.

Scherer, K. R. (2004). Which emotions can be induced by music? What are the underlying mechanisms? And how can we measure them? *Journal of New Music Research, 33*(3), 239–251.

Scherer, K., Banse, R., & Wallbott, H. G. (2001). Emotion inferences from vocal expression correlate across languages and cultures. *Journal of Cross-Cultural Psychology, 32*, 76–92.

Scherer, K., R., Zentner, M. R., & Schacht, A. (2001-2002). Emotional states generated by music: An exploratory study of music experts. *Musicae Scientiae*, Special issue 2001-2, 149–71.

Schjeldahl, P. (2005, March 7). Drawing lines: "Cy Twombly at the Whitney." *The New Yorker.* http://www.newyorker.com/magazine/2005/03/07/drawing-lines

Schopenhauer, A. (1966). *The world as will and representation* (E.F.J. Payne, Trans.). New York: Dover Publications, Inc.

Schubert E. (2004). Modelling perceived emotion with continuous musical features. *Music Perception: An Interdisciplinary Journal, 21*(4), 561–585.

Schubert, E. (2013). Emotion felt by the listener and expressed by the music: Literature review and theoretical perspectives. *Frontiers in Psychology, 4*, Article 837.

Scruton, R. (1998) *Art and imagination: A study in the philosophy of mind.* South Bend, IN: St. Augustine's Press.

Scruton, R. (2007). In search of the aesthetic. *British Journal of Aesthetics, 47*(3), 232–250.

Seghers, E. (2015). The artful mind: A critical review of the evolutionary psychological study of art. *British Journal of Aesthetics, 55*(2), 225–248.

Seiberling, D. (1959). The varied art of four pioneers. *Life, 47*(20), 74–86.

Seidel, A., & Prinz, J. (2017). Great works: A reciprocal relationship between spatial magnitudes and aesthetic judgment. *Psychology of Aesthetics, Creativity, and the Arts, 12*(1), 2–10.

Senior, J. (2017, April 27). A requiem for pain and secrets. *New York Times*, C1, 4. https://www.nytimes.com/2017/04/26/books/review-elizabeth-strout-anything-is-possible.html

Shamir, L. (2012). Computer analysis reveals similarities between the artistic styles of Van Gogh and Pollock. *Leonardo 45*(2), 149–154.

Shamir, L., Macura, N., Orlov, D. M., Eckley, I., & Goldberg, I. G. (2010). Impressionism, expressionism, surrealism: Automated recognition of painters and schools of art. *ACM Transactions on Applied Perception 7*(2), 8.

Shamir, L., Nissel, J., & Winner, E. (2016). Distinguishing between abstract art by artists vs. children and animals: Comparison between human and machine perception. *ACM Transactions on Applied Perception, 13*(3), Article 17.

Siegal, N. (2017, September 20). A painting emerges as a tale of caution. *New York Times*, C1.

Sievers, B., Polansky, L., Casey, M., & Wheatley, T. (2013). Music and movement share a dynamic structure that supports universal expressions of emotion. *Proceedings of the National Academy of Sciences of the United States of America, 110*(1), 70–75.

Simonton, D. K. (1994). *Greatness: Who makes history and why.* New York: Guilford Press.

Slayton, S. C., D'Archer, J., & Kaplan, F. (2010). Outcome studies on the efficacy of art therapy: A review of findings. *Art Therapy: Journal of the American Art Therapy Association, 27*(3), 108–119.

Sloboda, J. (1991). Music structure and emotional response: Some empirical findings. *Psychology of Music, 19*, 110–120.

Smith, B. D., Meyers, M. B., & Kline, R. (1989). For better or for worse: Left-handedness, pathology, and talent. *Journal of Clinical and Experimental Neuropsychology, 11*(6), 944–958.

Smith, J. K., Smith, L. F., & Tinio, P. L. (2017). Time spent viewing art and reading labels. *Psychology of Aesthetics, Creativity, and the Arts, 11*(1), 77–85.

Smith, R. K., & Newman, G. E. (2014). When multiple creators are worse than one: The bias toward single authors in the evaluation of art. *Psychology of Aesthetics, Creativity, and the Arts, 8*(3), 303–310.

Smith, R. K., Newman, G. E., & Dhar, R. (2015). Closer to the creator: Temporal contagion explains the preference for earlier serial numbers. *Journal of Consumer Research, 42*(5), 653–668.

Smolarski, K., Leone, K., & Robbins, S. J. (2015). Reducing negative mood through drawing: Comparing venting, positive expression, and tracing. *Art Therapy: Journal of the American Art Therapy Association, 32*(4), 197–201.

Snapper, L., Oranç, C., Hawley-Dolan, A., Nissel, J., & Winner, E. (2015). Your kid could not have done that: Even untutored observers can discern intentionality and structure in abstract expressionist art. *Cognition 137*, 154–165.

Specht, S. M. (2007). Successive contrast effects for judgments of abstraction in artwork following minimal pre-exposure. *Empirical Studies of the Arts, 25*(1), 63–70.

Stanovich, K. E., & West, R. F. (1989). Exposure to print and orthographic processing. *Reading Research Quarterly, 24*, 402–433.

Steadman, P. (2002). *Vermeer's camera*. Oxford, UK: Oxford University Press.

Steinberg, L. (1955). Month in review: Fifteen years of Jackson Pollock. *Arts, 30*(3), 43–44, 46.

Stendhal (1959). *Rome, Naples, and Florence* (R. N. Coe, Trans.). London: John Calder.

Strait, D. L., Hornickel, J., & Kraus, N. (2011). Subcortical processing of speech regularities underlies reading and music aptitude in children. *Behavioral and Brain Functions, 7*, 44.

Strauss, J. (1978). Jean Jacques Rousseau: Musician. *Musical Quarterly, 64*, 474–482.

Stravinsky, I. (1936). *Stravinsky: An autobiography*. New York: Simon and Schuster.

Stuckey, H. L., & Nobel, J. (2010). The connection between art, healing, and public health: A review of current literature. *American Journal of Public Health, 100*(2), 254–263.

Sulloway, F. J. (1996). *Born to rebel: Birth order, family dynamics, and creative lives*. New York: Pantheon Books.

Swaminathan, S., Schellenberg, E. G., & Khalil, S. (2017). Revisiting the association between music lessons and intelligence. Training effects of music aptitude? *Intelligence, 62*, 119–124.

Takahashi, S. (1995). Aesthetic properties of pictorial perception. *Psychological Review, 102*(4), 671–683.

Tamborini, R., Stiff, J., & Heidel, C. (1990). Reacting to graphic horror: A model of empathy and emotional behavior. *Communication Research, 17*(5), 616–640.

Tamir, D. I., Bricker, A. B., Dodell-Feder, D., & Mitchell, J. P. (2016). Reading fiction and reading minds: The role of simulation in the default network. *Social Cognitive and Affective Neuroscience, 11*(2), 215–224.

Taruffi, L., & Koelsch, S. (2014). The paradox of music-evoked sadness: An online survey. *PLoS ONE, 9*(10), e110490.

Temkin, A., & Kelly, E. (2013). *Chatham series*. New York: Museum of Modern Art Publications.

Terhardt, E. (1984). The concept of musical consonance: A link between music and psychoacoustics. *Music Perception: An Interdisciplinary Journal, 1*(3), 276–295.

Thompson, W. F. (2009). *Music, thought, and feeling. Understanding the psychology of music*. Oxford, UK: Oxford University Press.

Thompson, W. F., Schellenberg, E. G., & Husain, G. (2001). Arousal, mood, and the Mozart effect. *Psychological Science, 12*(3), 248–251.

Thorndike, E. L. (1924). Mental discipline in high school studies. *Journal of Educational Psychology, 15*(1), 98.

Thorndike, E. L., & Woodworth, R. S. (1901). The influence of improvement in one mental function upon the efficiency of other functions (I). *Psychological Review, 8*, 247–261.

Tolstoy, L. (1897/1930). *What is art?* Oxford, UK: Oxford University Press.

Tooby, J., & Cosmides, L. (2001). Does beauty build adapted minds? Toward an evolutionary theory of aesthetics, fiction and the arts. *SubStance, 30*, No. 1/2 (94/95), 6–27.

Tommasini, A. (2017, July 30). Trump is wrong if he thinks symphonies are superior. *The New York Times*. https://www.nytimes.com/2017/07/30/arts/music/trump-classical-music.html?mwrsm=Email

Tooby, J., & Cosmidis, L. (2001). Does beauty build adapted minds? Toward an evolutionary theory of aesthetics, fiction, and the arts. *SubStance, 30*(94/95), 6–27.

Toyoshima, K., Fukui, H., & Kuda, K. (2011). Piano playing reduces stress more than other creative art activities. *International Journal of Music Education, 29*, 257–264.

Trost, W., Ethofer, T., Zentner, M., & Vuilleumier, P. (2012). Mapping aesthetic musical emotions in the brain. *Cerebral Cortex, 22*, 2769–2783.

Tsay, C.-J., & Banaji, M. R. (2011). Naturals and strivers: Preferences and beliefs about sources of achievement. *Journal of Experimental Social Psychology, 47*, 460–465.

Uedo, N., Ishikawa, H., Morimoto, K., Ishihara, R., Narahara, H., Akedo, I., . . . Fukuda, S. (2004). Reduction in salivary cortisol level by music therapy during colonoscopic examination. *Hepato-Gastroenterology, 51*, 451–453.

Valladas, H., Clottes, J., Geneste, J.-M., Garcia, M. A., Arnold, M., Cahier, H., & Tisnérat-Laborde, N. (2001). Palaeolithic paintings: Evolution of prehistoric cave art. *Nature, 413*(6855), 479. doi: 10.1038/35097160

Van Dongen, N. N., Van Strien, J. W., & Dijkstra, K. (2016). Implicit emotion regulation in the context of viewing artworks: ERP evidence in response to pleasant and unpleasant pictures. *Brain and Cognition, 107*, 48–54.

van Gogh, V. (1882). Letter to Theo van Gogh (May 1). (R. Harrison, Ed. & J. van Gogh-Bonger, Trans.), No. 195. http://webexhibits.org/vangogh/letter/11/195.htm.

Varnedoe, K. (1994). Your kid could *not* do this, and other reflections on Cy Twombly. *MoMA, 18*, Autumn-Winer, 18–23.

Varnedoe, K. (2006). *Pictures of nothing: Abstract art since Pollock* (The A.W. Mellon Lectures in the Fine Arts). Princeton, NJ: Princeton University Press.

Vartanian, H. (2013, April 30). Some of the best responses to "My kid could do that." *Hyperallergic.* http://hyperallergic.com/69997/some-of-the-best-reponses-to-my-kid-could-do-that

Vaughn, K., & Winner, E. (2000). SAT scores of students who study the arts: What we can and cannot conclude about the association? *Journal of Aesthetic Education, 34*(3-4), 77–89.

Vendler, H. (2002). A life of learning. Charles Homer Haskins Lecture for 2001. *ACLS Occasional Paper*, No. 50, 1–18.

Vessel, E., Starr, G., & Rubin, N. (2012). The brain on art: Intense aesthetic experience activates the default mode network. *Frontiers in Human Neuroscience, 6*, Article 66, 1–17.

Vezzali, L., Stathi, S., Giovannini, E., Capozza, D., & Trifiletti, E. (2015). The greatest magic of Harry Potter: Reducing prejudice. *Journal of Applied Social Psychology, 45*(2), 105–121.

Volkov, S., & Shostakovich, D. D. (1979). *Testimony: The memoirs of Dmitri Shostakovich.* New York: Harper & Row.

Vollaro, D. R. (2009). Lincoln, Stowe, and the "Little Woman/Great War" story: The making, and breaking, of a great American anecdote. *Journal of the Abraham Lincoln Association, 30*(1), 18–34.

von Zastrow, C., & Janc, H. (2004). Academic atrophy: The condition of the liberal arts in America's public schools: A report to the Carnegie Corporation of New York. Washington, DC: Council for Basic Education.

Vygotsky L. S. (1967) Play and its role in the mental development of the child. *Soviet Psychology, 12,* 6–18.

Wagner, V., Menninghaus, W., Hanich, J., & Jacobsen, T. (2014). Art schema effects on affective experience: The case of disgusting images. *Psychology of Aesthetics, Creativity, and the Arts, 8,* 120–129.

Wakeford, M. (2004). A short look at a long past. In N. Rabkin & R. Redmond (Eds.), *Putting the arts in the picture: Reframing education in the 21st century* (pp. 81–102). Chicago: Columbia College.

Wassiliwizky, E., Wagner, V., Jacobsen, T., & Menninghaus. W. (2015). Art-elicited chills indicate states of being moved. *Psychology of Aesthetics, Creativity, and the Arts, 9*(43), 405–416.

Watanabe S. (2001) Van Gogh, Chagall and pigeons. *Animal Cognition, 4*(3-4), 147–151.

Watanabe S. (2011) Discrimination of painting style and quality: Pigeons use different strategies for different tasks. *Animal Cognition, 14,* 797–808.

Watanabe, S. (2013). Preference for and discrimination of paintings by mice. *PLoS ONE 8*(6), e65335. doi:10.1371/journal.pone.0065335

Watson, D., Clark, L. A., & Tellegen, A. (1988). Development and validation of brief measures of positive and negative affect: The PANAS scales. *Journal of Personality and Social Psychology, 54*(6), 1063.

Weeden, R. E. (1971). *A comparison of the academic achievement in reading and mathematics of Negro children whose parents are interested, not interested, or involved in a program of Suzuki violin* (Unpublished doctoral dissertation). North Texas State University.

Weitz, J. H. (1996). *Coming up taller: Arts and humanities programs for children and youth at risk.* President's Committee on the Arts and Humanities, Washington, DC.

Weitz, M. (1956). The role of theory in aesthetics. *Journal of Aesthetics and Art Criticism, 15,* 27–35.

Wellman, H. M., Cross, E., & Watson, J. (2001). Meta-analysis of theory-of-mind development: The truth about false belief. *Child Development, 72*(3), 655–684.

Werker, J. F., & Hensch, T.K. (2015). Critical periods in speech perception: New directions. *Annual Review of Psychology, 66,* 173–196.

Wexner, L. B. (1954). The degree to which colors (hues) are associated with mood tones. *Journal of Applied Psychology, 38,* 432–435.

Whiten, A. (1991). *Natural theories of mind: Evolution, development and simulation of everyday mindreading.* Oxford, UK: Basil Blackwell.

Whiten, A., & Byrne, R. W. (1988). Tactical deception in primates. *Behavioral and Brain Sciences, 11*(2), 233–273.

Wilson, J. (2018). Dostoyevsky and today's 'true crime.' *New York Times,* May 29, A23.

Winner, E. (1979). New names for old things: The emergence of metaphoric language. *Journal of Child Language, 6*(3), 469–491.

Winner, E. (1982). *Invented worlds: The psychology of the arts.* Cambridge, MA: Harvard University Press.

Winner, E. (1988). *The point of words: Children's understanding of metaphor and irony.* Cambridge, MA: Harvard University Press.

Winner, E. (1996). *Gifted children: Myths and realities.* New York: Basic Books.

Winner, E. (2004). Art history can trade insights with the sciences. *Chronicle of Higher Education,* July 2, B10–B12.

Winner, E. (2006). Development in the arts: Drawing and music. In W. Damon (Ed.), *Handbook of child psychology* (Vol. 2, pp. 859–904). New York: Wiley.

Winner, E., Blank, P., Massey, C., & Gardner, H. (1983). Children's sensitivity to aesthetic properties of line drawings. In J. Sloboda & D. Rogers (Eds.), *The acquisition of symbolic skills* (pp. 97–107). London: Plenum Press.

Winner, E., & Casey, M. B. (1992). Cognitive profiles of artists. In G. C. Cupchik & J. László (Eds.), *Emerging visions of the aesthetic process: In psychology, semiology, and philosophy* (pp. 154–170). Cambridge, UK: Cambridge University Press.

Winner, E., Casey, M. B., Dasilva, D., & Hayes, R. (1991). Spatial abilities and reading deficits in visual art students. *Empirical Studies of the Arts,* 9(1), 51–63.

Winner, E., & Cooper, M. (2000). Mute those claims: No evidence (yet) for a causal link between arts study and academic achievement. *Journal of Aesthetic Education,* 34(3-4), 11–75.

Winner, E., & Gardner, H. (1981). The art in children's drawings. *Review of Research in Visual Arts Education,* 18–31.

Winner, E., Goldstein, T. R., & Vincent-Lancrin, S. (2013). Art for art's sake? The impact of arts education. Educational Research and Innovation, OECD Publishing. http://www.oecd.org/edu/ceri/arts.htm

Winner, E., & Hetland, L. (Eds.). (2000). The arts and academic achievement: What the evidence shows. *Journal of Aesthetic Education,* 34(3-4), 3–307.

Wittgenstein, L. (1953). *Philosophical investigations.* New York: Macmillan.

Wollheim, R. (1980). *Art and its objects.* Cambridge: Cambridge University Press.

Wolz, S. H., & Carbon, C. C. (2014). What's wrong with an art fake? Cognitive and emotional variables influenced by authenticity status of artworks. *Leonardo,* 47(5), 467–473.

Wypijewski, J. (Ed.). (1997). *Painting by numbers: Komar and Melamid's scientific guide to art.* New York: Farrar Straus & Giroux.

Zajonc, R. B. (1968). Attitudinal effects of mere exposure. *Journal of Personality and Social Psychology Monograph Supplement* 9, 1–27.

Zatorre, R. (2016). Amazon music. *Nature,* 535, 496–497.

Zatorre, R. J., Chen, J. L., & Penhune, V. B. (2007). When the brain plays music: Auditory–motor interactions in music perception and production. *Nature Reviews: Neuroscience,* 8, 547–558.

Zeki, S. (1999). *Inner vision: An exploration of art and the brain.* Oxford, UK: Oxford University Press.

Zentner, M. R., Grandjean, E., & Scherer, K. R. (2008). Emotions evoked by the sound of music: Characterization, classification, and measurement. *Emotion,* 8, 494–521.

Zhensun, Z., & Low, A. (1991). *A young painter: The life and paintings of Wang Yani—China's extraordinary young artist.* New York: Scholastic.

Zuk, J., Ozernov-Palchik, O., Kim, H., Lakshminarayanan, K., Gabrieli, J. D., Tallal, P., & Gaab, N. (2013). Enhanced syllable discrimination thresholds in musicians. *PLoS ONE 8*(12), e80546. doi: 10.1371/journal.pone.0080546

Zunshine, L. (2006). *Why we read fiction: Theory of mind and the novel.* Columbus, OH: Ohio State University Press.

Zwaan, R. A. (1991). Some parameters of literary and news comprehension: Effects of discourse-type perspective on reading rate and surface structure representation. *Poetics, 20,* 139–156.

CPSIA information can be obtained
at www.ICGtesting.com
Printed in the USA
BVHW031448010922
646039BV00009B/14/J